The Palace Museum's Essential Collections

CHINESE TEXTILES AND EMBROIDERIES

The Commercial Press

CHINESE TEXTILES AND EMBROIDERIES

Chief Editor	Yan Yong 嚴勇
Deputy Chief Editor	Ruan Weiping 阮衛萍 , Zhang Qiong 張瓊 , Fang Hongjun 房宏俊
Editorial Board	Yuan Hongqi 苑洪琪 , Zhang Xin 章新 , Jing Wen 景聞 , Liang Ke 梁科 , Wang Hebei 王鶴北 , Yang Zitong 楊紫彤
Photographers	Hu Chui 胡錘 , Liu Zhigang 劉志崗 , Zhao Shan 趙山 , Feng Hui 馮輝 , Tian Mingjie 田明潔
Translator	Evangeline Almberg 吳兆朋
Editorial Consultant	Hang Kan 杭侃
Project Editors	Xu Xinyu 徐昕宇 , Fu Mei 傅薇
Cover Design	Zhang Yi 張毅
Published by	The Commercial Press (Hong Kong) Ltd. Eastern Central Plaza, 8/F, 3 Yiu Hing Rd, Shau Kei Wan, Hong Kong http://www.commercialpress.com.hk
Printed by	C & C Offset Printing Co., Ltd. C & C Building, 36 Ting Lai Road, Tai Po, N.T., Hong Kong
Edition	First Edition in December 2016
	© 2016 The Commercial Press (H.K.) Ltd.
	All rights reserved.
	ISBN 978 962 07 5665 8
	Printed in Hong Kong

Introducing the Palace Museum to the World

SHAN JIXIANG

Built in 1925, the Palace Museum is a comprehensive collection of treasures from the Ming and Qing dynasties and the world's largest treasury of ancient Chinese art. To illustrate ancient Chinese art for people home and abroad, the Palace Museum and The Commercial Press (Hong Kong) Ltd. jointly published *The Complete Collection of Treasures of the Palace Museum*. The series contains 60 books, covering the rarest treasures of the Museum's collection. Having taken 14 years to complete, the series has been under the limelight among Sinologists. It has also been cherished by museum and art experts.

After publishing *The Complete Collection of Treasures of the Palace Museum*, it is understood that westerners, when learning about Chinese traditional art and culture, are particularly fond of calligraphy, paintings, ceramics, bronze ware, jade ware, furniture, and handicrafts. That is why The Commercial Press (Hong Kong) Ltd. has discussed with the Palace Museum to further co-operate and publish a new series, *The Palace Museum's Essential Collections*, in English, hoping to overcome language barriers and help more readers to know about traditional Chinese culture. Both parties regard the publishing of the series as an indispensable mission for Chinese history with significance in the following aspects:

First, with more than 3,000 pictures, the series has become the largest picture books ever in the publishing industry in China. The explanations show the very best knowledge from four generations of scholars spanning 90 years since the construction of the Museum.

Second, the English version helps overcome language and cultural barriers between the east and the west, facilitating the general public's knowledge of Chinese culture. By doing so, traditional Chinese art will be given a fresher image, becoming more approachable among international art circles.

Third, the series is going to further people's knowledge about the Palace Museum. According to the latest statistics, the Palace Museum holds more than 1.8 million pieces of artefacts (among which 228,771 pieces have been donated by the general public and purchased or transferred by the government since 1949). The series selects nearly 3,000 pieces of the rare treasures, together with more than 12,000 pieces from *The Complete Collection of Treasures of the Palace Museum*. It is believed that the series will give readers a more comprehensive view of the Palace Museum.

Just as *The Palace Museum's Essential Collections* is going to be published, I cannot help but think of Professor Qi Gong from Beijing Normal University; famous scholars and researchers of the Palace Museum Mr. Xu Bangda, Mr. Zhu Jiajin, and Mr. Liu Jiu'an; and well-known intellectuals Mr. Wu Kong (Deputy Director of Central Research Institute of Culture and History) and Mr. Xu Qixian (Director of Research Office of the Palace Museum). Their knowledge and relentless efforts are much appreciated for showing the treasures of the Palace Museum to the world.

Looking at History through Art

YANG XIN

The Palace Museum boasts a comprehensive collection of the treasures of the Ming and Qing dynasties. It is also the largest museum of traditional art and culture in China. Located in the urban centre of Beijing, this treasury of ancient Chinese culture covers 720,000 square metres and holds nearly 2 million pieces of artefacts.

In the fourth year of the reign of Yongle (1406 A.D.), Emperor Chengzu of Ming, named Zhu Di, ordered to upgrade the city of Beiping to Beijing. His move led to the relocation of the capital of the country. In the following year, a grand new palace started to be built at the site of the old palace in Dadu of the Yuan Dynasty. In the 18th year of Yongle (1420 A.D.), the palace was completed and named as the Forbidden City. Since then the capital of the Ming Dynasty moved from Nanjing to Beijing. In 1644 A.D., the Qing Dynasty superceded the Ming empire and continued using Beijing as the capital and the Forbidden City as the palace.

In accordance with the traditional ritual system, the Forbidden City is divided into the front part and the rear part. The front consists of three main halls, namely Hall of Supreme Harmony, Hall of Central Harmony, and Hall of Preserving Harmony, with two auxiliary halls, Hall of Literary Flourishing and Hall of Martial Valour. The rear part comprises three main halls, namely Hall of Heavenly Purity, Hall of Union, Hall of Earthly Tranquillity, and a cluster of six halls divided into the Eastern and Western Palaces, collectively called the Inner Court. From Emperor Chengzu of Ming to Emperor Puyi, the last emperor of Qing, 24 emperors together with their queens and concubines lived in the palace. The Xinhai Revolution in 1911 overthrew the Qing Dynasty and more than 2,000 years of feudal governance came to an end. However, members of the court such as Emperor Puyi were allowed to stay in the rear part of the Forbidden City. In 1914, Beiyang government of the Republic of China transferred some of the objects from the Imperial Palace in Shenyang and the Summer Palace in Chengde to form the Institute for Exhibiting Antiquities, located in the front part of the Forbidden City. In 1924, Puyi was expelled from the Inner Court. In 1925, the rear part of the Forbidden City was transformed into the Palace Museum.

Emperors across dynasties called themselves "sons of heaven", thinking that "all under the heaven are the emperor's land; all within the border of the seashore are the emperor's servants" ("Decade of Northern Hills, Minor Elegance", *Book of Poetry*). From an emperor's point of view, he owned all people and land within the empire. Therefore, delicate creations of historic and artistic value and bizarre treasures were offered to the palace from all over the country. The palace also gathered the best artists and craftsmen to create novel art pieces exclusively for the court. Although changing of rulers and years of wars caused damage to the country and unimaginable loss of the court collection, art objects to the palace were soon gathered again, thanks to the vastness and long history of the country, and the innovativeness of the people. During the reign of Emperor Qianlong of the Qing Dynasty (1736 A.D. – 1796 A.D.), the scale of court collection reached its peak. In the final years of the Qing Dynasty, however, the invasion of Anglo-French Alliance and the Eight-Nation Alliance into Beijing led to the loss and damage of many art objects. When Puyi abdicated from his throne, he took away plenty of the objects from the palace under the name of giving them out as presents or entitling them to others. His servants followed suit. Up till 1923, the keepers of treasures of Palace of Established Happiness in the Inner Court actually stole the objects, set fire on them, and caused serious dam-

age to the Qing Court collection. Numerous art objects were lost within a little more than 60 years. In spite of all these losses, there was still a handsome amount of collection in the Qing Court. During the preparation of construction of the Palace Museum, the "Qing Rehabilitation Committee" checked that there were around 1.17 million items and the Committee published the results in the *Palace Items Auditing Report*, comprising 28 volumes in 6 editions.

During the Sino-Japanese War, there were 13,427 boxes and 64 packages of treasures, including calligraphy and paintings, picture books, and files, transferred to Shanghai and Nanjing in five batches for fear of damage and loot. Some of them were scattered to other provinces such as Sichuan and Guizhou. The art objects were returned to Nanjing after the Sino-Japanese War. Owing to the changing political situation, 2,972 pieces of treasures temporarily stored in Nanjing were transferred to Taiwan from 1948 to 1949. In the 1950s, most of the antiques were returned to Beijing, leaving only 2,211 boxes of them still in the storage room in Nanjing built by the Palace Museum.

Since the establishment of the People's Republic of China, the organization of the Palace Museum has been changed. In line with the requirement of the top management, part of the Qing Court books were transferred to the National Library of China in Beijing. As to files and essays in the Palace Museum, they were gathered and preserved in another unit called "The First Historical Archives of China".

In the 1950s and 1960s, the Palace Museum made a new inventory list for objects kept in the museum in Beijing. Under the new categorization system, objects which were previously labelled as "vessels", such as calligraphy and paintings, were grouped under the name of "*gu* treasures". Among them, 711,388 pieces which belonged to old Qing collection were labelled as "old", of wh2ich more than 1,200 pieces were discovered from artefacts labelled as "objects" which were not registered before. As China's largest national museum, the Palace Museum has taken the responsibility of protecting and collecting scattered treasures in the society. Since 1949, the Museum has been enriching its collection through such methods as purchase, transfer, and acceptance of donation. New objects were given the label "new". At the end of 1994, there were 222,920 pieces of new items. After 2000, the Museum re-organized its collection. This time ancient books were also included in the category of calligraphy. In August 2014, there were a total of 1,823,981 pieces of objects in the museum's collection. Among them, 890,729 pieces were "old", 228,771 pieces were "new", 563,990 were "books", and 140,491 pieces were ordinary objects and specimens.

The collection of nearly two million pieces of objects is an important historical resource of traditional Chinese art, spanning 5,000 years of history from the primeval period to the dynasties of Shang, Zhou, Qin, Han, Wei, and Jin, Northern and Southern Dynasties, dynasties of Sui, Tang, Northern Song, Southern Song, Yuan, Ming, Qing, and the contemporary period. The best art ware of each of the periods has been included in the collection without disconnection. The collection covers a comprehensive set of categories, including bronze ware, jade ware, ceramics, inscribed tablets and sculptures, calligraphy and famous paintings, seals, lacquer ware, enamel ware, embroidery, carvings on bamboo, wood, ivory and horn, golden and silvery vessels, tools of the study, clocks and watches, pearl and jadeite jewellery, and furniture among others. Each of these categories has developed into its own system. It can be said that the collection itself is a huge treasury of oriental art and culture. It illustrates the development path of Chinese culture, strengthens the spirit of the Chinese people as a whole, and forms an indispensable part of human civilization.

The Palace Museum's Essential Collections series features around 3,000 pieces of the most anticipated artefacts with nearly 4,000 pictures covering eight categories, namely ceramics, jade ware, bronze ware, furniture, embroidery, calligraphy, paintings, and rare treasures. The Commercial Press (Hong Kong) Ltd. has invited the most qualified translators and academics to translate the series, striving for the ultimate goal of achieving faithfulness, expressiveness, and elegance in the translation.

We hope that our efforts can help the development of the culture industry in China, the spread of the sparkling culture of the Chinese people, and the facilitation of the cultural interchange between China and the world.

Again, we are grateful to The Commercial Press (Hong Kong) Ltd. for the sincerity and faithfulness in their co-operation. We appreciate everyone who has given us support and encouragement within the culture industry. Thanks also go to all Chinese culture lovers home and abroad.

Yang Xin former Deputy Director of the Palace Museum, Research Fellow of the Palace Museum, Connoisseur of ancient calligraphy and paintings.

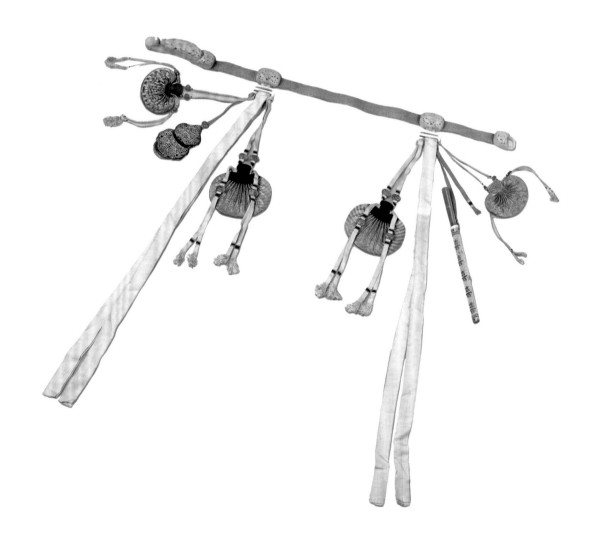

Contents

List of Textiles and Embroideries

TEXTILES AND EMBROIDERIES

TEXTILES

1 **Baoshou** in **Kesi**
with Patterns Featuring Mandarin Ducks Frolicking among Water Lilies

2 **Biaopian**
with Patterns of a Dragon in Clouds and the Character for "Longevity" on Gold *Kesi* Ground

3 **Jifu Pao** of **Kesi**
in Bright Yellow Ground with Patterns of Eight Treasures and Cloud Dragon

4 **Jifu Gua**
in Blue *Kesi* Ground with *Mang*-dragons in Clouds and the Character for "Longevity"

5 **Jifu Pao**
in Blue *Kesi* Ground with Figures of *Mang*-dragons among Colourful Clouds

6 **Jifu Pao**
in Gold *Kesi* Fabric with Dragon Figures in Blue

7 **Changfu Pao**
in Fabric of Green *Kesi* Ground with Patterns of Peony

8 **Changfu Pao**
in Brownish *Kesi* Ground Fabric Decorated with Roundels of Cranes and Flowers

9 **Fabric for Blouse**
with Yellow *Kesi* Ground and Multi-coloured Patterns Featuring *Fu, Yuan, Shan,* and *Qing*

10 **Blouse**
with Patterns of Landscape on *Kesi* Peach Pink Ground Fabric

11 **Huaidang**
of Yellow *Kesi* Ground with Figures of Two Dragons Holding the Character for "Longevity"

12 **Chair Panel**
in *Zhangrong* with Yellow Ground and Patterns of Bats and Lotus

13 **Zhangrong**
with Green Ground and Pattern of Plucked Chrysanthemum

14 **Panel of Zhangrong**
with Patterns of Plucked Chrysanthemum on a Yellow Ground

15 **Zhangduan**
with Blue Ground and Pattern of Coloured Twining Peony

16 **Double-layered Fabric**
in Red Ground with Patterns of Plucked Peony Sprig

17 **Double-layered Fabric**
with Brownish Red Ground and Phoenix Patterns

18 **Jingpi**
of Double-layered Weave with Blue Ground and Patterns of the Characters for "Happiness" and "Longevity" and Figures of Fishes

19 **Double-layered Fabric**
with Green Ground and Patterns of Tortoise Shells and *Qiulu*

20 **Song-style Brocade**
with Orange Ground and Multi-coloured Bands of Patterns of Flowers of All Seasons

21 **Tianhuajin**
with Red Ground and Patterns of *Sihe Ruyi*

22 **Ice-plum-patterned Brocade**
with Black Ground Weave

23 **Song-style Brocade**
in Pink Ground and Circular Patterns with Two Lions

24 **Patterned Brocade**
in Silver Grey Ground with Meandering Water, Fishes and Algae

25 **Tianhuajin**
with Brown Ground and *Baoxianghua* Patterns

26 **Patterned Brocade**
with Figures of Melons and Butterflies

27 **Patterned Brocade**
with Yellow Ground and Sprigs of Plucked Peony and Chrysanthemum

28 **Brocade**
with Red Ground and Picture of Myriads of Male Children

29 **Patterned Brocade**
with Blue Ground and Figures of Immortals Bringing Birthday Wishes

30 **Patterned Brocade**
with Brocade Group Ground and Patterns Figuring the "Three Many"

31 **Patterned Brocade**
with White Ground and Figures of Tortoise Shells and Plucked Peonies

32 **Song-style Brocade**
with Apricot Yellow Ground and Patterns of Series of Meandering Water and Interlinking Flowers

33 **Patterned Brocade**
with Blue Ground and Figures of Lanterns

34 **Patterned Brocade**
with Yellow Ground and Figures of Plucked Peony Sprigs

35 **Golden Brocade**
with Indigo Ground and Patterns of the Character for 卍 and Twining Lotuses

36 **Golden Brocade**
with Crimson Ground and Figures of the Character for "Longevity" and the Eight Auspicious Emblems

37 **Baodijin and Figures**
of Twining Peonies against a Yellow Backdrop

38 **Baodijin**
and Patterns of Peonies on Pale Blue Ground

39 **Baodijin**
and Patterns of Peonies and Morning Glories against a Red Backdrop

40 **Baodijin**
and Figures of Peony and Hibiscus on Yellow Ground Weave

41 **Baodijin**
with Gold and Silver Patterns on Light Crimson Ground Weave

COURT COSTUME OF THE QING DYNASTY

THE EMPEROR'S HATS AND CLOTHES

Lifu (Formal Court Costume): Courtly Robes

Lifu (Ceremonial Costume): Gunfu (Royal Costume)

Lifu (Ceremonial Costume): Duanzhao (Decorous Cover)

Jifu (Semiformal Court Costume)

EMBROIDERY ARTICLES FOR INTERIOR DISPLAY

Introduction to the Palace Museum Collection of Textiles, Embroideries, Costumes, and Adornments

YAN YONG

Being the first country in the world to have invented sericulture and silk weaves, China is the provenance of silk textiles. Since antiquity and over a very long period of time, the Chinese art of weaving silk, with its advanced techniques, rich variety and exquisite craftsmanship, has established a tradition of its own and retained its unique fascination in the world. Ancient Chinese textiles and embroideries reached far and wide through the "Silk Roads" both on land and over the seas, making outstanding contributions to the development of world civilization. Indeed, sericulture and silk weaves can be regarded as a shining pearl presented by the Chinese people to humanity.

The Palace Museum in Beijing houses 170,000 artefacts of textiles and embroideries from various periods throughout Chinese history. They include chiefly four categories, namely, woven and embroidered materials, costumes and ornaments, woven and embroidered calligraphy and painting, and woven and embroidered articles for interior decoration and display. Over 90% of these are old collections from the Qing court. Apart from a few items whose origin dates from the Han, Tang, Song, Yuan, and Ming periods, the majority consists of articles used in Qing palaces. This volume has selected from among them 273 choice items (or sets) to be introduced under finer classification.

ONE. MING AND QING TEXTILES AND EMBROIDERIES

By the Ming and Qing periods, the art and technology of ancient Chinese sericulture and silk weaves had already been developing in continuous innovation for well over a thousand years, reaching a stage of maturity and excellence, and the silk industry flourished in an unprecedented manner, producing a rich variety of silk textiles of high quality.

Silk textiles during the Ming Dynasty were produced in four main regions. The region around Suzhou, Nanjing, Hangzhou, and Jiaxing, whose production was greatest in quantity and finest in quality, became the national centre of silk textile production. Shanxi Province, from which came the famous *luchou*, plain silk weaves named after Luzhou there, ranked number two. *Shujin*, brocade from Sichuan, came third and it was thriving during the Ming period. The *gaiji* (literally, changing loom) and *zhangrong* (a pile weave of silk of Zhangzhou) from Fujian Province had their unique characteristics, while the satin and silk gauze from Guangdong Province were just as famous. These two southern provinces formed the fourth leading area of the silk industry.

The art and technology of sericulture and silk weaves developed further during the Qing Dynasty. Famous centres of production included Jiangning

(Nanjing), Suzhou, Hangzhou, Jiaxing, Chengdu, and Guangzhou. Nanjing, Suzhou and Hangzhou, in particular, did not only form the national hub of the industry but also became the district where the Qing court established its official magistracy governing the textile industry, i.e. the *Jiangnan San Zhizao* (or "the three textile manufacturers south of the Yangtze"). *Jiangnan San Zhizao* was a gargantuan institution with solid and enormous financial backing. Finely organized in its division of labour and competently managed, it shouldered almost the total supply of silk textile production to satisfy the need of the Qing court. Among the three, the Jiangning bureau manufactured *yunjin* (literally, "cloud brocade" for its gorgeous colours), *jianrong* (silk velvet made originally in Jiankang) and *shenbo* (funereal silk fabrics), and supplied the court chiefly with bolts of satin. The Suzhou bureau specialized in brocaded satin, cut silk or *kesi* tapestry and plain-weave silks for celebrations and other ceremonies. The main bulk consisted of bolts of satin for official use. The Hangzhou bureau manufactured *ling* (twill), *luo* (gauze), *juan* (tabby), and *chou* (plain-weave silk); and a large proportion of its production consisted of satin bolts as official rewards and gifts. Since these weaves were chiefly produced to supply courtly demand, the *Jiangnan San Zhizao* was not frugal with its investment constantly to improve the quality, pattern designs and variety of its products. They represented the highest level of technological development in the silk industry of the Qing Dynasty.

I. Ming and Qing Variety of Silk Textiles

Ming and Qing textiles housed in the Palace Museum include mainly *jin* (brocade), *duan* (satin), *ling* (silk twill), *luo* and *sha* (silk gauzes), *chou* (plain silk weaves), *kesi* (cut silk tapestry), *qirong zhiwu* (silk weave with piles), and *shuangceng zhiwu* (double-layered silk weaves). They form the richest and most complete treasure trove of actual articles for studying Ming and Qing textiles.

1. Jin (Brocade)

Jin-brocade here means a silk jacquard weave made with overlapping silk threads of two or more colours to achieve multicolour patterns. The raw material is expensive, the craft intricate, the design varied and the colours gorgeous. Hence its reputation for being worth its weight in gold.

During the Ming Dynasty, apart from the earlier existing Sichuan brocade and Song brocade, the cloud brocade or *yunjin* based on the Yuan practice of adding in gold threads became further developed into a new and world-famous product of *jiajin zhuanghua jinduan* (satin brocaded with gold threads).

Brocades of the Qing period included chiefly the *kujin* (literally "storehouse brocade," i.e. brocade woven with gold, silver and coloured threads sent to the imperial storehouse) from Nanjing, the Song-style brocade from Suzhou, the *shujin* from Sichuan, and other brocades from various minority regions.

2. Duan (Satin)

Duan-satin is a mainstream silk weave. Its float threads are relatively longer and there are fewer intersections of warps and wefts, being evenly distributed on the weave, whose surface is shiny, soft and smooth. The satins from Ming and Qing exhibit an exceedingly rich variety of pattern designs. In accordance with the craft behind these fabrics and the characteristic appearance, they can be divided into five categories, namely, *zhuanghuaduan* (brocaded satin), *zhijinduan* (satin with in-woven gold threads), *anhuaduan* (satin damask), *shanduan* (shimmering satin) and *huaduan* (patterned satin).

3. Chou (Plain-Weave Silk Fabric)

Chou is relatively simple plain or twill weave. It is particularly smooth, cool and crisp in feel and it is neither too thick nor too thin. Its surface is slightly less glossy than satin. Qing silk jacquards are basically twill weaves, such as *ningchou*, *gongchou* and *luchou*. In addition, there are some based on the tabby weave with veiled patterns in monochrome, such as *chunchou* and *fangchou*, which are fine and soft, most suitable as material for shirts or blouses.

4. Ling (Silk Twill)

Ling is a derivative from the *qi*, a variety of silk weave from the Han and the Tang periods. In its earlier days, it was mainly a twill weave in diagonal

alignment. By the Ming and Qing days, a satin variety had appeared. This twill is soft, light and thin. It may be plain twill or twill damask displaying a veiled pattern in monochrome.

5. Luo and Sha (Silk Gauzes)

Luo is a weave with twining warps, which involves a complicated process. It was a common weave of high quality during the Ming and Qing periods. The texture of *sha* is similar to *luo*, being also a weave with twining warps (except for the plain *sha* with square meshes). Both *sha* and *luo*, being thin, light, soft, and airy, were materials for the summer attire of civil and military officials as well as the royal house. During the Qing Dynasty, *zhijingsha* (gauze with straight warps), *shidisha* (patterned gauze by doup warp on plain-weave ground), *zhimasha* (sesame gauze), and *zhuanghuasha* (gauze with patterns brocaded on) of excellent quality were produced in Jiangning. In late Qing, a new gauze category called *taixisha* (western gauze) made of a kind of threads called *tiejisha* (iron-loom thread) became quite fashionable.

6. Kesi (Cut Silk Tapestry)

Kesi is a plain weave using long vertical warps with discontinuous wefts not running from selvedge to selvedge but returning and changing freely between threads of different colours to bring about the exquisite shades and patterns showing rich nuances and lively variations for aesthetic effects. It is therefore particularly suited for making textile facsimiles based on calligraphies and paintings. These *objets d'art* are called *kesi* calligraphy and *kesi* painting (to be elaborated on later). The craft of *kesi* was also employed in making courtly robes and other costumes and Buddhist scripture covers as well as other furnishing textiles.

7. Qirong Zhiwu (Pile Weave)

Qirong is a weave covered with dense pile loops, cut or uncut, above the ground fabric. During the process, a solid piling rod is inserted to make the pile warps form loops above the ground surface when the rod is subsequently removed. And if the loops are slit open, the pile warps will show as short hair or floss above the ground fabric.

Pile weaves can be divided into plain and patterned categories. *Surong* (plain pile weave) has all the loops slit while the fabric is still on the loom. *Huarong* (figured pile weave) stays unslit on the loom; and when the finished bolt is taken down, it is mounted tightly onto a frame called *rongbeng* (literally pile stretcher) for pile cutting. Certain loops are slit while others remain uncut, according to the need of the design, resulting in *gemaorong* (fur piles) and *lunquanrong* (loop piles) respectively for the effect of intended patterns on the fabric. Zhangzhou in Fujian Province is best known for this kind of pile weave, which is thus also named *zhangrong*.

There is yet another pile weave named *zhangduan* (Zhangzhou satin), which is a jacquard weave with an ordinary level ground but piles on top. Self-evidently, Zhangzhou is also the most famous for this craft. Typically, this fabric is based on six irregular warps for a satin ground and pile warps round rods to achieve loops for patterns. When the pile warps and the ground warps are of the same colour, the fabric becomes a *danse rongduan* (monochrome pile satin) of the family of damasks with veiled patterns. When the pile warps and the ground warps are of different colours, *caise rongduan* (multi-coloured pile satin) is resulted.

8. Shuangceng Zhiwu (Double-layered Weave)

Shuangceng zhiwu is a jacquard weave with double warps and double wefts, also known as *shuangceng jin* (double-layered brocade). It is woven with two sets of warps of different colours and wefts alternating between the upper and lower layers, thus creating two faces that have the same pattern but reverse colours of the ground and the pattern on either side of the fabric. Its structure may be double plain weave or double twill weave.

II. Characteristic Pattern Designs of Qing Fabrics

Silk textiles in general exhibit a rich variety of woven materials and pattern designs. Silk textiles from the Qing Dynasty in particular show even greater variety and carry unique characteristics.

Qing textiles have not only inherited the tradition and style of the Song and the Ming periods but further incorporated the essential pattern designs of minorities in China and even excellent foreign elements from western cultures, thus forming a pluralistic nature of these textiles. But owing to the parameter of a stringent institution of formal costumes, the designs of Qing textiles in content as well as in form failed to become free from the fetters of norms and formulae repressing their artistic expression and creativity. On the whole, the style of Qing silk textile designs can be seen in three stages of development, the early, the middle, and the late.

At the early stage of Qing silks, the patterns adopted the formality and decorum of the Ming Dynasty. They were based on the tradition of rich and deep but harmonious colours passing down from the Song period. These designs are delicate and refined, showing quiet elegance and beauty. Some textiles at this stage have, however, followed entirely the late Ming style with its dragons in very complicated and gorgeous layout. Some others exhibit formal compositions of overall patterns with interlacing branches and scattered dots, which are more flexible and denser than previous samples, employing also more often overlapping structures. Their style is strictly controlled, plain but harmonious and in compliance with classical elegance. Typical designs include *yun he* (cranes among clouds), lanterns, *baoxianghua* (flowers bearing precious appearance), *luohua liushui* (fallen petals on flowing stream), *ruyi yun* (auspicious clouds), *qipan gezi* (chessboard check) and so on. Even though the designs from early Qing textiles imitate those from the Song and Ming periods, its material layout and colour combination have nevertheless shown some occasional breakthrough from the old formulae. The *guijuwenjin* (regularly patterned brocades) during the reign of Kangxi, for example, do bear their own characteristics with *tuiyunfa* (gradual nuances in colour management) that shows elegant beauty, and its exquisite craftsmanship is superior to previous dynasties.

Qing silk textiles at the middle stage display naturalistic patterns in design. The colour management of gradually nuanced shades has become highly skilled and exquisite. The graduation of tones is demonstrated through subtle transitions, resulting in fresh bright colours and elaborate designs. The technical innovation and advancement of arts and crafts at this time made a strong impact also on the development of textile designs. For instance, the craft of weaving in gold threads and adding silver ones was clearly improved, so that not only were the gold threads fine like hair straws hidden tracelessly between pattern passes but even new weaving methods were introduced to enhance the novelty of designs. Owing to the increased economic and cultural exchange among peoples and nationalities, designs reflecting styles from the minorities such as Manchu, Mongolian, Tibetan and Uighur as well as the Han majority appeared at this time. With Western cultures and their arts approaching the East, silk textile designs from this time also showed traces of Baroque and Rococo, showing the hybrid style combining East and West that was particularly prominent during the reign of Qianlong. Examples include outlandish large floral patterns in Rococo containing traditional flowers like the peony, the rose and the lotus, and their shapes have often been modified in exaggerated manners to achieve the effect of opulence and extravagance. In addition, there were also designs imitating the styles of ancient Persia and Japan as well as those of European brocade.

The national decline of the late Qing saw also the downward trend of the standard of the arts and crafts of silk textiles. Many designs became crudely elaborate in craftsmanship; and being artistically uncreative, they became pretentious and stilted. However, there were some designs that show budding signs of realism. These are vivid and brighter in colours.

III. Embroideries from the Ming and the Qing Dynasty

Embroidery is the art of using threads of different colours and thickness to go in and out or up and down through ground fabrics to feature people, birds and flowers, landscapes and pavilions and so on to produce aesthetic effects.

Embroidery from the Ming Dynasty is divided into two schools, one from the south and the other north. Northern embroidery is represented by

methods of *saxianxiu* (literally "sprinkled stitches"), *yixianxiu* (literally "clothing yarn stitches"), and *jixianxiu* (literally "seizing stitches"). Embroidery in the south is distinguished by its reliance on famous paintings and calligraphies as blueprints for creating the products. The most famous is *guxiu* from the middle and late periods of the Ming Dynasty.

After the inception of Qing Dynasty, the art and craft of embroidery had formed a system of local specialities, marking clearly their unique individual styles according to their origins. The four regions that had attained the highest level of the art and craft of embroidery were *Su* (Jiangsu), *Xiang* (Hunan), *Yue* (Guangdong), and *Shu* (Sichuan); and they are acclaimed as the "four great embroideries" of China, about which more will be said later.

TWO. COURTLY COSTUMES AND ORNAMENTS OF THE QING DYNASTY

The system of Qing attire was more intricate, its scope larger, and its rules more numerous than all previous dynasties; while the courtly attire of the Qing Dynasty was graded the highest in the hierarchy, it also occupied a central position in the institution of Qing costume and adornment.

I. Categories of Qing Courtly Costumes

The courtly costumes and ornaments of the Qing Dynasty were rich in variety and elaborate in detail. The attire of emperors can be divided into seven categories, namely, *lifu* (ceremonial costumes), *jifu* (semiformal costumes), *changfu* (informal costumes), *xingfu* (travel apparel), *yufu* (rain apparel), *rongfu* (military apparel), and *bianfu* (casual wear). The attire of empresses are categorized into four sections, namely, the ceremonial, the semiformal, the informal, and the casual. These costumes were used variously on occasions like sacrificial ceremonies, court audiences, festivals, holidays, processions, and everyday domestic activities.

1. Lifu (Ceremonial Costumes)

Lifu was worn on very important occasions such as sacrificial ceremonies and court audiences. The emperor's attire includes *duanzhao* (decorous cover), *gunfu* (regal coat), and *chaopao* (courtly robe). The attire for the empress and imperial concubines includes *chaogua* (courtly jackets), *chaopao* (courtly robes), and *chaoqun* (courtly skirts). Ceremonial costumes ranked highest in their standards among the various categories of courtly attire during the Qing period.

Chaopao (courtly robes) is the major form of Qing ceremonial costumes. The institution of courtly dress was going through incessant revision and improvement from the time of Dynasty Founder *Nu'erhachi* (Nurgaci) to the reign of Emperor Qianlong. Since the official promulgation of the *Canon of Decorum for Ceremonies of the Great Qing Dynasty* in 1764 (twenty-ninth year of the reign of Qianlong) and the *Illustrated Catalogue of Sacrificial Vessels for the Imperial Court* in 1766 (thirty-first year of the reign of Qianlong) indicating the final coding of the system of Qing costumes, all later emperors followed basically the same rules without any modification.

Once the system had been established, the standard style of the emperor's courtly robe, as shown in the lined courtly robe in bright yellow satin embroidered with multi-coloured clouds and golden dragons (Figure 109), includes a round neckline, a broad front closing on the right, sleeves with hoof-shaped cuffs in Manchu style, a large collar folded out and spread on the shoulders, the bodice linked to the skirt, its full length reaching the feet, and the sleeves covering the hands. The robe is decorated with forty-three golden dragons together with the twelve emblems of imperial authority, including the sun, the moon and stars, mountains, a flowery creature, marks of distinction, sacrificial vessels, algae, fire, and rice grains, symbolizing the supremacy of imperial authority and the perfection of imperial morality.

There are four colours in imperial robes— blue (Figure 110), bright yellow (Figure 109), red (Figure 104) and pale blue (Figure 111)—to be worn

respectively at rituals of sacrifice to heaven, the earth, the sun and the moon. In addition, there should be courtly beads in the same colours worn to match the courtly costumes: blue lapis lazuli beads for heaven, brownish yellow amber beads for the earth, red coral beads for the sun, and pale blue turquoise beads for the moon. Besides, bright yellow courtly robes were also worn together with necklaces of *dongzhu* from Manchuria ("Eastern" courtly beads) at court audiences, sacrifices to the Holy Farmer, *mengxia shixiangji* (early summer rituals) at the imperial temple and worships at *Guandi* Temple. In addition to the necklaces, the emperor when donning courtly robes should also wear courtly headgear, a courtly girdle and courtly boots, forming a full set of courtly attire from top to toe.

Gunfu (the royal coat) is a jacket worn on top of the courtly robe. It has a round neckline, a front in symmetric halves, sleeves with level ends reaching the elbow, while the length of the jacket reaches the waist. The shoulders, the breast, and the back are decorated with a five-clawed golden dragon in a roundel. The two shoulders are further decorated with emblems respectively of the sun and the moon. Nobody but the emperor was allowed to wear the royal coat. Courtly garments worn by imperial princes do not bear the two imperial emblems and are not called royal coats but dragon jackets. Other princes and below including the nine different ranks of civil and military officials wore jackets with insignia squares called *bufu* (supplementary garment) or *bugua* (supplementary jacket) when clothed in courtly apparel.

Duanzhao (decorous covers) are opulent sleeveless fur coats of knee length with a round neckline, the front split in the middle, and sleeves with level ends reaching the wrists. They are outdoor furs for officiating at ceremonies in winter. The emperor kept himself warm with the cover on top of the robe.

The ceremonial dress of imperial concubines comprises the courtly jacket, the courtly robe and the courtly skirt, which must be donned altogether on the same occasion in an inward out order starting from the skirt to the robe and then the jacket.

The official form of the empress's courtly jacket has three variations. The most common is a sleeveless

shiqing (azurite blue) version with a round neckline and a symmetrically split front. It is slightly shorter than the robe. On both the front and the back are two vertical golden dragons.

The empress's courtly robes have also three variations according to official form. The most common is the version with a round neckline, a broad front closing on the right, a large collar turned down as lapel, a protective edge for each of the two shoulders, sleeves in Manchu style linking sleeves between the outer sleeves and the bodice, and slits on either side of the skirt. It is bright yellow, and except for the collar and the sleeves, there is overall decoration on the robe with nine golden dragons. The courtly robes for the emperor's mother and the imperial concubines are the same as the empress's, whereas ranks below the concubines are indicated through different colours.

The courtly skirts of imperial concubines, according to the *Canon of Decorum for Ceremonies of the Great Qing Dynasty*, are composed of two parts, the upper and the lower. The surface material for the upper part should be red silk satin embroidered with the character for longevity in gold threads; the lower should be azurite blue satin brocaded with flying dragons, its front having *biji* or *diezhe* (pleats) and tied with a sash. There is only one single courtly gown in the Palace Museum collection that agrees with this form. One example of relatively common courtly forms is shown in an azurite blue sleeveless lined dress with brocaded four-clawed dragons and inlaid pearls and gems (Figure 146). It has a round neckline, a broad front closing on the right, the bodice linked to the skirt, which carries folds round the waist and two ribbons hanging down the back. But this form has not been recorded in the canon.

2. Jifu (Semiformal Costumes)

Jifu was attire donned for such occasions as celebrations of festivals, for example, the *Wanshoujie* (Longevity Festival), *Qianqiujie* (birthday celebrations), the Lantern Festival of *Yuanxiao* (literally first night, which is the Fifteenth Day of the Lunar New Year), the *Qixijie* (Seventh Day of the Seventh Month of the lunar calendar) celebrating the mythic rendezvous of the cowherd and the weaver girl, and the Mid-Autumn

Festival. *Jifu* includes the *jifu gua* (semiformal jacket), the *jifu pao* (semiformal robe) or the so-called *longpao* (dragon robe).

The official form of the imperial dragon robe has a round neckline, a broad front closing on the right, and sleeves with hoof-shaped cuffs in Manchu style. It is a full-length robe with four slits. It is bright yellow and the whole is decorated with nine golden dragons and the twelve imperial emblems.

The colour and pattern design of the empress's dragon robe is exactly the same as that of the emperor's. The only differences are that the emperor's lacks the linking sleeves between the bodice and the sleeves as in the empress's robe and that the empress's has a slit on each of the two sides only, while the emperor's has four slits altogether including those on both the front and the back as well as the sides.

3. Changfu (Informal Costumes)

Changfu was donned during the fasting period for major sacrifices (such as those for heaven and earth and for the ancestral temple). It was used even during some minor rituals and *jingyan* (official lectures) as well as solemn occasions of awarding posthumous honorary titles, and presentation of the jade register and *cebao* (imperial seal) or other relatively formal occasions. *Changfu* includes *changfu gua* (jacket) and *changfu pao* (robe). The robe is long and has a round neckline, a large front, sleeves with hoof-shaped cuffs and four slits. The jacket has a round neckline, a front split in the middle and level-ended sleeves. In knee-length and azurite blue, it is worn on top of the robe. Its surface material, colours and patterns were not as strictly coded as the ceremonial and semiformal garments but were nevertheless confined within certain parameters and stayed relatively constant. It is usually plain and in monochrome damask.

Informal costumes do not observe as high a standard as ceremonial costumes but are nonetheless more ceremonially decorous than the *bianfu* (casual wear). To a considerable extent, wearing *changfu* expressed piety and respect. For instance, on a posthumous birthday of an ancestor, the emperor should be wearing plain white mourning clothes to show sorrow at the sacrifice, but he might have to don *changfu* instead in order to show respect to the divine spirits if the day happened to fall on the fasting period of the sacrifice. Wearing *changfu* might entail the adornment of courtly beads. The adornment would show even greater formality and propriety.

4. Xingfu (Travel Apparel)

Xingfu was donned by Qing emperors when they travelled to inspect their domain or when they went hunting. The travel apparel includes five parts, namely, a *xingguan* (travel hat), a *xingpao* (travel robe), a *xinggua* (travel jacket), a *xingchang* (travel dress), and around the waist a *xingdai* (travel sash). Imperial concubines of the Qing Dynasty did not wear travel garments. The main characteristic of *xingfu* is that it facilitates movements in riding, archery and hunting. It is uniquely Manchurian in style.

Xingfu was donned with the robe as an inner layer, covered with the jacket outside. The *xingchang* or dress was tied round the lower part of the body with a sash round the waist. The travel robe has a large front, hoof-shaped sleeves and four slits. It is one tenth shorter than the informal robe. From the lower right part of its front a one-foot (or *chi*) square piece was cut out and attached to the robe with a button; this loose piece could be re-attached to form a kind of informal robe when the rider had dismounted, so that while riding he could tuck up the lower right front and exploit the shorter length on the right side of the robe for mounting and dismounting. As the robe would look as if a patch was missing when the rider was on the horseback, it is also called the *quejin pao* or "robe with a missing bit on the front."

5. Yufu (Rain Apparel)

Yufu was worn by Qing emperors in the rain. It includes a *yuguan* (rain hat), a *yuyi* (rain dress), and a *yuchang* (rain coat). It was worn by donning first the *yuyi* inside and having it covered with the *yuchang*. The dress and the coat have the same colour. According to Qing codes, there were six styles of rain dresses for the emperor, and they were all bright yellow, but so far no artefacts coincide with the description of such rain apparel.

6. Rongfu (Military Apparel)

The Qing rulers conquered China by virtue of their skills in horsemanship and archery and were therefore keen admirers of martial achievements. Right at the beginning of the dynasty, the institution of *xingwei* (military exercises) and *dayue* (inspections) was established. It facilitated the emperor to organize large-scale regular military exercises and comprehensive inspections of the army's equipment and martial capability. These were measures to advocate horsemanship and archery and to sustain the strength of the *baqi* (Eight Banners) for combat. While participating in these events, the emperor would wear *rongfu*. It is called *dayuejia* (armoury for great inspection). It consists of eleven parts, namely, an upper bodice and a lower skirt, both being separate in two pieces—the left and the right—and shoulder covers, armpit covers, right and left sleeves, front crotch and left crotch.

7. Bianfu (Casual Wear)

Bianfu is the attire of the Qing emperors and empresses for everyday domestic activities. It includes the *bianpao* (casual robe), *magua* (short jacket), *changyi* (cloak), *chenyi* (shirt or blouse), *kanjian* (lined or padded sleeveless jacket), *ao* (padded coat), *doupeng* (cape) and trousers. Items of casual wear do not feature in the Qing canon for dress codes but in other documents archiving imperial apparel and articles for domestic living, and there is a great amount of actual articles still in existence.

Bianfu has the characteristics of a considerable variety of designs, colours and patterns, and it is convenient and comfortable to wear. The *bianpao*, for example, has a round neckline, a large front closing on the right, level-ended sleeves, and slits on the two sides. The material is usually plain monochrome or monochrome damask in *chou* (plain weave), *duan* (satin), or *sha* (gauze). The main difference between the *bianpao* (casual robe) and the *changfu pao* (informal robe) is that while the former has level-ended sleeves, the latter has hoof-shaped cuffs.

The most gorgeous of *bianfu* for imperial concubines is the cloak and the blouse. The cloak has a round neckline, a large front closing on the right and in straight cut, level-ended sleeves reaching the elbows, and two slits on the sides all the way up to the armpits. The design of the blouse is basically similar to the cloak except for the absence of the slits and there are none of the decorative cloud patterns found under the armpits of the cloak. The blouse was worn under the cloak. Since the casual wear for imperial concubines was not under stringent codes, it exhibits greater variety in design, brighter colours and more beautiful patterns.

Among the seven categories of attire above, the *lifu* (ceremonial costumes), *jifu* (semiformal costumes) and the *rongfu* (military apparel) were worn at highly important rituals. Their materials, designs, colours and patterns were made in compliance with strict rules and thus suggested a strong sense of political and ritual significance. The *xingfu* (travel apparel), *yufu* (rain apparel), and *bianfu* (casual wear) were used during travel or on casual occasions. Their materials, designs, and colours are relatively simple and random. The *changfu* (informal costumes) is special in that it entertains both the ritualistic and the simpler aspects. It is a transition from ritualistic to functional or utilitarian attire.

II. Characteristics of Qing Courtly Costumes and Ornaments

1. Stringent Hierarchy

The institution of courtly costumes and adornment was very strict in Qing Dynasty and the hierarchy was rigidly stratified. In a descending order the hierarchy included three major ranks respectively for the throne, the peerage, and officialdom. The throne represented the emperor and the empress as well as the imperial concubines. The peerage included aristocrats by birth such as imperial princes and other princes, chiefs of prefectures, *beile* and *beise* (nobles of the third and fourth ranks) and other commoners made aristocrats with titles conferred on them as dukes, marquises, earls, viscounts, and barons. Officialdom covered all nine ranks of officials. Within every rank there was a finer division into certain subranks. The costumes for every rank were defined

by strict codes which must not be overstepped.

The hierarchy of Qing courtly attire is mainly embodied in the five elements of materials, designs, colours, patterns, and accessories.

An example of the hierarchic expression through the material is the decorous cover, its leather being finer for higher ranks. According to the standard set in Qing dress codes, there are seven categories of materials for the cover, namely, black fox fur, purple mink fur, blue fox fur, mink fur, lynx fur, red panther fur, and brownish yellow fox fur. Decorous cover for the emperor were made of black fox fur or purple mink fur. Below the emperor, the crown prince wore black fox fur and the imperial princes purple mink fur; while other princes and their offspring, prefecture chiefs, *beile*, *beise*, and consorts to imperial princesses wore blue fox fur. Peers from the fifth to the seventh ranks, i.e. the *zhenguogong*, *fuguogong*, and *heshuo efu*, wore purple mink fur. Ranks for Han or *mingong* (non-Manchu peers conferred with titles), including civil ones above the third rank and the two top military ones as well as the *fuguo* general, and the *xianzhu efu* (county chief's son-in-law) wore mink fur. Top ranking royal guards wore lynx fur foiled with stripes of panther fur; second ranking ones wore red panther fur; and the third rank together with *lanling shiwei* (the one in charge of their rota) wore yellowish brown fox fur. Except for all those above, no others were entitled to using covers.

In respect of dress design, the number of slits would signify the ranks; hence, the more slits the higher the ranking. For example, semiformal robes for males carrying four slits indicate members of the imperial clan, while the other carry only a slit in front and one on the back.

In respect of colour, the highest rank used bright yellow, exclusively for the emperor, the empress mother, the empress, and the imperial concubines. The courtly costumes for the crown prince were apricot yellow (with allowance for accessories such as courtly beads and ribbons to have a little part in bright yellow). Imperial princes used golden yellow, while other princes and prefecture officials as well as civil and military officers wore blue or azurite blue courtly costumes. The colour codes of imperial concubines were very strict and rigid. The empress mother, the empress and the imperial concubine wore courtly robes and dragon robes in bright yellow; consort to the crown prince wore apricot yellow; imperial concubines and other concubines used golden yellow; courtly ladies in waiting, princes' concubines in the imperial harem and below wore *xiangse* (light incense-brown); consorts to *beile* and *beise* as well as the seven ranks of *mingfu* (women given titles of nobility) wore blue or various shades of azurite blue.

In respect of patterns, the most noble was the dragon and the *shi'er zhangwen* (twelve imperial emblems), exclusively reserved for the emperor alone. Semiformal costumes for his subjects were never called "*longpao*" (dragon robes) but "*mangpao*". Patterns on *mangpao* show nine five-clawed dragons for princes and prefects; for *beile*, *beise*, sons-in-law to *gulun*, and down to the first three ranks of civil and military officials, as well as *fengguo* generals, sons-in-law to prefects, and the top ranking royal guards, the nine *mang*-dragons (literally python or boa) on their robes had only four claws each. The fourth rank of civil and military officials and the *feng'en* generals as well as the second rank of guards and downwards to the sixth rank of civil and military officials had only eight four-clawed *mang*-dragons on their costumes. Costumes for the lowest three ranks (i.e. the seventh, eighth and ninth) of civil and military officials bore only five four-clawed *mang*-dragons.

On top of the robe was often a *gua* (coat or jacket). Such jackets for officials are called either *bufu* or *bugua*, i.e. jacket bearing an insignia. The standard patterns of costumes with insignia during the reign of Emperor Qianlong were as follows: four roundels of flying five-clawed dragons—two on the shoulders, one on the front and one on the back—for prefects; one roundel of a static obverse four-clawed *mang*-dragon on the front and one on the back for *beile*; *beise* and *gulun efu* had one roundel of a flying four-clawed *mang*-dragon on the front and one on the back; *zhenguogong*, *fuguogong*, and *heshuo efu* as well as dukes, marquises, and earls had only a square insignia with a static obverse four-clawed *mang*-dragon on the front and the back. The nine ranks of civil officers had respectively the following insignia in descending order: the celestial

crane, the golden pheasant, the peacock, the wild goose, the silver egret, the heron, the *jile*, the quail, and the flycatcher. Patterns of insignia for the nine ranks of military officers were respectively *qilin* (the mythic unicorn), the lion, the panther, the tiger, the bear, the tiger cub, the rhinoceros, and the seahorse.

It is evident from the above that a round insignia signifies a higher rank than the square insignia and that the more patterns are included in the roundel, the higher is the ranking. The static dragon is higher than the flying one, and the dragon proper is higher than the *mang*-dragon. The five-clawed *mang* is higher than the four-clawed one, while the *mang per se* is higher than fowls and beasts, which in turn are ranked according to their degree of rarity or ferocity.

In respect of adornments, the top of the winter courtly headgear for males, for example, was decorated with different gems and other materials according to the ranking, which in descending order were the *dongzhu* ("Eastern pearl," i.e. pearls originated from Manchuria or northeastern China), ruby, coral, sapphire, lapis lazuli, crystal, tridacna gem (*chequ*), plain gold and carved gold. If two hats were both decorated with pearls, then the number would decide the ranking: sixteen for the emperor, for princes ten, prefects eight, *beile* seven, and going down gradually to one for the lowest ranking civil officer.

Such ranking standards are too numerous to be listed fully. It was through these hierarchic rules and restrictions of the courtly costumes and adornment that the Qing rulers established the differences of outer appearance from the emperor down to ordinary officials in order to form a system of dress codes to distinguish the upper from the lower, the honoured from the humble and the noble from the meagre, so as to reach their goal of *bian deng wei, zhao ming zhi* ("differentiating the authority of hierarchy and manifesting the order of status").

2. The Mutual Influence and Merging of Manchu and Han Cultures

First of all, the Qing courtly costumes have kept a lot of the distinct characteristics of Manchu national costumes.

In ancient China, rites and music formed an important integral part of the civilization. Since the institution of the codes for attire had the functions of ruling through rites, educational enlightenment and the differentiation between classes and ranks, it was much emphasized and exploited by rulers throughout history. All of them set up new codes and systems for costumes and adornment whenever there was a dynastic shift in order to mark and symbolize the change. As the great Confucian scholar of the Han Dynasty Dong Zhongshu said, "The monarch must be endowed with the mandate before taking the throne. The monarch must ratify the calendar, modify the colours of costumes and lay down new rites and music in order to unify the land under heaven." So did the Qing Dynasty. When the Manchu rulers took over the country, they abolished altogether the Han national costumes with their loose bodice and broad sleeves and by force pushed forth their own national costumes with their nomadic characteristics of tight bodice and sleeves convenient for riding and archery in order to mark the shift of dynasties. Besides, the Manchu rulers also regarded as supreme glory their military might of horsemanship and archery by which to achieve their sweeping conquest over central China. Thus, their decisive pursuit to use Manchu costumes and to maintain their hereditary culture of riding and shooting indicate also they set great store by their own national culture, which they did their utmost to defend. As Qing Emperor Gaozong said, "Apparel represents a dynasty, and Yin would not inherit it from Xia. Every dynasty follows and practises its own laws, and this is to say that rites remind us of our roots."

For instance, in respect of materials, Qing courtly costumes used large quantities of hide and fur, mainly from the northeast, i.e. provenance of the Manchu people. On the one hand, this had its practical reason of keeping warm, and on the other hand, there was the more important reason of implying that the people would not forget the old customs of their ancestors.

In respect of appearance, Qing courtly costumes also kept the style of costumes suitable for the Manchurian sports of equestrianism and archery, featuring robes and jackets with tight sleeves, robes with a piece missing in front, collars with

lapels, hoof-shaped cuffs, and skirts with four slits. This remained the major characteristic of Qing courtly costumes, which generations of Qing rulers maintained with utmost efforts and which basically did not undergo any change for three centuries. As the Qing Emperor Taizong instructed the *beile* princes, he said, "The system of dress codes is a mainstay of the nation… and it is hoped that our posterity will not easily change or forsake their ancestral institutions."

Nevertheless, the courtly costumes of the Qing did inherit and assimilate some characteristics of the traditional Han costumes and adornment.

Since 1644 when the Manchu rulers entered China proper, they had become steeped in the ambience of the broad and profound Han culture, and the two cultures underwent constant clashes, exchanges and fusions. Inevitably, the courtly costumes of the Qing Dynasty inherited and assimilated some characteristics of the traditional Han costumes and adornment.

In ancient times in China, there were only two main categories of style in clothing: One consisted of the upper part and the lower parts of the dress as being separate, so that there was the bodice and there was the skirt. The other consisted of only one piece with the bodice and the skirt linked together, e.g. the *pao* or robe. The courtly robe of Qing Dynasty belongs to the latter style, and yet it is distinctly different from other robes in appearance. Normally, a robe would stretch all the way from the top portion to the lower portion in one piece, whereas the courtly robe is cut around the waist and sewn together again, showing a seam called *yaowei*. Thus it gives the appearance of a dress in one piece but achieves at the same time the visual effect of the bodice and the skirt being apart. This is a unique design among Qing costumes and it differentiates the courtly robe from other costumes. Why then is the courtly robe for Qing emperors like this?

In the beginning of ancient Chinese clothing, the bodice and the skirt were separate. As said in the latter part of *Xici* in the *Book of Change*, "Huangdi, Rao, and Shun handed down the bodice and the skirt to posterity and reigned the world in peace, for that had come from *qian* and *kun*." *Qian* means heaven and *kun*

earth. Thus, the divine and the human correspond to each other. To make things (including clothes) by simulating nature through observing its phenomena is an important characteristic of the spirit of traditional Chinese culture and the Chinese way of thinking. This form of separating the bodice and skirt is an analogy of the correspondence between the phenomenon of clothing and that of heaven and earth. In the first part of *Xici* in the *Book of Change*, it is said, "Heaven is noble and earth humble, thus establishing the respective positions of *qian* and *kun*. The humble and the noble show the difference between the high and the low." To emphasize a strict and rigid hierarchic order is firmly established by following the inherent natural law of "heaven above and earth below" and this is reasonable. All previous dynasties and generations had adopted this implication of hierarchic order in the code of "bodice above and skirt below" in their dress code institution, and the Qing Dynasty was no exception.

However, the courtly robes for the Qing emperors did improve upon the principle of "bodice above and skirt below." The design of separate bodice and skirt, with an opulent top and broad sleeves, would make a loose and fluttering robe restricting free movements and thus contradicting the tradition of the Qing rulers' emphasis on equestrianism and archery. But if the bodice and skirt run in one piece, the deep cultural implication would be lost. Hence the stipulated style of the bodice and the skirt looking as if separate but in reality linked together.

In respect of colours, bright yellow was exclusively reserved for only the emperor and the empress, and their authority must not be overstepped by any other. This has assimilated the Han cultural traditional thought of *wuxing* (the "five elements"). According to the theory of *wuxing*, *jin* (metal), *mu* (wood), *shui* (water), and *huo* (fire) stand respectively for the four directions of *xi* (west), *dong* (east), *bei* (north), and *nan* (south), while *tu* (earth) is situated in the middle commanding the four directions, and the colour of earth is yellow. The emperor was the symbol of centralized power. To apply the colour of yellow to the emperor's costumes was to symbolize the dignity of the emperor by virtue of his ownership of earth. To own earth entitled him

also to supreme authority. *The Historical Records of Han Dynasty* says, "Yellow is the colour of the centre and the attire of the emperor."

Qing courtly robes included four colours, i.e. bright yellow, blue, red, and pale blue. This reflects the traditional Chinese values concerning colours. In the days of antiquity in China, heaven, earth, sun, and moon were believed to wield supernatural power. A relationship between the monarch in the human world and the gods in nature was recognized. Therefore, while conducting sacrifices to communicate with the gods, the colours of the sacrificial costumes of emperors should correspond to the respective gods. Blue was used for the sacrifice at the *Huanqiutan* or *Tiantan* (Altar of Heaven) during Winter Solstice to signify heaven; bright yellow was used for the sacrifice at the *Fangzetan* or *Ditan* (Earth Altar) during Summer Solstice to signify earth; red was used for the sacrifice at the *Chaoritan* or *Ritan* (the Altar to the Sun) during Spring Equinox to signify the sun, and pale blue was used for the sacrifice at the *Xiyuetan* or *Yuetan* (Moon Altar) at Autumn Equinox to signify the moon. Thus the emperor reached the realm where Man and Nature became one, so as to fortify the concept of "*junquan shen shou*" that the mandate of the monarch was given to him by heaven.

In respect of patterns, the dragon, exclusively reserved for monarchs, features frequently on the ceremonial and semiformal costumes of the emperor and of the empress, and it expresses the uniquely honoured *zhen long tianzi* ("true dragon son of heaven")

with his supreme authority. The courtly robe of the emperor was decorated with forty-three dragons; the dragon robe was decorated with nine dragons, because "nine" is the ultimate *yang* number in ancient China, and thus "nine dragons" became also the symbol of the emperor. Further, the distribution of the nine dragons all over the garment was very subtle in that from whichever angle the robe was viewed, only five dragons could be seen at one time on either the front or the back. This also cleverly implies the numbers of nine and five "*jiuwu*," completely matching the saying in the *Book of Change* that the son of heaven was "*jiuwu zhi zun*" and therefore commands supreme dignity.

Apart from the figures of dragons, the courtly robes and the semiformal costumes of the emperor were also decorated with the pattern of the twelve imperial emblems. This had always been an important pattern on the attire of monarchs in ancient China, and it was endowed with a beautiful symbolic meaning so as to manifest the perfection and supremacy of the son of heaven. The lower portion of courtly robes and dragon robes were all decorated with rocks and treasures standing on the waves of rough waters, and these are called the patterns of *babao ping shui* ("eight treasures calming water"), *babao li shui* ("eight treasures standing on water"), implying auspiciously that *jiangshan yong gu* (the country would forever stay strong) and that *wanshi shengping* (there would be peace and prosperity for thousands of generations).

These Qing patterns show clearly significant influence from traditional Han culture.

THREE: CALLIGRAPHY AND PAINTING IN EMBROIDERED TEXTILES

Painting and calligraphy in embroidered textiles combine the arts of weaving and embroidery with the arts of painting and calligraphy by employing the materials, techniques and skills of weaving and embroidery to represent the images made in calligraphy and painting. The craft is usually based on some calligraphy, painting, or poetry as blueprints and it exploits various techniques and skills such as *kesi* tapestry, brocade, and embroidery to copy the

spirit of the work of art while adding to it the gloss and texture that ink and brushwork could not attain. This is a special category of arts and crafts with its own characteristics.

I. Kesi or Cut Silk Tapestry of Calligraphy and Painting

Kesi is a weave based on a plain ground weave with wefts twining in different colours to achieve the

patterns. It has a long history starting the latest by the Tang Dynasty from which actual artefacts show that some basic functional or practical articles were made in *kesi* with simple multi-coloured patterns. In the Song period *kesi* tapestry broke away from the functional to turn to purely aesthetic creations, reaching the first peak of its artistic development. By the reign of Emperor Qianlong in the Qing Dynasty, after continuous development, *kesi* had become a flourishing craft that had reached its second historic pinnacle.

1. The Development of Song and Ming Kesi Calligraphy and Painting

Baoshou (wraps for painting and calligraphy or canon rolls) to protect the ends of the axles were usually made in *kesi* during the Northern Song Dynasty. By the time of the Southern Song, the craft of *kesi* had exceeded that of making merely functional articles and turned to creative work for aesthetic appreciation; it attained very high artistic achievements, reaching a climax of the art of *kesi* hard to surpass in its entire history. Textiles in *kesi* weave were so versatile that various techniques such as *guan* (flinging), *gou* (connecting), *jie* (knotting), *dake* (dovetailing), *zimujing* (warp joining), *changduanqiang* (straggling propping), *baoxinqiang* (propping with variation from periphery to centre), and *chanhuoqiang* (propping with vertical hue variation) could "freely represent images of flowers, plants, birds and beasts." Most *kesi* tapestries are facsimiles of calligraphies and paintings by famous artists from the Tang and Song periods, featuring landscapes, pavilions, flowers, birds, beasts, and people as well as calligraphy in various styles such as *zhengkai* (the regular script), *caoshu* (cursive script), *lishu* (official script), and *zhuanshu* (seal style).

During the Southern Song, accomplished *kesi* experts became grand masters in the trade, Zhu Kerou and Shen Zifan being two outstanding examples. Their subject matter included paintings from the academic school; they were given such exquisite *kesi* treatment and they became such vivid copies in structure and texture that they sometimes superseded the originals. Their standards were so high that none

has surpassed them during the past thousand years. For instance, the *kesi* items by Shen Zifan selected for the present volume, namely, the scrolls "Plum Blossoms and Magpies in the Cold" (Figure 203) and "Blue and Green Landscape" (Figure 204) are overwhelmingly life-like and expressive.

The art of *kesi* tapestry during the Yuan Dynasty went against the exquisite and graceful style of Southern Song and exercised characteristics of being terse but bold, primitive but vigorous and simple but natural. *Kesi* tapestry of that period came usually in the form of hanging scrolls connected with Buddhism and birthday celebrations. The Mongol rulers of Yuan had a predilection for gold. So textiles including *kesi* silk tapestries incorporated great quantities of gold threads, creating an extraordinary gorgeous effect. This became the trend of the time and had its own character. However, Yuan *kesi* failed to inherit the fine tradition of Song or to develop it further to any technical or artistic level. On the contrary, it became far inferior to its predecessors.

Objets d'art in *kesi* tapestry from the Ming Dynasty also used paintings by famous artists as blueprints, and there could be dozens of hues involved. The colourful lustre was gorgeous in appropriate degrees of light and shade, and the workmanship was minute and meticulous, reflecting the style and tone of the original. The production of *kesi* reached a peak in the middle of the Ming Dynasty. The major places of provenance were Suzhou, Nanjing, and Beijing. Products from Suzhou were the best of all. As men of letters gathered there at the time, the art of Suzhou *kesi* shows significant influence from literary paintings of the region south of the Yangtze.

Apart from the continued adoption of *kesi* techniques from the Song and Yuan periods, Ming *kesi* artists also created techniques of highly decorative effects such as *fengweiqiang* (phoenix tail propping) and *shuang zimujing* (double-warp joining). Ming *kesi* often employed the techniques of weaving in threads made of gold, peacock feathers, and double twisted filaments. The craft of using peacock feather wefts entailed the twisting together of threads made of peacock plumes and silk threads for weaving velvet. The finished fabrics would become opulent and

beautiful, showing bright and eye-arresting patterns, and their colours would never fade.

Generally speaking, the artistic style of Ming *kesi* is rather delicate and gorgeous, and it is different from the decorous elegance of Song *kesi*, each maintaining its special virtues and complementing each other. From the reign of Jiajing onwards, however, *kesi* articles used complementary colours too often, and the threads were not fine enough, while the weave became relatively crude and the art declined.

2. Development of the Art of Qing Kesi Calligraphy and Painting

The art and craft of *kesi* during the reign of Qianlong in the Qing Dynasty reached a new height since the Song period. It is characteristically fine, smooth, even, delicate, firm, dense, and neat, and it exhibits a great variety of exquisite pictures, making the products priceless treasures. During the Qianlong reign, *kesi* was rich in subject matters, including chiefly flowers, birds, beasts, landscape, people and folk customs, auspicious patterns, poetic texts, calligraphy and religion.

On top of keeping traditional *kesi* techniques, Qing calligraphy and painting in *kesi* also invented the novel double-sided *kesi* called *touke* with identical patterns on both sides. It is level and clear, fine and decorous, and no ends or knots are visible. This *kesi* technique is of high aesthetic as well as practical value. This category of Qing *kesi* uses threads of two different colours or threads of different lustre combined together to form polychrome threads so as to enhance the expressive quality due to the variation of textures and shades.

The colour scheme of Qing *kesi* calligraphy and painting tend to use one colour in different nuances graduating softly from the darker to the lighter by using techniques called the *sanlan kefa* ("three blue *kesi* method"), *shuimo kefa* ("water ink *kesi* method") and *sanse jin kefa* ("tricolour gold *kesi* method"). *Sanlan kefa* uses dark blue, royal blue and whitish blue, i.e. threads of the same family of colour in different shades, to bring forth an effect of gradually fading away on a light-coloured ground, and various floral patterns are woven in by propping. This technique makes brighter

pictures and distinguishes itself from the plain elegance and sobriety of Ming *kesi*. *Shuimo kefa* uses black, dark grey and light grey threads in graduation on a light-coloured ground to weave patterns by propping, and white or gold edges are added on to achieve an aesthetic effect of modest elegance and sobriety. *Sanse jin kefa* uses *chi yuanjin* (reddish round gold), *dan yuanjin* (light round gold), and silver threads twisted together and woven on a dark-coloured ground, achieving a shimmering effect with patterns.

In the middle of the Qing Dynasty there came a kind of *kesi* calligraphy and painting in which the ground weave was in silk while the patterns were made of woollen threads called *kemao* or *kesi* wool. This technique makes the patterns stand out like the woollen piles. A *kemao* hanging panel titled "Chicks Waiting to Be Fed" (Figure 223) was woven with threads made of silk and wool twisted together, and with the help of techniques like *changduanqiang* (straggling propping), *pingke* (plain-weave *kesi*) and *dasuo* (shuttle joining), the nuances and texture of the chicken's plumes become especially vivid.

Since the Southern Song period, some *kesi* had been brushed up with colour in minute places, but such works made up only a very small portion. By the time of Qianlong there appeared works made by combining the techniques of *kexiu hunhe fa* (*kesi* and embroidery). These products employed the three techniques and skills of *kesi*, embroidery and painting in combination and became a very popular form of textiles at the time. To a certain extent, this approach enhanced the decorative effect of the textile and enriched the artistic expression of *kesi*. In the scroll titled "Dispelling Chill on Double Nine Day" (Figure 221, *Kesi* Plus Embroidery), the background and the supporting patterns of the sky, the earth, the rocks, the clouds and the pond in *kesi* weave, and the people, the main design of the children's faces, the clothes, the goats and the plants are embroidered on, while the trunks and branches of the plum tree, the tea bushes and the birch are formed by painting on with a brush on the ground of *kesi* and embroidery. This enhances the decorative effect.

An unprecedented batch of enormous works of *kesi* appeared during the reign of Qianlong. The *kesi*

scrolls titled "Laozi Riding on the Buffalo" (Figure 220) and "Sakyamuni's Portrait with an Inscription of Eulogy by Qianlong" (Figure 219) are both representative examples of huge *kesi* works from the Qing Dynasty.

After Qianlong, with the decline of the Qing Dynasty, *kesi* calligraphy and painting never revived. Many a time *kesi* tapestry was produced merely with the outline in *kesi* technique while the details and the graduation of colours were made merely with brushwork on top. Hence, it gives more the feel of painting rather than *kesi*. Even among courtly articles are seldom found any rare items of fine quality.

II. Brocaded Calligraphy and Painting

Brocaded calligraphy and painting is an integral part of the art of calligraphy and painting in textile and embroidery. Brocade is a generic name for silk jacquard weaves. It uses delicately dyed threads as warps and wefts, often combined with gold and silver threads. The artistic standards are very high and the products are extremely valuable. Finished works of brocaded calligraphy and painting are therefore very rarely found. Those in the Palace Museum collection are all brocaded paintings from the Qing period, such as the scroll titled "Coloured Brocade Showing the Painting of Paradise by Ding Guanpeng" (Figure 225), which exhibits exquisite workmanship, rich colour scheme, closely integrated composition and a grand spectacle. This is the largest extant brocaded painting in the world and a masterpiece of ancient Chinese sericulture and silk weave.

III. Embroidered Calligraphy and Painting

Embroidery is a major art and craft for showing the art of calligraphy and painting in textile. During the Ming and Qing periods, the embroidery from different places in China had its own characteristics in stitches, colour schemes, threads, compositions and subject matters according to its definite traditions. During the Ming Dynasty, *guxiu* and *luxiu* (respectively from Jiangsu and Shandong) became most famous far and wide and enjoyed acclaim for their sophisticated craft and artistic profundity. During the Qing Dynasty, it was embroidery from Jiangsu, Hunan, Guangdong and Sichuan that attained the highest standards and gained the good name of *Si Da Ming Xiu* (the Four Reputable Embroideries). In benign competition, they enhanced each other's achievements in colour scheme and composition, and produced *objets d'art* of calligraphy and painting in embroidery with national characteristics.

1. Guxiu (Embroidery from the Jiangsu-Zhejiang Region)

Guxiu, also known as *Luxiangyuan guxiu* or *Gushi Luxiangyuan Xiu*, was originated during the reign of Jiajing of Ming Dynasty. It denoted the embroidery made by the famous clan of Gu Mingshi in Shanghai, but the name was also applied to embroidered articles with the same technique and in the same style. For its use of especially fine threads, its rich variety of stitches, and its sophisticated colour schemes combining the art of painting with the craft of embroidery, *guxiu* has won its unique reputation of outstanding achievements throughout the ages since antiquity.

Gu Mingshi became a *jinshi* (for having attained the highest degree in the imperial examination) in the thirty-eighth year during the reign of Jiajing (1559). The women in his clan were accomplished artists in the delicate embroidery of paintings, and his grandson's consort, Han Ximeng, was the most outstanding of them all. She searched and gathered famous originals of paintings from the Song and the Yuan periods as blueprints for her facsimiles in embroidery, and compiled her works into a tome known to the world as "Famous *Guxiu* from the Song and Yuan Dynasties (in Eight Sections)" (Figure 233) in the seventh year of the reign of Chongzhen (1634). This catalogue contains her painstaking works with whole-hearted input over many years. They are praised not only for her individual techniques of using finely split filaments, colour schemes and skilled stitches but also for her bold innovation to combine the consummate skill of embroidery with the subtle brush work of painting, thus assimilating the texture of paintings in the art of embroidery. This marriage between painting and embroidery has benefitted both partners. It represents the highest achievement of

guxiu (Gu-style embroidery) itself as well the pinnacle of the art of Chinese embroidery in general.

Guxiu became world-famous during late Ming and early Qing periods. Despite its exceptionally high prices, the demand was, nevertheless, greater than the supply. After the reign of Qianlong, however, the workmanship declined, and more and more pieces were done with the brush rather than the needle, and some products, called *kongxiu* (literally "empty embroidery"), even employed the method of merely embroidering the outline and filling in the rest with painting in colours. As a result, the prices went down and makers of embroidery became rare.

2. Luxiu (Embroidery from Shandong)

Luxiu denotes embroidery artefacts from the Shandong region during the Ming and Qing periods. They were usually made by embroidering with thicker threads containing two filaments on ground weaves of *anhuachou* (plain silk damask), *anhuaduan* (satin damask) and *anhualing* (silk twill damask). As the threads with double filaments are called *yixian* (clothes threads), *luxiu* is also called *yixian xiu*. These products are characterized by their thick threads, long stitches, sparse meshes and steady colours. Their functional durability, their simple, neat and broader uninhibited stitches, and their natural but vigorous patterns distinguish them from the dense stitches in fine threads, and the lucid beauty of classical elegance in *guigexiu* (embroidery from boudoirs) in the region south of the Yangtze. They embody the candid and bold style of folk embroidery of the north.

3. Suxiu (Embroidery from the Region around Suzhou)

Suxiu means embroidery from the region around Suzhou as the centre. *Suxiu* in the Qing dynasty was appraised for its elegant beauty, and embroidered articles used at the contemporaneous court were usually *Suxiu* items. The workmanship of *Suxiu* is extremely fine, its stitches being richly varied, its threads thin but compact, and its fabric seamlessly smooth and comfortable. Its characteristic attributes can be summed up in eight characters, namely, "*ping, guang, qi, yun, he, shun, xi* and *mi*" (level, glossy, neat, even, harmonious, smooth, fine and dense). Its colour

schemes are delicately elegant, often combining three or four different shades of the same colour or closely related hues to achieve effects of gradual mixtures with facility. Its patterns have origins from a broad spectrum of designs and they include flowers, people, landscape, beasts, etc. symbolizing celebratory joy, longevity and auspiciousness. Products featuring flowers and birds were especially popular favourites.

4. Xiangxiu (Embroidery from Hunan)

Xiangxiu means embroidery from areas centring on Changsha and Ningxiang in Hunan Province. Its remarkable rise during the late Qing period was based on the folk embroidery of Hunan with assimilation from the strengths of *Suxiu* and *Yuexiu*. Its special attributes include bold but beautiful composition, exquisite but flexible embroidering techniques, gorgeously rich colours, threads split to filaments finer than hair and velvety surface without piles, and it is therefore good at embroidering velvety patterns that feel realistic. *Xiangxiu* often uses Chinese ink painting as blueprints and employs mixed stitches to bring forth the transition between darker and lighter shades of the same colour, thus accentuating the shifts of nuances with *yin* and *yang* contrasts and rendering the objects illustrated livelier and suppler as in paintings. *Xiangxiu* is rich in stitches, colours, nuances and vivid shapes. It has been eulogized in words like "Embroidered flowers can emit fragrance, embroidered birds can sing, embroidered tigers can run and embroidered people can be life-like."

5. Guangxiu (Embroidery from Guangdong)

Guangxiu means embroidery from areas in Guangdong with Guangzhou as its centre. It is renowned for its full layout, luxuriant patterns, lively scenes and rich colours. The stitches of *guangxiu* are much varied. Thread arrangements are exploited to express the texture of the objects illustrated, and in combination with the various degrees of tightness, density and direction of stitches; this enhances the artistic expressiveness of the embroidery. The colour schemes of *guangxiu* are gaudier than those of *Suxiu*, while there is an emphasis on the variation of light and shade. Gold threads are often used to make outlines of patterns, and the contrasts between the

colours of threads are strong, often having red and green threads next to each other in a dazzling manner. With its strongly decorative quality, *guangxiu* is suitable for creating a lively atmosphere. Favourite subject matters for its patterns include the phoenix, peony, ape, deer and fowls such as cocks and geese. Hence the "*bai niao chao feng*" (Phoenix Holding Court with Hundreds of Birds), "*kongque kai ping*" (The Peacock Spreading out Its Tail), "*san yang kai tai*" (Three Rams Heralding Spring) and "*xing lin chun yan*" (Spring Swallows in the Apricot Woods).

6. Shuxiu (Embroidery from Sichuan)

Shuxiu, alias *chuanxiu*, means folk embroidery with the Chengdu area in Sichuan as its centre. *Shuxiu* originated early and enjoyed great fame already in the late Han period and the Three Kingdoms period. By the Qing period it had grown into a large-scale industry, and after a long process of development *shuxiu* had formed its unique art and technique in manoeuvring stitches to include hundreds of variations with their respective capability of expressing different special effects. The composition of *shuxiu* is succinct with appropriate shifts between the sparse and the dense. The patterns are concentrated while the ground fabric has empty spaces, in an unpretentious style of *hua qing di bai* ("plain ground and clear patterns"). The subject matters often include landscape, people, flowers, birds, fishes and insects, e.g. the hibiscus or lotus, the carp, cocks, and the cockscomb.

FOUR: TEXTILES AND EMBROIDERIES FOR INTERIOR DISPLAY

Because carpets and tapestries have the attributes of thick fibres, great elasticity, strong lustre and pressure resistance, they were broadly used in the palaces of both the Ming and the Qing Dynasty. They were ubiquitous from floors to walls and from seats to beds. They can be categorized according to their purposes into carpets for the floor, covers for the *kang* (earthen beds with inbuilt heating), hanging tapestries for walls, covers for the table and chair, panels for the throne and covers for the saddle. Even the *chuanghu dang* (curtains or window blinds) hanging in front of windows to ward off the wintry winds were tapestries. According to their materials and skills involved, these can in turn be categorized into *zairongtan* (tufted rugs) (including woollen and silk ones), *pingwentan* (plain-weave tapestries), *maotan* (woollen tapestries) and *xiyangtan* (western-style tapestries). Tufted rugs or *zairongtan* form the majority and the other categories are relatively rare. For want of space, this essay will make only a brief and sketchy account of these items for interior decoration and display.

There are extant today in the Palace Museum about a thousand carpets and tapestries of various categories once used in the Ming and Qing palaces. These include wall-to-wall carpets covering the floors of grand halls as well as small panels for desks, chairs and beds; there are monochrome rugs of simple workmanship as well as *kesi* woollen tapestries and tapestries with piles of intertwined gold and silver threads, products requiring very intricate crafts.

Weaving carpets and tapestries involve highly sophisticated skills and they are very valuable and expensive. The material is chiefly wool combined with some silk, gold and silver threads. The large carpets with piles used in huge halls are usually made of warps of pure silk threads, much more expensive than cotton threads, to show the extravagance of carpets for royal use.

The Qing tufted rugs made of silk are generally completely hand-made by the *zairong* method with the thread or yarn cut to length and inserted, which facilitates the liberty of pattern designs and the variation of colour schemes. The silk rugs from that period demonstrate dozens of colours and twisted threads of gold (and silver) were often used. The twisted gold threads usually form the ground weave while the coloured silk threads make the patterns in piles. Such silk rugs are different from others in that not all their parts are tufted, and this craft shows a major characteristic of tufted rugs in silk from the mid-Qing Dynasty.

Carpets and tapestries used in courtly palaces were only partly made by court craftsmen. Great quantities of the rugs were specially commissioned

goods from distant places adept in weaving carpets such as Xinjiang, Mongolia, Ningxia, Gansu, Qinghai and Tibet.

The art and craft of making carpets in the Qing Dynasty formed various systems in the respective regions of provenance. The famous ones include Beijing carpets, Ningxia carpets, Xinjiang carpets and Tibetan carpets. Beijing carpets have assimilated the decorative approach in silk textiles with symmetrical patterns, forming a new category bearing traditional styles that are gorgeous and exquisite. Ningxia carpets use the special raw material of very fine *tanyang* (a special sheep of fine wool from the region) wool from Ningxia. They are carpets of fine and excellent quality. Xinjiang carpets are covered with geometric patterns that achieve the decorative effect of being dazzling and eye-arresting. Tibetan carpets are known for their fine woollen tones and beautiful colours. The patterns are usually bold with varying colours and shapes. Their predominant colours are yellow, red, blue, green and white and they are distinctly different from most other carpets in darker tones.

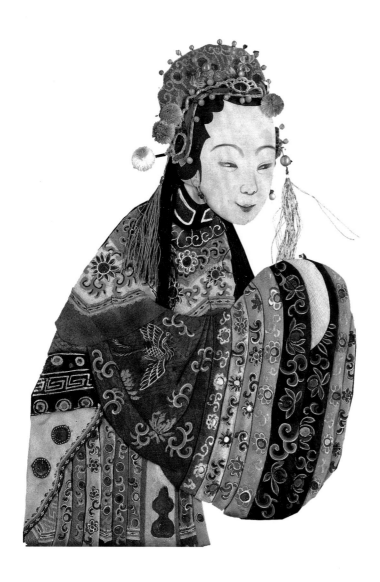

TEXTILES AND EMBROIDERIES

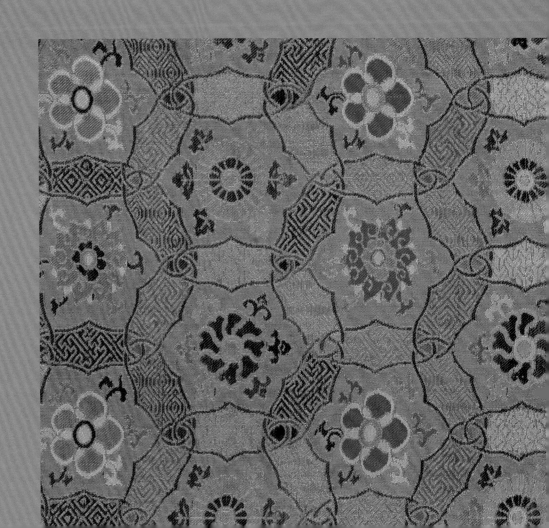

1

Baoshou in *Kesi*
with Patterns Featuring Mandarin Ducks Frolicking among Water Lilies

Ming Dynasty

Length 24.4 cm　Width 22 cm
Qing court collection

This wrap shows a picture of mandarin ducks frolicking among lotus flowers woven out of multi-coloured warps and wefts. The flowers standing on long stalks in the middle are in full bloom. Above them a mandarin duck is dancing, while another is playing on the water around, mutually enhancing the pleasurable sight. This symbolizes the harmony of a loving couple of man and wife.

The weaving of this *baoshou* involves various cut silk techniques including the *pingke* (plain cut silk), *gouke* (connecting cut silk), *taoke* (interlocking cut silk), *qiangke* (propping cut silk) and *dake* (dovetailing cut silk). The cut silk workmanship is extremely fine and the wrap looks like a meticulously detailed (*gongbi*) painting on tabby. As the Yuan painter Ke Jiusi writes in his *Fifteen Court Ci-poems*, "Rowing on the imperial pond and watching the water lilies / I saw jade green mandarin ducks frolic among the green leaves. / I told my little girl to remember this well / For embroidering on the imperial dress a pond full of charm." Ke made a note saying, "During the reign of Tianli, imperial clothing was often decorated with scenes from ponds, and such patterns were called *manchijiao* (pond full of charm)." It is understood from this that embroidered items with such scenes were also called *manchijiao*.

Kesi (cut silk) is a Chinese traditional silk textile. Its name is due to the fact that the weaving process results in meshes and crevices between the patterns and the ground weave and between different colours. It is also called *kesi* written in two other characters with the same sound of *kesi*. The *baoshou* is a wrapping for scrolls of calligraphy or painting covering the ends of the axles. According to archives, this wrap was used round the painting *Tangren Chunyan Tu* (People of Tang at a Spring Feast).

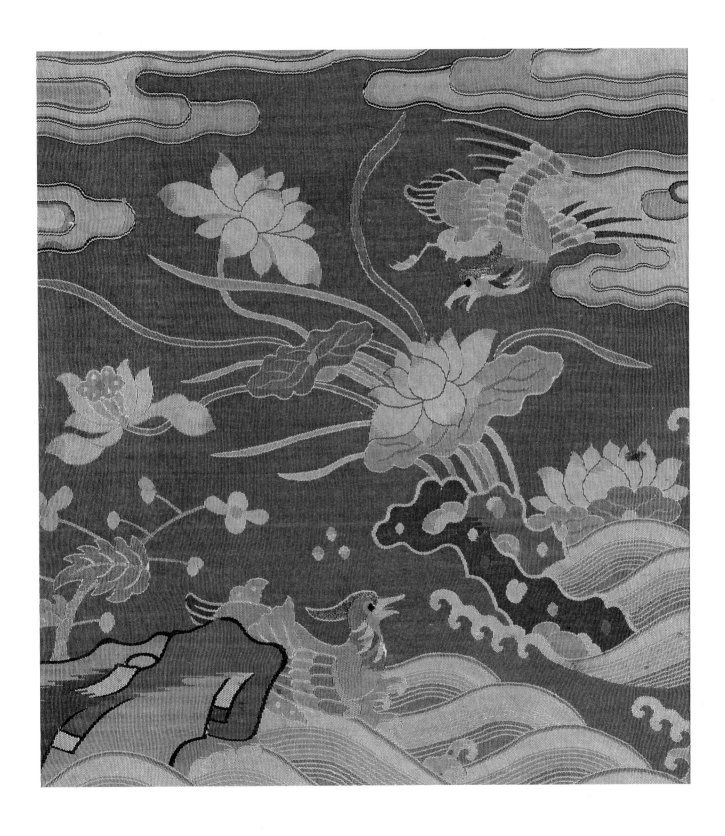

2

Biaopian
with Patterns of a Dragon in Clouds and the Character for "Longevity" on Gold *Kesi* Ground

Ming Dynasty

Length 38 cm Width 37 cm

The *biaopian* (silk tabby for mounting painting) is woven with white raw silk threads as warps and twisted red gold threads as wefts to make the ground with golden weft *kesi* (cut silk) patterns. In addition, there is an obverse dragon intertwined with auspicious clouds made from wefts of gold threads twisted with blue, green and yellow threads, and all around are the characters *wan* (卍) and *shou* (longevity) to imply *wanshou wujiang* (everlasting life).

This *biaopian* formed the front of the emperor's dragon robe. Its weaving involved the techniques of *pingke* (plain *kesi*), *taoke* (coiling *kesi*), *gouke* (connecting *kesi*), *guanke* (throwing *kesi*), *kelin* (*kesi* fish scales) and *dake* (dovetailing *kesi*). Even though the colours have faded, the sophisticated craft of *kesi* is still visible.

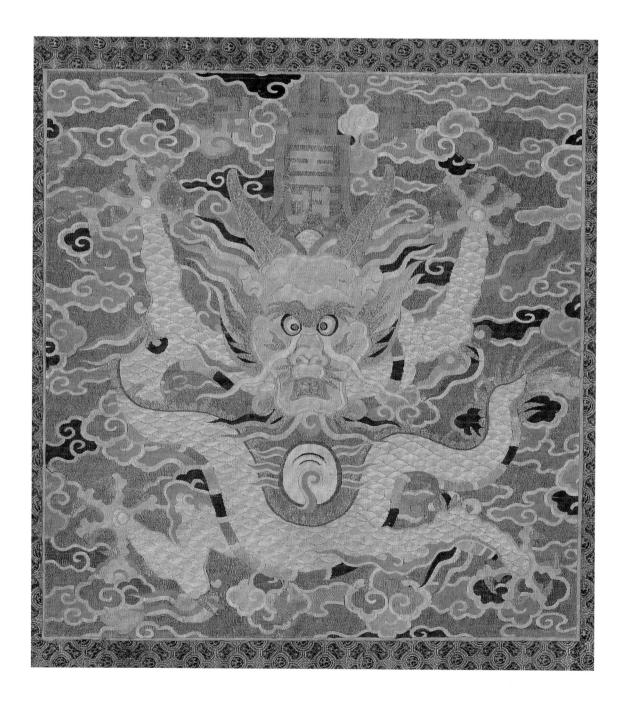

3

Jifu Pao of Kesi
in Bright Yellow Ground with Patterns of Eight Treasures and Cloud Dragon

Qing Dynasty Shunzhi period

Length 154 cm
Width across both sleeves 138 cm
Width along the lower hem 140 cm
Qing court collection

The fabric of the *jifu pao* (semiformal courtly robe) is woven from white silk warps and bright yellow silk threads as the *kesi* (cut silk) wefts to make a bright yellow surface. On the upper part of the robe, gold threads and multi-coloured threads have been twisted to make weft patterns of an obverse dragon in *kesi* across the shoulders. In between are colourful clouds, the dharma wheel (*falun*), a fish, a parasol, a dharma conch, a chime stone (*qing*), and the auspicious knot, being figures from the eight Buddhist treasures (*babaowen*). In the middle are woven two dragons playing with the pearl. In the lower part of the robe are patterns of sea waves lapping the shore.

The eight Buddhist treasures are traditional auspicious patterns. They can be represented in various forms. One form is composed of eight instruments from Buddhism, namely, the dharma wheel, the dharma conch, the precious parasol, the white canopy, the lotus flower, the precious jar, the gold fish and the auspicious knot, and these are called the eight auspiciousness (*bajixiang*); another is composed of the chime stone, the auspicious clouds, the double lozenge knot (*fangsheng*), the magic fungus (*lingzhi*), the clappers, the rhinoceros horns, and the gold ingot, and these figures are called the mixed treasures (*zabaowen*).

This robe is made of fabric woven with the techniques of plain cut silk or *kesi*, twining *kesi*, connecting *kesi*, *kesi* gold, *kesi* fish scale and straggling propping. The institution of dress code at the early-Qing court was not yet complete and it kept traces of the Ming system. The dragon across the shoulders in this robe is a typical example of remnants of Ming dragons.

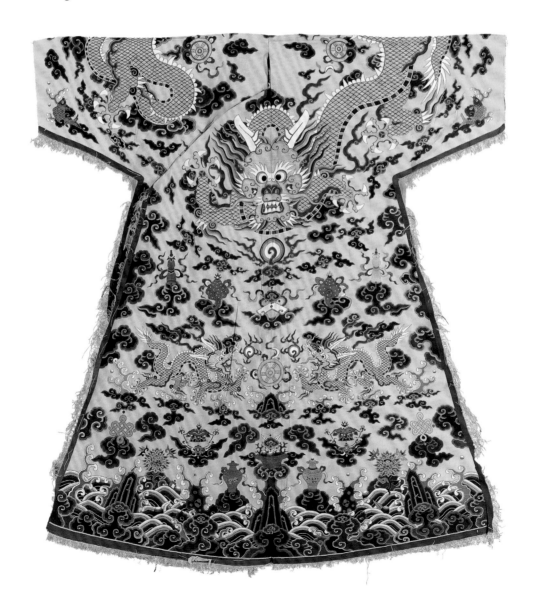

4

Jifu Gua
in Blue *Kesi* Ground with
Mang-dragons in Clouds and
the Character for
"Longevity"

Qing Dynasty Shunzhi period

Length 154 cm
Width across both sleeves 152 cm
Width along the lower hem 122 cm
Qing court collection

The ground fabric of this semiformal jacket (*jifu gua*) is blue. The figure of an obverse *mang*-dragon on the breast is woven in *kesi* (cut silk) with gold threads twisted together with peacock plumes. On top of the *mang*-dragon's head is a golden character for "longevity." At each of the *mang*-dragon's front claws is raised a fire pearl with the character for 卍. On the lower front is the figure of two *mang*-dragons playing with pearls. On either shoulder is an obverse *mang*-dragon. Thus there are altogether five *mang*-dragons seen from the front and four from the back, making a total of nine. Among them are decorations of auspicious clouds, sea water by the shore and a golden character for "longevity" in seal style (*zhuanshu*).

The fabric for this jacket is woven in *kesi* fish scale, connecting *kesi*, dovetailing *kesi*, flinging *kesi* and shuttle-joining *kesi*. The *kesi* workmanship is exquisite and intricate and the colour scheme is sophisticated. It is representative of the art and craft of cut silk during the early-Qing period.

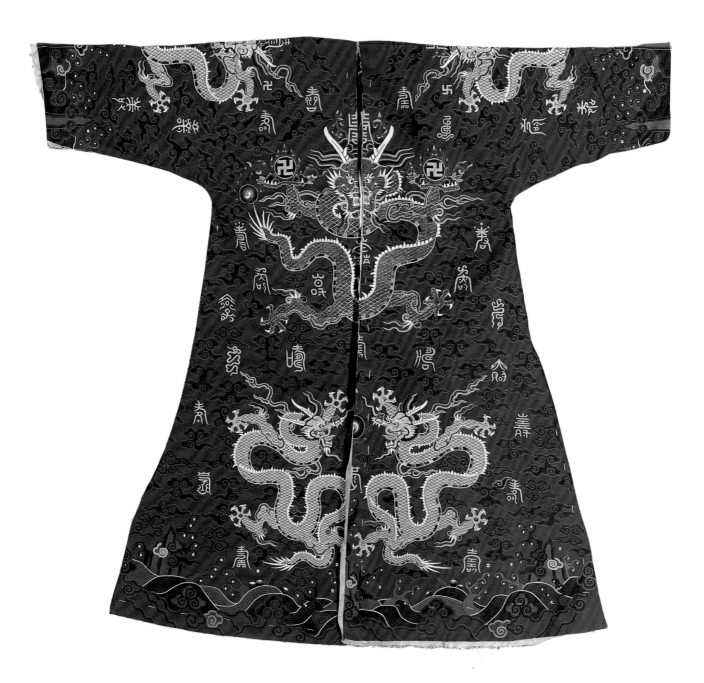

5

Jifu Pao
in Blue *Kesi* Ground with
Figures of *Mang*-dragons
among Colourful Clouds

Qing Dynasty Shunzhi period

Length 158 cm
Width across both sleeves 144 cm
Width along the lower hem 135 cm
Qing court collection

The *jifu pao* (semiformal courtly robe) is made of blue plain-weave fabric, on which are woven figures of *mang*-dragons among clouds and the character for "longevity" with *kesi* (cut silk) wefts made from twisting together multi-coloured woollen threads of over twenty colours, e.g. green, blue, red, yellow, white and other hues in combination with gold threads. On top of the *mang*-dragon head in the middle is a character for "longevity" and its front claws too hold each the same character. Below these are two *mang*-dragons playing with pearls. On the upper front and under the armpits are altogether fifteen *mang*-dragons among clouds, some playing with pearls and others with their heads tilted fighting for the character for "longevity." On the lower portion of the front are waves lapping the shore, and all over are clouds in five alternating colours and figures of *lingzhi* (the magic fungus) holding the golden character for "longevity."

The fabric of this robe is woven in plain *kesi*, *kesi* gold, dovetailing *kesi*, connecting *kesi*, *kesi* fish scale, straggling propping and flinging *kesi*. The *kesi* workmanship is smooth, neat and delicate. It is a representative choice item of cut silk from the Qing period.

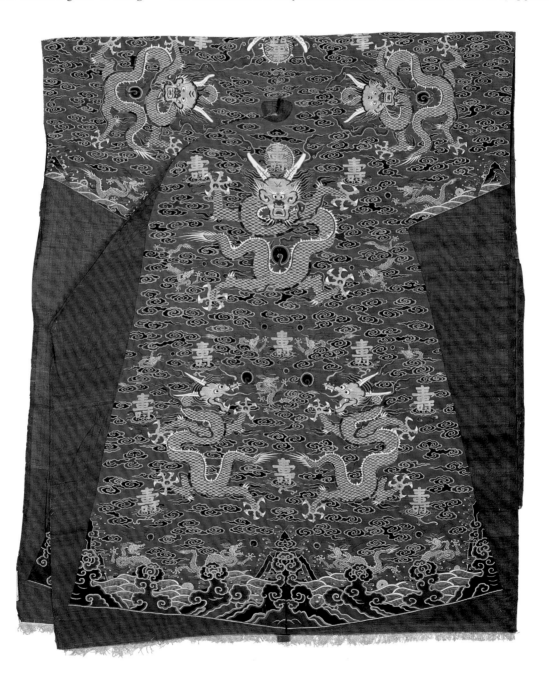

6

Jifu Pao
in Gold *Kesi* Fabric with Dragon Figures in Blue

Qing Dynasty Qianlong period

Length 146 cm
Width across both sleeves 122 cm
Width along the lower hem 126 cm
Qing court collection

The *jifu pao* (semiformal courtly robe) is woven in white raw silk warps and *kesi* (cut silk) wefts with twisted gold threads making a face of gold ground for the robe. The pattern wefts are silk threads in ten colours including blue, red and green. The *kesi* weave features dragons in various postures and decorated with multi-coloured clouds, bats and the eight auspicious signs of the wheel of dharma, the dharma conch, the precious parasol, the white canopy, the lotus flower, the magic jar, the gold fish and the auspicious knot. The lower part of the front is decorated with waves lapping the shore and the patterns of rising water and mixed treasures (*zabaowen*).

The fabric of this robe is woven by *kesi* methods including plain *kesi*, coiling *kesi*, connecting *kesi*, flinging *kesi*, *kesi* fish scales and shuttle joining. The craftsmanship is fine and intricate and the colour scheme sophisticated. There is an obverse dragon on the front, one on the back and one on each of the shoulders. On the lower parts of the front and the back are two rising dragons and on the top of the front one rising dragon, making a total of nine, but only five of these are visible from the front, implying the dignity of the emperor in the expression "*jiuwu zhi zun*" (the authority of the emperor as symbolized by nine and five according to Chinese numerology). This is special fabric for monarchs.

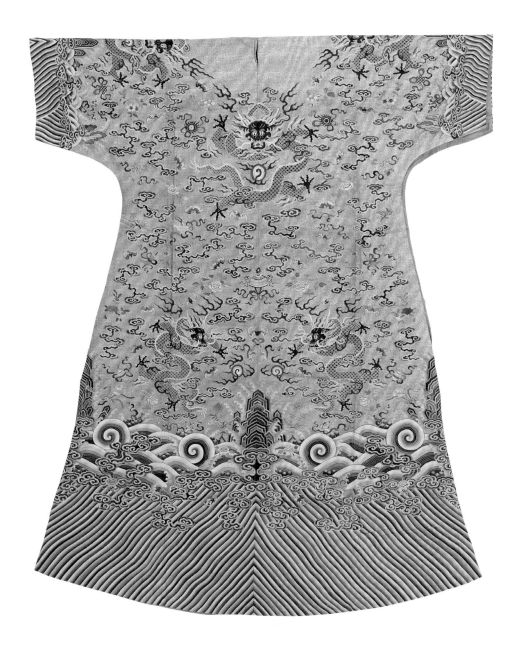

7

Changfu Pao
in Fabric of Green *Kesi* Ground with Patterns of Peony

Qing Dynasty Daoguang period

Length 155 cm
Width across both sleeves 193 cm
Width along the lower hem 135 cm
Qing court collection

The fabric of this *changfu pao* (informal robe) is woven with white raw silk warps and green silk wefts as *kesi* wefts to make a green face. Multi-coloured silk threads are used as pattern wefts for the *kesi* (cut silk) weave showing peony, magnolia, chrysanthemum, morning glory, day lily, etc. symbolizing wealth, longevity and fertility, etc.

This fabric uses methods of plain *kesi*, connecting *kesi*, dovetailing *kesi*, etc. But the gradual shades of nuances of the flowers are achieved by means of dyeing and colouring.

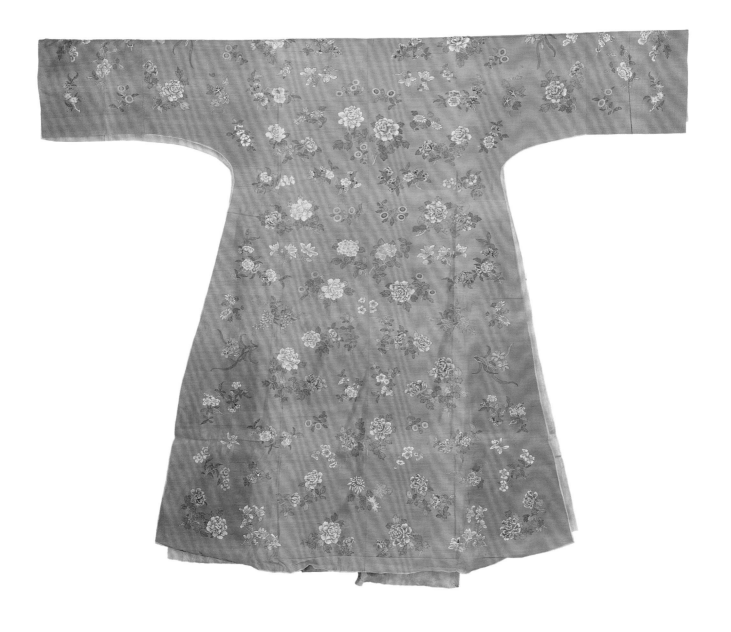

8

Changfu Pao
in Brownish *Kesi* Ground
Fabric Decorated with
Roundels of Cranes and
Flowers

Qing Dynasty Daoguang period

Length 144.5 cm
Width across both sleeves 121 cm
Width along the lower hem 123 cm
Qing court collection

The fabric of this *changfu pao* (informal robe) is woven with white raw silk warps and brownish boiled silk threads as *kesi* (cut silk) wefts to make a brownish face. Pattern wefts of boiled silk in red, green, yellow, greyish pink (*ouhe*), blue and pale blue (moon white) show figures of the celestial crane, dappled deer, peach, bamboo, peony, bats and other mixed treasures and form eight roundels surrounded by flying ribbons with the character for *wan* (卍) and the *ruyi* symbol as well as waves lapping the shore. On the lower portion of the front are patterns of rising water. The groups of patterns imply the auspiciousness of "deer and cranes in spring," "happiness and longevity as wished" (*fushou ruyi*) and "power over the domain for ten thousand generations." (*jiangshan wandai*)

This fabric is woven with the methods of plain *kesi*, coiling *kesi*, straggling propping, connecting *kesi*, dovetailing *kesi*, etc. specially for making informal robes for imperial concubines.

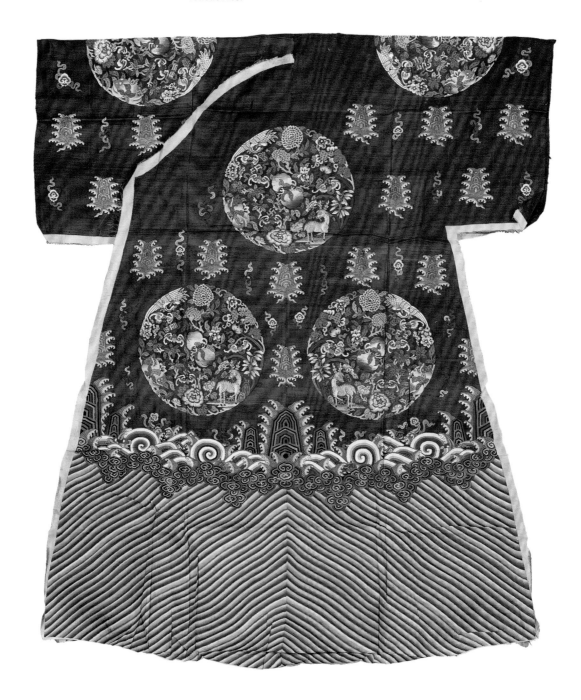

9

Fabric for Blouse
with Yellow *Kesi* Ground and Multi-coloured Patterns Featuring *Fu, Yuan, Shan, and Qing*

Qing Dynasty Tongzhi period

Length 147 cm
Width across both sleeves 190 cm
Width along the lower hem 139 cm
Qing court collection

The fabric of this blouse is woven with white raw silk warps and yellow boiled silk wefts on a yellow *kesi* (cut silk) ground. Multi-coloured silk threads are used as pattern wefts to make patterns of the character for "happiness" in red and multi-coloured mixed treasures such as pearls, fans and stone chimes alternating with patterns of plucked peonies, peach blossoms, orchids and daffodils to symbolize "happiness, serendipity, benevolence and celebrations" (*fu yuan shan qing*) and "wealth and long life." (*fugui changshou*)

This fabric is woven with cut silk techniques such as plain *kesi*, connecting *kesi*, coiling *kesi*, propping *kesi* and shuttle joining. The *kesi* craftsmanship is succinct and the patterns are elegant and tasteful. The red character of "happiness" is especially eye-arresting.

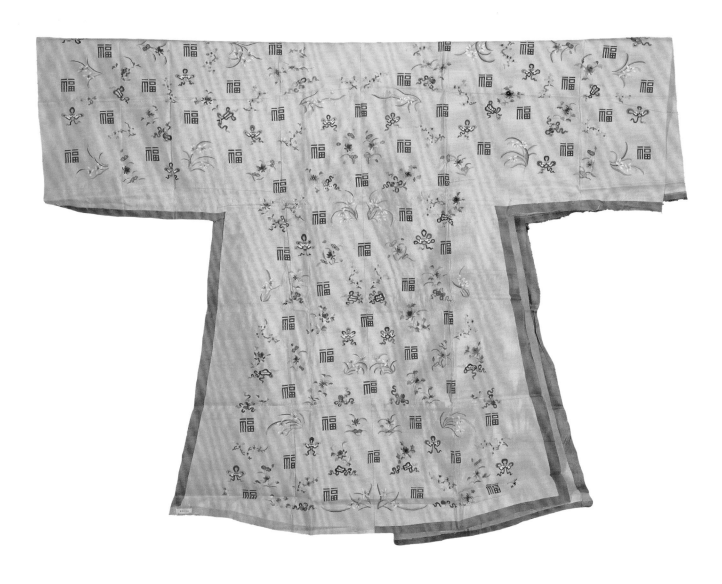

10

Blouse
with Patterns of Landscape on *Kesi* Peach Pink Ground Fabric

Qing Dynasty Tongzhi period

Length 151 cm
Width across both sleeves 200 cm
Width of lower front 114 cm
Qing court collection

The fabric of this blouse is woven with white raw silk warps and peach pink silk threads as wefts to make a *kesi* (cut silk) peach pink ground. Multi-coloured silk threads are used to make *kesi* patterns of landscape with pavilions, little bridges over running brooks, trees and flowers. There are also butterflies, birds, and bats fluttering around. Tree trunks are painted with colours.

This fabric has employed methods of straggling propping, plain *kesi*, *kesi* in three shades of blue (*sanlanke*), connecting *kesi* and shuttle joining. The *kesi* craftsmanship is intricate and fine and the composition of the patterns is constrained and orderly. The patterns go from bottom up and according to the perspective in which the near appears larger than the distant. The technique of making gradual shades of hues is much employed, resulting in a masterpiece from the period of the reign of Tongzhi.

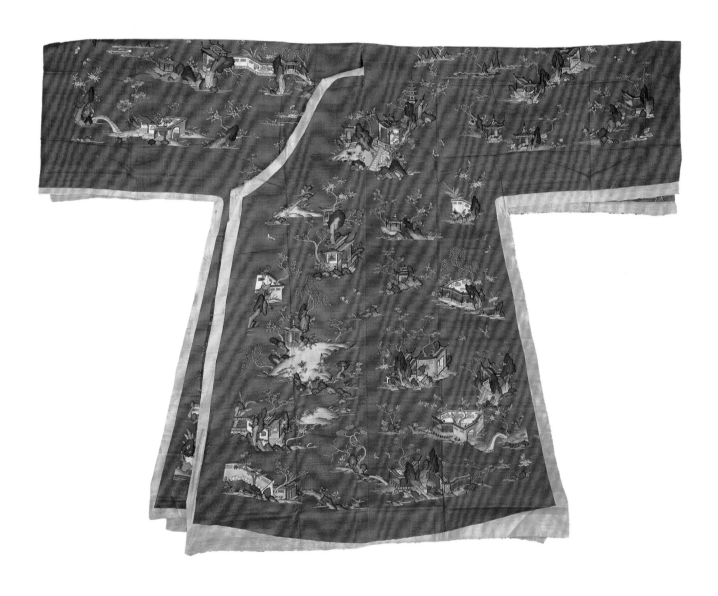

11

Huaidang
of Yellow *Kesi* Ground with Figures of Two Dragons Holding the Character for "Longevity"

Qing Dynasty Guangxu period

Length 86 cm Width 86 cm
Qing court collection

The napkin has a yellow ground and the theme of its decorative pattern is "two dragons holding longevity" with two dancing dragons encircling a roundel of the character for "longevity." Around these are faintly the eight Daoist immortals, featuring "deer and crane in spring," "house full of chips at receding flood" and "five happinesses holding longevity," and the edges are decorated with the character for 卍, bats and the character for "longevity." All these imply long life and birthday wishes.

Huaidang (table napkin) was a special article, similar to table napkins, for monarchs and their consorts. This *huaidang* is woven with techniques involved in coiling *kesi* (cut silk), connecting *kesi*, flinging *kesi*, shuttle joining *kesi*, straggling propping, *kesi* gold, *kesi* fish scales and the three-blue-hues *kesi*. The trunk of the pine tree is painted with colours, while the dragon's eyes are embroidered. This is a choice item of late-Qing *kesi* called *kexiu hunse* (*kesi* embroidery with colours merging).

"House full of chips at receding flood" (*hai wu tian chou*) implies "prolonged longevity," an auspicious symbol often used in the Qing period. According to legend, in the sea there was a house with a jar inside containing longevity for the human world. If the immortal crane could be made to deliver a chip into the jar, life could be prolonged by a hundred years.

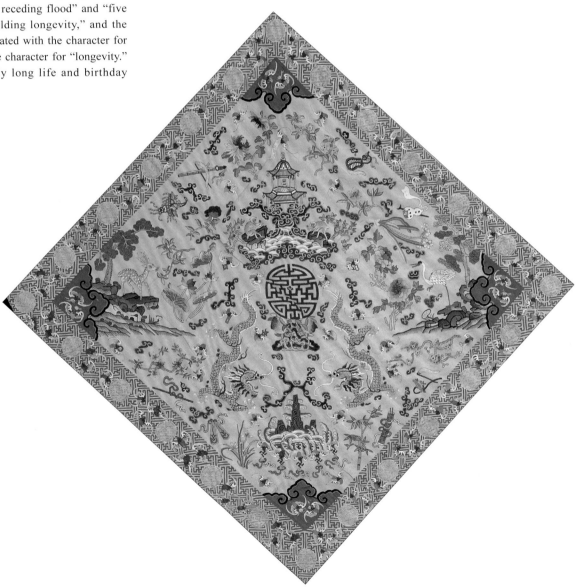

12

Chair Panel
in *Zhangrong* with Yellow Ground and Patterns of Bats and Lotus

Qing Dynasty Kangxi period

Length 227 cm Width 68 cm
Qing court collection

This piece of *zhangrong* (pile weave in Zhangzhou style) is woven with yellow warps and wefts in sets of four to make a twill ground and, in addition, yellow pile warps and pile rods (*jiazhiwei*) to make a yellow pile ground. Pattern wefts made from threads of dark green, light green, red and peach pink woollen threads twisted together with gold threads interlock with dark red pattern warps to make figures of lotus, bats and the character for *wan* (卍) to symbolize boundless happiness (*wanfu wu bian*). The edges are decorated with patterns of lotus and the *kui*-dragon (*kuilong*, a mythic dragon with only one leg).

The fabric for this chair panel was woven with the shuttle going from selvedge to selvedge to feature the lotus flower with leaves and twigs, while the bats and the lotus buds were woven in sections. The outline of the flowers were made in gold threads. The craftsmanship is exquisite and the composition succinct. The colours are bright and beautiful. It is a choice item of pile weave from the reign of Kangxi.

Pile weave (*qirong zhiwu*) has existed since the Han period and it became popular during the Ming and Qing dynasties. The best of its kind came from Zhangzhou, Fujian Province during the Ming Dynasty. Hence its name *Zhangrong*.

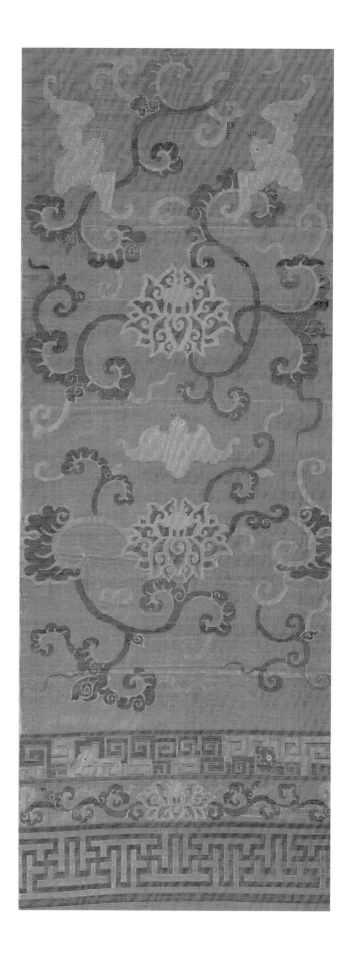

13

Zhangrong
with Green Ground and Pattern of Plucked Chrysanthemum

Qing Dynasty Qianlong period

Length 871 cm Width 60.3 cm
Qing court collection

This piece of *zhangrong* (pile weave in Zhangzhou style) is woven with green warps and wefts in sets of four to make a firm twill ground. Green pile warps intertwine with pile rods (*jiazhiwei*) to make a green pile ground. Silver threads are used as pattern wefts to intertwine with green pattern warps to make a lozenge frame, inside which are plucked chrysanthemums made by intertwining blue, red, yellow and white pile warps with float wefts. The patterns are in alternating series of two rows, one yellow and one red, for a pass to form continuous patterns on all sides.

Zhangrong is a pile weave with pile loops made with warps. Its weaving method is to use a pile rod (*qimaogan*) inserted to float the loops. The pile warps and the pile rods interlock to make the ground and the patterns. The so-called multi-coloured *zhangrong* means *zhangrong* whose ground weave and pile weaves have different colours.

14

Panel of *Zhangrong* with Patterns of Plucked Chrysanthemum on a Yellow Ground

Qing Dynasty Qianlong period

Length 117 cm Width 58.6 cm
Qing court collection

This fabric in *zhangrong* (pile weave in Zhangzhou style) is woven with bright yellow warps and wefts in sets of four to form a firm ground of twill weave. The pile ground is woven with yellow pile warps intertwining pile rods; and the pattern wefts are pile wefts in eight colours such as green, blue, red and beige intertwining with dark red pattern warps to feature coiling chrysanthemum in weft twill. The edge is decorated with a geometric pattern like a shorter T.

The chrysanthemum leaves and twigs are woven with the wefts going from selvedge to selvedge. The apricot-coloured ground is woven with the technique of *wasuo*, i.e. using different shuttles for various patterns and the wefts are cut in accordance with the need instead of going through the whole width, in order to have respectively different colours. The yellow pile for the pistil of the chrysanthemum is particularly vivid for its three-dimensional effect. It is a choice item of *zhangrong* from the reign of Qianlong.

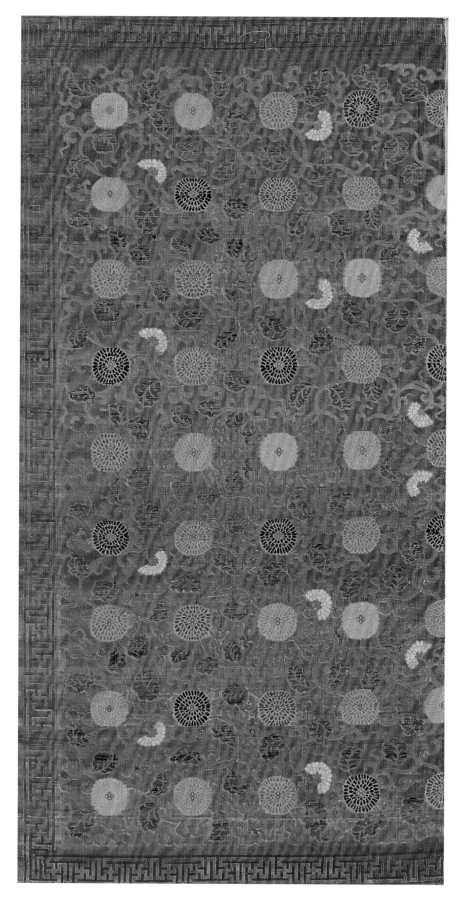

15

Zhangduan
with Blue Ground and Pattern of Coloured Twining Peony

Qing Dynasty Qianlong period

Length 896 cm Width 74 cm
Qing court collection

This piece of *zhangduan* (pile satin in Zhangzhou style) is woven with six sets of three floating satin warps to form a blue firm ground. Pile warps in light green, dark green, bright red, purplish red and beige are used to weave twining sprigs of peony to imply long-lasting wealth and honour (*fugui mianchang*).

This piece of *zhangduan* was manufactured by Jiangning (Nanjing) Textile Bureau during the Qing Dynasty. The craftsmanship is exquisite, the composition succinct and the patterns gorgeous. Evoking a strong sense of being three-dimensional, it is a precious sample representing the best pile satin weave with the most colours from the Ming and Qing periods.

Zhangduan is a high-quality weave with pile patterns on a satin ground. It was used mainly for costumes and furnishing panels. The best pile satin in the Ming period was produced in Zhangzhou, Fujian Province, hence its name. During the Qing Dynasty pile satin was also produced in Nanjing and Suzhou, and it is one of the most valuable weaves of the Qing Dynasty.

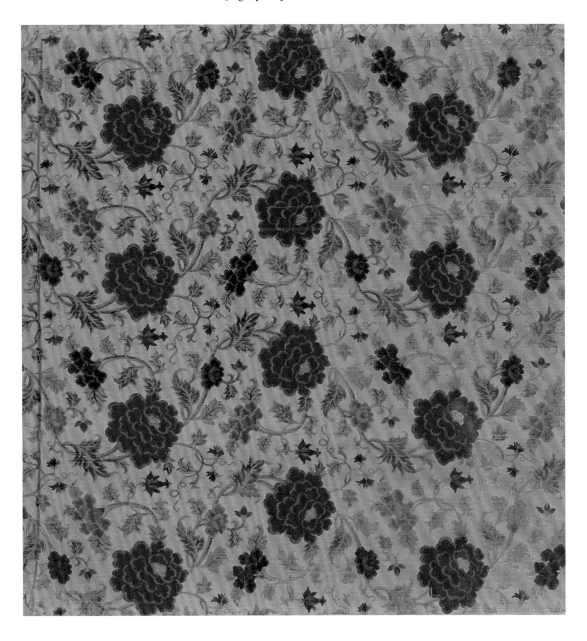

16

Double-layered Fabric
in Red Ground with Patterns of Plucked Peony Sprig

Mid-Ming period

Length 137 cm Width 32.5 cm
Qing court collection

The double-layered fabric uses red warps and wefts for the ground in plain weave and green warps and wefts for the plain-weave patterns of peony and chrysanthemum. The patterns have passes of series with two rows alternating, one of chrysanthemum turning downward and another with peony tilting up, forming together roundels of flowers, leaves and twigs on all sides for a continuous decorative pattern that symbolizes wealth and longevity (*fugui changshou*).

Double-layered fabrics are also called double-layered brocade (*shuangceng jin*). The weave uses two sets of warps and two sets of wefts in different colours to make two faces with identical figures on opposite sides which have the reverse colour schemes so that the ground on the one side has the same colour as the patterns on the other and vice versa.

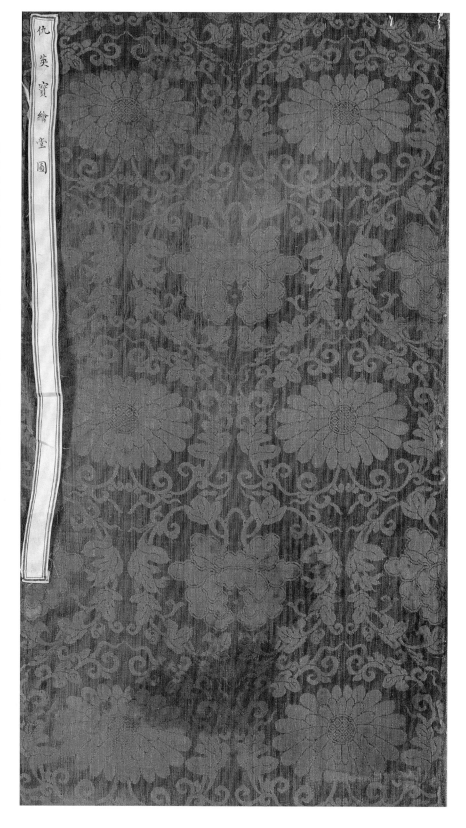

17

Double-layered Fabric
with Brownish Red Ground and Phoenix Patterns

Ming Dynasty

Length 38 cm Width 26.5 cm
Qing court collection

The double-layered fabric uses brownish red (*muhong*) warps and wefts for the ground in plain weave and white warps and wefts for patterns in plain weave. The patterns have passes of series with two rows alternating; one row shows flying phoenixes with their heads facing down, while the other shows flying phoenixes with their breast stretching and head facing up, thus forming pairs of phoenixes dancing with each other. In between are decorative patterns of clouds and the eight treasures including the canopy, the jar, the knot and flowers to symbolize auspiciousness.

This fabric is delicately woven, its composition stringently rich and full, its lines fluent and its patterns clear and elegant. It is a fine piece among Ming double-weaves. As two sets of warps and wefts of different colours have been used separately for the ground and the patterns of either face, the fabric is connected only in the patterns along the selvedges, and the rest forms an upper and a lower layer.

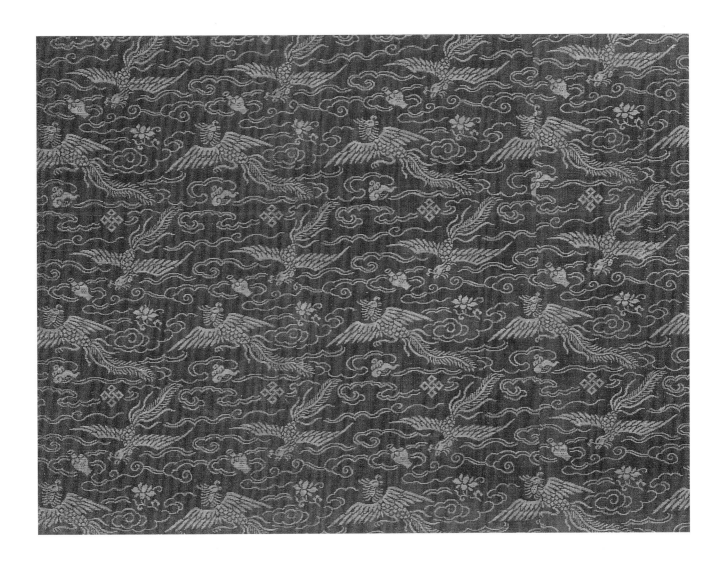

18

Jingpi
of Double-layered Weave with Blue Ground and Patterns of the Characters for "Happiness" and "Longevity" and Figures of Fishes

Ming Dynasty

Length 35 cm Width 14.5 cm
Qing court collection

This double-layered fabric is made of blue warps and wefts for the plain-weave ground and yellow warps and wefts to make up the plain-weave patterns of twin fishes and characters for "happiness" and "longevity." The patterns are in passes of two-row series, with one row showing the *ruyi* pattern enclosing the character "happiness," the lotus flowers, the precious swords and the twin fishes, and the other row showing the *ruyi* pattern enclosing the character for "longevity," the lotus, the precious swords and the twin fishes. The patterns alternate and intertwine, symbolizing happiness, longevity and fulfilment (*fushou ruyi*) and surplus every year (*liannian youyu*).

Jingpi, also called *biaopian*, is the jacket for Buddhist scripture covers. This *jingpi* has a subtle and novel design; its patterns and the ground weave show strong contrasts in colour, and the patterns are simple and natural. It is a choice piece of double-layered fabric from the Ming period.

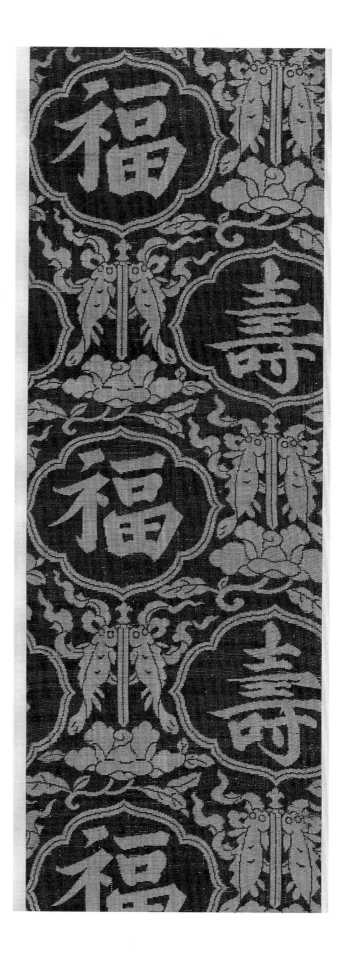

19

Double-layered Fabric
with Green Ground and Patterns of Tortoise Shells and *Qiulu*

Ming Dynasty

Length 66.5 cm · Width 25.8 cm
Qing court collection

This double-layered fabric is woven with green warps and wefts for the ground and white warps and wefts for the tortoise pattern in brocade, on top of which are patterns of interlocking circles. Inside the circles are white patterns in plain weave. The big and small circles form the frame of the patterns. Inside the big ones are lotus flowers and outside running rabbits and the magic fungus (*lingzhi*). Between every two big circles are small circles, inside which are figures of dragon and tortoise shells as ground filled with *baoxianghua* (flower of precious countenance) in roundel to form continuous patterns on all sides.

Qiulu means the pattern based on a big circle as the centre and small circles around, all interlinking. Inside the circles are other decorative patterns.

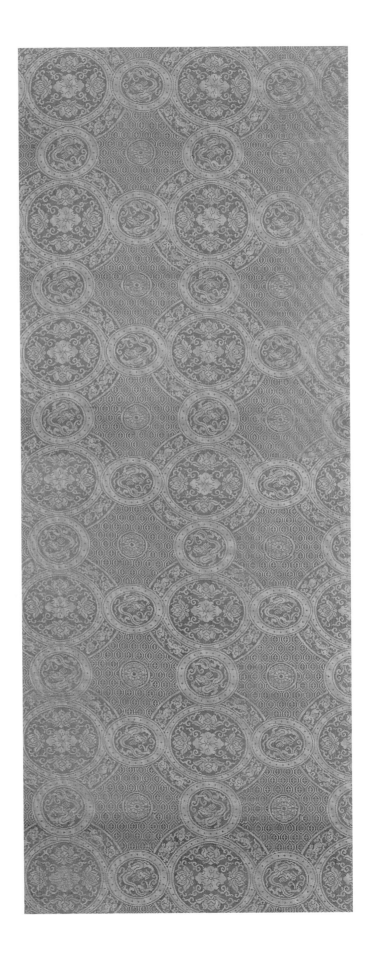

20

Song-style Brocade
with Orange Ground and
Multi-coloured Bands of
Patterns of Flowers of All
Seasons

Ming Dynasty

Length 142 cm Width 32 cm
Qing court collection

The brocade is woven with orange-coloured warps and wefts for the ground. The patterns of meandering water, ancient coins, tortoise shells, squares (*juwen*), winding figures (*huiwen*) and locks (*suoziwen*) are woven in orange pattern warps and multi-coloured pattern wefts in blue, green, red, yellow and gilded paper strips. The floral bands are tied up with one another to form a series of framework called "*pantao*." In the *pantao* are patterns of flowers of all seasons interlocking horizontally with one another in rows of different colours. The edges of the *pantao* are in azure blue outlined with gilded paper strips. The outline of the patterns is very lucid.

This brocade uses long running shuttles to carry wefts of azure, bright yellow and gold all the way through the width of the weave in combination with shuttles that carry wefts of other colours covering only parts of the width. It is highly decorative and a choice item of Song-style brocade.

Brocade denotes generally polychrome silk weaves accentuating patterns. It requires very highly skilled craftsmanship for the intricate weaving. It is one of the most valued fabrics of ancient times. Song-style brocade is the brocade which textile artists and craftsmen in Suzhou during the Ming and Qing periods made by copying the characteristics and style of the structure and pattern of brocade from the Song period. Such imitation became famous in its own right.

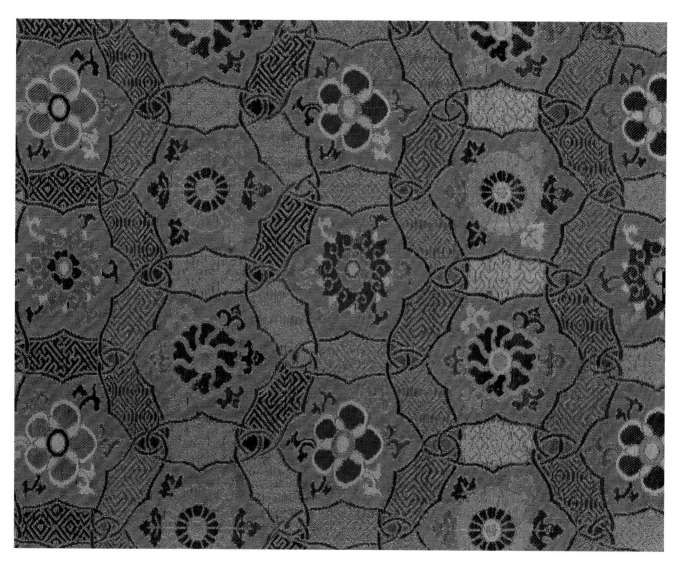

21

Tianhuajin
with Red Ground and Patterns of *Sihe Ruyi*

Ming Dynasty

Length 207 cm Width 75 cm
Qing court collection

The brocade is woven with three sets of red pattern wefts to make a left-slanting twill ground and floss of various colours as pattern wefts. It uses both long running shuttles from selvedge to selvedge and shuttles for shorter runs for sections to make a foundation of chessboard chequers of grass-green squares. Pale blue squares are placed corner to corner so as to build a geometric framework of vertical, horizontal and diagonal chequered patterns. Inside are figures of the *baoxianghua* (flower of precious countenance), flowers in roundel and the *sihe ruyi* (square ruyi emblem or square emblem of fulfilment).

The framework of this brocade is evenly constructed, succinct and tasteful. The patterns are natural and fluent, and the colour scheme is intricate and gaudy without losing its decorum. Gilded paper strips are subtly applied to achieve a highly decorative effect.

Tianhuajin (brocade of heavenly brilliance, or brocade with additional patterns) is a kind of Song-style brocade with its origin in the *badayun*, also known as *tianhuajin* or *jinqun* (group of brocades) from the Song period. It is characterized by its geometric patterns of circles, squares and lozenges in regularly alternating juxtapositions of vertical, horizontal and diagonal arrangements. Inside are various other figures and in the middle is accentuated a large floral pattern, forming a rich variation of fully covering patterns known as "*jin shang tian hua.*" (adding flowers on brocade)

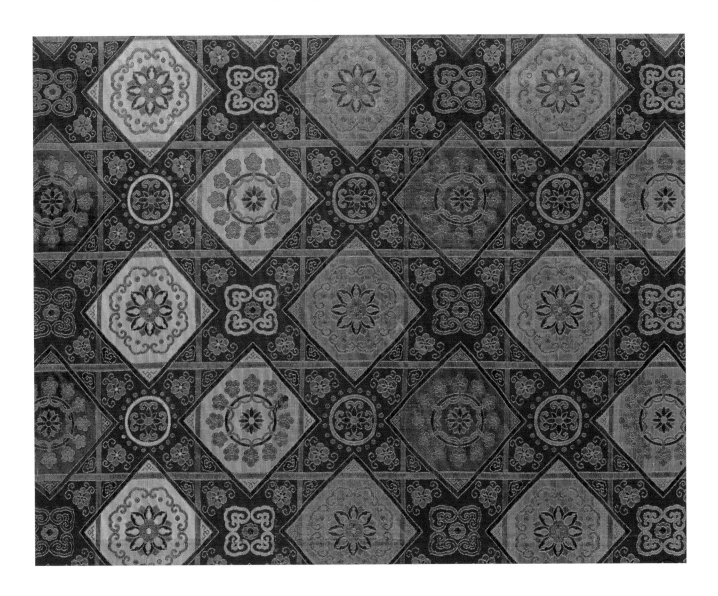

22

Ice-plum-patterned Brocade
with Black Ground Weave

Qing Dynasty Kangxi period

Length 296 cm Width 76 cm
Qing court collection

The brocade uses black warps and wefts with five sets of two floating pattern warps to weave the satin pattern ground. One gilded thread and one white thread, i.e. one gold and one coloured pattern weft, are used to make the damask ice-plum pattern. There are irregular patterns of ice cracks covering the ground, supplemented with plum patterns in gold and white, thus forming a contrast between the lines and the surface and creating the artistic effect of "order in chaos" (*luan zhong jian zheng*)—a highly elevated realm of elegant experience.

This brocade uses a long-running shuttle from selvedge to selvedge for the patterns. The colours are sparse and the texture light and thin. It is suited for garments and decoration for the borders of hats and clothing. It can also be used for bags, boxes and cushion covers.

This kind of brocade is also called *caikujin* (polychrome brocade for the imperial storehouse). It uses few colours but looks delicate and attractive, and its texture is fine. Its characteristics include small units of patterns and not so time-consuming in creating the design and the patterns. It can create varied and delicate patterns within a small area.

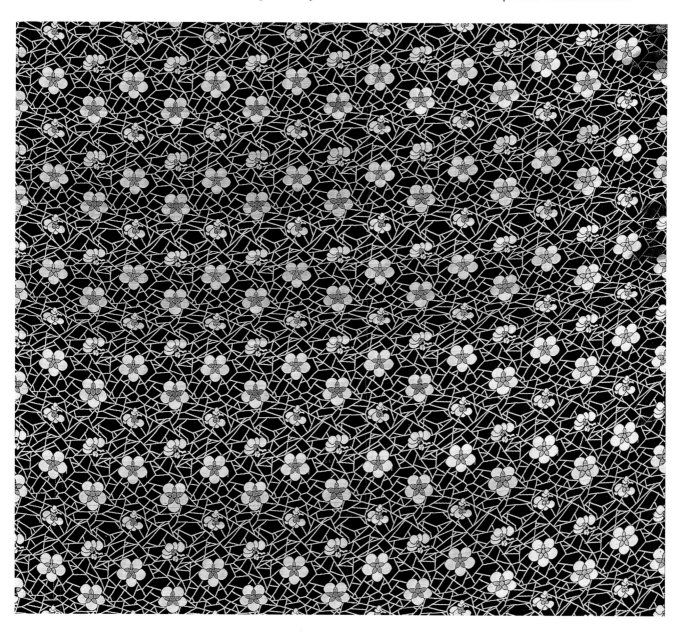

23

Song-style Brocade
in Pink Ground and Circular Patterns with Two Lions

Qing Dynasty Kangxi period

Length 69 cm Width 75 cm

This brocade is woven with pink warps and wefts to make a twill ground of three sets of warps. The pattern wefts are coloured pile threads in gold, bright red, royal blue, pale blue, green and beige. Damask patterns of interlocking circles and two lions are made by long-running shuttles from selvedge to selvedge. In the centre of the circles are the figures of a pair of lions playing with a ball, decorated with a one-legged dragon (*kuilong*), a cock, a running hare and plucked flowers. Between rows of the circles are flowers of precious countenance (*baoxianghua*), symbolizing auspicious things like fame and fortune (*gongming fugui*).

This piece of brocade is a choice item manufactured by the official Suzhou Textile Bureau during the Qing Dynasty. The craftsmanship is exquisite, the silk of superb quality, the texture very fine and the colour scheme of strong contrasts. On the border of patterns and between the changing shades of colours is gilded paper (also known as "*baojinbian*"— edge wrapped in gold) to unify the strongly contrasted colours in a basic tone of harmony.

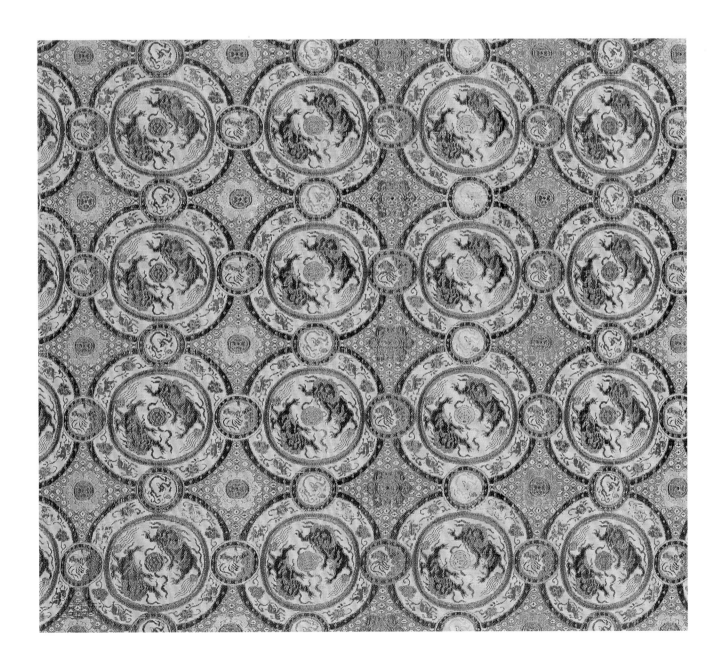

24

Patterned Brocade
in Silver Grey Ground with
Meandering Water, Fishes
and Algae

Qing Dynasty　Kangxi period

Length　30.5 cm　Width　30 cm
Qing court collection

The brocade is woven with silver grey warps and wefts with a face of satin pattern ground made by six sets of two floating irregular warps. Pattern wefts are pink and green silk threads, with the pink meandering water and the green algae made by full-running shuttles. At the same time, short-running alternating shuttles are used to make sections with patterns of fish, flowers and conch using pattern threads of red, pale blue, camel brown, smoky grey, yellow and blue colours. "Fish" puns with "surplus" and is often used to imply wealth, auspiciousness and good fortune. Algae connote the extended meaning of "cleanliness" and they were patterns often used in ancient days to decorate clothing.

This piece of brocade has a classic understated elegance in its colour scheme; its craftsmanship is exquisite, and it provides good material evidence for the study of the art of brocade weaving during the early-Qing period.

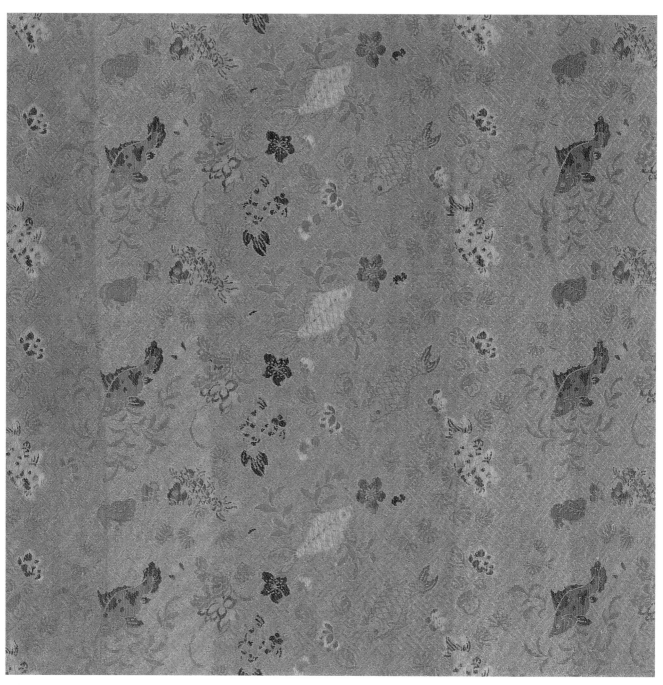

25

Tianhuajin
with Brown Ground and
Baoxianghua Patterns

Qing Dynasty Kangxi period

Length 56.5 cm Width 21.5 cm
Qing court collection

This piece of *tianhuajin* (brocade of heavenly brilliance, or brocade with additional patterns) is woven with brown warps and wefts in sets of three right-slanting warps to make the face of a twill pattern ground. Pattern wefts are silk threads in light brown, ginger yellow, clear light blue, green, pink and pale blue. Short-running shuttles for different sections create a brocade framework with rich variations of patterns in twill by crisscrossing and overlapping regular geometric shapes of circles, squares and octagons with the wefts. Inside this are figures of *baoxianghua* (precious-countenance flower), the cross, ancient coins and lotuses.

This piece is exquisite and decorous. The brocaded patterns are various and the decorations are rich but regular, with the effect described as "flowers in the brocade and brocade in the flowers." It is a typical example of *tianhuajin* from the early-Qing period.

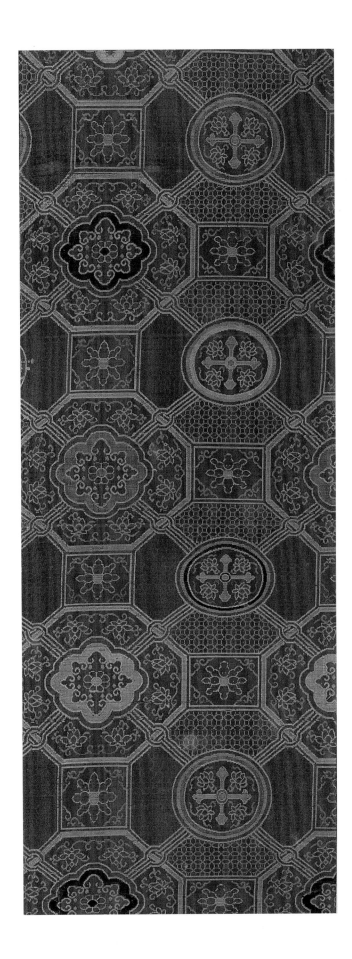

26

Patterned Brocade
with Figures of Melons and Butterflies

Qing Dynasty Kangxi period

Length 65 cm Width 73 cm
Qing court collection

This piece of brocade is woven with blue warps and wefts, making a patterned ground with six sets of two floating irregular warps as satin face. The pattern wefts are pile threads of red, peach pink, green, white, apricot yellow and bronze brown. Figures of twining peonies, melons and butterflies are woven by the method of using both long-running shuttles from selvedge to selvedge and short-running ones interchanging for various sections. Twining peonies symbolize long-lasting wealth (*fugui mianchang*). Melons contain a lot of seeds, and butterfly (*die*) puns with the little melon called *die*. The combination becomes "*guadie mianmian*," implying "prosperity for posterity."

This brocade weave employs the art and craft of polychrome weaving using the model method of *tiaohua jieben* (an ancient damask whosepattern is shownwith the warp and weft)to make the patterns neat and regular. In addition, white threads are used to trace the edges of patterns to achieve the effect of regularity despite many colours, and they are also decorative. This sample represents the style and standard of the art of brocade during the early-Qing period.

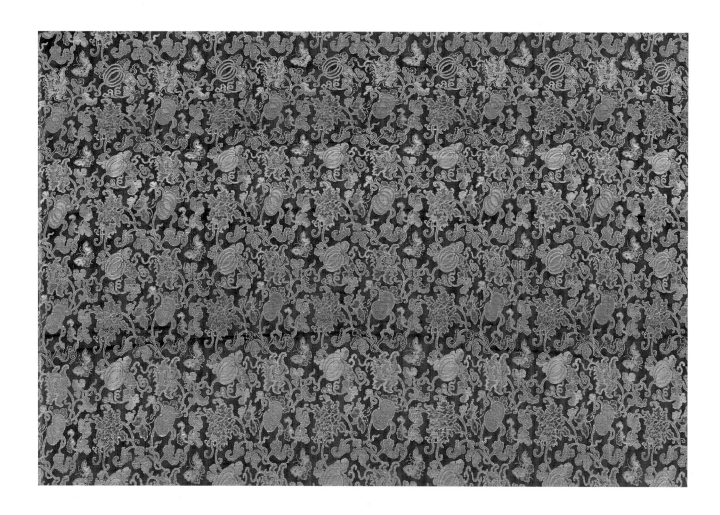

27

Patterned Brocade
with Yellow Ground and Sprigs of Plucked Peony and Chrysanthemum

Qing Dynasty Yongzheng period

Length whole bolt Width of bolt 74.5 cm

The brocade is woven with yellow warps and wefts; the patterned ground is made with five sets of three floating warps for the satin face, and blue floss threads are used as pattern wefts. The blue floral pattern is done with shuttles running through the whole width with four sets of twill wefts. The plucked peonies and chrysanthemums are made with short-running shuttles for sections with floss pattern wefts in colours of green, date-red, brown, white, beige, crimson, camel brown and incense brown. In between are multi-coloured butterflies and bats. At the head of the bolt are spread patterns of one-legged *kui*-dragons (*kuilong*) and continuous lines of symbols for 卍.

This bolt of brocade was meant for making mattresses or beddings for heated earthen beds. Its figure patterns and colour schemes are both characteristic of the art and craft of satin brocade in the early-Qing Dynasty. Satin brocade is a weave manufactured by the Qing Dynasty's Suzhou Textile Bureau. It is basically a brocade weave but modified with a ground of satin patterns woven by interlocking wefts of three or more colours to produce a fabric with multiple wefts.

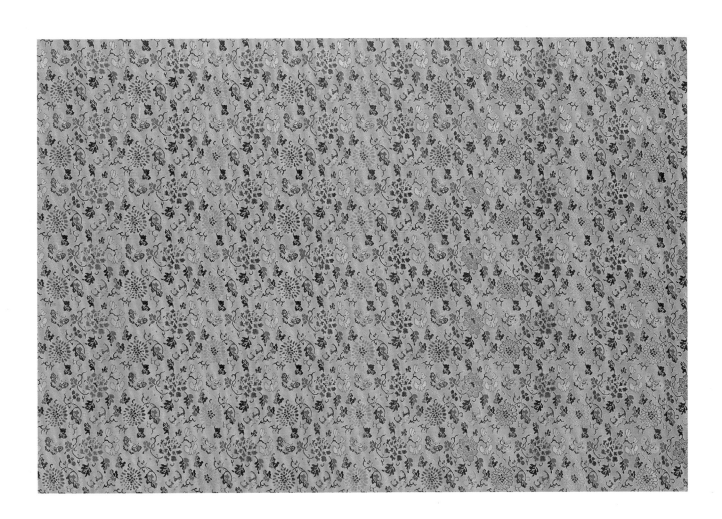

28

Brocade
with Red Ground and Picture of Myriads of Male Children

Qing Dynasty Qianlong period

Length 224 cm Width 72 cm

This piece of brocade is woven with red warps and wefts, and six sets of two floating irregular warps are used to make the patterned ground with satin face. The pattern wefts include floss in date-red, green, incense brown, blue, pale blue, beige, yellow and off-white as well as gilded paper strips. The technique uses section shuttles leading twill wefts to make damask patterns showing wishes for many sons and grandsons and for happiness and longevity. At the two ends are phoenixes, peonies and butterflies to compose the auspicious patterns of *feng chuan mudan* (phoenix among peonies) and *jiebao fugui* (prompt report of fortune).

This piece of brocade shows exquisite craftsmanship. Being soft and light, it was specially woven for making a quilt cover.

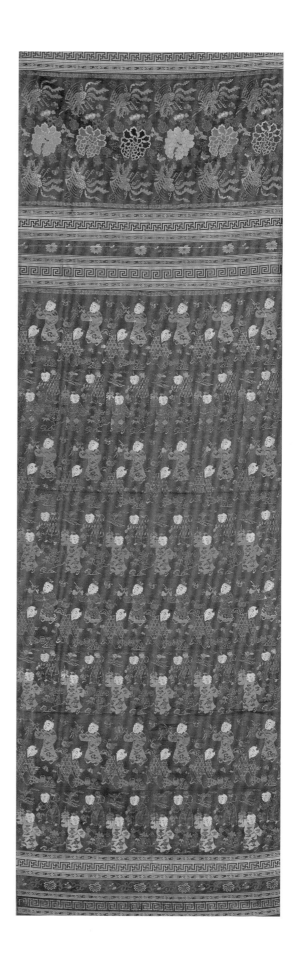

29

Patterned Brocade
with Blue Ground and
Figures of Immortals
Bringing Birthday Wishes

Qing Dynasty Qianlong period

Length 42 cm Width 33.5 cm
Qing court collection

This piece of brocade is woven with blue warps and wefts, and eight sets of three floating warps are used to make the patterned ground with satin face. The pattern wefts include multi-coloured floss in green, pale blue, red, yellow and silver grey. Section shuttles are used to make patterns of *lingzhi* (the magic fungus), daffodils, bamboo, peaches and peonies. *Lingzhi* and daffodils are magic herbs, while *zhu* (bamboo) puns with *zhu* for "wish" and peach connotes long life and peony wealth. The combination implies wishes for longevity and wealth from immortals—*lingxian zhushou* and *fugui changshou*.

This is a finely woven piece of brocade and its texture is light and soft. Its surface shows a polished pile effect, which is quite unique.

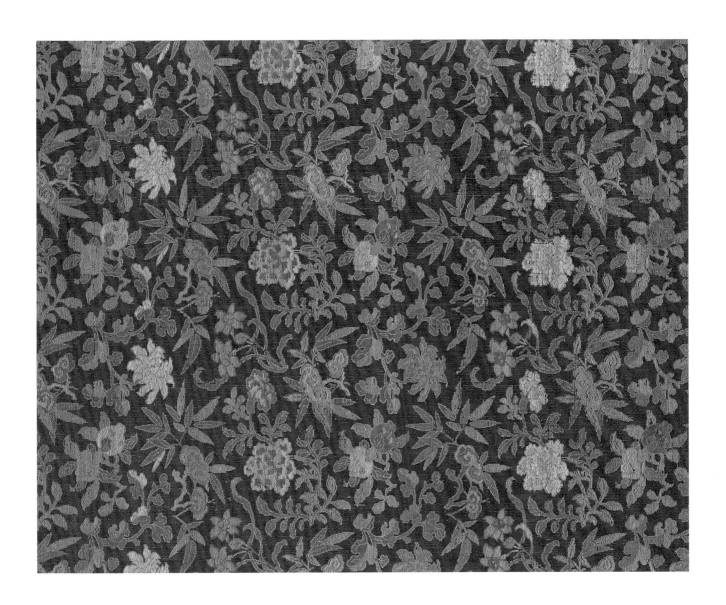

30

Patterned Brocade
with Brocade Group Ground
and Patterns Figuring the
"Three Many"

Qing Dynasty Qianlong period

Length 178 cm Width 75 cm
Qing court collection

The framework of this piece consists of blue warps and wefts with seven sets of two floating warps to make a satin figure of tortoise shell. Inside the frame are chrysanthemums or *baoxianghua*. Around it are patterns of ancient coins, character for 卍 in twill, locks and square *ruyi* symbols, forming thus a group of brocade patterns covering the ground. The wefts above are green, blue, red, white and yellow threads twisted with gold threads and they intertwine with pattern warps to make figures of fruits such as lotus seedpods, pomegranates, the Buddha's-hand melon (*foshou*) and peaches. Lotus seedpods and pomegranates contain a lot of seeds, and *fo* for Buddha is a near-pun with *fu* for happiness or blessings, while the peach fruit connotes longevity; thus the group means "many sons, much happiness and great longevity."

This piece of brocade has a very complicated composition, and its colours are gaudy, craftsmanship accomplished and patterns gorgeous and varied. It achieves the effect of artistic enhancement by "adding flowers to brocade."

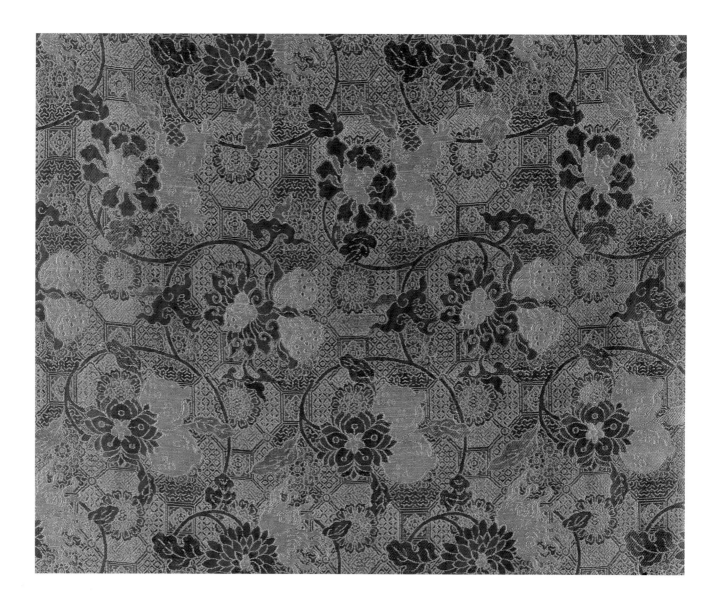

31

Patterned Brocade
with White Ground and Figures of Tortoise Shells and Plucked Peonies

Qing Dynasty Qianlong period

Length 210 cm Width 75.5 cm

This piece of brocade is woven with white warps and wefts, and the patterned ground is made with eight sets of three floating warps for the satin face, while the pattern wefts are made of floss in blue and pale blue. Full-running shuttles are used to make the damask tortoise shell patterns, while section shuttles are used to make the peony figures in damask with floss threads of three units of colours such as light brown, beige, brown, red and green.

This brocade involves very complicated craftsmanship. The damask weave is rich in nuances and the fabric has body, a material suited for decorating everyday articles in courtly life.

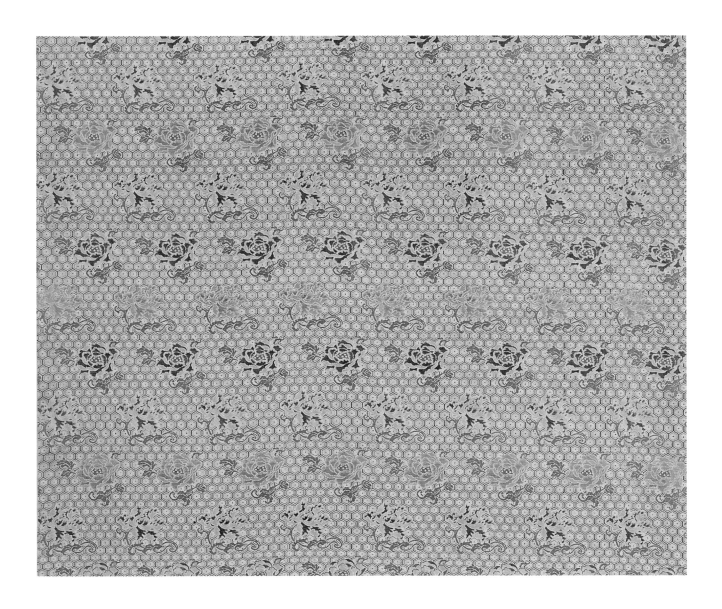

32

Song-style Brocade
with Apricot Yellow Ground and Patterns of Series of Meandering Water and Interlinking Flowers

Qing Dynasty Qianlong period

Length 50 cm Width 37 cm
Qing court collection

This piece of brocade is woven with apricot yellow warps and wefts and the patterned ground is made with three sets of twill warps, while pattern wefts are made of floss in blue, green, yellow and white. Roundels in weft twill damask are made with long-running shuttles from selvedge to selvedge, and inside are figures of interlinking rings and flowers. The space outside the roundels is filled with meandering water patterns made by pattern wefts of threads wrapped in gilded paper. This is decorated with figures of twining sprigs of *baoxianghua*. This combination of patterns is called "meandering water and interlinking flowers" or "flowers in the mirror."

The ground warps of this fabric are each composed of two threads combined, and every warp has been processed by twisting the silk filaments so as to achieve a very strong sense of texture. Its colour scheme is subtly achieved by utilizing the overlapping appearance of the patterns that gives dazzling looks of colours. This appears especially gorgeous and opulent when accentuated by the brocaded pattern of golden meandering water. It lives up to its reputation of being a masterpiece of Song-style brocade facsimile from Suzhou during the Qianlong period of the Qing Dynasty.

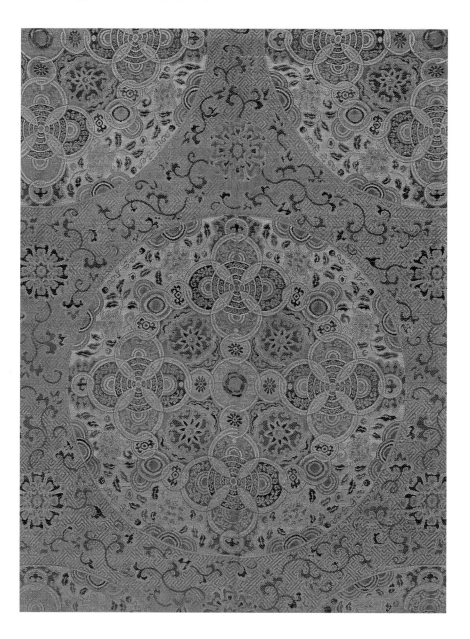

33

Patterned Brocade
with Blue Ground and Figures of Lanterns

Qing Dynasty Daoguang period

Length whole bolt Width of bolt 75 cm

The brocade is woven with blue warps and wefts, and the patterned ground is made with six sets of three irregular warps for a satin face. The wefts are made from threads wrapped in gilded paper and floss in bright red, grass green, dark green, pale blue and white colours. Figures of lanterns and fringes are in polychrome damask. In the lanterns are characters for "auspiciousness" (*ji*) and "longevity" (*shou*) and red lotus flowers. The fringes are composed of figures of the mixed treasures (*zabaowen*) such as the knot for auspiciousness (*ruyi*), the stone chime (*qing*), the precious-countenance flower (*baoxianghua*), the lozenge knot, the character for 卍 and the square *ruyi*. These imply "auspicious celebration of long life" (*jiqing changshou*) and "happy celebration of everlasting life." (*fuqing wanshou*) At the head of the bolt is woven the mark for "Subject No. 74 of Jiangnan Textile Manufacturer."

Brocade with figures of lantern (*denglong wenjin*) is brocade made in Chengdu during the Song Dynasty. Its name is due to the gold threads used in making the pattern. This piece is an imitation from the Qing Dynasty. It is woven with a long-running shuttle across the whole width combined with threads wrapped in gilded paper to trace the borders of the lanterns and the fringes.

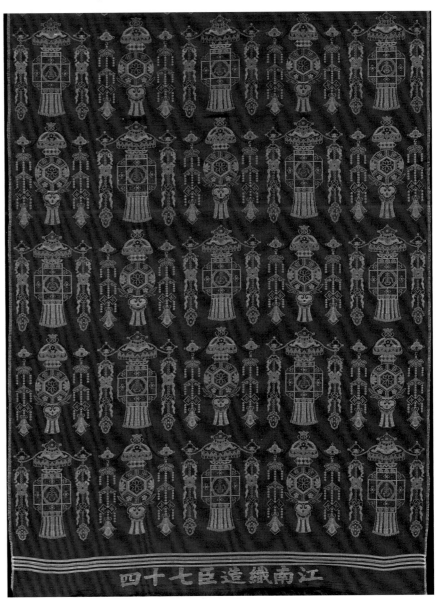

34

Patterned Brocade
with Yellow Ground and
Figures of Plucked
Peony Sprigs

Qing Dynasty Daoguang period

Length whole bolt Width of bolt 75 cm
Qing court collection

This brocade item is woven with yellow warps and wefts, and the patterned ground is made with eight sets of three floating wefts to make a satin face. Pattern wefts of floss in red, tile grey, beige, light pink, blue and fruit green are used to make figures of peony. At the head of the bolt is woven the mark for "Subject No. 74 of Jiangnan Textile Manufacturer."

The pattern of this piece is achieved using short-running shuttles to make different sections of weft twill damask. The flowers are made with the technique of graduating two colours and subtly exploiting the colour of the ground weave to hide the *yin* threads, so that the register of colours is much nuanced, giving an effect of so-called "*duiling*." (pile-up silk twill tabby)

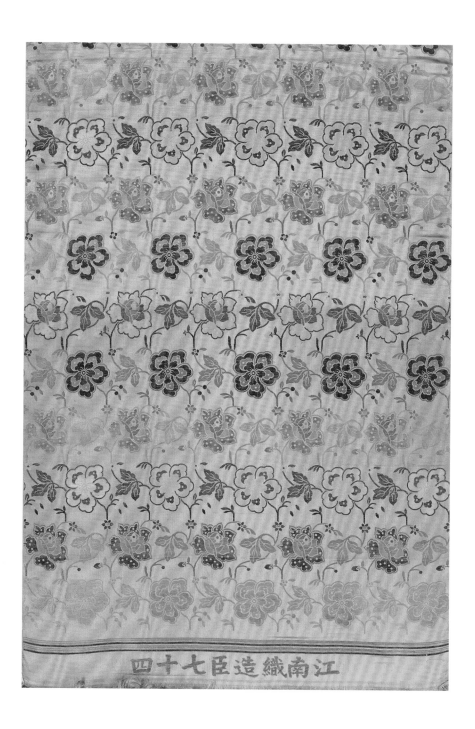

35

Golden Brocade
with Indigo Ground and Patterns of the Character for 卍 and Twining Lotuses

Qing Dynasty　Xianfeng period

Length whole bolt　Width of bolt 78 cm
Qing court collection

This brocade item is woven with indigo warps and wefts, and the patterned ground is made with eight sets of three floating wefts to make a satin face. Twisted gold threads and yellow silk threads are combined to form units and the weaving is done with shuttles running through the whole width. The ground is covered with brocaded figures of the character for 卍. Twining lotus flowers are embroidered with multi-coloured floss.

This brocade has body and the patterns show the three-dimensional effect of relief in clear outline. It was generally used for making book jackets, mattress covers and cushion covers at court.

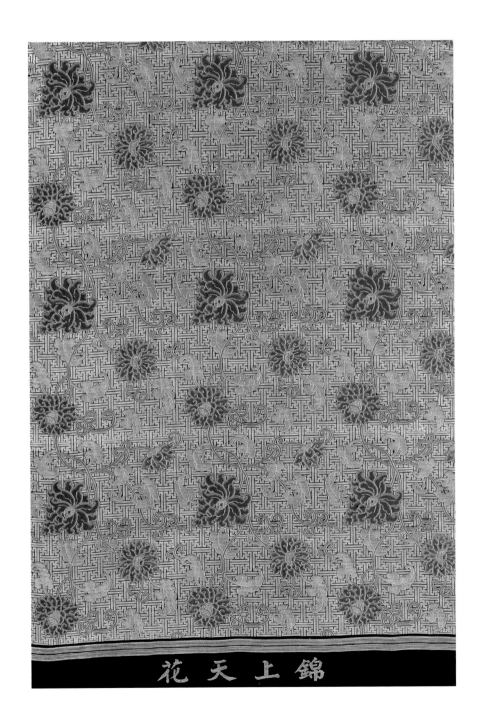

花 天 上 錦

36

Golden Brocade
with Crimson Ground and
Figures of the Character for
"Longevity" and the Eight
Auspicious Emblems

Qing Dynasty Guangxu period

Length whole bolt Width of bolt 77.5 cm
Qing court collection

This brocade item is woven with crimson warps and wefts, and the patterned ground is made with eight sets of three floating wefts to make a satin face. Pattern wefts are made of twisted golden threads and threads of floss in green, ginger yellow, greyish brown, clear blue, white and peach pink, making elongated or round characters for "longevity" with figures for the eight auspicious emblems including the dharma wheel, the dharma conch, the precious parasol, the white canopy, the lotus flower, the precious jar, the gold fish and the Buddhist knot (*panchang*). Together with the character for "longevity," these connote "long life and auspiciousness." (*changshou jixiang*) At the beginning of the bolt is woven the mark "Loom at Wanlong Anzi Hao, Hangzhou."

The ground warps of this item are made of very thick and almost untwisted crimson floss, so that the ground shows the effect of "pile." When the long-running shuttle makes the damask pattern, it shows the patterns with right slanting twill, making the outline very lucid and neat against the ground and evoking a sense of pile in relief.

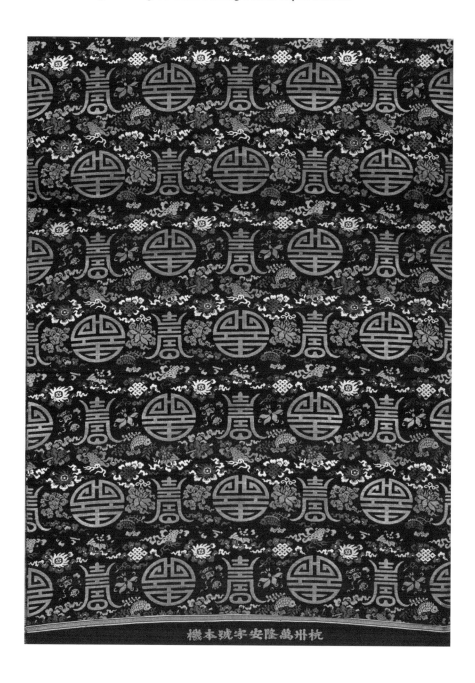

37

Baodijin and Figures
of Twining Peonies against a Yellow Backdrop

Qing Dynasty　Qianlong period

Length　284 cm　　Width　62.5 cm
Qing court collection

The ground wefts of this piece of brocade are made of twisted double gold threads intertwining with orange ground warps to make a patterned ground of satin with six sets of irregular wefts. Patterns of peonies, hibiscuses and crabapple flowers are created with beige, green, clear blue, turquoise, peach pink, watery blue, light pink, gilded paper, twisted silver and twisted gold threads as pattern wefts to intertwine with ground warps.

The composition of the patterns is very elaborate and the colours are gorgeous. The craftsmanship is exquisite. This is not only a representative piece of brocade from the Qianlong period but also a rare extant treasure of Nanjing *yunjin* (called "cloud brocade" for its beauty). It is given first priority as material for making quivers for arrows and covers for seats.

Baodijin (brocade with precious golden ground) is a Nanjing category of brocade with additional decorations. It is made by weaving multi-coloured patterns on top of a ground weave with threads wrapped in paper gilded with gold foil. It looks exceedingly opulent and grand.

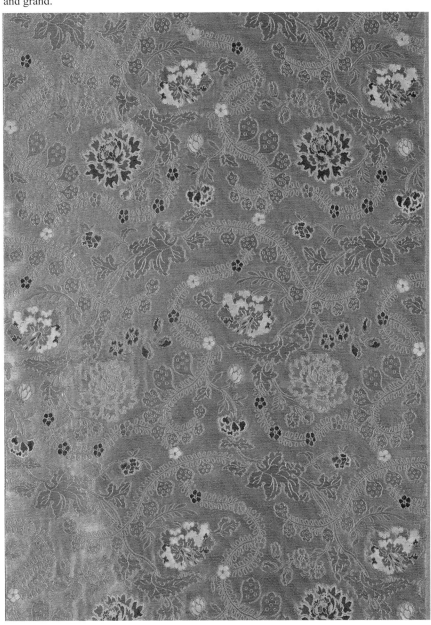

38

Baodijin
and Patterns of Peonies on Pale Blue Ground

Qing Dynasty Jiaqing period

Length 354 cm Width 55 cm
Qing court collection

This piece of *baodijin* (brocade with precious golden ground) is woven with pale blue threads in plain weave for the ground. Pattern wefts made of twisted gold threads, gilded paper strips and floss in colours of white, purple, snow blue, bright red, peach pink, beige, green, fruit green and yellow are used to make symmetrical patterns of peonies and pomegranates by using shuttles that do not go through the width but return wherever the pattern requires. The figures imply wealth and fertility.

The ratio for the diameters of the warps and the wefts in this piece of brocade is 1:5. Thus on the face of the ground weave are clearly shown spiral forms both vertically and horizontally, which enhances the texture of the work. The peonies are shown in three nuances of hues in gradual change, while the leaves are made with twisted gold threads and threads in gilded paper. This results in a strong sense of three-dimensionality and visual effects. The deep perspective and the vivid sense of relief of the piece is further accentuated with flowers and leaves in damask, making it excellent for decorative purposes.

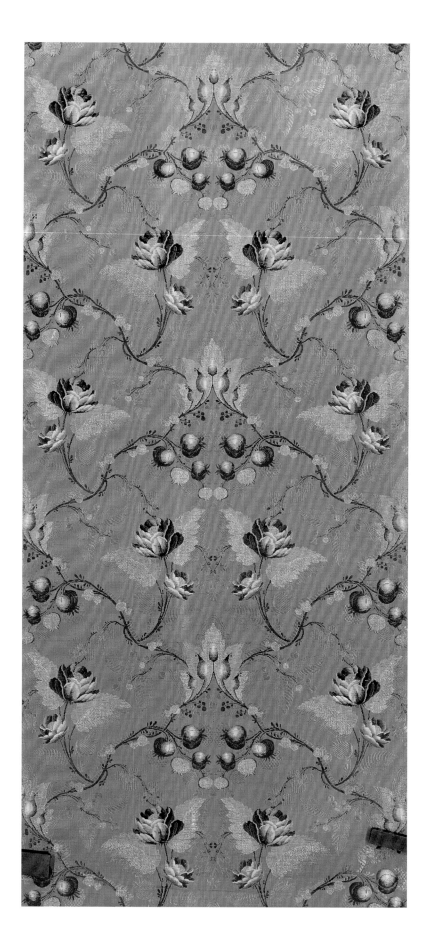

39

Baodijin
and Patterns of Peonies and Morning Glories against a Red Backdrop

Mid-Qing Dynasty

Length whole bolt Width of bolt 60.5 cm
Qing court collection

For its ground weave the brocade has seven sets of three floating red warps as satin face, and pattern wefts made of twisted gold threads and gilded paper strips weave out lozenges that cover the ground weave, on top of which are figures of peonies and morning glories added with pattern wefts made of coloured floss in red, white, black, blue and green led across by shuttles that do not go through the whole width but return wherever the pattern requires.

This *baodijin* (brocade with precious golden ground) has body and splendid multi-coloured patterns. The art and craft of using multiple layers of wefts to make patterns is very special.

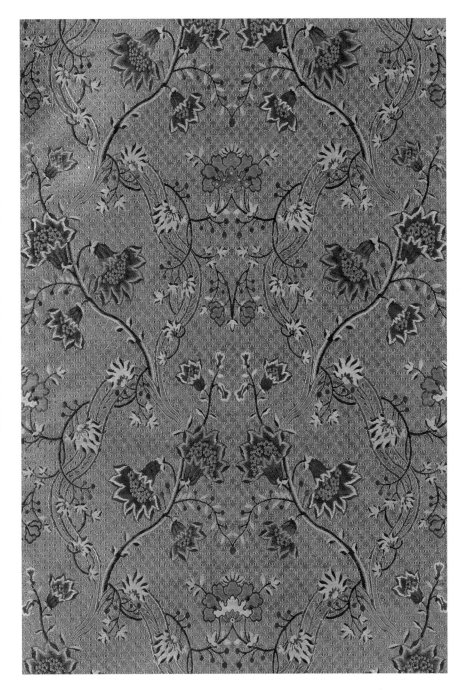

40

Baodijin
and Figures of Peony and Hibiscus on Yellow Ground Weave

Mid-Qing Dynasty

Length whole bolt Width of bolt 63 cm
Qing court collection

This piece of brocade has a satin face made with seven sets of three yellow floating warps. A golden ground is woven with double twisted gold threads, on top of which is jacquard weave made of pattern wefts combining gold foil on paper strips and floss in rose red, peach pink, yellow, green, fruit green, clear blue and royal blue, featuring twining peonies and hibiscuses to symbolize prosperity and wealth.

The colour scheme of the patterns is unique, in that the flowers and leaves are made with twisted gold threads and twisted silver threads to attain a *yin-yang* contrast enhancing the nuance and the three-dimensional effect of the figures. It is representative of brocade with precious golden ground (*baodijin*) during the mid-Qing period.

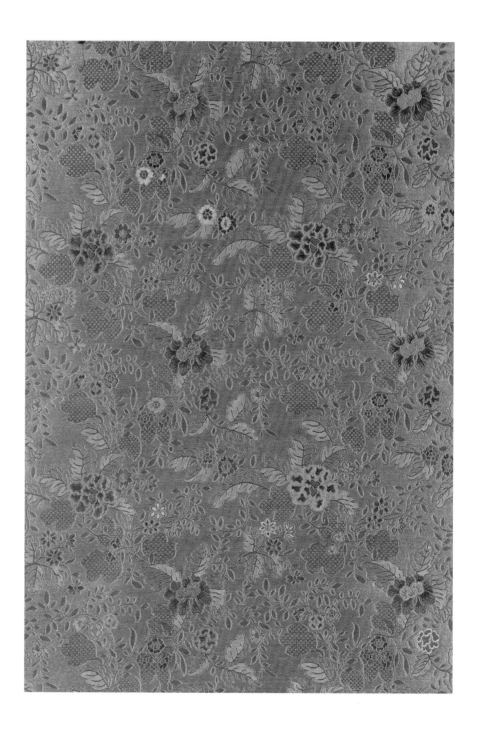

41

Baodijin
with Gold and Silver Patterns on Light Crimson Ground Weave

Mid-Qing Dynasty

Length 96 cm Width 54 cm
Qing court collection

This piece of *baodijin* (brocade with precious golden ground) is woven with light crimson warps and wefts to form a patterned ground with a satin face made of five sets of two floating warps. The pattern wefts are white silk threads and twisted silver threads. A shuttle running back and forth the whole width is used to make fully covering lozenge figures in silver, while patterns of melons, pomegranates, persimmons and western flowers are made with ground warps and pattern wefts in light crimson. The combination of these figures makes an intriguing picture similar to an animal face.

The fabric has firm body. The silver patterned ground is woven by jacquard technique with special pattern wefts each composed of one white silk thread, two twisted silver threads and one more white silk thread. This gives the fabric a texture of shimmering silvery stars.

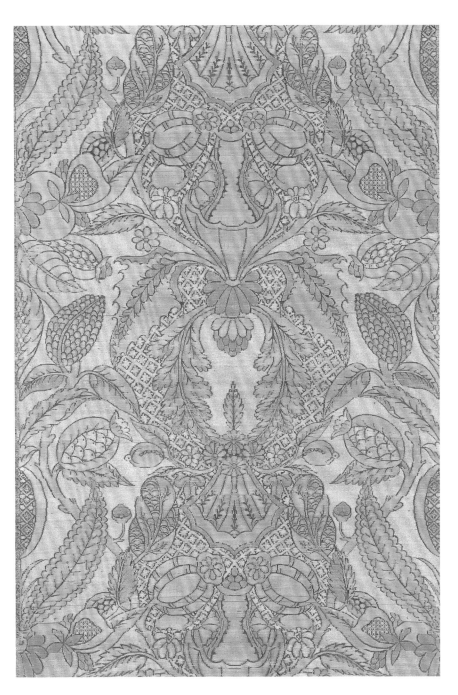

42

Guangduan
with Green Ground and
Patterns of Flowers and Birds

Qing Dynasty

Length whole bolt Width of bolt 74 cm
Qing court collection

This piece of *guangduan* (satin originated from Guangdong) is woven with green warps and wefts for a patterned ground and seven sets of three floating warps for a satin face. The technique of polychrome jacquard weave is employed to make patterns of intertwining sprigs with blossoms and birds woven with wefts of floss in white, yellow and crimson. One bird spreads its wings to fly and its tail feathers gently coil around the flowery sprigs. The pattern has a horizontal arrangement, with every row showing slightly different colours and contents.

The patterns of this piece are woven with short-running shuttles in sections for making the blossoms and long-running shuttles for making the parts with the leaves and the birds. The craft is very complicated, and the patterns show rich and gorgeous colours in neat arrangement, materializing the characteristics of the colourful craft of *guangduan*.

This brocade is woven in satin arrangement with boiled silk threads. Its name is due to its provenance in Guangdong Province. Its weaving technique is the same as that of *jin* (brocade), both using pattern wefts for polychrome jacquard weave and both being very valuable fabrics with multiple warps and wefts.

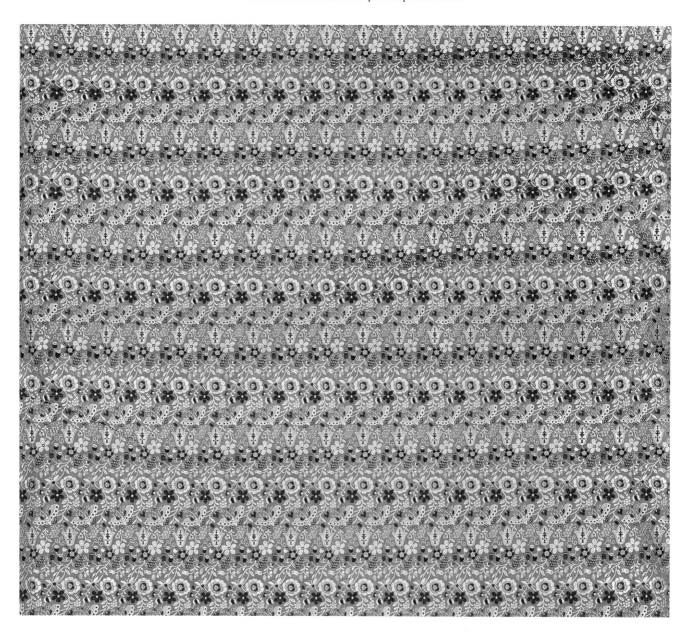

43

Zhuanghuaduan
with Dark Green Ground
and Floral Patterns

Ming Dynasty Jiajing period

Length 46.5 cm Width 46.5 cm
Qing court collection

This piece of *zhuanghuaduan* (satin with patterns added) is woven with dark green warps and wefts to make a satin face for the pattern ground from five sets of two floating warps, and the pattern wefts are made of gold leaf on paper strips and floss in black, clear blue, light green, yellow, silver grey and light yellow (*xiangse*). Figures of *baoxianghua* floral pattern, peach blossoms and peonies are woven by the technique of using extra short-running shuttles to add figures of peaches, the Buddha's-hand melon (*foshou*) and pomegranates to connote auspiciousness and wealth and longevity and fertility.

The weaving of this fabric was very stringently executed. The figures are expressed in geometric patterns. The colour scheme is simple, showing poise and decorum.

"*Zhuanghua*" is a sophisticated technique in the art and craft of *yunjin* originated from Nanjing. It denotes the method of adding patterns to a fabric by sectional short-running shuttles leading multi-coloured weft threads. *Zhuanghuaduan* has satin as the ground fabric on which to add patterns made by the above technique. It is the most representative of silk fabrics in jacquard weave.

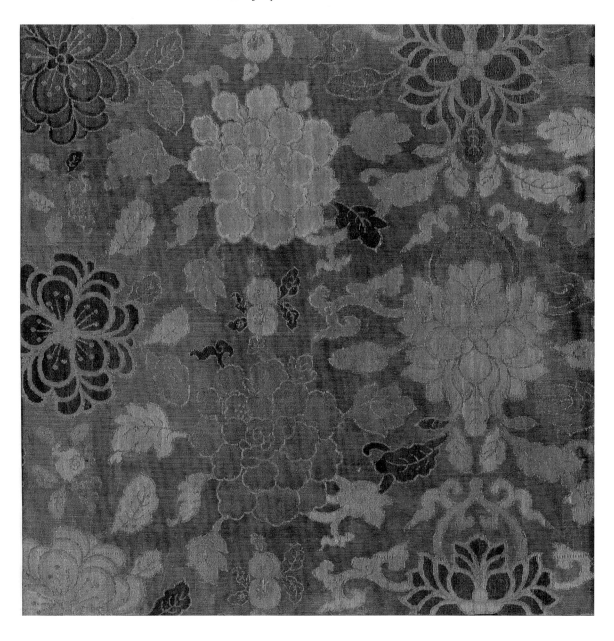

44

Zhuanghuaduan
with Green Ground and
Patterns of *Mang*-dragons
among Clouds

Ming Dynasty Wanli period

Length 330 cm Width 67.5 cm

This piece of satin brocaded with patterns is woven with green warps and wefts for the pattern ground with five sets of two floating warps for the satin face. The pattern wefts are made of twisted gold threads and floss in bright red, peach pink, spring onion green, dark green, yellow, royal blue, clear blue, snow blue, white, black and crimson. The figure of "rising dragon" is made by the technique of using long-running shuttles for jacquard weave, but as it has only four claws, it is called "*mang*" in accordance with the standard that dragons are five-clawed whereas *mang* has four claws. In between are multi-coloured designs of the auspicious *ruyi* clouds.

This is an extremely rare treasure of *zhuanghuaduan* (satin with patterns added) from the Ming Dynasty, and it was specially meant for making courtly robes with the *mang*-dragon symbol. The *zhuanghua*-brocade craftsmanship shows adept skills. The many colours appear in a neat order, and the satin arrangement is clear and bright. However, the warps in Ming satin are short ad superficial, making its lustre inferior to that of Qing satin.

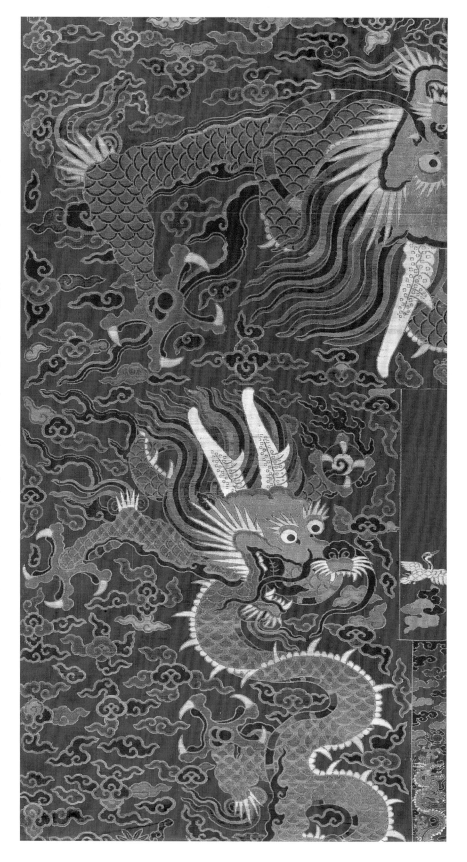

45

Zhuanghuaduan
with Yellow Ground and Patterns of
Intertwining Sprigs of Peony and Lotus

Ming Dynasty Wanli period

Length 73.5 cm Width 21.5 cm
Qing court collection

This piece of *zhuanghuaduan* (satin with patterns added) uses yellow warps and wefts to weave a patterned ground with five sets of two floating warps for a satin face. Figures of twining sprigs of peony and lotus are woven with pattern wefts composed of gold leaf on paper strips and floss in red, pink, blue, clear blue, pale blue, green and black. These figures are arranged in rows by the measurement of four *ze* (see below). The technique uses short-running shuttles to make ribbon bands.

The pattern of this satin uses the method of making two shades of the same colour gradually going into each other. The outline of the veins of leaves and the edges of flowers are all traced with gold foil on paper strips. It is a rare treasure produced by the official Nanjing Textile Bureau. It was normally used to make tents, curtains or jackets for book covers.

"*Zeshu*" is the unit to measure horizontal patterns along the width of the bolt of Nanjing *yunjin*. "*Size*" (four *ze*) means four horizontal figures in a row. Owing to the use of *zhuangcai* (add-colour) technique, the figures of the four units are the same but in different colours, accentuating the characteristics of *zhuanghua* fabrics.

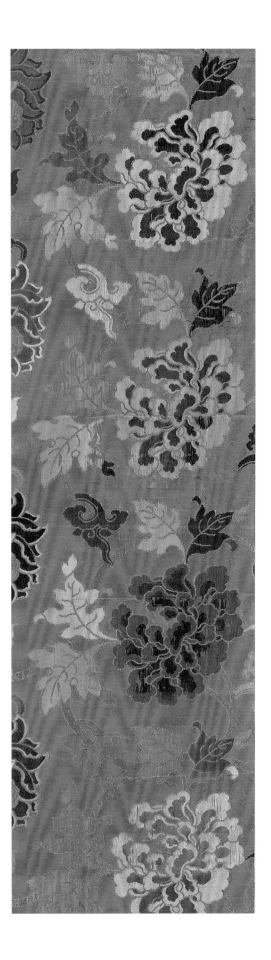

46

Zhuanghuaduan
with Green Ground and Patterns of Dragons, Phoenixes and Flowers

Qing Dynasty Yongzheng period

Length 216×3 cm Width 76.5 cm
Qing court collection

This item comprises actually three pieces of *zhuanghuaduan* (satin with patterns added) sewn together. All three pieces have ground with eight sets of three floating warps in green to make the satin face. The dragon and phoenix figures are woven in gold threads, while other patterns are woven with floss in dark green, bright red, pink, dull red (*muhong*), blue, pale blue, silver grey, incense brown, bright yellow, apricot yellow and white by short-running shuttles for sections. The figure in the middle are two obverse dragons, one big and one small, dancing up and down. In between are figures of auspicious phrases including "*wufu peng shou*" (five blessings holding up longevity), "*babao sheng hui*" (eight treasures in radiance), "*fuqing ruyi*" (happy celebration of fulfilment) and "*wanhe ruyi*." (all things agree as wished) The figures on the left and on the right are identical. On the upper part is "*feng chuan mudan*" (phoenix among peonies) and in the middle "*er long xi zhu*." (two dragons playing with pearls) In between are figures of "*liu kai bai zi*" (pomegranates open with hundreds of sons), "*wanfu laichao*" (ten thousand bats—pun with blessings—paying homage)," and "*fuqing ruyi*." At the top and the bottom of all three pieces are border patterns of melons and butterflies to form the figures for "*gua die mianmian*." (long line of progeny)

This piece of satin was meant for making a quilt cover. The colours are brisk and bright and the patterns rich in variety. The material is light and soft. It is beautiful and practical at the same time, showing the high standard of *zhuanghuaduan* during the Qing period.

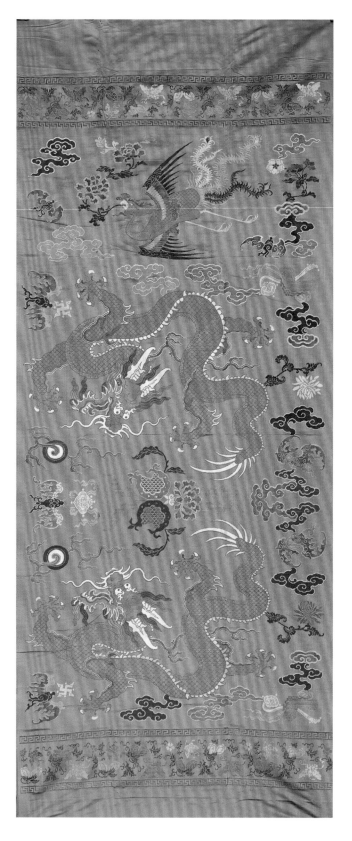

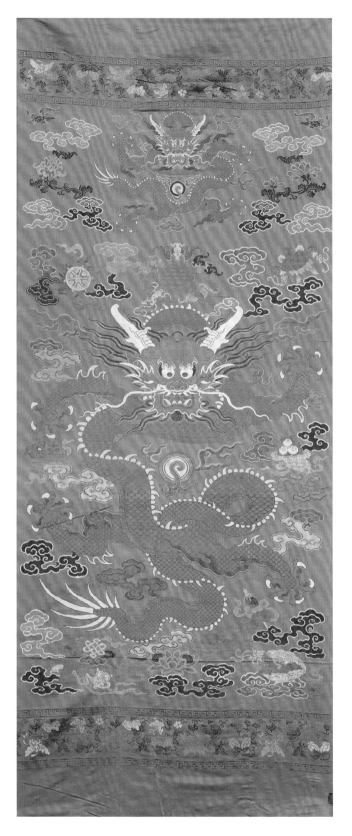
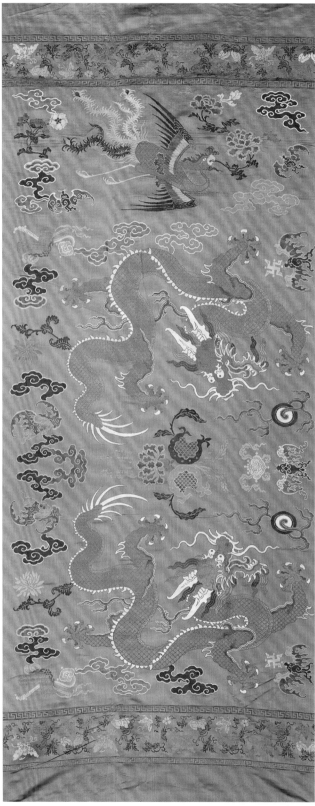

47

Zhuanghuaduan
with Yellow Ground and
Figures of Plucked Sprigs
with Flowers and Butterflies

Qing Dynasty Qianlong period

Length whole bolt Width of bolt 78 cm
Qing court collection

This piece of *zhuanghuaduan* (satin with patterns added) uses yellow warps and wefts to weave a patterned ground with seven sets of three floating warps for a satin face. The pattern wefts are made of twisted gold threads and floss in twenty-odd colours including red, crimson, blue, pale blue, clear blue, black, green, bluish purple, turmeric yellow, white and light brown. Figures of butterflies, the Buddha's-hand melon (*foshou*) and flowers of all seasons like hibiscus, peony, Chinese rose, hollyhock, corn poppy, plum blossoms and peach blossoms are made by the method of short-running shuttles for sections. These figures are scattered sporadically on the fabric, connoting auspicious phrases like "*siji changshou*" (longevity for all seasons) and "*duofu duoshou*" (much happiness and great longevity). At the head of the bolt is the trace of a worn-out mark saying "*jiangning zhizao chen Gaojin.*" (Subject of Jiangning Textile Official Gaojin)

The form and shape of the patterns in this piece are very vivid, and the colour scheme is very rich but quietly elegant. As the satin ground is quite visible, it gives the impression of embroidery rather than weave. This material was specially manufactured by the Jiangning Textile Bureau for the Qing court for making informal costumes.

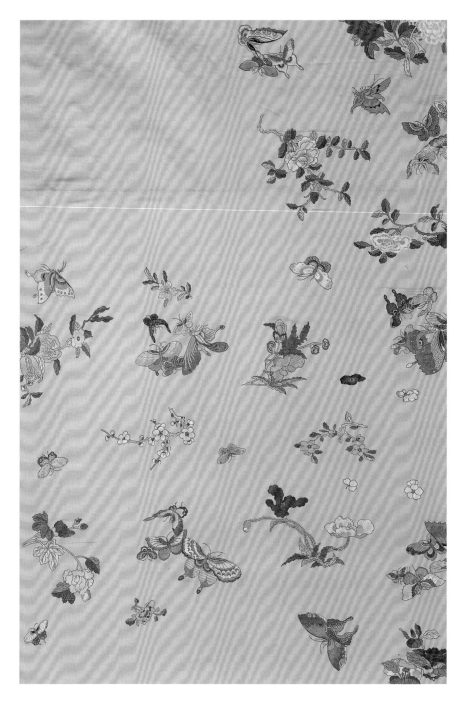

48

Zhuanghuaduan
with a Bright Yellow Ground
and Figures of
Twining *Dayanghua*

Qing Dynasty　Qianlong period

Length whole bolt　Width of bolt 59.5 cm
Qing court collection

This piece of *zhuanghuaduan* (satin with patterns added) uses bright yellow warps and wefts to weave a patterned ground with eight sets of three floating warps for a satin face. The pattern wefts are made of twisted gold threads and floss in green, bluish violet, camel brown, white, brown, earth yellow, blue, pale blue, red and pink. The twining "big foreign flowers" are made by the method of short-running shuttles for sections, and the leaves and twigs are expressed asymmetrically by means of "S" shapes.

Dayanghua ("big foreign flower") was a very popular decorative pattern during the Qianlong period. Its name is due to the western artistic influence on the colours and the shapes of its flowers and leaves.

The weaving standard of this piece of satin is very high. The figures can be as long as 63.5 cm, showing that the floss for the pattern wefts are very thick. Besides, the colours added are done in right-slanting twill wefts, creating thus depth between the ground and the patterns in perspective. Intuitively it gives the impression of embroidery.

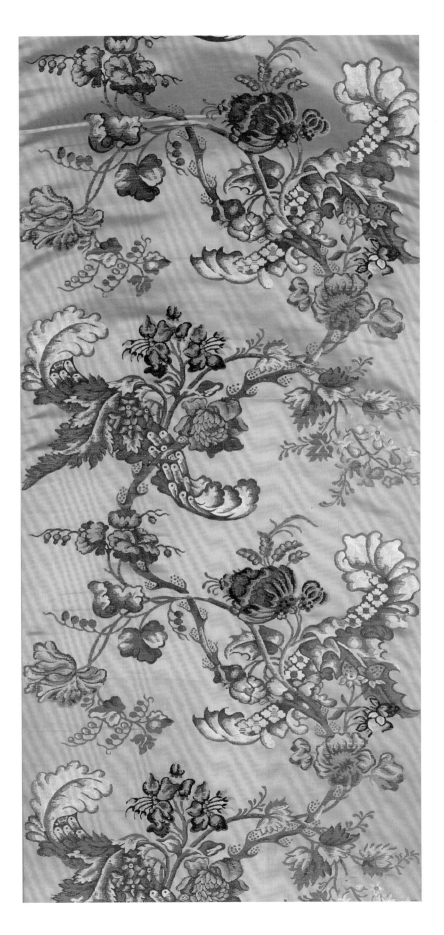

49

Zhuanghuaduan
with Fruit Green Ground and
Patterns of Peony, Lotus and
the Figure of *Sanduowen*

Qing Dynasty Jiaqing period

Length whole bolt Width of bolt 76.5 cm
Qing court collection

This piece of *zhuanghuaduan* (satin with patterns added) uses fruit green warps and wefts to weave a patterned ground with eight sets of three floating warps for a satin face. The pattern wefts are made of floss in lemon colour, yellow, purple, red, pink, rose colour, clear blue, white and silver grey and twisted gold threads. Sectional shuttles are used to add colourful figures of twining peonies and lotuses. In between are decorative groups of the Buddha's-hand melon (*foshou*), longevity peaches with the character for 卍 and pomegranates, all implying "much happiness, great longevity and many sons," i.e. the so-called *sanduowen*—pattern of the "three many." There are also figures of the bat (*fu*) and two coins (*qian*) with the inscription "*tianxia taiping*," punning respectively with the phrase "*fu zai yanqian*" (Happiness is right here.) At the head of the bolt is the mark of "Loom of *Wanyuanhao*."

The units of patterns are big on this bolt, which makes it more difficult to weave. There are over a dozen colours shown in gradually merging shades. The outlines of the leaves and the flowers are decoratively traced with earth yellow floss. As there are so many colours involved, the coloured pattern wefts, when not in use, are hidden on the reverse side of the weave to become floating threads, which is a characteristic of *zhuanghuaduan*.

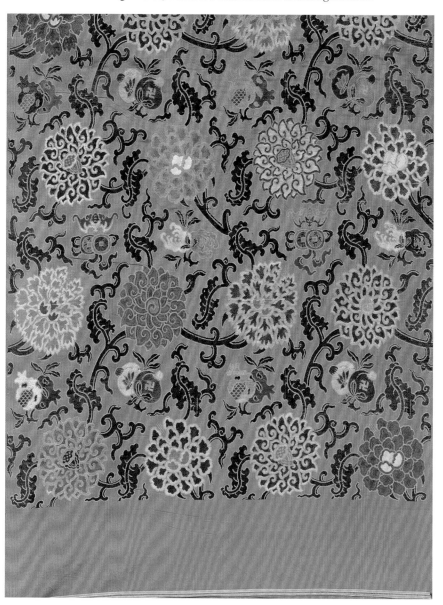

50

Zhuanghuaduan
for a Cloak with Bluish
Purple Ground and Figures
of *Fugui Wannian*

Qing Dynasty Guangxu period

Length 770 cm Width 78.5 cm
Qing court collection

This piece of *zhuanghuaduan* (satin with patterns added) uses bluish purple warps and wefts to weave a pattern of bamboo with eight sets of three floating warps for a satin ground. The pattern wefts are made of floss in over ten colours such as red, blue, green and yellow and twisted gold threads interlocking with the ground warps to make figures of the character for 卍 and peonies encircled in a ring formed by elongated and round characters of "longevity" symbolizing long-lasting wealth (*fugui wannian*) and wealth and longevity (*fugui changshou*). At the head of the bolt is the mark "Loom of *Jiangnan Zhengyuan Xingji*."

This satin is very finely woven and the composition is unconventional. The patterns are outstanding and the hues change with ease, reaching a realm of special beauty. It is a rare piece of *zhuanghuaduan* from the Guangxu period.

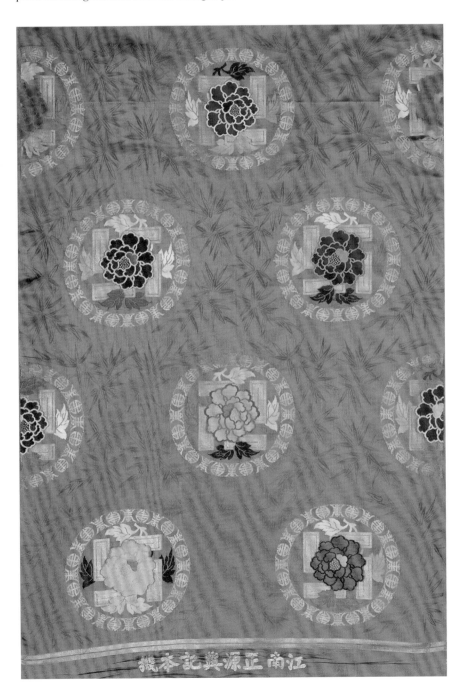

51

Zhuanghuaduan
for a *Magua* with Royal Blue
Ground and Patterns of
Orchids and Butterflies

Qing Dynasty Guangxu period

Length whole bolt Width **77** cm
Qing court collection

This piece of *zhuanghuaduan* (satin
with patterns added) uses royal blue warps
and wefts to weave a patterned ground
with eight sets of three floating warps for
a satin face. The pattern wefts are made
of twisted gold threads and floss in white,
green, water blue, turmeric yellow, incense
brown, pink and beige. Sectional short-
running shuttles are used to make ribbon
band figures of orchids and butterflies.
At the head of the bolt is marked "*Zhe
Hang Wan Fengzai tixuan shang jinhua
rongsaixiu kuduan*".

The pattern design of this piece of
satin for *magua* (jacket) is realistic. The
orchids, from their flowers to their very
fine roots, are portrayed in exquisite
details. The colour scheme is hyperbolical,
achieving the effect of embroidery. This is
highly typical of late-Qing textiles.

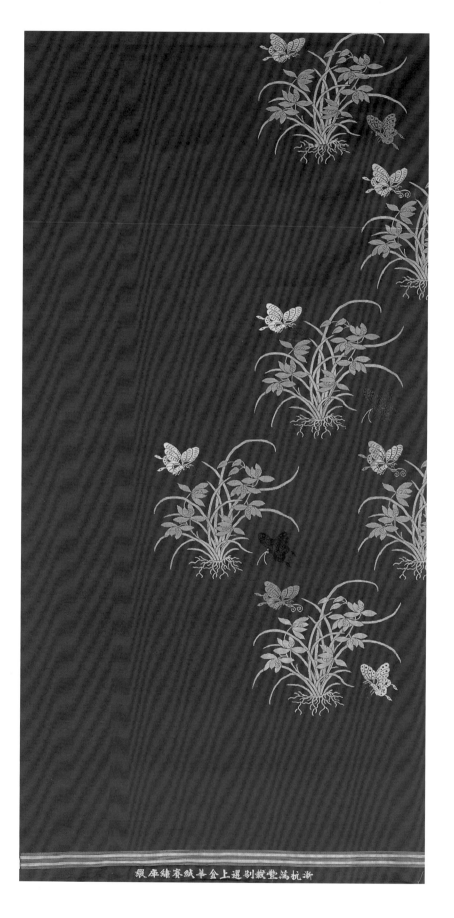

52

Zhijinduan
with Red Ground Weave and
Patterns of Square *Ruyi*
Cloud with Phoenix

Mid-Ming Dynasty

Length 276.5 cm Width 73 cm
Qing court collection

This piece of *zhijinduan* (satin woven with gold threads) uses red warps and wefts to weave a patterned satin ground with five sets of two floating threads. Gold foil on paper strips is used to weave the special Ming pattern showing square *ruyi* clouds interspersed with freely flying phoenix figures.

Zhijinduan is also called *kuduan*. Its warps are finely twisted, while its wefts are thicker and untwisted, and pattern wefts made of threads wrapped in gold foil are used to show the satin figures. It is by convention included into the category of weaves called *yunjin* for making courtly cushion covers. The history of using gold threads and gold foils in Chinese textile and embroidery is very long. Such products date back to the Three Kingdoms period and this art and craft developed and greatly advanced during the Song period.

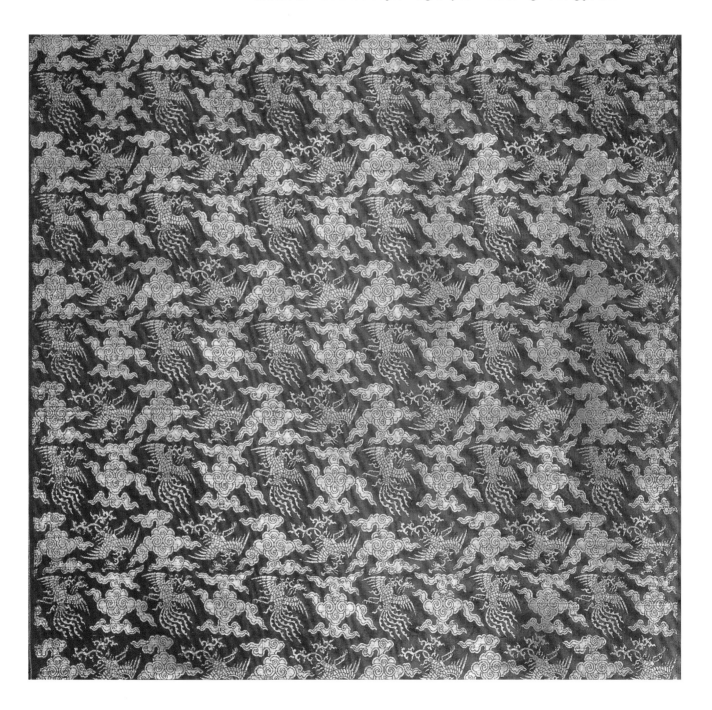

53

Zhijinduan
with Apricot Yellow Ground and Twining Lotus Patterns

Ming Dynasty

Length 22 cm Width 61 cm

This piece of *zhijinduan* (satin woven with gold threads) uses apricot yellow warps and wefts to weave a satin patterned ground with five sets of two floating threads and gold foil on paper strips to weave lotus figures. The pointed lotus petals and the small lotus pith as well as the leaves and stems are boldly exaggerated to twine around the lotus flowers in an "S" shape. In between are decorative figures of the so-called *zabaowen* (pattern of mixed treasures) including rhinoceros horns, fire pearls and corals.

Lotus stands for the Pure Land of the West according to Buddhism, and it is there that souls are nurtured. Concepts of beauty, love, long life and holy chastity make up together the traditional auspicious pattern.

54

Zhijinduan
with Bright Yellow Ground and Figures of Passion Flower

Qing Dynasty Kangxi period

Length whole bolt Width of bolt 78 cm
Qing court collection

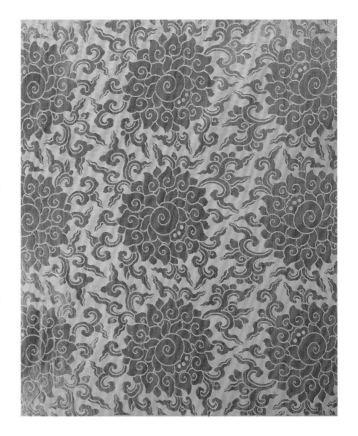

This piece of *zhijinduan* (satin woven with gold threads) uses bright yellow warps and wefts to weave a satin patterned ground with five sets of two floating threads and gold foil on strips of paper to weave passion flower figures. The flowers look strong and large, while the leaves and stems merge subtly. The patterns are arranged in neat rows radiating a beauty of curvature.

The passion flower pattern measures 20 cm in diameter, which is more common among satin weaves from the early-Qing period. The manner in which the lotus leaves and stems are featured is also a standard mode of expression during the Qing Dynasty.

55

Zhijinduan
with Red Ground and Figures of
Immortals Celebrating Longevity

Qing Dynasty Qianlong period

Length whole bolt Width of bolt 73.5 cm
Qing court collection

This piece of *zhijinduan* (satin woven with gold threads) uses red warps and wefts to weave a satin patterned ground with six sets of irregular satin pattern. Figures of the magic *lingzhi*-fungus, daffodils, peonies and evergreens are woven with threads wrapped in gilded paper. Daffodils like the magic fungi are immortal plants and evergreens stand for longevity, while peonies stand for wealth. These form together the picture of *lingxian zhushou* (immortals celebrating longevity) being auspicious symbols for "longevity" and "wealth."

This fabric merges various flowers subtly together giving a first impression of disorder but looking on closer view regular patterns in clear outline, which shows that the designer must have done in-depth studies of these flowers.

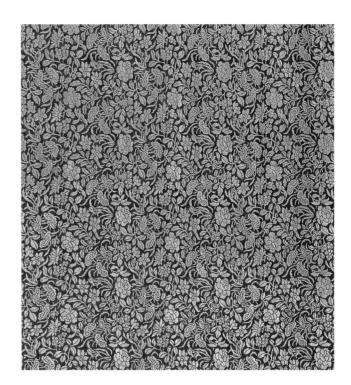

56

Zhijinduan
with Green Ground and Figures of Peonies

Qing Dynasty

Length whole bolt Width 76.5 cm
Qing court collection

This piece of *zhijinduan* (satin woven with gold threads) uses green warps and wefts to weave a satin patterned ground with seven sets of two floating threads. The twining peony figures are woven with peach pink threads, and the pistils are woven with double threads wrapped in gilded paper. In between are figures of *zabaowen* (mixed measures) including *fangsheng* (double-lozenge *ruyi*), *ruyi* and rhinoceros horns.

The peach pink silk threads used for this satin are untwisted and rather thick, while the pistils are woven with gilded threads in pairs. Thus the rather ordinary patterns look very vivid and reap the result of "dotting the dragon with eyes." (*hualong dianjing*) This is also a typical way of making *zhijinduan* during the late-Qing period.

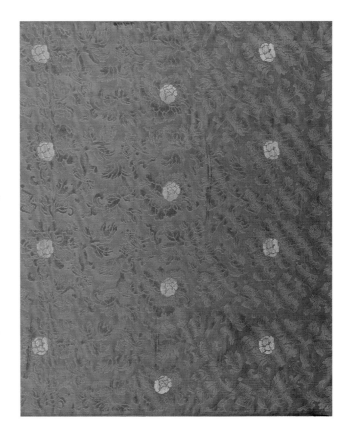

57

Duo-coloured Satin
with Green Ground and Figures of Twining Yellow Lotus Stems

Ming Dynasty

Length 34.5 cm Width 14 cm

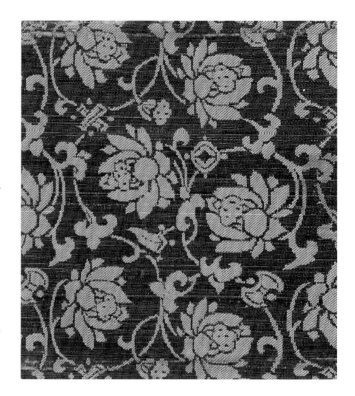

The duo-coloured satin is a weave with five sets of two floating threads for the satin ground. The warps are fine green silk threads, and the wefts are rather thick yellow silk threads in pairs for showing the figures. Twining lotus stems form the theme of the pattern, decorated in between with *zabaowen* figures such as rhinoceros horns, ancient coins and silver ingots.

The satin is material meant for making covers for scriptures or prayer books. Duo-coloured satin (*erseduan*) is also called "*dihualiangsekuduan*" (imperial storehouse satin in two different colours respectively for the ground and the pattern). During the Qing Dynasty it was specially named "*neiduan*" (inner satin) belonging to the group of *kuduan*, under a traditional category of Nanjing *yunjin*. Its warps and wefts are of two different colours, the warps for the ground and the wefts for the patterns, making a satin weave with two different colours for the ground and the pattern.

58

Shanduan
with Green Ground and Patterns of Phoenix among Peonies

Ming Dynasty Wanli period

Length 42.8 cm Width 33.5 cm
Qing court collection

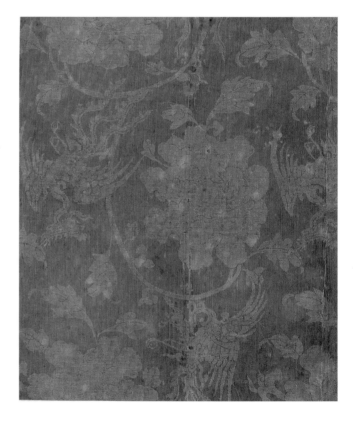

Shanduan (shimmering satin) is a weave with five sets of floating threads for the satin pattern. The warps are strong but fine green twisted silk threads, while the wefts untwisted and thicker dull red (*muhong*) silk threads to make the pattern of phoenix among peonies, symbolizing good fortune and happiness.

Shanduan is similar to *erseduan*, both having different colours for the warps and the wefts respectively and using warps for the ground and wefts for the pattern. But these two weaves are also different in that *shanduan*'s warps are strong, twisted and fine while its wefts are untwisted and thicker. *Shanduan*'s density is also smaller than other satin weaves and its warps cannot fully cover the wefts. Besides, the colour contrast between the warps and the wefts is greater; thus, any change of the viewing angle would make the fabric infract the light differently and shimmer.

59

Shanduan
with Royal Blue Ground and Pattern of Hundreds of Butterflies

Qing Dynasty

Length 375 cm Width 77 cm
Qing court collection

This piece of *shanduan* (shimmering satin) is a weave with eight sets of three floating threads for the satin pattern. Figures of butterflies in various postures and forms are woven with warps made of twisted and fortified fine silk threads in royal blue and wefts made of thicker untwisted silk threads in purplish rosy red.

This fabric was meant for making informal garments for imperial concubines during the Qing period. There are eight different patterns for the figures of butterflies, and every unit or pass is as large as 40 cm, entailing therefore much difficulty for the weaving.

60

Shanduan
with Red Ground and Figures
of Plucked Sprigs of Peony

Qing Dynasty　Tongzhi period

Length 1445 cm　Width 75 cm
Qing court collection

This piece of *shanduan* (shimmering satin) is a weave with seven sets of three floating threads for the satin pattern. The warps are made of fortified and twisted but fine red silk threads and the wefts of thicker untwisted green silk threads for figures of peonies, which are arranged in passes of two alternating horizontal rows.

The workmanship of this fabric is very fine and its pattern composition simple but succinct. The colour contrast is strong and the pattern gorgeous but natural. It is a choice item among *shanduan* samples.

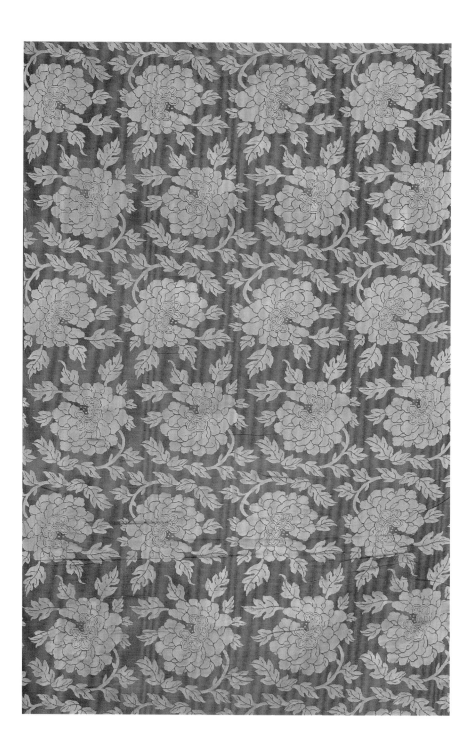

61

Yuanyangduan
with *Huse* Ground and
Pattern of *Fugui Wannian*

Qing Dynasty Tongzhi period

Length whole bolt Width 106 cm
Qing court collection

This piece of *yuanyangduan* (mandarin-duck satin) is a plain weave, whose face uses warps and wefts that are both *huse* (clear light green) and untwisted, while it is the wefts that show the character for *wan* (卍) and its mirrored image and figures of peony, symbolizing *fugui wannian* (everlasting wealth). On the reverse side are winding series of lozenge shown by wefts in a clear cold blue (*pinyuese*).

This fabric was meant for making *qipao* (cheongsam) for imperial concubines.

Yuanyangduan is a weave first appearing in the later mid-Qing period and it belongs to the category of patterned satin. The weave has the arrangement of one-warp-and-two-wefts series, showing a plain weave on both sides, while the wefts have usually two different colours. To achieve the effect of having different colours and different patterns on either side, the whole set of wefts are made to float on the fabric face to make overall-covering patterns.

62

Taixiduan
with Blue Ground and Patterns of Plucked Peonies

Late-Qing Dynasty

Length 540 cm Width 56.2 cm
Qing court collection

This piece of *taixiduan* (western satin) is a weave with eight sets of three floating threads for the satin pattern. The warps are black and twisted, while the wefts are in two groups, the ground wefts being white and twisted and the pattern wefts royal blue and untwisted. The figures are plucked peonies, somewhat distorted. The outline of both the buds and the petals are traced with royal blue silk threads, while the pistils and the leaves and stems are woven with the white ground wefts.

The strong contrast of the colour scheme of this fabric creates quite a visual impact.

Taixiduan was a textile woven by imported machines from the west during the late-Qing period. Its weave is even and shows a high density and lustre. The unusual novel method of weaving the patterns makes it look particularly refreshing.

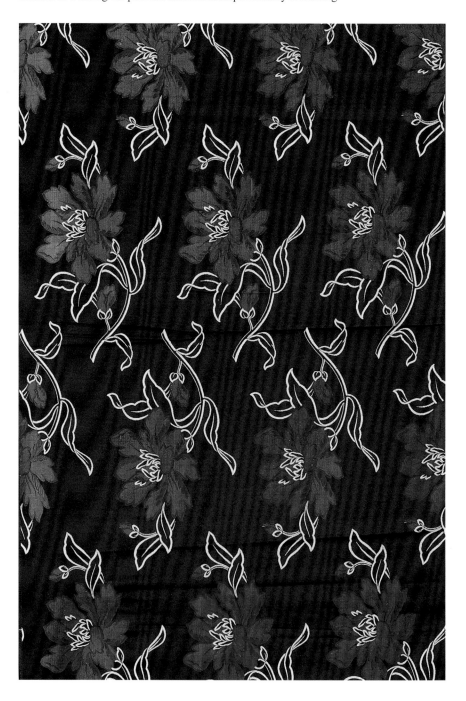

63

Taixiduan
with Cream-coloured Ground
and Rosy Pink Patterns

Late-Qing Dynasty

Length 556 cm Width 70.5 cm
Qing court collection

This piece of *taixiduan* (western satin) is a weave with eight sets of five floating threads for the satin pattern. The warps are twisted beige silk threads and the wefts pinkish and untwisted. Patterns are shown by means of various weaves, e.g. plain weave, twill weave and satin weave, thus accentuating the effect of merging the light and shade of the roses and a sense of three-dimensionality. The decorative patterns alone have already made this fabric approach the effect of modern textiles.

The fact that *taixiduan* resembles modern textiles is inseparable from its being woven on western looms. Traditional Chinese wooden looms were operated manually and sewn only single patterns, while imported looms were highly automated and flexible in making varying the weaves. The latter were thus superior to the former.

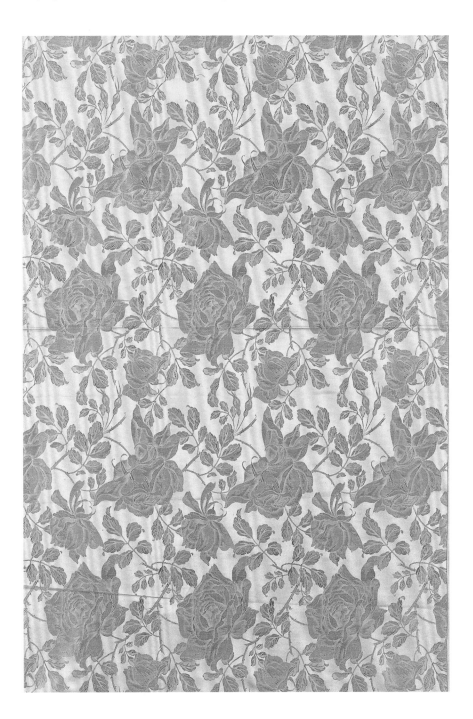

64

Anhuaduan
with Green Ground and Pattern of Linked Clouds

Ming Dynasty Wanli period

Length whole bolt Width 67.8 cm

This piece of *anhuaduan* (veiled-design or damask satin) is a weave with five sets of two floating threads for the satin pattern. Both the warps and the wefts are green, the warps making the ground and the wefts the pattern. The pattern features clouds in square *ruyi* forms intertwining in rows up and down. The ground face is glossy while the pattern is matt, and vice versa on the reverse side.

This fabric shows high standards of the characteristics of weaves from the Ming period in respect of weave structure, pattern design and damask technique. It is a typical example of Ming damask satin.

Anhuaduan is also called *zhengfanduan* (positive-vs.-negative satin) with the ground by warps and the patterns by wefts. By virtue of the satin weave with its warps and wefts of different lustre, the two sides of the fabric can show the same colours and patterns in mirrored structures.

65

Anhuaduan
with Light Brown Ground and Figures of
Phoenix among Clouds

Ming Dynasty

Length 49.5 cm Width 17.5 cm

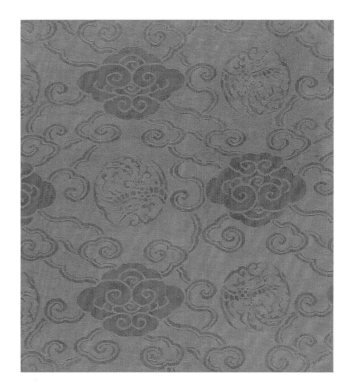

This piece of *anhuaduan* (veiled-design or damask satin) is a weave with five sets of two floating threads for the satin pattern. Both the warps and the wefts are light brown (*xiangse*). The warps are twisted and fine, the wefts untwisted and thicker. The pattern shows phoenixes among clouds linked together in four groups to form lozenges filled with phoenix figures in roundels. The shapes are regular and rich, at once masculine and feminine in compatible contrast. The patterns look harmonious and unified as a whole, thanks to its unique concept of design.

66

Anhualing
with the Character for "Ten Thousand" in
Blue and Figures of Fans

Ming Dynasty

Length 33 cm Width 12.7 cm

This piece of *anhualing* (silk twill damask) is a twill weave with four sets of threads for a left-slanting pattern. Both the warps and the wefts are blue and untwisted, with the warps for grounding and wefts for patterning. The characters for 卍 form the backdrop, while figures of folding fans, *ruyi* clouds and the *sheng* instrument as well as the character for 卍 are arranged in horizontal alternating rows.

Ling is a silk textile developed on the basis of *qi*. It is thin and light. There are two kinds of *ling*, one in twill and another in satin weave. It first appeared during the Han period and reached its pinnacle in Tang Dynasty. By the Ming and Qing dynasties, its weaving technique had advanced further but it was produced only in small amounts, while it was getting more and more replaced by satin. *Anhualing* has a twill ground (satin ground appeared first in Ming) on which are woven twill patterns. Its wefts are never twisted.

67

Biaopian in *Zhuanghualuo*
with Red Ground and
Patterns of Eight Auspicious Emblems

Ming Dynasty

Length 35.4 cm Width 12.4 cm
Qing court collection

This piece of *zhuanghualuo* (brocaded gauze) is woven by
crossing the red ground warp with the douping warp and then
the red ground weft to form the double-warp plain-weave gauze
ground, on top of which are woven twill patterns by intersecting
pattern wefts made of floss in green, blue, pink and tea green
and gilded paper strips with the ground warps. The pattern
shows figures of chrysanthemum, camellia sinensis and the eight
auspicious emblems including Buddhist instruments like the
dharma wheel, the dharma conch, the precious parasol, white
canopy, the precious jar, the lotus blossom, the gold fish and the
Buddhist knot (*panchang*). These figures alternate in series of four
rows.

The composition of this piece of *luo* for a *biaopian* (silk tabby
for mounting painting) is simple and neat, the colour scheme is
rich, and the weave is fine. Figures of chrysanthemum, lotus and
camellia sinensis are woven with gold threads led by a long-running
shuttle from selvedge to selvedge; while the eight auspicious
emblems are woven with floss led by short-running shuttles
that return as required by the figures. This results in outstanding
splendid patterns of gold blending with other colours. It is a choice
piece of *zhuanghualuo* from the Ming Dynasty.

Luo is a light and thin weave in which the warps cross and
intersect each other. *Zhuanghualuo* is a variant of *zhuanghua*
textiles of the Nanjing *yunjin* on a ground weave of *luo*-gauze. It is
a multi-coloured damask weave using various techniques, such as
long and short-running shuttles and extra short-running shuttles.

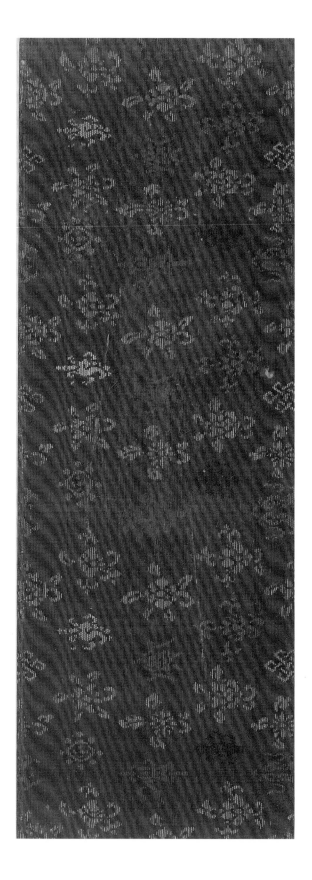

68

Jingpi in *Zhijinluo*
with Red Ground and
Patterns of Phoenix among Peonies

Ming Dynasty

Length 35.5 cm Width 14 cm
Qing court collection

This piece of *zhijinluo* (gauze woven in gold) is woven by crossing red ground warps with douping warps and then intersecting with the ground wefts to form a double-warp plain-weave gauze ground, on which are woven figures of flying phoenix among peony bushes with gilded paper strips as pattern wefts intersecting with ground warps led by long-running shuttles across the whole width. Around these are intertwining sprigs of chrysanthemum and camellia sinensis.

The pattern of this *luo* piece for a *jingpi* (jacket for Buddhist scripture covers) has a rich and full composition in bright colours and fluent lines. It is a choice piece among *zhijinluo* from the Ming Dynasty.

Zhijinluo belongs to the category of *yunjin*. It is a damask weave using gauze as the ground with patterns woven with wefts made of gilded paper strips twisted with golden threads. There was *zhijinluo* already during the Southern Dynasties period. It developed further through the Yuan and Ming dynasties and reached its heyday in the Qing Dynasty.

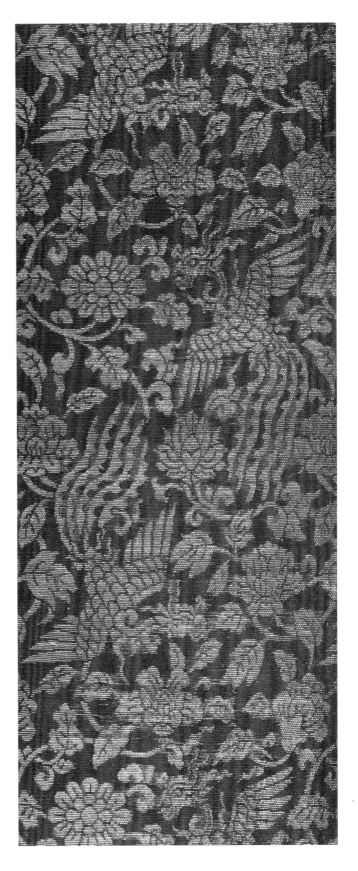

69

Erseluo
with Blue Ground and Patterns of Circling Luan-Phoenix from Zabaowen

Ming Dynasty Jiajing period

Length 33.5 cm Width 28 cm
Qing court collection

This piece of *erseluo* (duo-coloured gauze) is woven by crossing blue ground warps and doup warps and then intersecting with blue ground wefts to weave a double-warp plain-weave gauze ground, on which are added the flowing clouds in square *ruyi*, *luan*-phoenix circling in the air and the *zabaowen* (mixed treasures) figures including ancient coins, silver ingots, rhinoceros horns and corals.

Erseluo first appeared in the Ming Dynasty, but there are very few extant samples from that time, and there are even fewer from the Qing period. Its craft entails weaving patterns with wefts of a different colour on a gauze ground. There are altogether two colours, one for warps and another for wefts. This textile belongs to the category of *zhuanghua* or brocade.

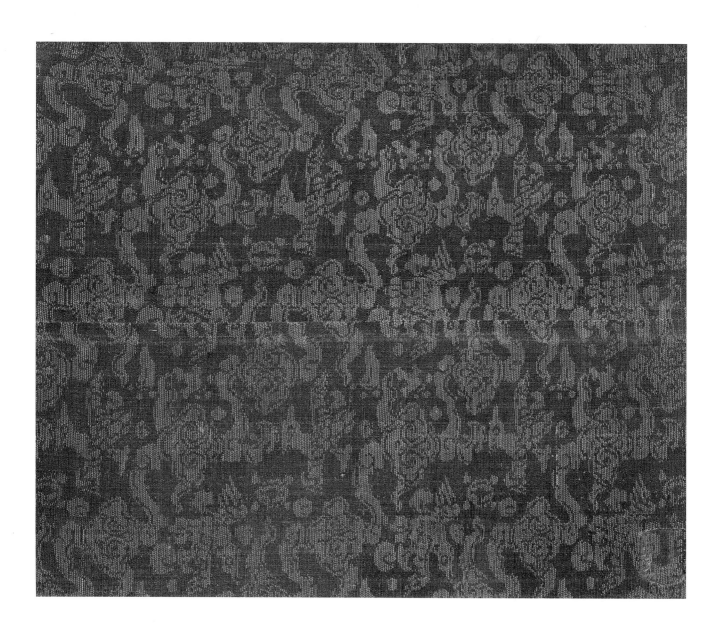

70

Anhualuo
with Pink Ground Weave and Patterns of Twining Lotus

Mid-Ming Dynasty

Length 540 cm Width 57 cm
Qing court collection

This piece of *anhualuo* (damask gauze) is woven with pink warps and wefts into three-shuttle gauze in plain weave. On this is woven plucked lotus.

The pattern of this piece has a simple composition. The weave is fine, using twill warps for the patterns. The long floating warps create an effect of flowers gleaming through the veiled ground. It is a choice example of *anhualuo* from mid-Ming Dynasty.

Anhualuo is a jacquard weave with patterns showing on a ground of the same colour. It first appeared during the Warring States period and stayed quite popular from the Tang to Qing dynasties. Its craft may use three or five or seven shuttles, i.e. after completing every three or five or seven passes, the doup warps would be crossed once so as to shift their positions. This sample is a three-shuttle gauze.

71

Zhuanghuachou
with Yellow Ground and Patterns of Twining Lotus

Ming Dynasty

Length 36.5 cm Width 13.8 cm

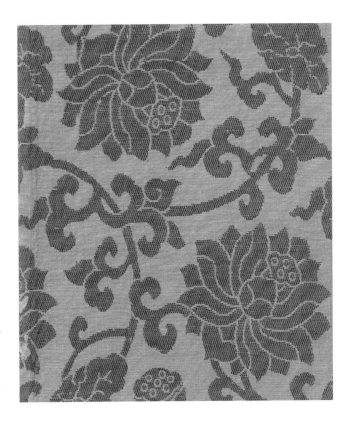

This piece of *zhuanghuachou* (plain silk weave with brocaded patterns) is a twill weave with four sets of right-slanting threads. Its ground warps are yellow and twisted, and its ground wefts also yellow but untwisted. Patterns of lotus flowers, lotus pods and lotus leaves linked together to form twining lotus stems are woven in red pattern wefts.

Chou denotes generally plain or twill close silk weaves. *Chou* appeared first in the Western Han Dynasty. By Ming and Qing times, it had reached a pinnacle and become a major category of silk weaves. *Zhuanghuachou* is a weave made by adding wefts in one or two or several colours on a ground weave of *chou* by means of small short-running shuttles or long ones across the width with the wefts cut whenever necessary to make the pattern for a jacquard weave.

72

Zhuanghuachou
with Apricot Yellow Ground Weave and Patterns of Peony and Lotus Flowers

Mid-Qing Dynasty

Length whole bolt
Width of the bolt 54 cm
Qing court collection

This piece of *zhuanghuachou* (plain silk weave with brocaded patterns) is in plain weave. Both the ground warps and wefts are untwisted threads in apricot yellow; while flowers like peony, lotus and daffodil are made out with pattern wefts in green, purple, black, white and blue as well as apricot yellow, leaves are made out with gilded paper strips and threads wrapped in gold foils. Auxiliary patterns are made out by means of cream-coloured pattern wefts looking like dragons hugging pillars (*longbaozhu*).

This *chou* involves a very difficult technique by which to weave a complicated pattern shown through pattern wefts, but it accentuates the patterns very clearly. It belongs to the thicker and heavier type of *zhuanghuachou*, usually meant for making cushion covers.

"Dragon hugging the pillar" means employing a fine but strong twisted silk thread as the pillar around which a thicker and strongly twisted silk thread spirals its way up, looking like a dragon twining round a pillar.

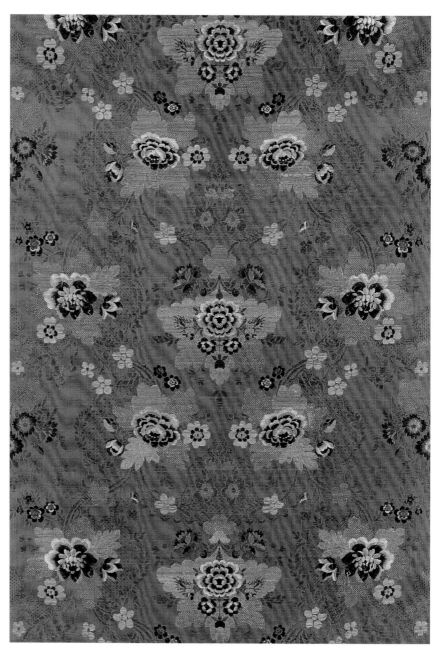

73

Zhijinchou
with Red Ground Weave and Patterns of Twining Peony, Lotus, Chrysanthemum and Chinese Crabapple

Ming Dynasty

Length 66.5 cm Width 49.5 cm
Qing court collection

This piece of *zhijinchou* (silk weave with gold) has a structure of three sets of right-slanting twill threads. The ground warps are red twisted threads and the wefts also red but untwisted. Blossoms of chrysanthemums, Chinese crabapples, peonies and lotuses intersecting alternately in horizontal rows are woven with pattern wefts of gilded paper strips intertwine with ground warps. The stems and the leaves are interlinked and intertwined, crisscrossing one another.

This piece of *chou* has fully exploited the gold threads for showing the patterns designed in a very close and somewhat over-elaborate arrangement.

Zhijinchou is a weave using gilded paper strips and threads wrapped in gold foil to make patterns on a *chou* ground. It is an expensive textile of superior quality among weaves of the *chou* category. It is usually used for furnishing high-class everyday articles.

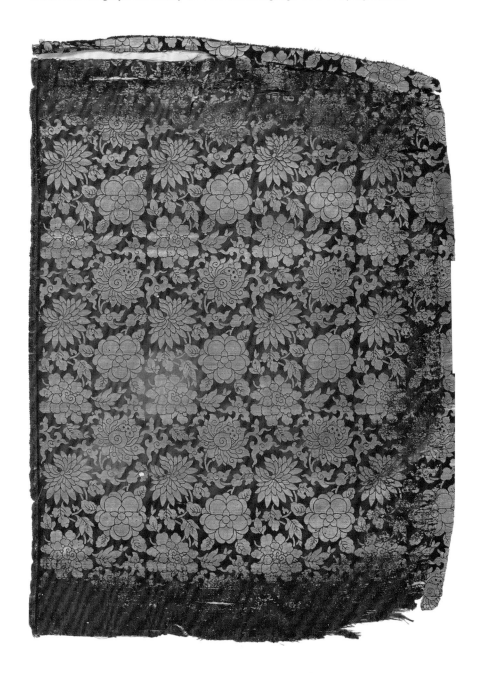

74

Jingpi in *Ersechou*
with Green Ground and Figures of Yellow Peony and the Character for "Longevity"

Ming Dynasty

Length 35 cm Width 14.5 cm

This piece of *jingpi* (jacket for Buddhist scripture covers) has a ground weave with three sets of left-slanting twill woven with green ground warps interlacing with yellow ground wefts. On it are woven figures of peony and longevity by means of the wefts. The peony blossoms alternate with the characters for "longevity," which looks like peonies holding up longevity, implying "wealth and long life."

Ersechou appeared first in the Ming period. Typically, its warps and wefts are in different colours, and the warps make the ground while the wefts make the patterns. Its weaving method and effect are similar to those of *shanduan* (shimmering satin).

75

Anhuajiangchou
with Apricot Ground and Patterns of Lotus and the Character for Double Joy in Roundels

Qing Dynasty Tongzhi period

Length 688 cm Width 80 cm
Qing court collection

This piece of *anhuajiangchou* (Jiangning *chou* with veiled patterns) is a weave with apricot yellow warps and wefts interlacing to make a twill ground with three sets of right-slanting warps. The patterns of lotus and the words for double joy (*xi*) in roundels are woven by means of the wefts, symbolizing double joy with lotus (*helian shuangxi*).

Jiangchou is so named because it was a silk textile produced in Jiangning (Nanjing). It is a weave with twisted warps and untwisted wefts, which were dyed before the weaving, and its monochrome veiled patterns are shown by the wefts. The weave is close, even and terse.

76

Zhuanghuasha
with Yellow Ground and Figures of Rabbit Holding a Flower between its Lips

Ming Dynasty Xuande period

Length 48.5 cm Width 47 cm
Qing court collection

This piece of *zhuanghuasha* (gauze with brocaded patterns) has a ground of plain weave woven with yellow warps and wefts. The patterns also in plain weave are woven with pattern wefts of twisted gold threads, twisted silver threads and threads in other colours such as brown, dark green, orange, yellow, white, blue and pink, interlacing with the ground warps. The patterns are arranged in passes of three rows: the first contains rabbits holding *lingzhi*-fungi with chrysanthemums in between, the second contains rabbits holding osmanthuses with peonies in between, and the third again rabbits holding *lingzhi* with chrysanthemums in between the figures. All the rabbits tilt their heads upward, their chests stretched and one leg held high up in a posture to please. Both the peonies and the chrysanthemums have their outlines traced in white. The patterns symbolize wealth and long life (*fugui changshou*).

This piece of *sha*-gauze is a fine weave of exquisite craftsmanship. The pattern composition is stringent and its colours gorgeous and elegant. The figures are woven by means of the *wasuo* technique using small short-running shuttles that go only as far as the pattern requires and wefts that are also cut wherever required. This gives a strong sense of three-dimensionality. This fabric is a rare item of the *yunjinzhuanghua* category from Nanjing in the early Ming period.

Sha and *luo* have very similar structures. Apart from the *sha* with plain weave or square meshes, all other variants require doup warps crossing each other. *Zhuanghuasha* belongs to the category of Nanjing *yunjinzhuanghua*. It often consists of a *sha* ground on which multi-colour wefts or gold wefts and peacock plumes are used to add colourful patterns by the *wasuo* technique or using simply ordinary long-running shuttles from selvedge to selvedge.

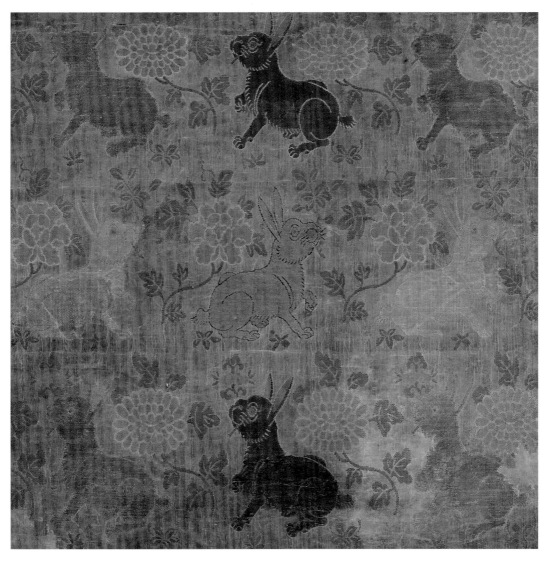

77

Zhuanghuasha
with Blue Ground and Figures of Cranes among the Clouds

Ming Dynasty

Length 34.2 cm Width 20.2 cm
Qing court collection

This piece of *zhuanghuasha* (gauze with brocaded patterns) has a plain-weave and square-meshed ground. The ground warps are blue and twisted and the wefts also blue but untwisted. Patterns of the multi-coloured square *ruyi* clouds and cranes are woven with wefts in five colours and gilded paper strips carried by long-running shuttles across the width.

According to legend, cranes belong to the family of immortal birds and the saying goes that cranes live a thousand years. They are therefore symbols of longevity. Cranes among clouds are traditional auspicious patterns, broadly used in clothing and furnishing the home.

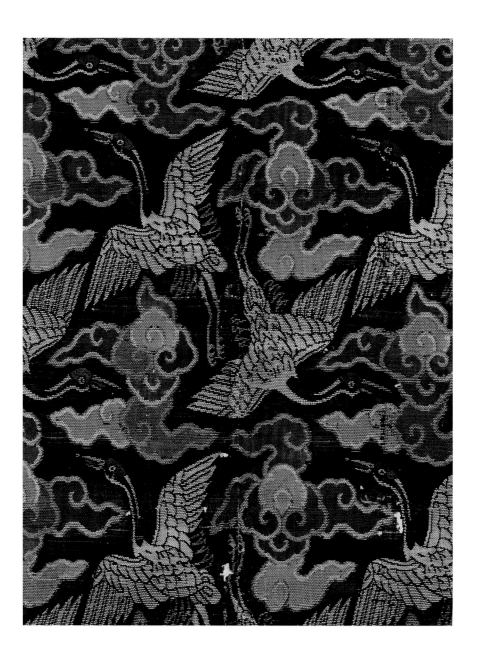

78

Curtain for Doorway
in *Anhuasha* with Greyish Brown Ground and
Patterns of Squirrels and Vines

Qing Dynasty Kangxi period

Length 205 cm Width 80 cm
Qing court collection

Anhuasha (gauze damask) is gauze with a firm plain-weave ground and veiled patterns woven with brownish warps interlacing with wefts. Patterns of vines, pine trees, clouds, squirrels, bees and butterflies are shown with ground warps crossing doup warps and then intertwining with ground wefts. The squirrels climb on the vines as if stealing the grapes, while bees and butterflies flutter among the vines. The picture implies reports of bumper harvests (*jie bao fengshou*).

Shidi'anhuasha is also called *shidisha*. It was popular during the Qing period. The ground is made of firm ground gauze and the patterns with two warps crossing doup warps to weave out veiled patterns of the same colour as the ground.

79

Taixisha
with Cream-coloured Ground and Patterns of Peony

Late-Qing Dynasty

Length 780 cm Width 56.5 cm
Qing court collection

This piece of *taixisha* (western gauze) uses cream-coloured ground warps, doup warps and ground wefts to make a plain weave with three shuttles and twist into a row of empty space as ground, on which to weave peony sprigs of the same colour with eight sets of three floating threads for satin pattern. The pattern ground is woven in plain weave, on which are woven the pistils and buds of peony by means of pattern wefts in pinkish grey (*ouhe*) and black carried by small shuttles for *wasuo* to attain the craft of adding decorative colours.

This piece of gauze has quiet tasteful colours. The weave is very fine and the craft sophisticated. It is a rare piece of *taixisha* from the late-Qing period.

Taixiasha was produced in the late-Qing period by using looms imported from Germany. The patterns of the fabric are veiled in the same colour as the gauze ground or accentuated in multi-colours, or added on with colour.

80

Huihuijin
with Grey Ground Weave and Patterns of Twining Sprigs

Qing Dynasty Qianlong period

Length 288 cm Width 62 cm
Qing court collection

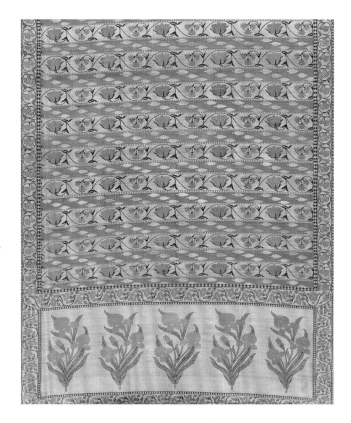

The ground of piece of *huihuijin* (Uighur brocade) has a plain weave in blue silk threads. The wefts are in grey, orange, green and camel brown. The thematic patterns are geometrically stylized twining sprigs woven with various shuttles alternating. At the two ends are larger patterns of plants and tassels of twisted gold threads.

Huihuijin is a textile made in the north-western region of China, mainly by Uighur people. The patterns are rich in the artistic style of Persia and Central Asia. Its characteristic lies in the generous use of golden threads, giving a sense of gorgeous splendour.

81

Huihui Zhuanghuaduan
with Purplish Rosy Ground and Patterns of Walnuts

Mid-Qing Dynasty

Length whole bolt Width of bolt 77 cm
Qing court collection

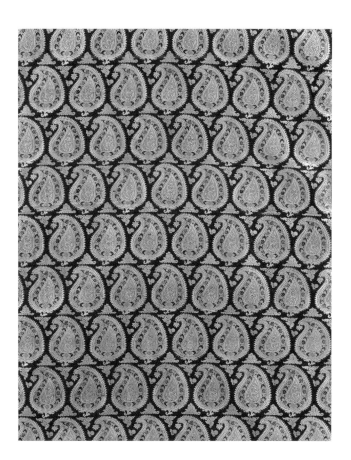

This piece of *huihui zhuanghuaduan* (satin with added patterns of Uighur origin) has a pattern ground woven with purplish rosy ground warps and wefts intertwining to make five sets of three floating warps for the satin face. The pattern wefts are made of twisted gold threads and twisted silver threads and floss in red, aubergine purple and green. *Wasuo* method is used to make walnut patterns (also called *baidanmu* patterns) in horizontal rows of added colours, and a method called *wasuo huose* (flexible shuttle and living colours) is also used to make leaves and flowers in stylized shapes of many colours. In between are triangular figures of flowers and leaves in gold, which breaks the stilted regularity of figures arranged rigidly in rows.

This piece of satin is a traditional Xinjiang Uighur fabric. Both its patterns and colours are rich in sentiments of the western region and the style of Islam culture.

82

Hetianchou
with Green Ground and Geometric Patterns

Qing Dynasty Qianlong period

Length 180 cm Width 38 cm
Qing court collection

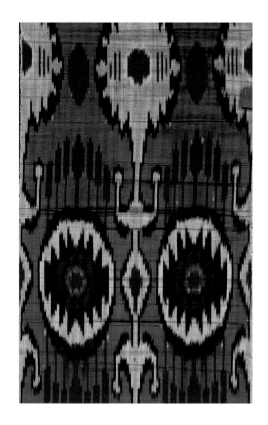

Hetianchou (plain or twill silk weave from Hetian) uses green silk warps and brown cotton wefts interlacing to make a twill ground with four warp sets, and oval roundels of various colours are woven with warps and wefts in colours such as white, green, greyish pink, yellow and red.

This fabric is a rare treasure of *Hetianchou* from the Qianlong period. The weave is very fine and the patterns novel. The colours are rich and bright. The various colours of the warps are dyed by batik method.

Hetianchou is also called "*aidelisichou*" or "*shukulachou*". It is a traditional textile of Xinjiang Uighurs, which was very popular in Xinjiang during the Ming and Qing periods for making skirts and blouses for local people.

83

Hetian *A'ermibiyanchou* Silk
Weave with Multi-coloured Lozenge Patterns

Qing Dynasty Qianlong period

Length 518 cm Width 32.4 cm
Qing court collection

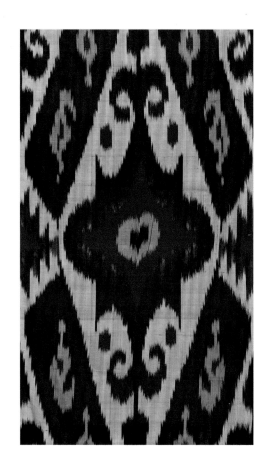

Both the plain-weave ground and the patterns of this piece of *a'ermibiyanchou* are woven with multi-coloured warps and red wefts. Lozenge frames are made of yellow, red, blue, purple and green warps, and inside are floral patterns.

This fabric is light and soft; its colours are rich, and the patterns look like brocade. It is a rare piece among *a'ermibiyanchou* from Xinjiang.

A'ermibiyanchou is a textile unique to Xinjiang. Its weaving craft is the same as that of *Hetianchou*. Its artefacts are found solely among the Qing articles of tribute in the holding of the Palace Museum.

84

Xinjiang *Mashilu*
Pile Textile with Figures of Tree in Multi-coloured Weave

Qing Dynasty Qianlong period

Length 386 cm Width 41.8 cm
Qing court collection

This piece of *mashilu* cloth has a firm ground with vertical stripes woven in greyish purple or green (*puhui*) silk warps and green cotton wefts to make twill in four sets of warps. In sections are warps of various colours dyed by batik method and float wefts to weave a pile ground and patterns. Green floss is used for the ground and white, *zanglan* (Tibetan blue), royal blue, yellow and red floss to make geometric patterns that look like flowering trees or fringes.

This piece of cloth is exquisitely woven with novel pattern composition and rich colours with natural gradual shades. It is a choice item of pile textile from the Hetian district of Xinjiang.

There was *mashilu* cloth already as early as in the Song period. It was called "*qiemianli*" during Yuan times. By the time of Qing, it had become very popular in the Xinjiang region. Its method of weaving is the same as the *Hetianchou*, and it is a pile textile with dyed warps unique to Xinjiang. It is used mainly for making seat covers.

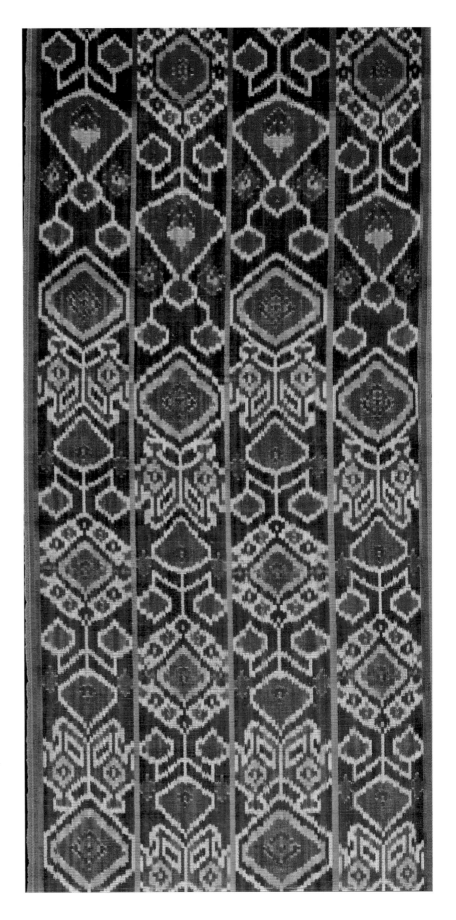

85

Fabric for *Jifupao*
in Bright Yellow Satin with
Saxianxiu and Patterns of
Cloud Dragon

Ming Dynasty Wanli period

Length of robe 147.5 cm Width throughout
both sleeves 144 cm
Width of lower part of the front 142 cm
Qing court collection

The surface material of the *jifupao* (semiformal courtly robe) is bright yellow satin with veiled patterns of clouds and dragons. Across the shoulders are figures of clouds and dragons forming the shape of a persimmon calyx. The shoulders have a gauze backdrop with red warps and the

patterned ground is brocaded with light brown double sewing threads to make lozenge meshes of the gauze. Further patterns are embroidered with floss and double sewing threads in twenty colours including mainly green, red, blue, black and yellow. In the centre are clouds in five colours and eight pairs of dragons playing with pearls. In between are *lingzhi-fungi* and all around are waves lapping on the shore.

This robe fabric is a choice item of embroidery from Beijing (*jingxiu*). There are three or four colours merging in gradual shades. The stitches are various, including open loop stitch, regular stitch, chain stitch, face propping stitch, reverse propping stitch, loose stitch, *kelin* (scale-carving) stitch, *dingzhen* (pin stitch) and *pingjin* (coiling gold threads) stitch. The pattern composition is elaborate and rigid with the patterns varying—obvious or veiled—in a neat order. The colours are strong and bright, and the needlework is exceedingly intricate and fine.

Saxianxiu (embroidery with scattered stitches) is a category of embroidery from Beijing. It belongs to the group called gauze embroidery (*shaxiu*). The craft consists in counting the gauze meshes at regular intervals according to the varying length of the stitches to perform the needlework.

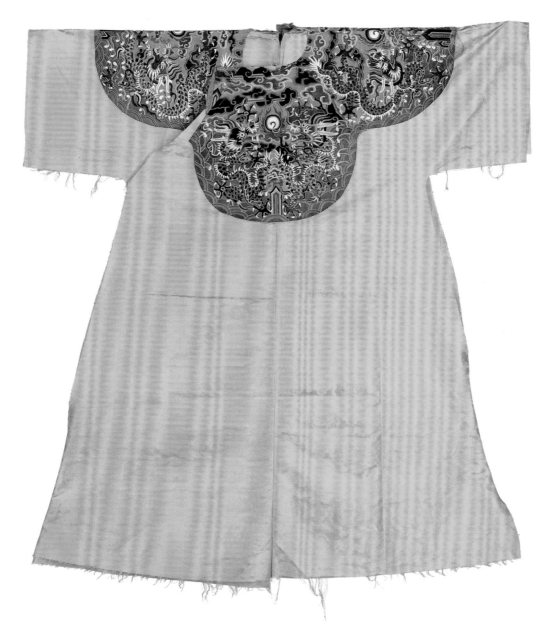

86

Jingpi
in Green *Saxianxiu* Ground and Multi-coloured Patterns of Chrysanthemum

Ming Dynasty

Length 30 cm Width 14 cm

The *jingpi* (prayer book jacket) in *saxianxiu* (embroidery with scattered stitches) has a backdrop of gauze with red warps. The brocaded ground shows figures of lozenges embroidered with light green threads. Patterns are embroidered on this with floss and sewing threads in eighteen colours, the thematic colours being green, red, yellow and blue. In the middle is a fully blooming chrysanthemum plant; on the upper edge is the pattern of auspicious clouds and, on the lower, waves lapping against the shore.

This prayer book jacket or cover involves the technique of merging two to four colours and the needlework of various stitches such as the forward chain stitch, open loop stitch, net embroidery, pin-thread, chain stitch, regular stitch and reverse propping stitch. As the sewing threads for embroidering the clouds and the chrysanthemum leaves are relatively matt, while the floss for the flowers has more lustre, the effect is a dimmer ground accentuating the bright patterns. The petals are made in reverse propping stitches, making the edges neat and outstanding and giving a sense of nuances in perspective.

87

Jingpi
with Light Brown *Saxianxiu* Ground and Figures of Two Dragons Playing with Pearls

Ming Dynasty

Length 37 cm Width 15.5 cm

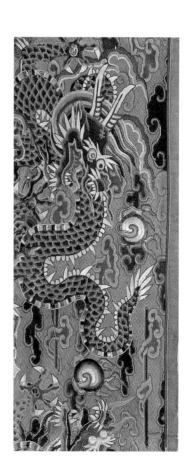

The *jingpi* (prayer book cover) of *saxianxiu* (embroidery with scattered stitches) has a backdrop of crimson gauze. The ground is woven with brown double threads to make lozenge figures. The dragons playing with pearls are embroidered in floss and sewing threads in twelve colours including mainly red, green and blue. The blue dragon gallops among the clouds with its beard and hair flying and dancing and its head turning back to look at the fire pearl. Behind it is a partially visible red dragon showing only the head and the front claw as if chasing the fire pearl.

This cover is a rare item of Beijing embroidery (*jingxiu*) using the method of merging two to four colours. The craft involves using silk filaments one to fifteen at a time to make the colourful clouds and the body of the dragons. The needlework for the fire pearl, the dragon eyes, the horns, the hair, the sharp claws and the fins on the back includes reverse propping stitches, face propping stitches, regular stitches and couching stitches. The embroidery craftsmanship is superbly exquisite.

88

Material for Robes
in Gold Ground Embroidered
with Multi-coloured Patterns
of Clouds and Dragons

Qing Dynasty　Shunzhi period

Length 140 cm
Width throughout the sleeves　132 cm
Width of lower hem of the front　128 cm
Qing court collection

The fabric has bright yellow silk plain weave as the backdrop. The ground is embroidered overall with twisted gold threads. Patterns showing dragons playing with pearls are embroidered with peacock plumes, twisted red gold threads and floss in sixteen colours, mainly, red, green, blue, white and black. In between are figures of silver ingot, ancient coins, jewels, corals, bells, stone chimes, *ruyi*, clouds and the character for 卍. On the lower part of the front are waves lapping against the shore.

This fabric uses the method of merging two to four colours and the needlework includes mainly reverse propping stitches and chain stitches. Auxiliary stitches are the face propping stitch, *kelin* stitch, chicken feather stitch, open loop stitch, couching stitch and padded satin stitch. It is a very rare piece of Beijing embroidery (*jingxiu*) from the Shunzhi period.

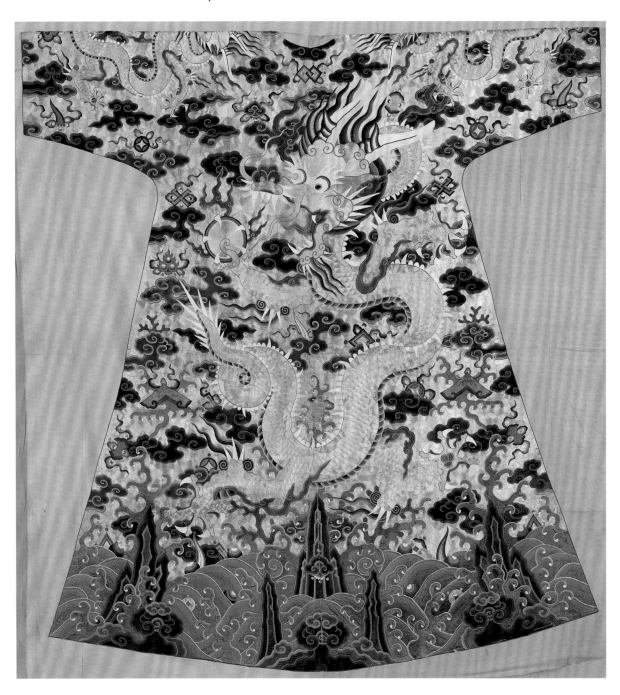

100

89

Table Frontal
Made of *Nasha* with Multi-coloured Patterns of Lotus and Egrets

Qing Dynasty Yongzheng period

Length 273 cm Width 82.3 cm
Qing court collection

The table frontal has a backdrop of white straight-warp gauze. Vermilion floss is used to sew close stitches on the ground and multi-coloured floss to sew close stitches to make the pattern of "lotus and egrets." (*hehua lusi tu*) The lotus blooms luxuriantly on the water and the egret's beak holds clams and small fishes. In the air are spring swallows frolicking and chasing each other up and down. On the slope and on the river bank are embroidered willow trees, evergreens, camellia sinensis and *lingzhi*-fungus, symbolizing "prosperity and glory all the way" (*yilu ronghua*) and "longevity and wealth." (*changshou fugui*) The upper part is a ground like a chequered chessboard; around the waist are characters for "*shou xi shou, heqing haiyan, shou xi shou*" (long life celebrates long life, the world is peaceful and long life celebrates long life). Every character is surrounded by a *kui*-dragon. In the centre is the character for "long life" holding up the character for 卍, implying everlasting life.

This table frontal uses two to four colours merging and the embroidery is done by needlework including the reverse propping stitch, face propping stitch, chicken feather stitch, open loop stitch and chain stitch. The colours are strong and rich and the needlework is very fine. This is a rare treasure of *nasha* (straight-warp gauze in close tight stitches) embroidery from the period of Yongzheng.

Nashaxiu is also called *chuoshaxiu* (jabbing-the-gauze embroidery). It has its origin from *suxiu* (Suzhou embroidery) which was adopted later by *jingxiu* (Beijing embroidery), and this piece is *jingxiu*. The craft lies in counting the meshes in the gauze to be sewn and closed according to the pattern requirement. There are two categories, one being perpendicular and the other slanting. When the embroidery threads and the wefts are perpendicular, it is the straight strings, and when the embroidery threads meet the wefts at an angle of 45 degrees, it is the slanting strings.

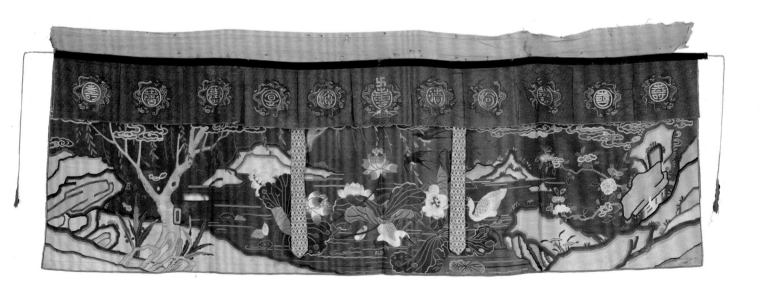

90

Material
for a Semiformal Courtly Robe with Blue Plain-weave Silk Ground and Patterns of Twining Chrysanthemums and *Mang*-dragons in Couching Stitches with Gold and Silver Threads

Qing Dynasty Qianlong period

Length of robe 153 cm
Width across both sleeves 145 cm
Width of lower part of the front 147 cm
Qing court collection

The surface of the robe is made of blue plain-weave silk. Nine golden *mang*-dragons are embroidered with the so-called "dragon embracing the pillar" (*longbaozhu*) of strongly twisted black threads and twisted gold threads. The ground is decorated with twining chrysanthemum sprigs, and the lower part is decorated with waves lapping against the shore and figures of bamboo and peach.

This fabric uses the method of merging two colours. The embroidery is done in outline stitches and couching stitches of gold and silver thread as well as sewing on mother of pearl. Gold threads are used to embroider the scales on the coiling *mang*-dragon, while chrysanthemums are made out with silver threads, the *mang* figure glitters and radiates the air of royalty. This is a choice sample of *jingxiu* (Beijing embroidery) in gold couching stitch from the period of Qianlong.

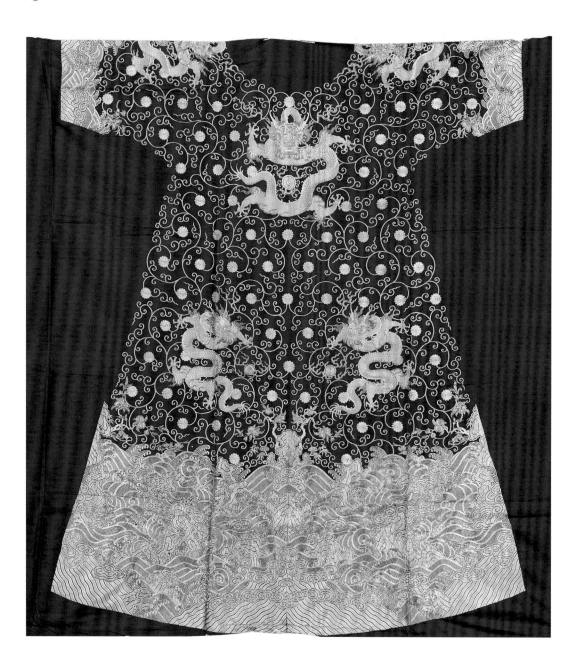

91

Material
for Semiformal Courtly Robe in Bright Yellow Satin with Patterns of Multi-coloured Clouds and Dragons

Qing Dynasty Qianlong period

Length of robe 155 cm
Width across both sleeves 156 cm
Width of lower portion along the hem 158 cm
Qing court collection

The material has a bright yellow satin face. The thematic tones are red, blue, green, yellow and white. Figures of nine dragons playing with pearls are embroidered with small pearls, twisted silver threads and floss in eighteen colours. In between are patterns of clouds, red bats, "the eight covert immortals" (*anbaxianwen*) and the eight auspicious emblems, implying "full happiness" (*hongfu qitian*) and "longlife and fulfilment." (*changshou ruyi*) On the lower portion are waves lapping the shore and various precious patterns (*zabaowen*) such as corals, jewels, ancient coins, auspicious clouds and painting and calligraphy.

The eight immortals are the Daoists Tieguai Li, Han Zhongli, Cao Guojiu, Han Xiangzi, Lan Caihe, Zhang Guolao, Lü Dongbin and He Xiangu. Patterns are composed of the instruments they hold, namely, the gourd, the fan, the ivory court tablet (*huban*), the flute, the flower basket, the drum, the sword and the lotus are called *anbaxian*. Like the *baxian* (eight immortals) figures, they symbolize wishes for long life.

This robe fabric is a creation of *suxiu* (Suzhou embroidery). It uses the method of merging two to five colours. Figures of dragons are made in outline stitches, with auxiliary stitches such as the open loop, the chicken feather stitch, the regular stitch, the couching gold or silver stitch, padded satin stitch, running stitch and net stitch. The needlework is superbly exquisite. It was material meant for making robes for the empress.

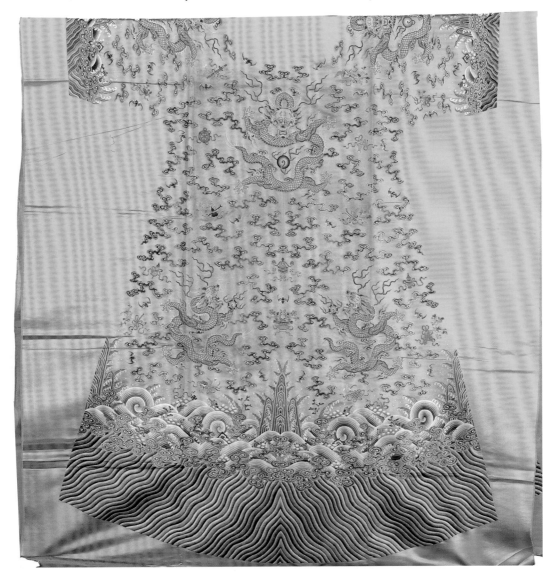

92

Square Insignia
of Azure Blue Satin with
Embroidery of Multi-co-
loured Red-crested Cranes
Facing the Sun

Qing Dynasty Qianlong period

Length 36 cm Width 36 cm
Qing court collection

The square insignia has a ground of azure blue satin. The thematic tones are red, green, blue, yellow and white. Patterns including the figure of *danhe chaoyang* (red-crested crane facing the sun) are embroidered with twisted gold threads and floss in twenty-two colours. In the centre is an immortal crane looking up to a glowing sun as if about to take flight, implying *yipin dangchao* (first rank court administration). All around are such patterns as the *ruyi*, peaches, bats and the eight auspicious emblems. On the lower part are waves lapping the shore and figures of the mixed treasures (*zabaowen*). On the water is a jar in which stand three halberds with a stone chime hanging from them, beside which is a fish. All this is to pun with and imply "*pingsheng sanji*" (promotion by three ranks) and "*jiqing youyu.*" (surplus for celebration)

This square insignia is a *suxiu* (Suzhou embroidery) creation, using the method of merging two to three colours and needlework involving mainly stitches like the open loop, the cart wheel, the *kelin* and the couching gold stitch with auxiliary stitches like the knot stitch, the regular stitch and the chicken feather stitch. It is for sewing on the official garment of a first rank civil official during the Qing Dynasty.

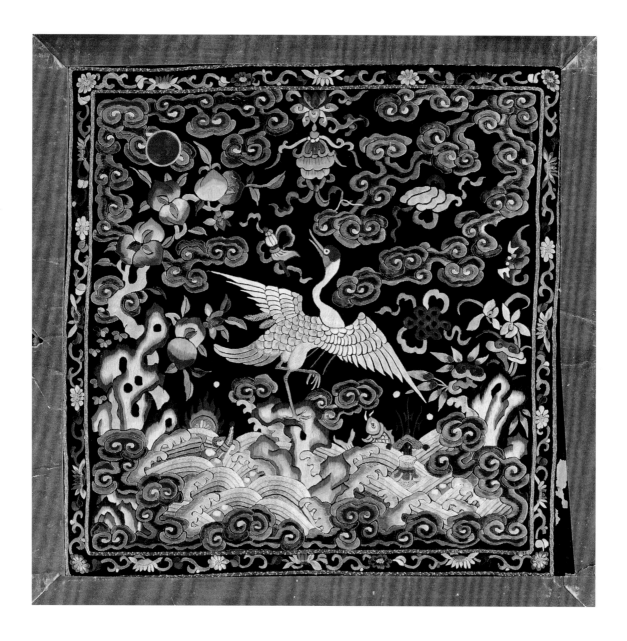

104

93

Material
for Informal Costume in Red Satin Embroidery with Eight Roundels Containing Figures of Lotus, Bats and Flowers with Water

Qing Dynasty Jiaqing period

Length 296 cm Width 152 cm
Qing court collection

This robe fabric has a red satin face, and its chief patterns of eight roundels containing twining lotus and bats and embroidered with twisted gold threads, twisted silver threads and peacock feathers. Between the roundels are figures of the plucked flowers of orchid, plum, bamboo and chrysanthemum—the so-called four *junzi* and other decorative patterns such as the day lily, the *lingzhi*-fungus, the daffodil, the pomegranate, the crabapple, the Chinese rose and the bat. On the lower part are waves lapping the shore.

This fabric is a *jingxiu* (Beijing embroidery) creation using the method of merging two colours in gradation. The needlework involves the couching stitch and couching gold and silver stitch. The composition is opulent and the colours gorgeous and elegant. The material was meant for making informal garments for imperial concubines.

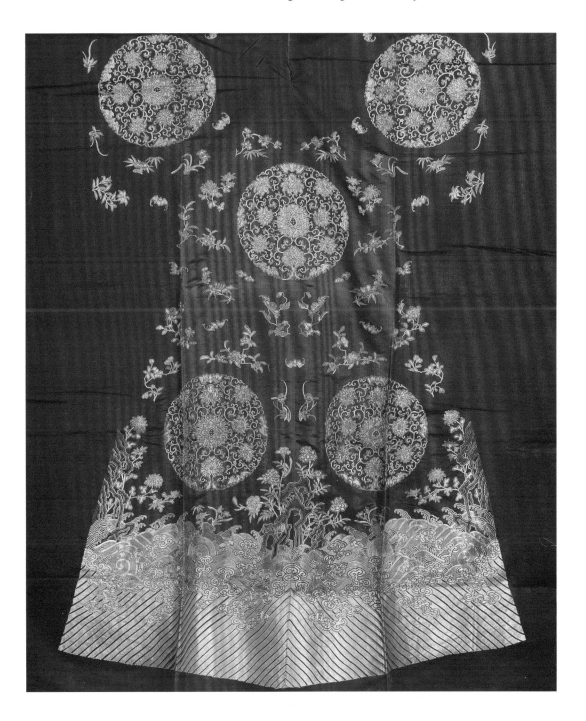

94

Material
for Informal Courtly Robes in
Green Satin Embroidered
with Multi-coloured Patterns
of Peony Blossoms

Qing Dynasty Jiaqing period

Length 262 cm Width 155 cm
Qing court collection

The fabric has green satin face. The thematic tones are red, green, blue, yellow and black. The blossoms are embroidered with multi-coloured floss in twenty-two hues. The plucked peony sprigs form the theme, decorated in between with peach blossoms, chrysanthemum, Chinese roses, pomegranate blossoms, orchids, corn poppy, plum blossoms, *lingzhi*-fungus, wisteria sinensis, dianthus chinensis, lotus, day lily and crabapple, implying the good omen of wealth, fertility and longevity.

This piece is a *suxiu* creation, using the method of merging two to three colours in gradation and the needlework of chiefly knot stitch, running stitch and chicken feather stitch. The needlework is exquisite. The material was meant for making informal courtly robes for imperial concubines.

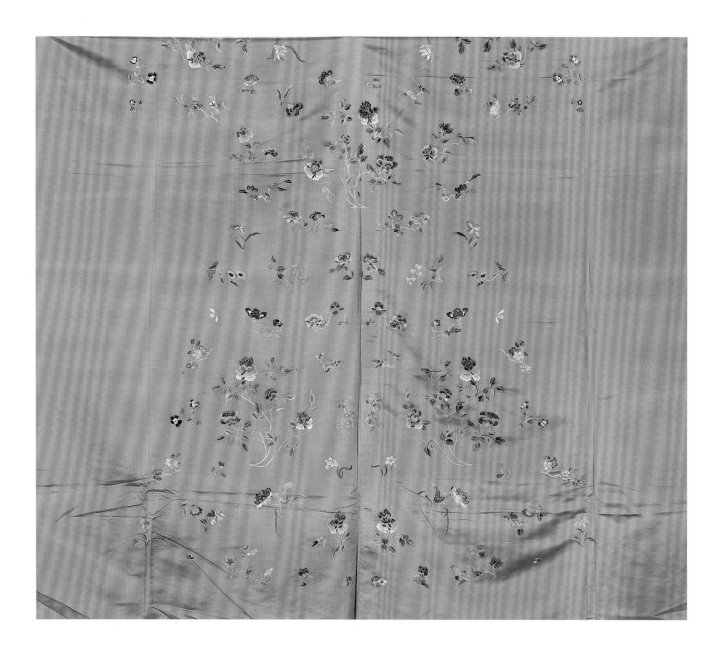

95

Material for a Robe
in Brown and Covered with
Embroidered Peacock
Feathers on the Ground and
Decorated with the Figure of
a *Mang*-dragon

Qing Dynasty Jiaqing period

Length 306 cm Width 149 cm
Qing court collection

The material of the robe has dark brown *chou* as the face. The ground is fully embroidered with green peacock feather threads. The major tones are red, yellow, green, blue and white. Nine *mang*-dragons are embroidered with twisted gold threads and twisted silver threads plus floss in twenty-two colours. In between are decorative figures of clouds, bats, cranes, "the eight covert immortals" (*anbaxianwen*), the eight auspicious emblems, peaches and waves lapping against the shore.

This fabric for a robe is a rare piece of *guangxiu* (Guangdong embroidery). It uses the method of merging two to four colours. The needlework is chiefly couching stitch and *kelin* stitch. Auxiliary stitches include the open loop, the face propping, the reverse propping, the regular, the knot stitch, the running stitch, couching stitch, straight stitch, the outline stitch, the net stitch and the padded satin stitch. The colours are bright and clear and the needlework exquisite.

Guangxiu is also called *yuexiu*, denoting generally embroidery from Guangdong Province, as one of the four famous provenance of Chinese Embroidery. It was first seen in the Ming Dynasty and became popular in late Qing.

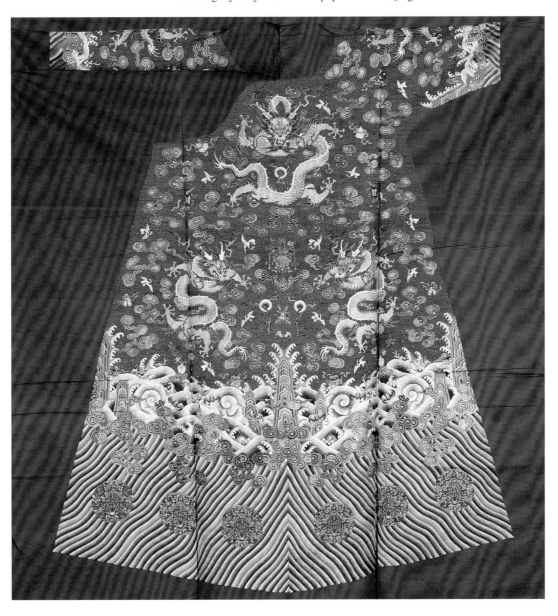

96

Material
for an Informal Robe in Red Satin Embroidered with Phoenixes and Flowers in Eight Roundels

Qing Dynasty Daoguang period

Length 295 cm Width 154 cm
Qing court collection

The material has a red satin face. The thematic tones are red, blue, green, yellow and white. Floss in twenty-odd colours together with twisted gold threads and twisted silver threads have made out in embroidery the main body of eight pattern roundels composed of figures of palm-tailed-phoenixes (*kuifeng*), auspicious clouds, *lingzhi*-fungi, the "eight auspicious images" (*bajixiang*), waves lapping on the shore and bats with peach and lotus between their beaks, implying happiness and longevity. Between the roundels and on the lower front of the garment are *lingzhi*-fungi, longevity rocks, longevity chrysanthemum, peony, peach blossoms, plum blossoms, Chinese rose, camellia sinensis, crabapple and bats.

This piece of fabric is a rare precious item of *suxiu* (Suzhou embroidery) from the Daoguang period. It uses the method of merging two to four colours in gradation and the needlework involving the open loop stitch, the regular stitch, the *kelin* (carving scales) stitch, the chicken feather stitch, the running stitch and the gold couching stitch.

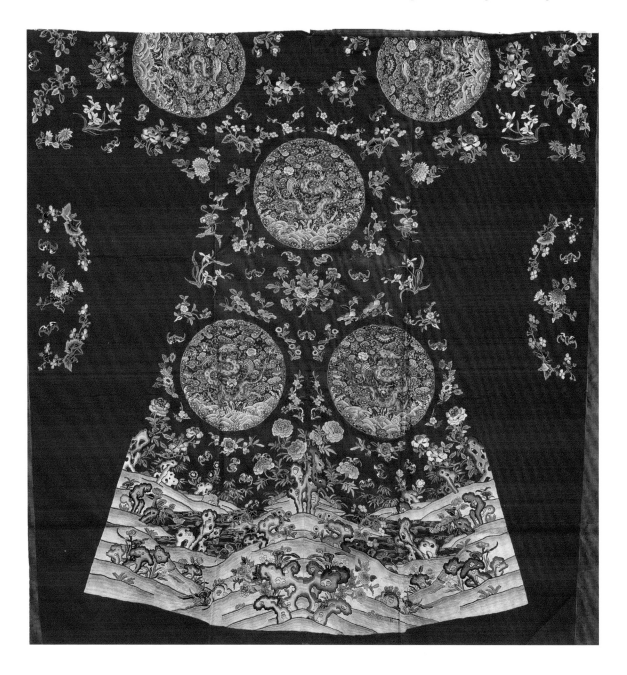

97

Lined Blanket
in Pink Satin Embroidery with Patterns of the Eight Auspicious Symbols Including Peach, Bats and Blossoms

Qing Dynasty Daoguang period

Length 271.5 cm Width 212 cm
Qing court collection

The blanket with lining has a pink satin face. The thematic tones are red, blue, green, yellow and white. The decorative patterns of longevity peaches, bats, geranium, plum blossoms, daffodils, longevity chrysanthemums and day lilies are embroidered with floss in twenty-five colours. They imply wealth, long life and many sons (*fugui changshou* and *yinanduozi*). On the beige upper part are embroidered the eight auspicious symbols (*bajixiang*) and the mixed treasures (*zabaowen*).

The blanket with lining is a *suxiu* (Suzhou embroidery) creation, employing the method of merging two to three colours. The spiral lines and the spots of the dharma conch are embroidered in the outline stitch; the leaves in chicken feather, the *lingzhi*-fungi, daffodils and peach blossoms in face propping stitch with supplementary stitches like the open loop, the straight, the knot, the running and the scale-carving.

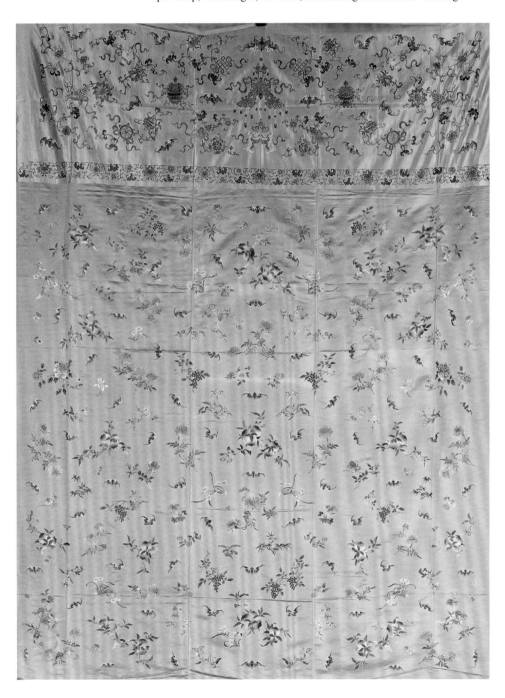

98

Material
for an Informal Courtly Robe
in Purplish Pink Satin with
Figures of Multi-coloured
Phoenixes among Flowers

Qing Dynasty　Xianfeng period

Length　310 cm　Width　148 cm
Qing court collection

This material for a robe has a purplish pink satin face. The thematic tones are green, yellow, white, red, blue and black. The decorative patterns of phoenixes, peonies and chrysanthemums are embroidered out with floss in twenty-four colours as well as twisted gold threads and twisted silver threads. The peonies and the chrysanthemums are in full bloom with a few phoenixes hovering among them. This implies the auspicious wishes for "phoenix among peonies" (*feng chuan mudan*) and "wealth and long life." (*fugui changshou*)

This fabric is a rare piece of *suxiu* (Suzhou embroidery) from the Xianfeng period. It employs the method of merging two to five colours in gradation. The petals are embroidered by face propping stitches, the pistils by knot stitches, peacock tails and phoenix claws by punching stitches and plumes of peacock tails by sparse stitches in horizontal rows. All these are supplemented by straight stitches, scale-carving stitches, running stitches and couching gold stitches, thus effecting layers of nuances.

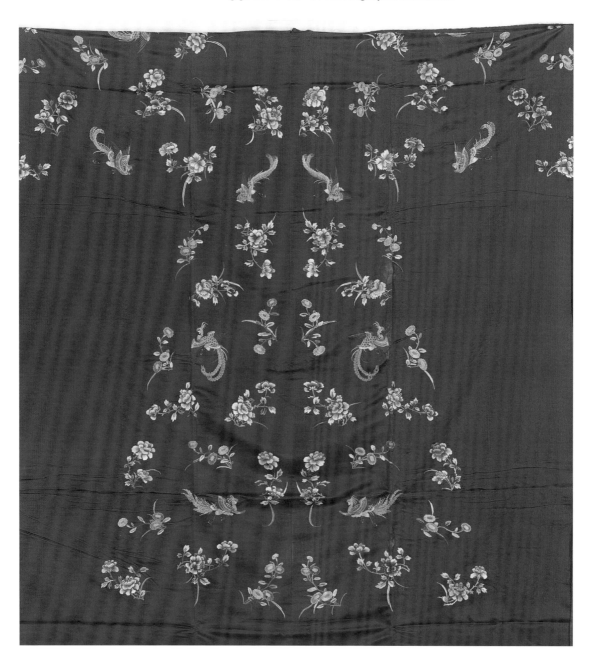

99

Material
for a Jacket in Watery Blue *Chou* with Embroidery of Light-coloured Vines, Magnolia and Characters for "Longevity"

Qing Dynasty Guangxu period

Length 80 cm Width 74 cm
Qing court collection

The jacket material uses watery blue *chou* (plain-weave silk cloth) as surface with the main tons of grey, blue, yellow, purplish pink and white. The magnolia and the grapes are embroidered with floss in sixteen colours and twisted gold threads. In between are decorations of round characters for "longevity," implying wealth, long life and fertility.

This jacket material is a choice item of *suxiu* (Suzhou embroidery), using the method of merging two to three colours in gradation. The magnolia, vine leaves and the grapes are embroidered in face propping stitches. The top of the grapes are embroidered in knot stitches, supplemented with straight stitches and couching stitches.

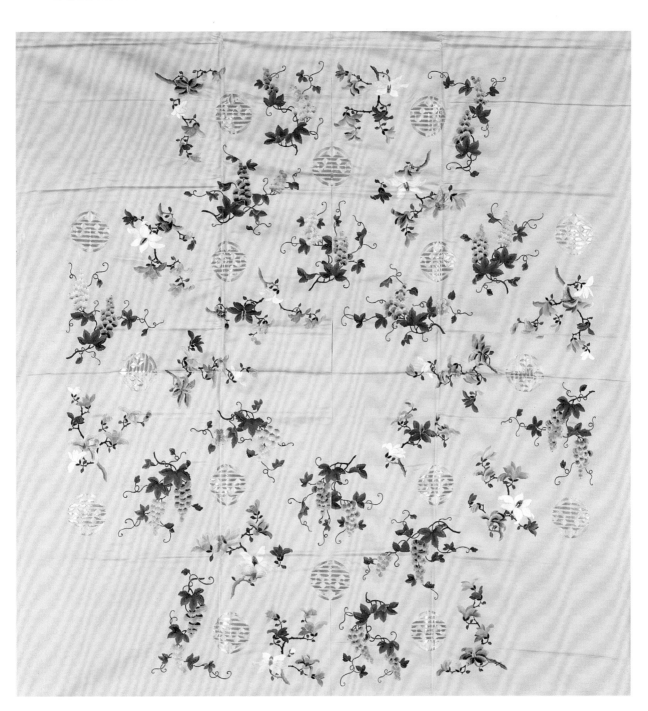

100

Material
for Seat Cover in Red Satin Embroidered with Picture of Myriads of Male Children

Qing Dynasty Guangxu period

Length 110 cm Width 97.5 cm
Qing court collection

The seat cover is made of red satin face. The picture of Myriads of Male Children is embroidered with multi-coloured floss and twisted gold threads. The background is a slope with rocks and a pavilion. In the middle of the picture is embroidered an old pine tree, under which are children playing with firecrackers. On the upper right corner, inside and outside the pavilion are children playing with puppets, and on the left upper corner are children playing with drums, gongs and lanterns. It is a joyful scene of festive celebrations. All around the borders are decorations of gourds, characters for "double happiness" and bats holding longevity peaches in their mouth.

The fabric of this cover is a *suxiu* (Suzhou embroidery) creation in brisk bright colours and elaborate needlework. Its success lies in using different stitches to express different scenes and people. It conveys the delight of brushwork in painting and yet expresses an exquisite delicacy beyond brushwork.

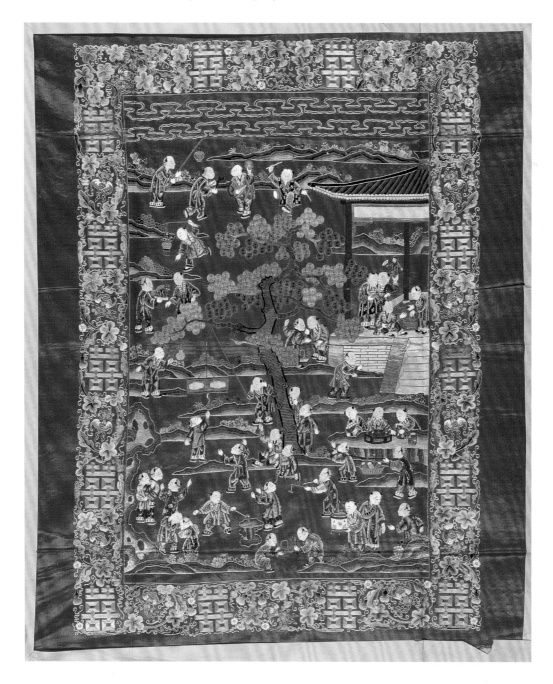

COURT COSTUME OF THE QING DYNASTY

101

Fur Courtly Robe
in Yellow Satin with Patterns of Colourful Clouds and Golden Dragon

Qing Dynasty Kangxi period

Length of robe 150 cm
Width across both sleeves 194 cm
Width along the lower hem 152 cm
Collar 120×42 cm
Qing court collection

The courtly robe is made of yellow satin surface. Both the collar and the skirt are bordered with purple mink (*zidiao*), while the horse-hoof cuffs are bordered with azurite blue mink (*xundiao*) and lined with the hide of corsac fox (*tianma*). The robe is decorated with brocaded patterns. The golden dragon is woven with threads wrapped in gold foil carried by small short-running shuttles and the borders are traced with gold threads, which refract light differently to create nuances. The auspicious clouds and the waves lapping the shore are woven in multi-coloured silk threads.

This robe was used by Emperor Kangxi at major celebratory ceremonies during winter. The hide is soft and lustrous. The robe is light and dignified. It is a very well preserved and invaluable choice item. On the yellow tag is written record by the Qing court.

The writing on the yellow tag attached to Qing court costumes was done at the time by eunuchs belonging to the management of the court. These tags have become significant material for historical research, but owing to the inadequate knowledge and education of the eunuchs, their descriptions were inaccurate and sometimes even erroneous so that they are not entirely reliable.

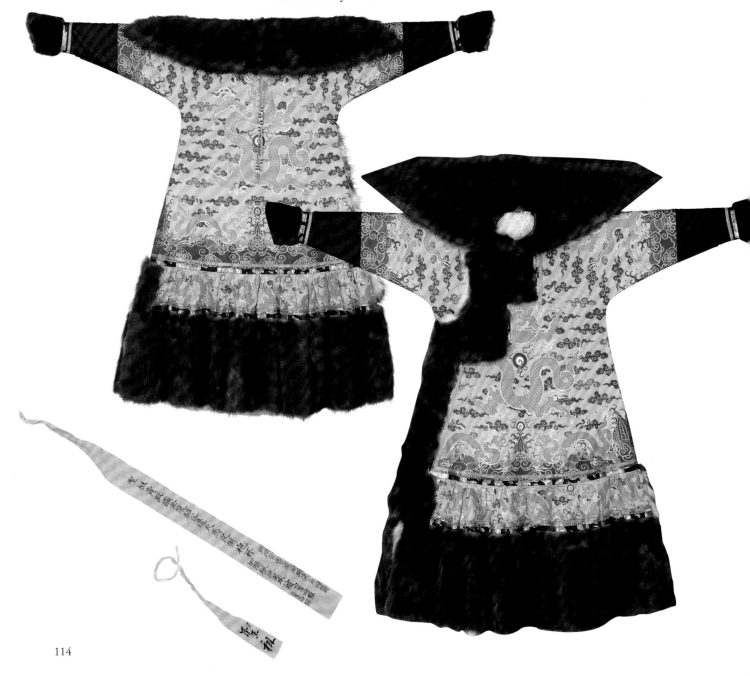

102

Fur Courtly Robe
in Blue Satin with Patterns of Colourful Clouds and Golden Dragon

Qing Dynasty Kangxi period

Length of robe 150 cm
Width across both sleeves 208 cm
Width along the lower hem 153 cm
Collar 122×42 cm
Qing court collection

The courtly robe is made of plain satin surface. Both the collar and the skirt are bordered with purple mink (*zidiao*), while the horse-hoof cuffs are bordered with azure mink (*xundiao*) and lined with the hide of corsac fox (*tianma*). The robe is decorated with brocaded dragon patterns, nine in gilt threads on the bodice and seven flying ones in the folds. In between are multi-coloured auspicious clouds.

This robe was used by Emperor Kangxi at major celebratory ceremonies during winter. The colour of the hide is even, and the fur is soft and light. The robe is a superb creation. On the yellow tag is written record by the Qing court.

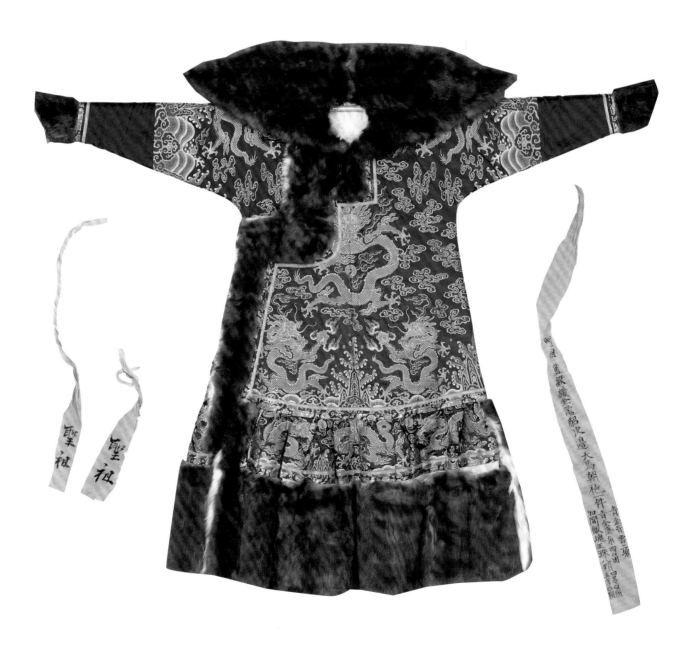

103

Fur Courtly Robe
in Yellow Satin Embroidered
with Patterns of Colourful
Clouds and Golden Dragon

Qing Dynasty　Kangxi period

Length of robe　148 cm
Width across both sleeves　202 cm
Width along the lower hem　160 cm
Collar　110×41 cm
Qing court collection

The courtly robe is made of yellow satin surface and lined with mink fur. Both the collar and the sleeves are blue, bordered with sea dragons embroidered in threads looped in gilt paper. All over are figures of dragons embroidered in threads with gold threads spiralling around. There is a dragon facing front on the front, one on the back and one on each of the shoulders. Around the waist are five flying dragons and in the folds are nine roundels with dragons spread over the front and the back. On the skirt are two dragons facing the front and four flying ones. The main colours are blue, purple, green and light brown, with three auxiliary colours in various shades merging to embroider flowing clouds and flames in between.

This robe was used by Emperor Kangxi at major celebratory ceremonies during winter. Between the persimmon calyx pattern round the neck and the waist-piece are four roundels of dragons in front and on the back, while the front is not decorated with patterns, which is a practice from the late period of Kangxi. On a yellow tag in ink was written only: "Emperor Kangxi (*shengzu*)."

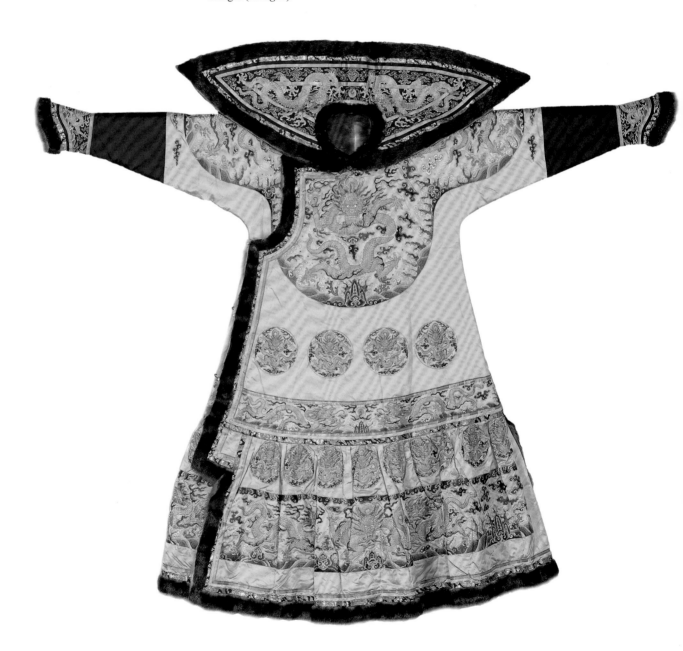

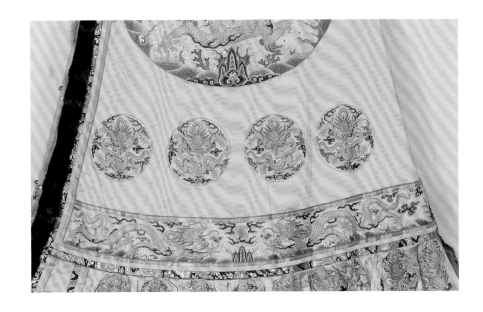

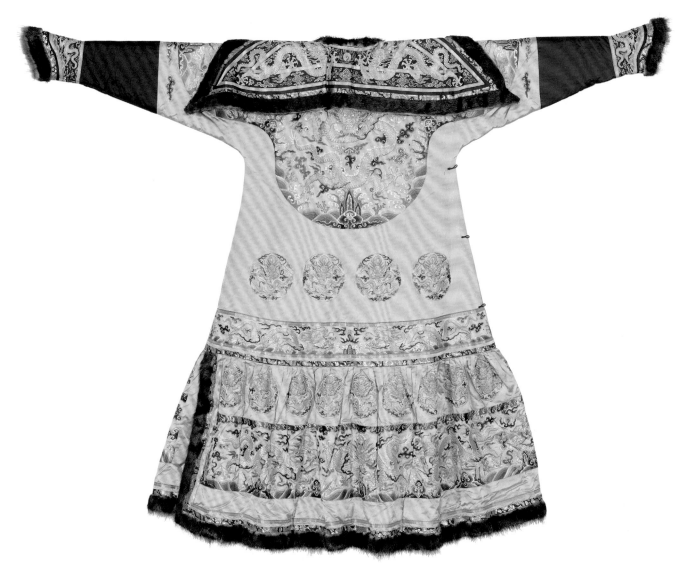

104

Fur Courtly Robe
in Bright Red Satin Embroidered with Patterns of Colourful Clouds and Golden Dragon

Qing Dynasty Yongzheng period

Length of robe 145 cm
Width across both sleeves 192 cm
Width along the lower hem 136 cm
Collar 100×34 cm
Qing court collection

The courtly robe has a round neckline, a broad front closing on the right, sleeves with horse-hoof cuffs and no *beiyun* pendants on the back. Below the waist are gathered folds. The satin has bright red face. The collar and the sleeves are blue with borders embroidered with sea dragons in threads looped round gilt paper. The lining is made of lamb skin for the upper part and snow weasel fur for the lower. On the robe are brocaded four dragons, colourful clouds, and waves lapping the shore to form the persimmon calyx pattern around the neckline. Around the waist are five flying dragons, five on the front and five on the back of the skirt. Two flying dragons are embroidered on the collar, one on each of the ends of the sleeves, and along the lapel on the front are patterns of landscape.

It was only from the first year of the reign of Yongzheng that bright yellow, blue, bright red and pale blue were coded as colours for the emperor's ceremonial robes. This bright red courtly robe was worn by Emperor Yongzheng on days of ritual sacrifice. On the yellow tag is written "*shizong*" for Yongzheng.

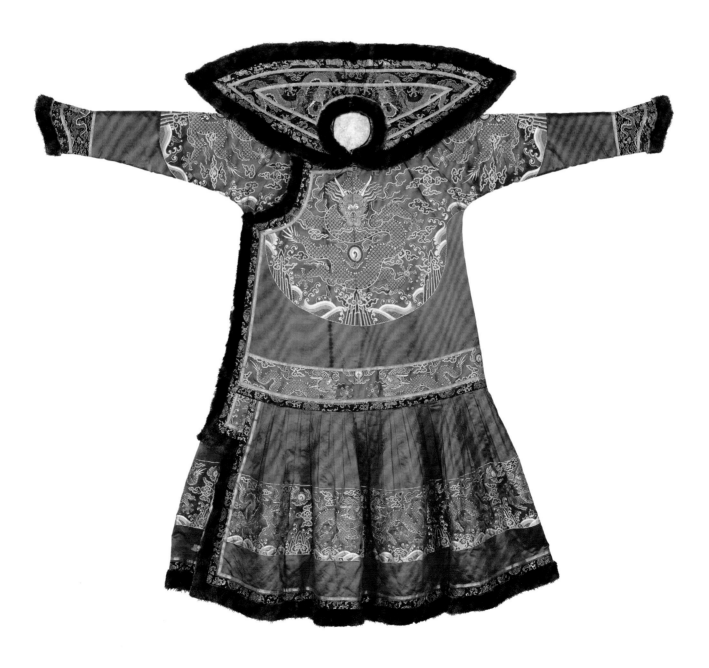

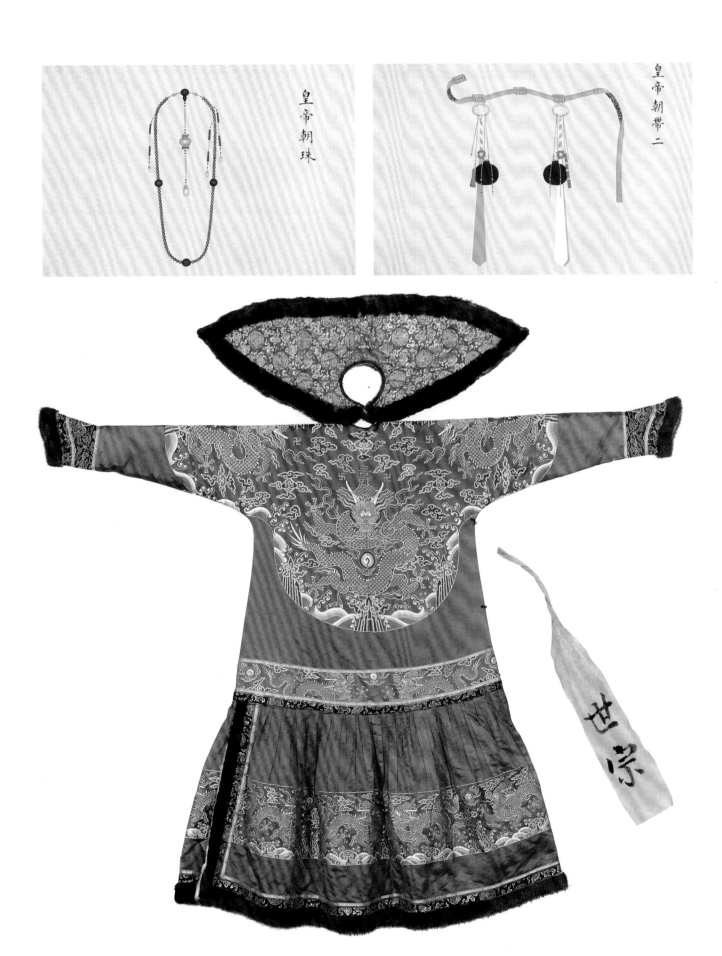

皇帝朝珠

皇帝朝帶二

世宗

105

Fur Courtly Robe
in Bright Yellow Satin
Embroidered with Patterns of
Colourful Clouds and
Golden Dragon

Qing Dynasty Yongzheng period

Length of robe 149 cm
Width across both sleeves 200 cm
Width along the lower hem 172 cm
Collar 106×38 cm
Qing court collection

The courtly robe has a bright yellow satin surface. The lining is made of lamb skin for the upper part and snow weasel fur for the lower. The lapel and the collar as well as the lower part of the robe are made of purple mink fur, and the sleeves blue mink fur. These are bordered with plain-weave silk in azure blue floral and cloud patterns. The lining for the collar is plain-weave silk with gold threads to embroider the red roundels with mixed treasures (*zabaowen*). There are no *beiyun* pendants on the back. The face side of the robe has two to four colours merging in gradation to weave the figures of golden dragons, multi-coloured clouds and waves lapping on the shore.

The weaving of the fabric of this robe is exquisite and the colours are solemn. It is a choice product for brocaded satin ceremonial robes from the Jiangning Textile Bureau during the Yongzheng period. On the yellow tag is written record by the Qing court.

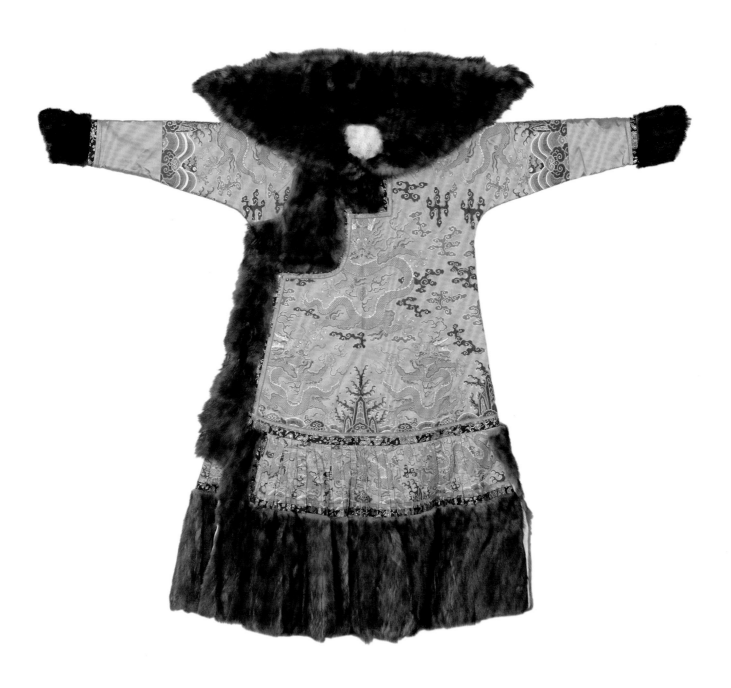

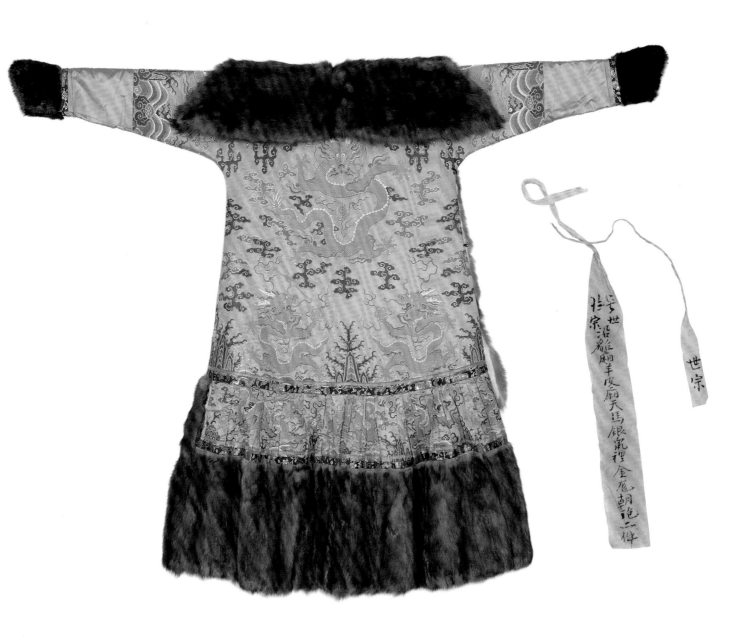

106

Lined Courtly Robe
in Azurite Blue with Patterns of Multi-coloured Clouds and Golden Dragons

Qing Dynasty Yongzheng period

Length of robe 146 cm
Width across both sleeves 193 cm
Width of lower front 172 cm
Collar 100×34 cm
Qing court collection

The courtly robe has an azurite blue surface and a lining made of clear blue damask tabby with patterns of twining chrysanthemum. The collar is lined with golden plain-weave silk, decorated on the back with *zabaowen* (mixed treasures) in a red roundel. There are no *beiyun* pendants on the back. The lapel is made of plain weave with gold threads and decorated with azurite blue clouds, flowers and *zabaowen,* and the border is traced with yarns looped with golden threads. The surface of the robe uses the method of merging two to four colours in gradation to weave the golden dragons, the multi-coloured clouds and the waves lapping on the shore and form the persimmon calyx round the neck and the upper bodice.

The craftsmanship of this robe is exquisite, and the colours are gorgeous but decorous, while the patterns are natural and bold. The robe is a choice piece among brocaded courtly robes made by the Jiangning Textile Bureau during the period of Yongzheng. On the yellow tag is written "*shizong*" for Yongzheng.

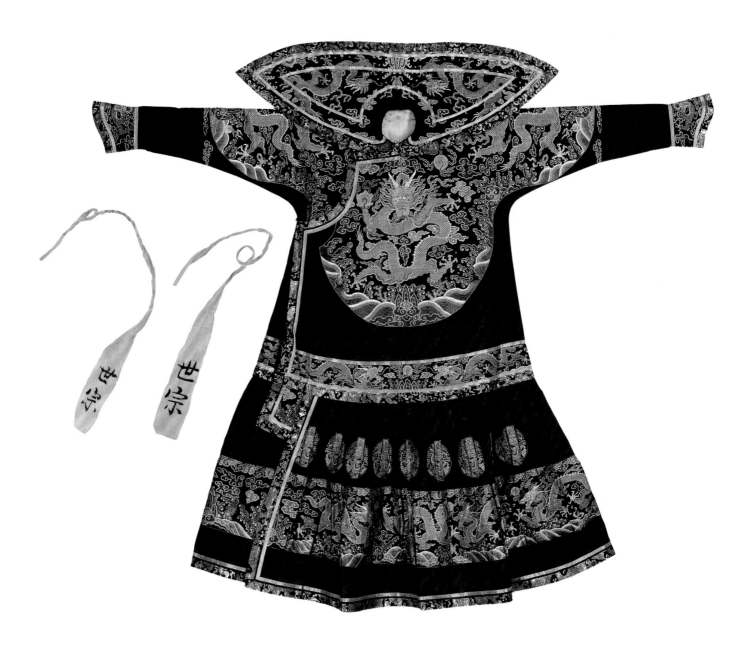

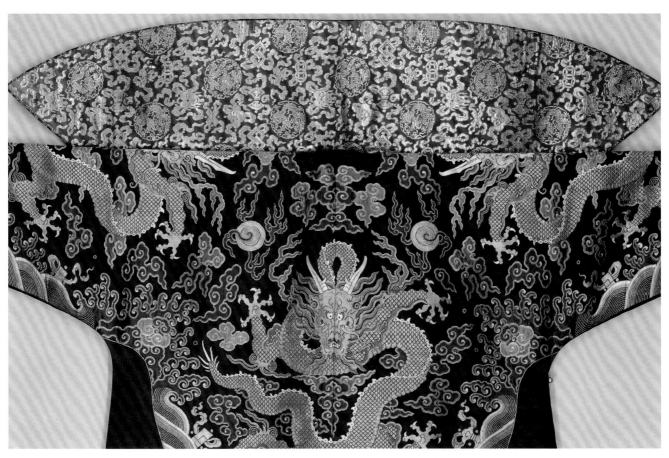

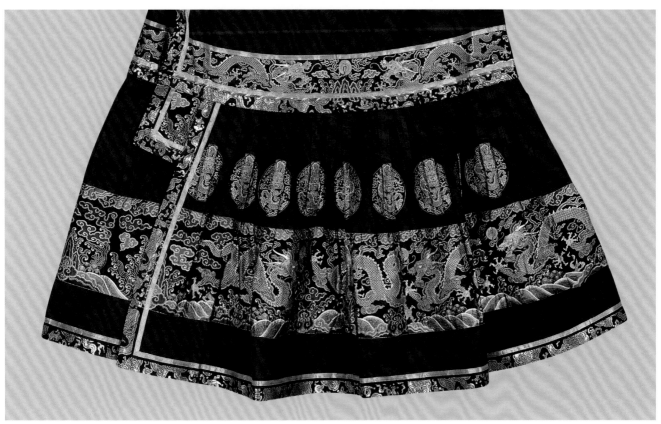

107

Unlined Courtly Robe
in Yellow *Sha*-gauze
Embroidered with
Multi-coloured Clouds and
Golden Dragons

Qing Dynasty Yongzheng period

Length of robe 143 cm
Width across both sleeves 196 cm
Width along the lower hem 139 cm
Collar 105×36 cm
Qing court collection

The courtly robe is in bright yellow and made in gauze woven with straight warps. Both the collar and the sleeves are in azurite blue, on which are figures of twining sprigs outlined with gold. On the persimmon calyx around the upper part of the chest, the back and the sleeves are embroidered a dragon each as well as multi-coloured clouds and lapping waves. Below the waist are five flying dragons and in the folds are nine roundels with dragons on the front and nine on the back. On the skirt are two frontal dragons and four flying ones.

This robe was used by Emperor Yongzheng at major ritual sacrifices during summer. The dragons are embroidered in plain stitches and the clouds in tighter stitches binding warps at intervals (*nasha*). Locking stitches (*lasuozhen*) are used to embroider waves and flames. The design is quietly elegant and the needlework various. Around the waist are embroidered four dragon roundels and on the lapel are landscape patterns unique to Yongzheng courtly robes. On the yellow tag is written record by the Qing Court.

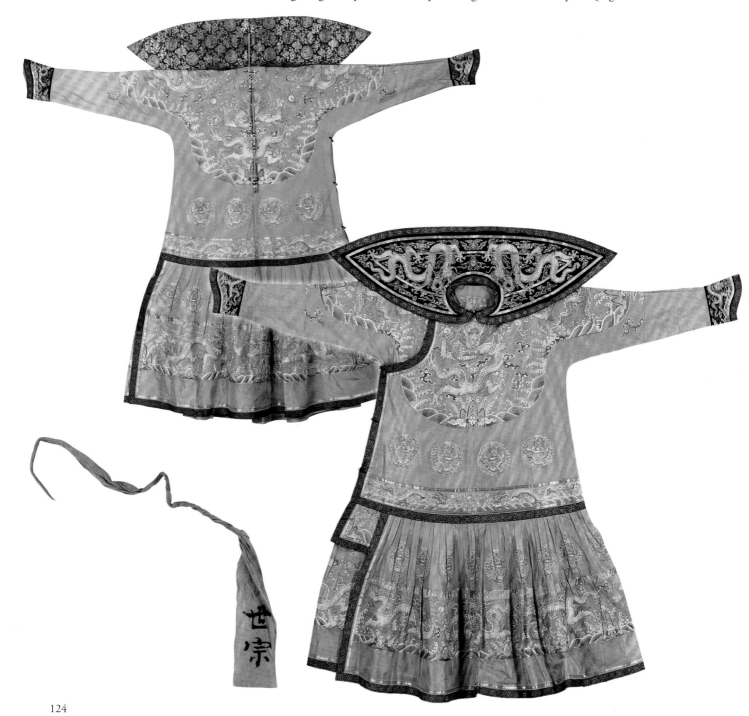

108

Lined Courtly Robe
Made of Pale Blue *Sha*-gauze Woven with Multi-coloured Clouds and Golden Dragons

Qing Dynasty Yongzheng period

Length of robe 144 cm
Width across both sleeves 196 cm
Width along the lower hem 149 cm
Collar 93×32 cm
Qing court collection

The gauze surface of the robe is pale blue and the lining is made of clear blue *shidisha* (gauze with extra twining warps)

to make damask patterns of roundels with dragons and *zabaowen*. The lining for the collar is plain-weave silk with gold threads with red roundels of dragons and *zabaowen*. The neckline and the sleeves are decorated with azure blue square *ruyi* and floral patterns on gold brocaded satin and tricolour golden borders. There are no *beiyun* pendants on the back. The robe's surface uses the method of merging two to four colours in gradation to form the persimmon calyx form in which to weave cloud dragons and lapping waves. The waist and the lower part of the skirt are decorated with flying dragons. The folds are embroidered with dragon roundels.

The special success of this robe may be attributed to the use of gold leaf and the tricolour threads looped with gold for tracing the outlines and the dragons look very much alive. The craftsmanship is exquisite and the colours gorgeous, embodying the characteristics of the art and craft of brocaded gauze produced by the Jiangning Textile Bureau in the reign of Yongzheng. On the yellow tag is written record by the Qing court.

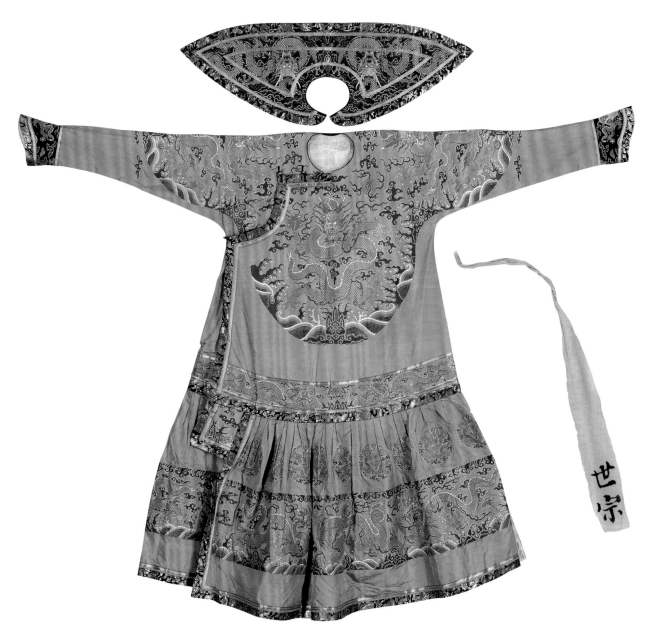

109

Lined Courtly Robe
in Bright Yellow Satin
Embroidered with
Multi-coloured Clouds and
Golden Dragons

Qing Dynasty Qianlong period

Length of robe 144 cm
Width across both sleeves 190 cm
Width along the lower hem 162 cm
Collar 100×34 cm
Qing court collection

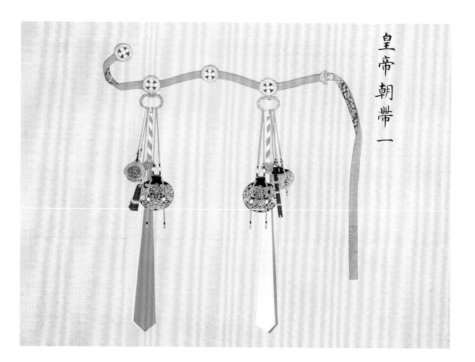

The courtly robe has a round neckline, and the broad front closes on the right. The sleeves have horse-hoof cuffs, and a collar is attached. There are two bright yellow silk ribbons with *beiyun* pendants hanging behind. From the waist down are folds for the skirt. The satin surface is bright yellow, while the collar and the sleeves are azure blue and traced on the edges with threads wrapped in gilt paper. The lining for the sleeves' end is snow weasel fur with upright hair. The front and back of the robe and the shoulders are decorated each with a frontal dragon, and the waist with five flying dragons. The lapel bears also a frontal dragon, while the folds have nine dragon roundels on both the front and the back. The skirt has two frontal dragons and four flying ones. The collar has two flying dragons and the sleeves' ends a frontal dragon each. In between are five-coloured clouds and a parade of the twelve imperial emblems, and the lower skirt has the eight treasures calming the waters. The outlines of all the patterns are traced with yarns wound with gold threads.

Worn by Emperor Qianlong as the ceremonial garment at morning audiences or other major ceremonies, this robe shows the standard fashion of courtly robe for Qing emperors. The fine hair that shows outside the edges of the fur garments of the Qing Dynasty is called *chufeng* (out of the peak or sticking out). On the yellow tag is written record by the Qing court.

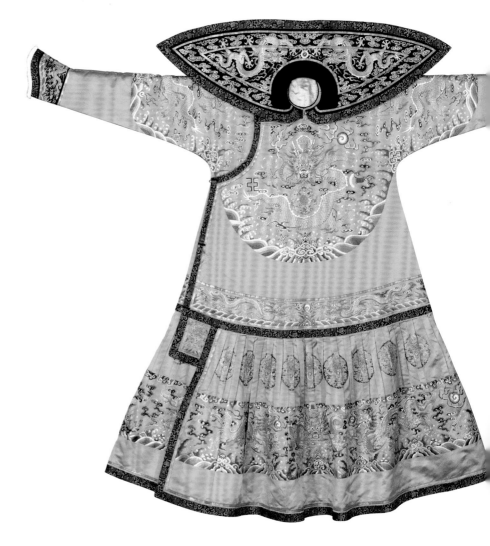

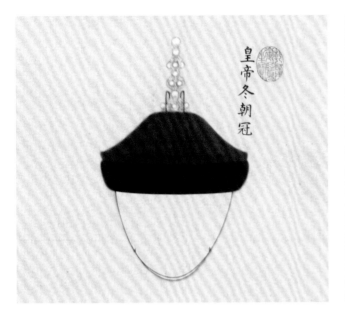

皇帝冬朝冠

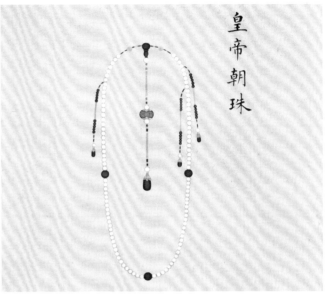

皇帝朝珠

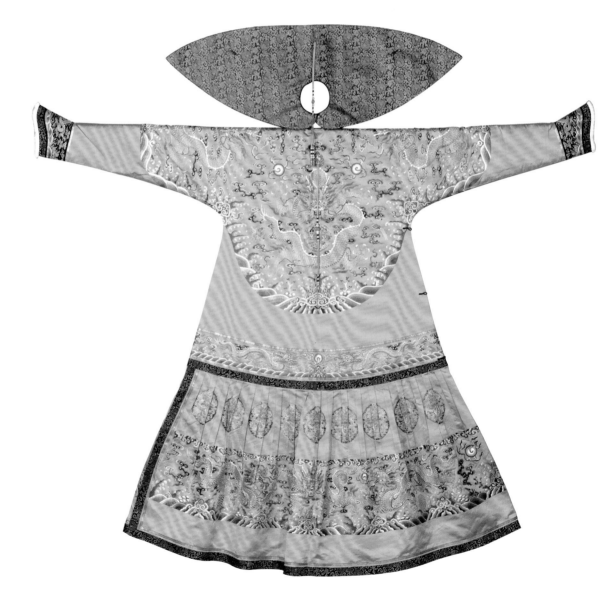

110

Unlined Courtly Robe
in Blue *Kesi* with Patterns of
Multi-coloured Clouds and
Golden Dragons

Qing Dynasty Qianlong period

Length of robe 144 cm
Width across both sleeves 194 cm
Width along the lower hem 160 cm
Collar 100×34 cm
Qing court collection

This court has a round neckline and the broad front closes on the right. The sleeves end in horse-hoof cuffs. There is a collar attached and two bright yellow silk ribbons hang from the back. Below the waist are folds gathered. The surface is woven in blue *kesi* (cut silk). The collar and the sleeves are both azure blue and the edges are traced with gold threads. On the body of the robe are woven in *kesi* patterns of gold dragons with threads looped with gold and silver threads. Auspicious clouds calming the waters are woven with multi-coloured silk threads in red, green, blue, light purple and light brown. The twelve imperial emblems are shown here and there among the clouds.

This robe was worn by Emperor Qianlong at major sacrificial ceremonies and it represents one of the standard fashions of courtly robes for Qing emperors. On the yellow tag is written record by the Qing court.

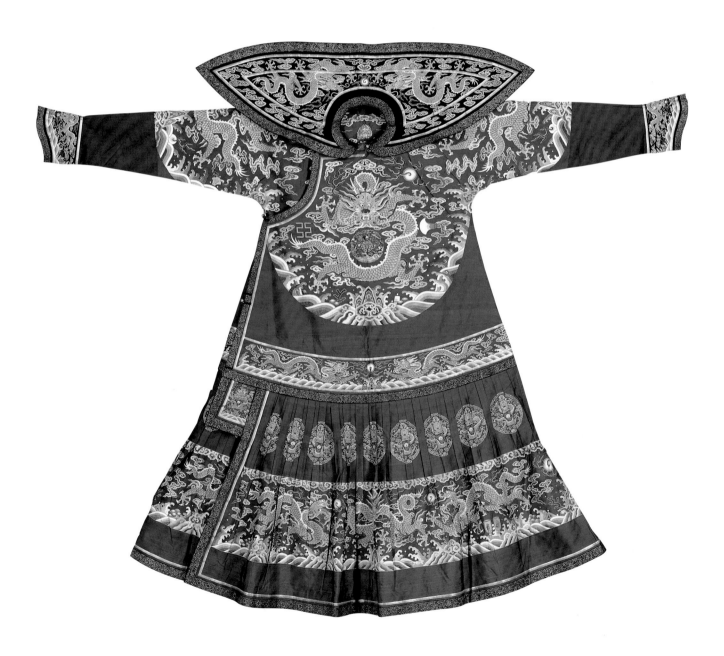

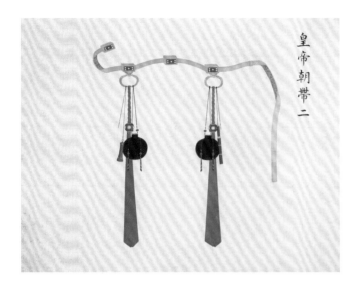

皇帝朝帶二

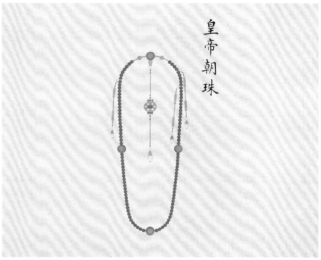

皇帝朝珠

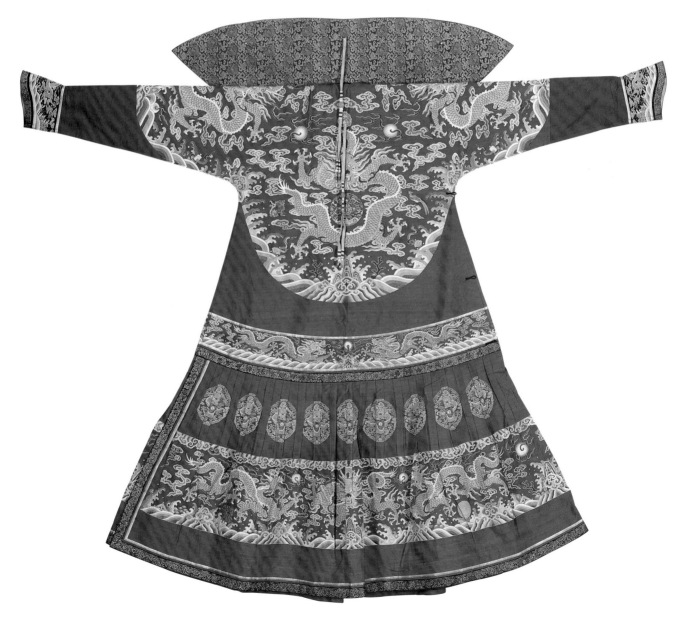

111

Unlined Courtly Robe
in Pale Blue *Kesi* with Patterns of Multi-coloured Clouds and Golden Dragon

Qing Dynasty Qianlong period

Length of robe 148 cm
Width across both sleeves 190 cm
Width along the lower hem 146 cm
Collar 100×33 cm
Qing court collection

This courtly robe has a round neckline and the broad front closes on the right. The sleeves end in horse-hoof cuffs. There is a collar attached and two bright yellow silk ribbons with clouds in red coral *beiyun* pendants hang from the back. Below the waist are folds gathered. The ground of the fabric is woven in pale blue *kesi* (cut silk). The collar and the sleeves are both azure blue and the edges are traced with gold threads. The shoulders and both the front and the back of the robe are decorated with a gold frontal dragon each. Below the waist are five flying dragons and on the lapel one frontal dragon. In the folds are nine dragon roundels on both the front and the back. The skirt is also decorated both in front and behind with a frontal dragon and two flying dragons. Each of the ends of the sleeves bear a frontal dragon, while the collar bears two flying ones. The twelve imperial emblems are shown here and there all over the body of the robe.

This robe was worn by Emperor Qianlong at the Autumn Equinox sacrificial ceremony, and it represents one of the standard fashions of courtly robes for Qing emperors. On the yellow tag is written record by the Qing court.

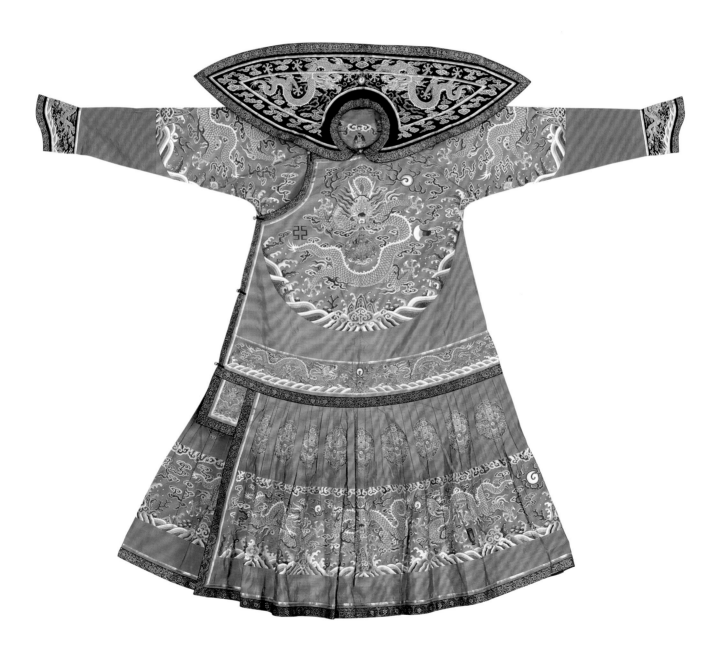

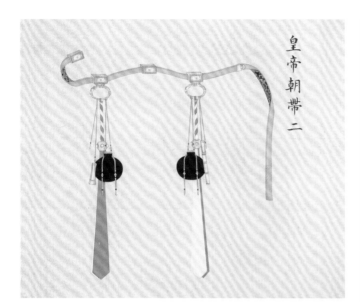

皇帝朝带二

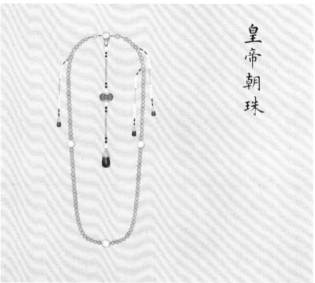

皇帝朝珠

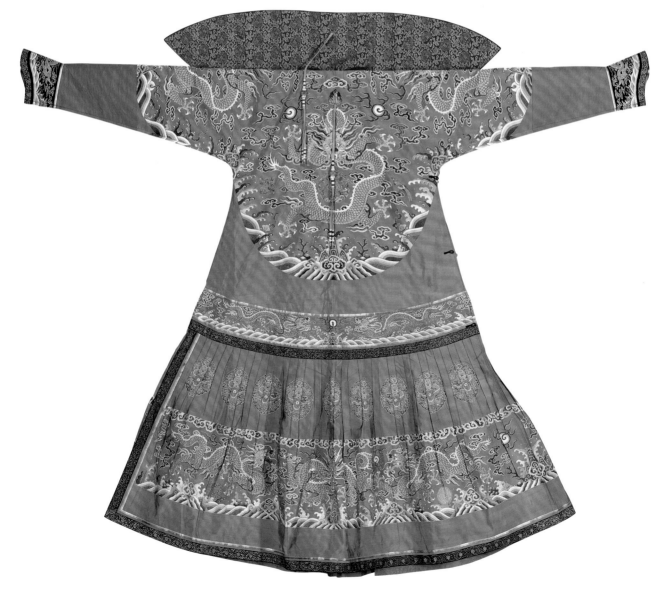

112

Lined Courtly Robe
in Golden Yellow Satin
Woven with Patterns of
Multi-coloured Clouds and
Golden Dragons

Qing Dynasty　Qianlong period

Length of robe　135 cm
Width across both sleeves　182 cm
Width along the lower hem　124 cm
Collar　93×35 cm
Qing court collection

This courtly robe has a golden yellow satin surface and borders in azure blue traced with golden satin on the edges. The lining is made of pale blue plain-weave silk. The collar and the ends of sleeves are brocaded satin with azurite golden dragons. The sleeves' folds are in golden yellow plain satin. Inside the persimmon calyx of the robe body are woven four golden frontal dragons, decorated with multi-coloured clouds and lapping waves. Around the waist are four flying dragons and eight flying ones are on the lower part of the skirt, decorated in between with multi-coloured cloud patterns and the eight treasures calming waters.

This robe was worn by imperial princes and other princes receiving gifts from the emperor as well as second-rank aristocrats, and it is very rare among holdings of the Qing court collection. On the yellow tag is written record by the Qing court.

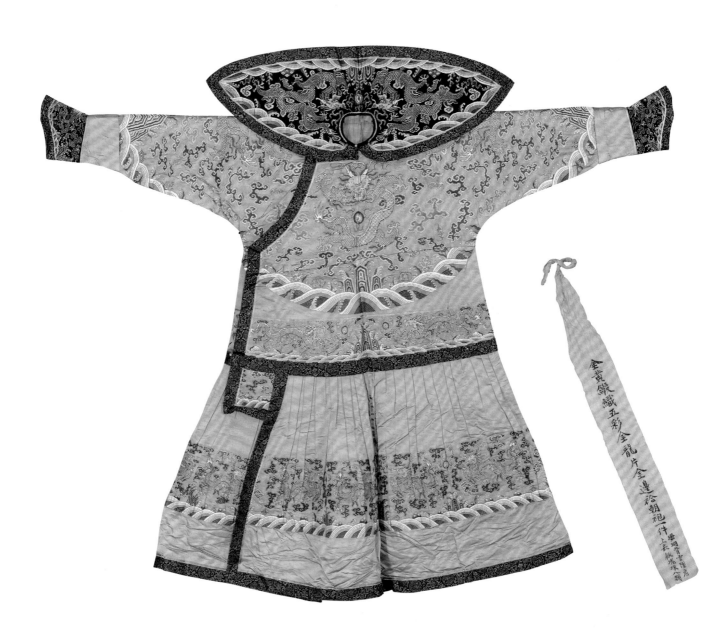

113

Lined Courtly Robe
in Azurite Blue Satin Embroidered with Multi-coloured Clouds and Golden Dragons

Qing Dynasty Xianfeng period

Length of robe 145 cm
Width across both sleeves 200 cm
Width along the lower hem 142 cm
Qing court collection

The robe has an azure blue satin surface, and the edges are bordered with azure blue satin woven with golden threads. The lining is made of pale blue plain weave with veiled patterns. There is neither any collar nor any *beiyun* (pendants hanging on the back). A frontal dragon is embroidered with golden threads on either shoulder as well as on the front and the back. Around the waist are four flying dragons, and one on the lapel. The skirt has eight flying dragons and one at the sleeves' end. Here and there are patterns of cloud-bats, flowers and sea water embroidered in multi-coloured silk threads.

This robe was a ceremonial garment for Qing royal princes and second-rank aristocrats at major ceremonies during spring and autumn. The needlework is rich in variation and the embroidery exquisite, but the embroidery threads are relatively thick and the gilt threads have a low lustre. The craft is somewhat inferior to that of the previous dynasty's. On the yellow tag is written record by the Qing court.

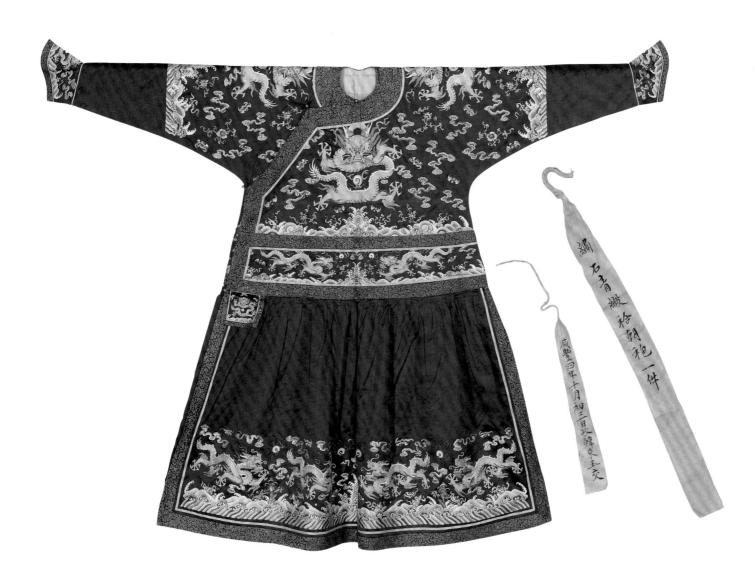

114

Courtly Robe
in Bright Yellow *Sha*-gauze
with Embroidered Patterns of
Multi-coloured Clouds and
Golden Dragons

Late-Qing period

Length of robe 79 cm
Width across both sleeves 114 cm
Width along the lower hem 96 cm
Collar 56×25 cm
Qing court collection

The robe has a surface of bright yellow *sha*-gauze with straight warps. The edges are sewn with azure blue *shidisha* (gauze with extra twining warps) and silk threads twining with silver threads. Both the collar and the horse-hoof cuffs are azurite blue and there are no long ribbons with tassels (*beiyun*) hanging down the back. The body of the robe is embroidered with golden dragons, a frontal one on the front and the back and on either shoulder. Around the waist are four flying dragons and nine dragon roundels in the folds in front and behind. On the lower part of the skirt are six flying dragons and one on the lapel. The collar bears two flying dragons and one on each of the horse-hoof cuffs. In between are figures of the twelve imperial emblems, five-coloured clouds and the water calming patterns of the eight treasures (*babao pingshui wen*).

The three late-Qing emperors—Tongzhi, Guangxu and Xuantong—all came to their throne at a tender age. This robe was worn by them at childhood as a ceremonial garment. Although the size is small, the decorative patterns and the coded form agree with the institutionalized standards. The dragon figures are embroidered in gold threads, and silver threads and outlines are used as decoration to create three-dimensionality. Auspicious clouds and calm water are expressed in various colours merging in groups of three or four or seven. The needlework alternates between strings of slanting stitches and a string of perpendicular stitches. The twelve emblems are embroidered fully, using loop stitches, punching stitches, slanting twining stitches and so on.

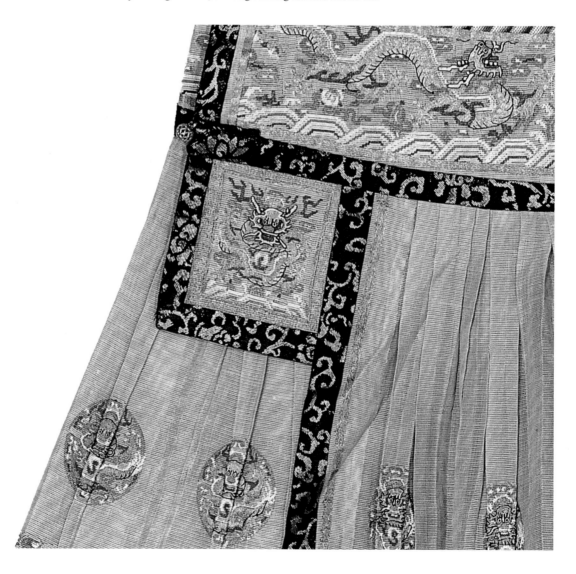

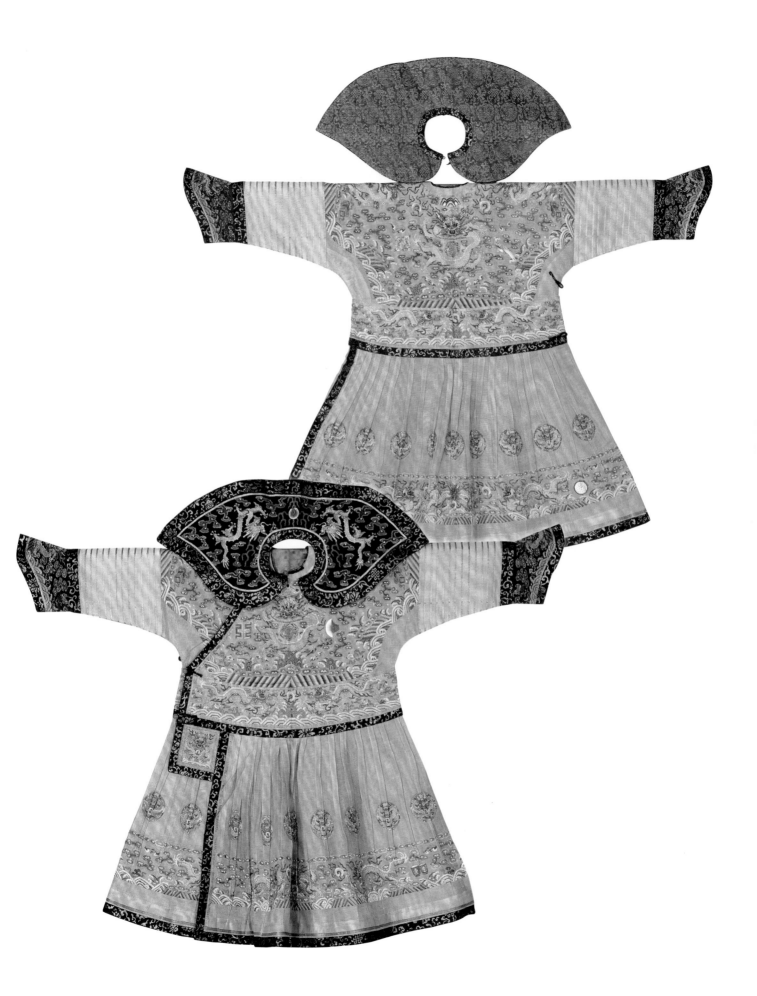

115

Fur Jacket
in Azure Blue Satin Decorated with Four Roundels of Clouds and Dragons Sewn with Small Pearls

Qing Dynasty Kangxi period

Length of robe 109 cm
Width across both sleeves 146 cm
Width along the lower hem 118 cm
Qing court collection

The fur jacket or coat (*gua*) has a round neckline and the front opens in the middle. The sleeves have level ends and reach the elbow. There are slits on both sides, in front and on the back. The face material is azure blue satin, while there is lining with snow weasel fur. On the chest and the back as well as both shoulders are four roundels with decorative patterns of clouds and dragons made out with pearls, corals and agates sewn on. The outline is traced with yarns in white and moon-white threads spiralling up called *longbaozhuxian* (dragon-embracing-pillar threads).

The design of this robe is decorous. The pearls are round and even and the stringing is tight. The dragon roundels have a diameter of 29 cm. The use of small pearls and corals combined on the backdrop of azure blue satin has made the patterns brighter and clearer.

The royal coat or jacket (*gunfu*) was the garment worn on top of the emperor's courtly robe. The outer jacket to match the imperial prince's courtly robe, however, was not to be called royal coat but dragon jacket or coat (*longgua*). The jacket or coat worn on top of their courtly robes by other princes and all the nine ranks of civil or military officials were called *bufu* (garments with insignia squares) or *bugua* (jackets with insignia squares). The jacket has a yellow tag from Qing court.

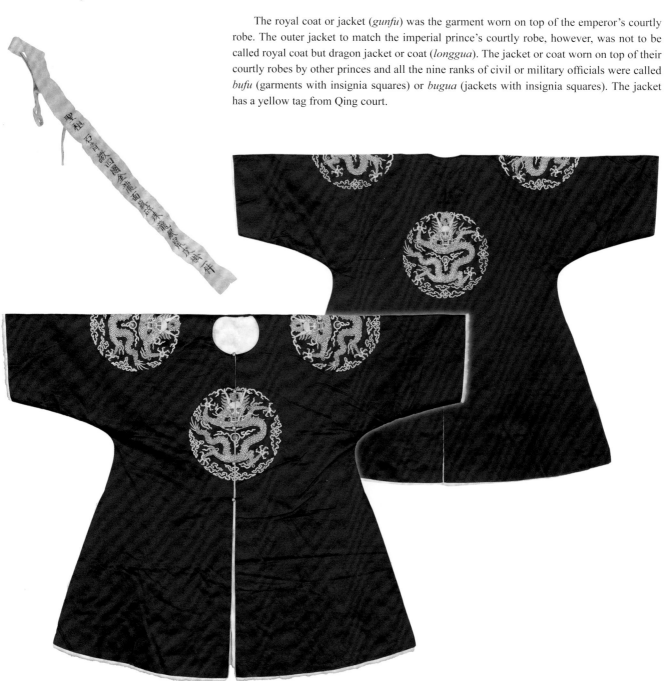

116

Lined Jacket in Azure Blue Satin Woven with Longevity Pattern and Roundels with Two Golden Dragons Playing with Pearls

Qing Dynasty Kangxi period

Length of jacket 115 cm
Width across both sleeves 150 cm
Width along the lower hem 118 cm
Qing court collection

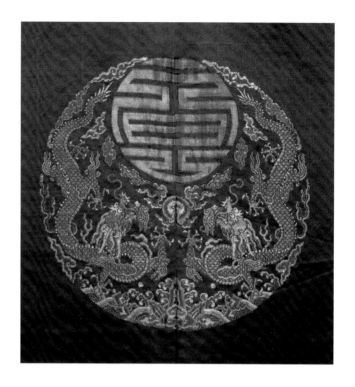

The face of the jacket is in azure blue satin, and the lining is made of pale blue silk tabby with veiled patterns of the character for 卍 and patterns of meandering water. On the chest and the back as well as the shoulders are four roundels enclosing brocaded golden dragons holding up the word longevity. The two dragons play with a pearl and on their heads are roundels of longevity woven in golden threads. On the lower part of the jacket are patterns of waves lapping on the shore.

The design of this jacket is free and comfortable. The nuances are lucid and the colours merge in three hues naturally and elegantly. The jacket has a yellow tag from Qing court.

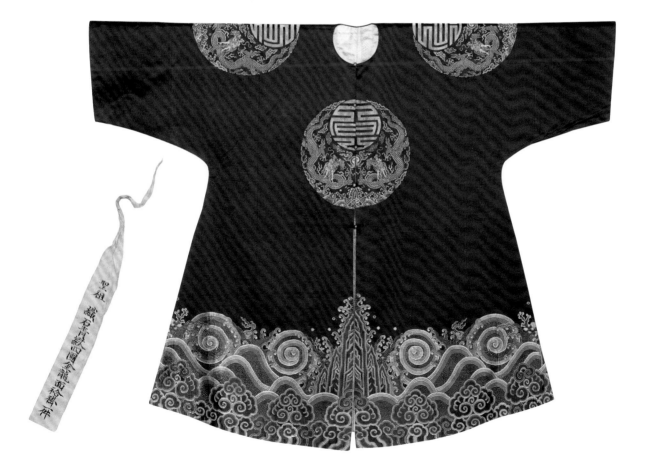

117

Padded Jacket
in Azure Blue Satin Face
Embroidered with Four
Roundels Enclosing Golden
Dragons

Qing Dynasty　Qianlong period

Length of jacket 113 cm
Width across both sleeves 147 cm
Width along the lower hem 116 cm
Qing court collection

The jacket has a surface made of azure blue satin and the lining in pale blue tabby with veiled patterns of twining sprigs. The padding inside is a thin layer of silk floss. On the shoulders as well as the chest and the back are altogether four roundels embroidered with five-clawed frontal dragons.

The jacket is woven in twisted gold threads and the floss is finely split. The needlework involves various stitches and the craftsmanship is neat; the colours are rich and merging naturally. The jacket has a yellow tag from Qing court.

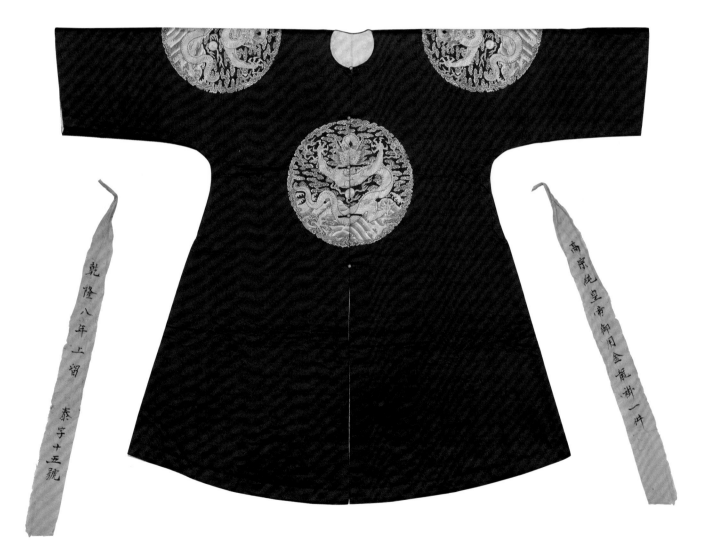

118

Unlined Jacket
in Azure Blue *Nasha*
Embroidered with Patterns of
Four Roundels Enclosing
Golden Dragons

Qing Dynasty Qianlong period

Length of jacket 116 cm
Width across both sleeves 148 cm
Width along the lower hem 115 cm
Qing court collection

On the azure blue *sha*-gauze ground weave of this unlined jacket are embroidered four roundels with golden dragons. There is also one such each on either shoulder, the chest and the back. The golden dragons on the shoulders hold up the sun and the moon from the twelve imperial emblems, while those on the chest and the back hold each a golden character for "longevity." The golden dragons are embroidered with the method called *pingjin*, which lets the gold thread coil flat on the surface to cover the figures intended. Around these are twining lotus sprigs, calm waters and *ruyi* clouds embroidered by the method of *nasha* (close tight stitches) with multi-coloured silk threads in pink, blue, green and light brown. The sun and the moon are embroidered by the method using full close stitches (*manna*) supplemented with running stitches to trace the outlines.

This royal garment follows the stringent standards of the Qianlong period in regard of both the dress code and the decorative patterns. The jacket has a yellow tag from Qing court.

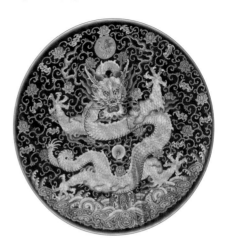

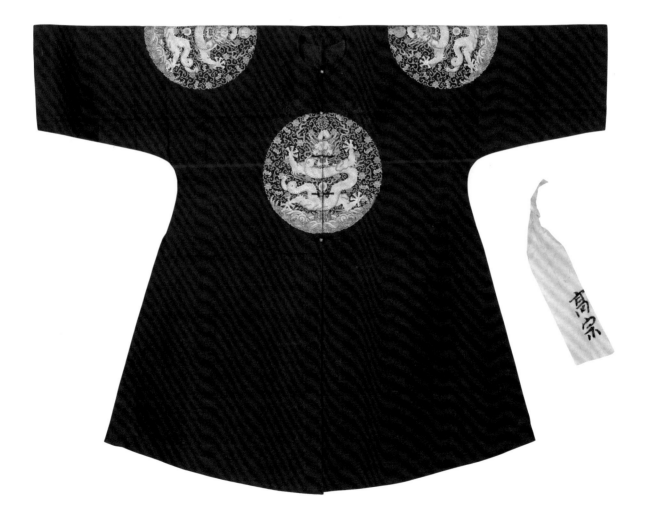

119

Decorous Cover
in Black Fox Fur Lined with
Yellow Plain-weave Silk Cloth
from Jiangning with Veiled
Pattern of Dragons
in Roundels

Qing Dynasty

Length of cover 120 cm
Width across both sleeves 164 cm
Width along the lower hem 112 cm
Qing court collection

The cover has a round neckline, front open in the middle, sleeves with level ends and slits on either side and the back. The neckline is sewn round with a border in azure blue plain satin. A bright yellow silk ribbon hangs from the back. Down the two slits on the sides hang two bright yellow plain silk braids each.

Decorous covers (*duanzhao*) are ceremonial garments worn outdoors on top of courtly robes by Qing emperors during winter. This *duanzhao* is made of black fox fur. The colour is pure and the hair straws soft. It is an excellent garment against cold.

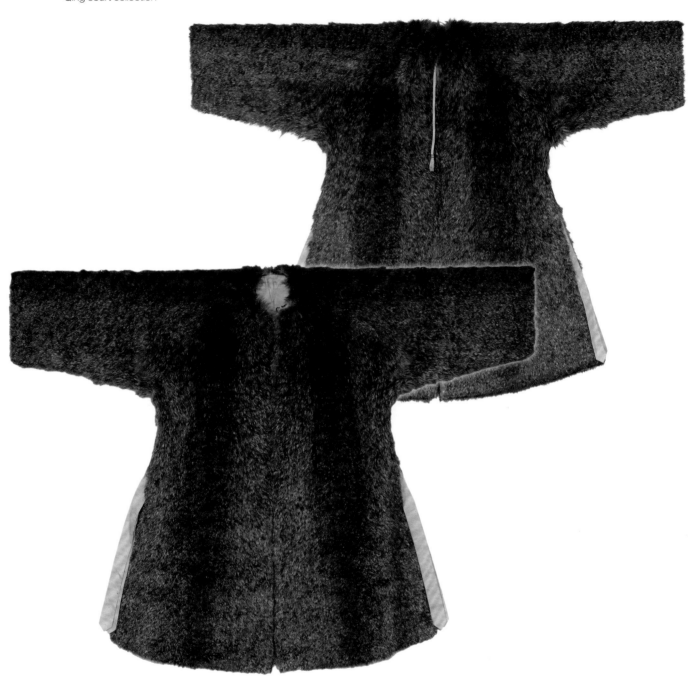

120

Unlined Dragon Robe
in Light Brown Gauze
with Patterns of Eight
Roundels Enclosing Golden
Dragons Embroidered in the
Pingjin Stitch

Qing Dynasty Kangxi period

Length of robe 150 cm
Width across both sleeves 192 cm
Width along the lower hem 146 cm
Qing court collection

This dragon robe has a round neckline, a broad front closing on the right, sleeves with level ends and four slits. The surface is in light brown gauze with veiled patterns of square *ruyi* clouds and dragons. Behind the eight roundel patterns are supplementary light brown gauze with straight warps. Matching the sleeves are pale blue *shidisha*-gauze with veiled patterns of clouds and dragons, and the edges of the neckline and the sleeves' end are bordered with azure blue duo-coloured cloud-and-dragon patterns. On the outer edges are plain azure blue silk ribbons woven in herringbone pattern.

The robe is decorated with sets of one to four twisted gold and silver threads embroidering eight cloud-and-dragon roundels in flat gold-thread coils (*pingjin*). Frontal dragons are embroidered on the front, the back and the shoulders. On the lower part of the lapel are flying dragons. The composition is succinct; the density of the gold threads are in proper order; and the lines are fluent and fine, attaining the effect of Chinese traditional painting with its sketch technique. On the yellow tag is written record by the Qing court.

Jifu (semiformal robe) was donned at courtly festivities such as the birthday of the emperor (*Wanshoujie*), birthdays of imperial concubines (*Qianqiujie*), Mid-Autumn Festival, Fifteenth Day of the Lunar New Year or Lantern Festival (*Yuanxiao*) and Seventh Day of the Seventh Month of the lunar calendar (*Qixijie*), and sometimes at minor sacrifices.

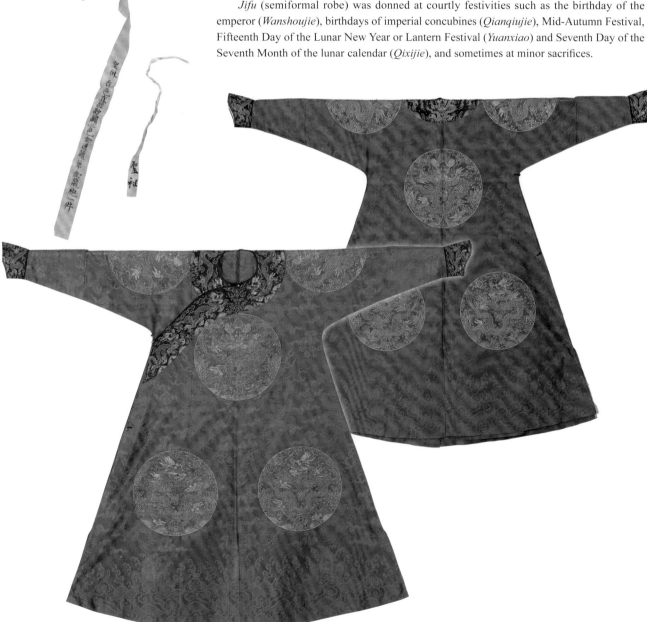

121

Dragon Robe
in Bright Yellow Satin Embroidered with Patterns of Colourful Clouds and Golden Dragons and Lined with Fur

Qing Dynasty Yongzheng period

Length of robe 142 cm
Width across both sleeves 194 cm
Width along the lower hem 130 cm
Qing court collection

This dragon robe has a round neckline, broad front closing on the right, horse-hoof cuffs and four slits. The surface is in bright yellow satin, and the lining is done with white fox fur, while the sleeves' ends are bordered with purple mink. The method of merging two to four colours in gradation is used to embroider colourful clouds, golden dragons and the seven imperial emblems including the sun, the moon, the stars, the two *fu* emblems (a black and blue pattern and a black and white pattern), the pheasant (*huachong*) and the wine vessel (*zongyi*). Some parts are done in light colours merging.

The needlework of this robe involves ten different stitches such as the close stitch, the flat coil stitch, the twining stitch, the loop and the padded stitch. The craftsmanship is exquisite, the composition strict and precise, and the colours harmonious. On the yellow tag is written record by the Qing court.

The Qing code of rites ruled that semiformal robes for the emperor, the empress mother, the empress and the imperial concubines were to be called "dragon robes." Robes for all others at court including princes were to be called only "*mang*-dragon robe." The two are different in coded forms, colours and patterns. The dragon for "dragon robes" has always five claws, while *mang*-dragons may have sometimes four and sometimes five claws.

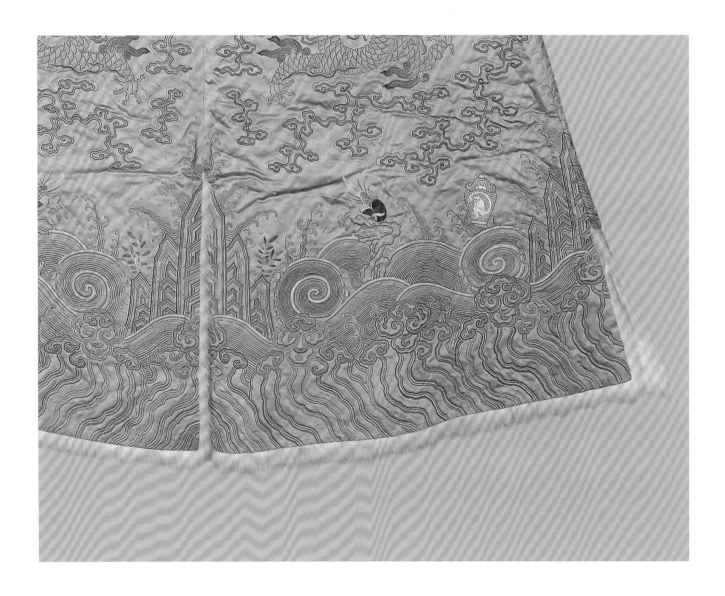

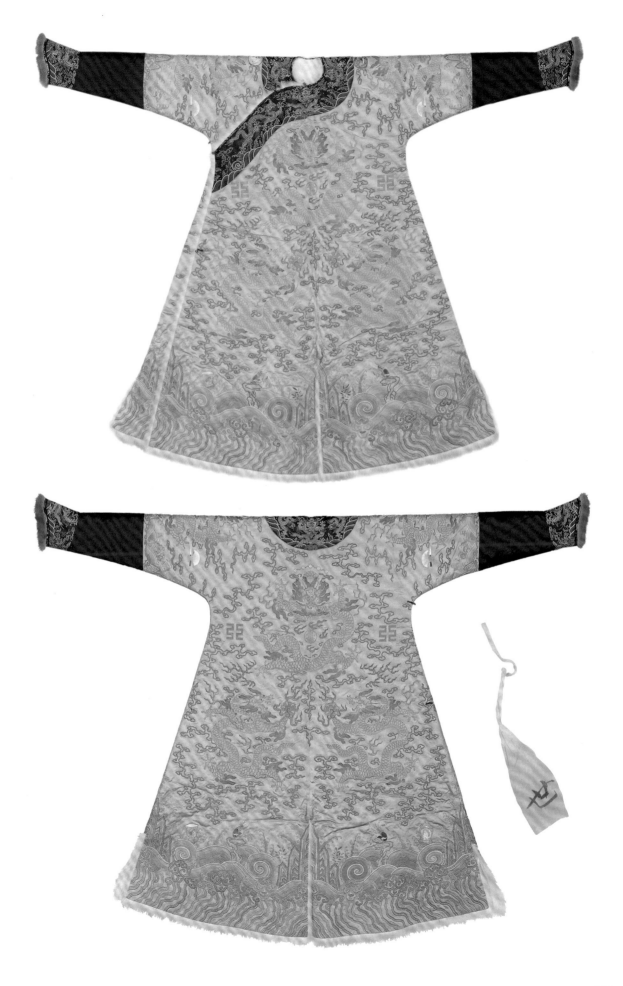

122

Lined Dragon Robe
in Yellow Gauze with Colourful Clouds and Golden Dragons

Early-Qing period

Length of robe 112 cm
Width across both sleeves 136 cm
Width along the lower hem 100 cm
Qing court collection

This dragon robe is cut in yellow gauze surface brocaded with colourful clouds and golden dragons. The lining is made of yellow straight-warp gauze with veiled patterns of the eight treasures. The edges of the cuffs and the collar are bordered with golden satin. There is a frontal dragon on the chest, the back and the shoulders. Two flying dragons are embroidered on the lower lapel and a frontal dragon decorates its lining. On each of the edge of the sleeves is a flying dragon and five on the collar's edge. Along the lower front are patterns of waves lapping the shore, and all over the robe are flowing clouds in many colours.

The gold used for this robe is full of lustre and the craftsmanship exquisite. It is a representative form of dragon robe from the Qing period.

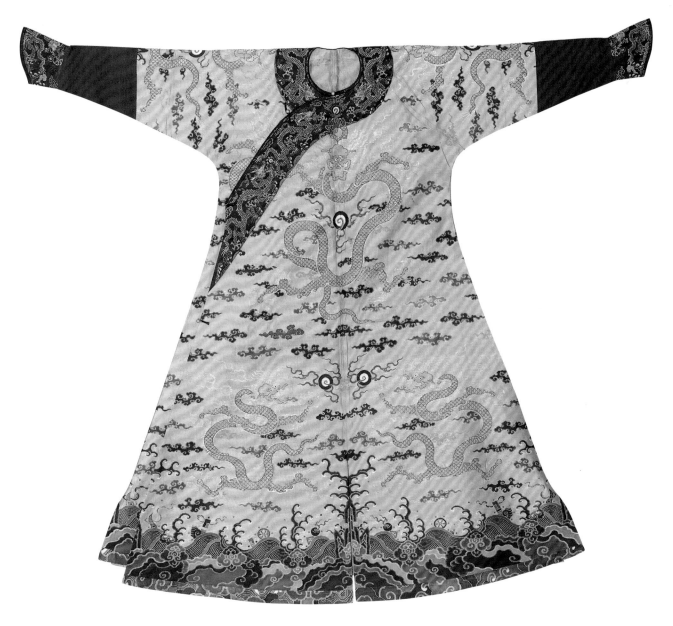

123

Fur Dragon Robe
in Bright Yellow Satin
Embroidered with Colourful
Clouds and Golden Dragons

Early-Qing period

Length of robe 143 cm
Width across both sleeves 198 cm
Width along the lower hem 126 cm
Qing court collection

This dragon robe has an upright collar and bright yellow satin face. The lining is made up of small irregular patches of snow weasel fur sewn together with hair straws sticking out. The sleeves and the collar are lined with mink. The shoulders as well as the chest and the back bear each a frontal dragon, the lower part of the lapel four flying dragons and the inner lapel one flying dragon, making altogether nine, five of which are visible from the front. This implies the dignity of the emperor according to Chinese numerology in the phrase "dignity of nine and five" (*jiuwuzhizun*), being respectively the ultimate and the middle of single digits. In between are decorations of cloud-bats and the character for "longevity." On the lower part of the robe are embroidered patterns of waves lapping on the shore and the *ruyi* clouds.

The embroidery on this robe is made with yarns wrapped in gold threads and the horns, claws and tail of the dragons are decorated with close white stitches and the outline is traced with black threads to make the relief effect. The needlework is mainly in open loop stitches and sometimes in close stitches, *pingjin* stitches and *shimaozhen* (sparse stitches in rows). The craftsmanship is exquisite and the colours merge naturally.

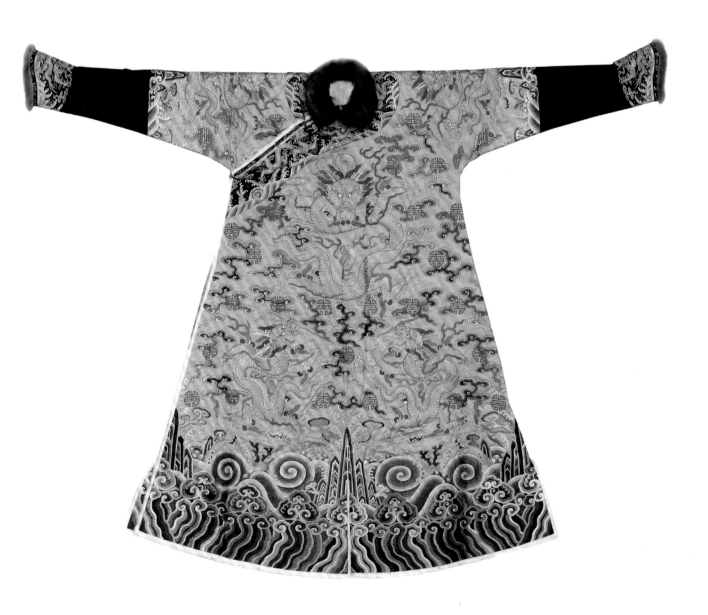

124

Fur Dragon Robe
in Yellowish Green *Kesi* with
Patterns of Colourful Clouds
and Golden Dragons

Qing Dynasty Qianlong period

Length of robe 148 cm
Width across both sleeves 196 cm
Width along the lower hem 124 cm
Qing court collection

This dragon robe has a round neckline. Both the collar and the sleeves are in azure blue with edges bordered with thread wrapped in gilt paper. The lining is made of fox hide and mink hair straws stick out from the cuffs. On the face of the yellowish green *kesi* (cut silk) are nine golden dragons woven in yarns wrapped in gold threads. There is a frontal dragon on either shoulder both in front and behind. Where the lapels meet there is a flying dragon on either side, and at the end of each sleeve is a frontal dragon. Flowing clouds in lighter colours are woven in *kesi* with white threads. Patterns of waters from the eight treasures are woven with threads in the four colours blue, green, purple and yellow combined with gold threads. All over the robe are seen rows of the twelve emblems and in between are cloud-bats in five colours and the elongated or round character for "longevity."

This robe was made specially for Emperor Qianlong. The institution of the parade of the twelve emblems was initiated also during the reign of Qianlong. The "twelve emblems" originated from *Shangshu: Yiji*. These emblems denote patterns of the sun, the moon, the stars, mountains, the dragon, the pheasant, algae, fire, rice, the wine vessel and the two *fu* s, representing the twelve talents and virtues of the monarch. On the yellow tag is written: "*Gaozong.*"

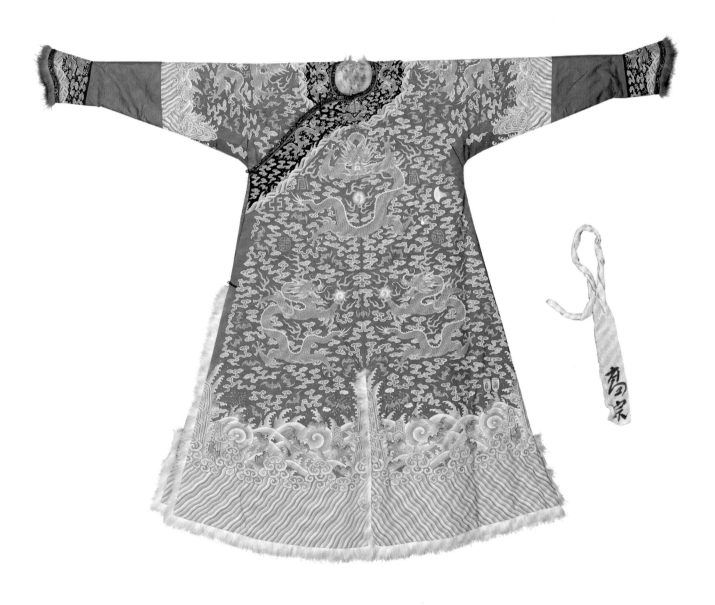

125

Lined Dragon Robe
in Pale Blue *Kesi* with Patterns
of Colourful Clouds and Blue
Dragons

Qing Dynasty Qianlong period

Length of robe 147 cm
Width across both sleeves 149 cm
Width along the lower hem 128 cm
Qing court collection

This dragon robe has an upright collar and blue plain-weave silk for the turned-out cuffs. The edges of the collar and the sleeves' end are sewn with threads wrapped in gilt paper. The *kesi* (cut silk) face is pale blue, on which are woven nine blue dragons and the twelve imperial emblems. In between are characters for "longevity" and patterns of cloud-bats. The lower part is decorated with waves lapping the shore.

This is a semiformal robe worn by Emperor Qianlong in summer. The colour combination is light and elegant. The *kesi* craftsmanship is adept and refined. Apart from the usual plain *kesi* and dovetailing methods, the phoenix-tail propping is used for weaving sprays and the straggling propping for ripples. With the shuttles joining, the gaps are minimized so that the patterns will be more even and practical. On the yellow tag is written record by the Qing court.

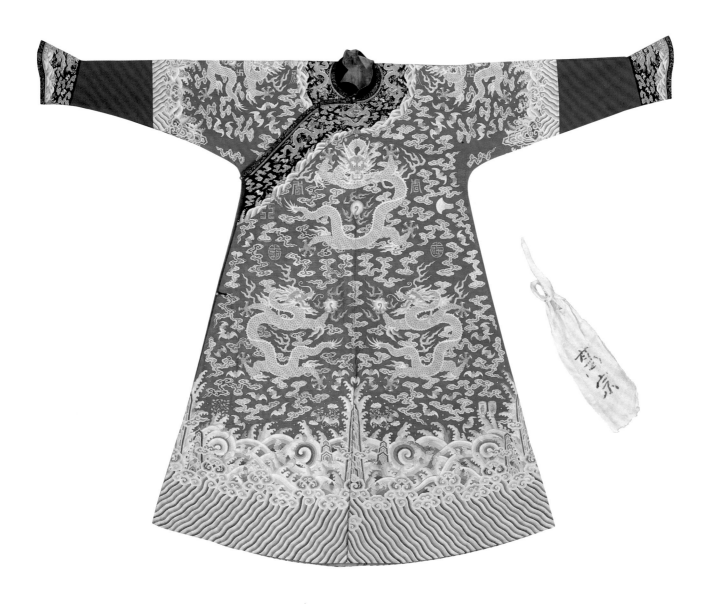

126

Unlined Dragon Robe
in Yellow Gauze with *Shuang-mianxiu* and Colourful Clouds and Golden Dragons

Qing Dynasty Qianlong period

Length of robe 140 cm
Width across both sleeves 190 cm
Width along the lower hem 126 cm
Qing court collection

The face of this dragon robe is made of yellow *zhimasha* (sesame gauze). The *jiexiu* that links the sleeves with the bodice is in bright yellow; along the edges of the collar and the lapel as well as the sleeves' end are patterns of azure blue cloud-bats and golden dragons sewn with threads wrapped in gilt paper. The robe is decorated by the method of double-face embroidery (*shuangmianxiu*) with a frontal dragon on each of the shoulders and on the chest and the back. There are four flying dragons on the lower lapel and one flying dragon on the lapel of the lining. The frontal dragons on the chest and the back are surrounded by groups of cloud-bats. Inside are two dancing phoenixes holding ribbons and mixed treasures between their beaks. On the lower part are longevity stones, *lingzhi*-fungus and algae, implying "longevity presented by a pair of phoenixes" (*shuang luan xian shou*) and "happiness and longevity as wished." (*fu shou ru yi*) On the lower part are patterns of the eight treasures and waves (*babao lishui*). All over are decorations of flowing clouds and flying bats.

This robe was exclusively donned by Emperor Qianlong. On the yellow tag is written record by the Qing court.

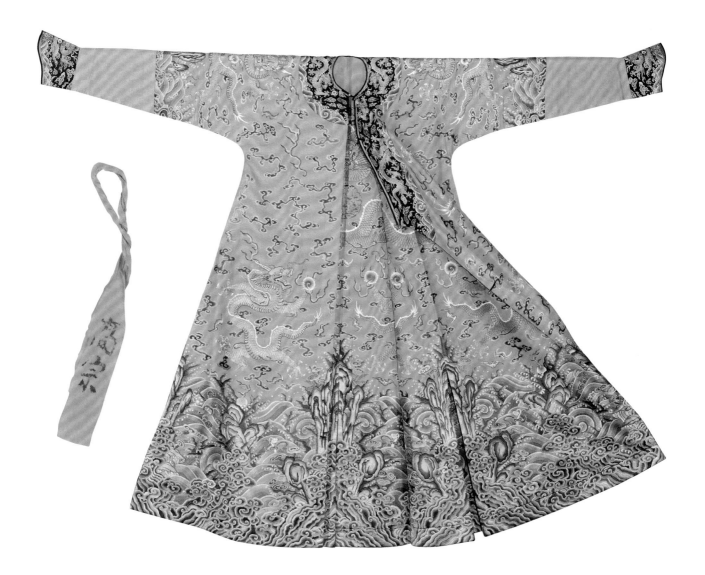

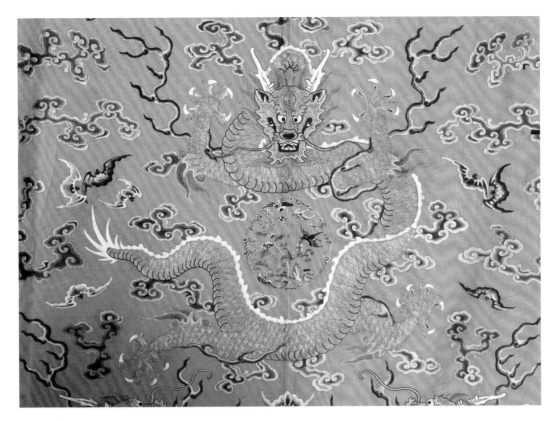

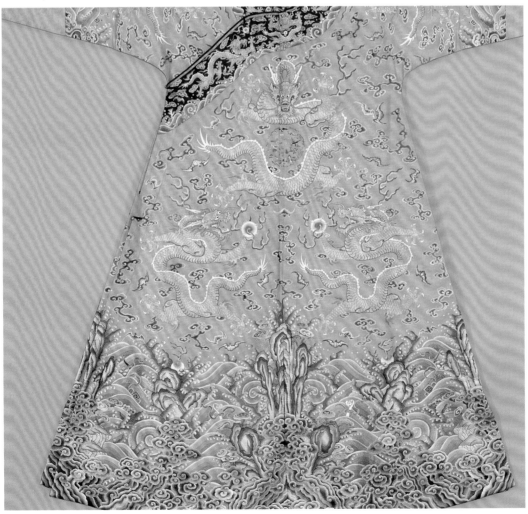

127

Lined Dragon Robe
in Blue Jiangning *Chou* with Twining Chrysanthemum Woven in Gold and Silver Threads

Mid-Qing period

Length of robe 145 cm
Width across both sleeves 190 cm
Width along the lower hem 130 cm
Qing court collection

This dragon robe has a blue Jiangning plain-weave silk (*chou*) face; the lining is made of clear blue silk tabby (*ling*) with veiled patterns of twining chrysanthemum. The edges of the collar and the sleeves' end are bordered with azure blue Jiangning plain-weave silk sewn with threads wrapped in gilt paper. The body of the robe is decorated with the methods of alternating between gold and silver threads in coiling stitches and sewing on shells and mother of pearl to embroider patterns of golden and silver dragons and twining chrysanthemum sprigs.

The twisted gold threads in this robe are even and fine. The craft of making coils of gold threads is very neat, making the patterns clear and pretty. The appropriate combination of gold and silver threads with shells and mother of pearl attains the effect of bringing everything to life like dotting the painted dragon's eyes.

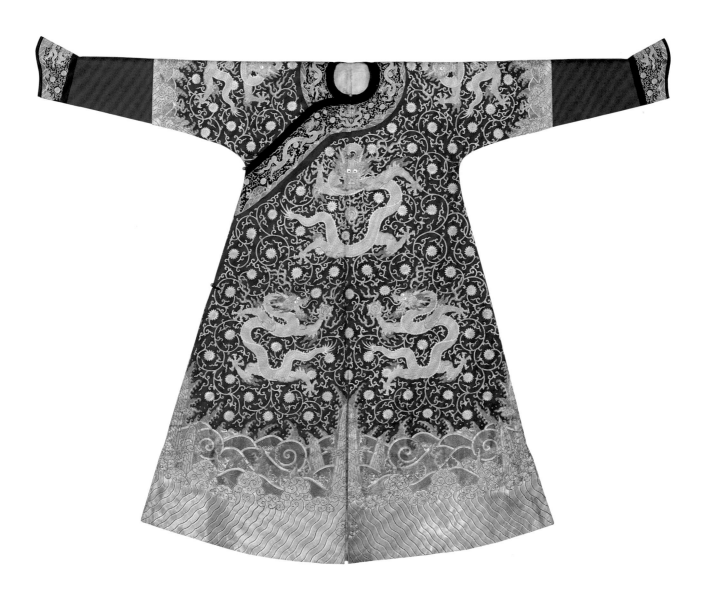

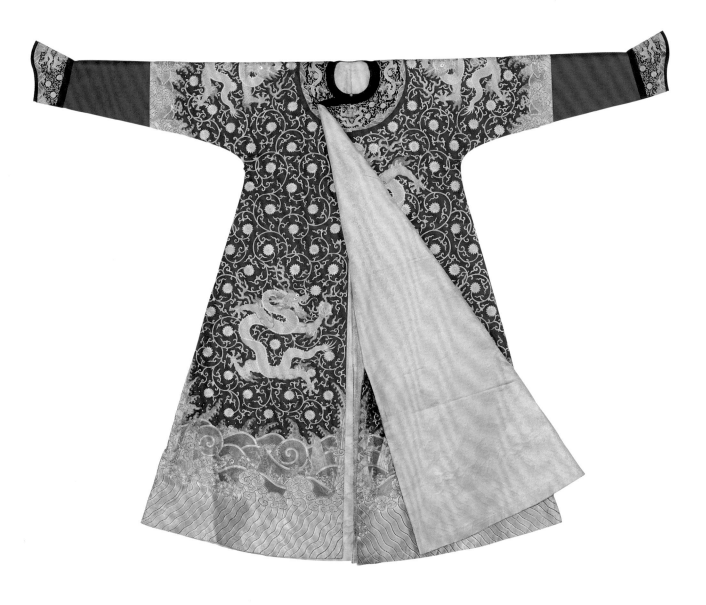

128

Lined *Mang*-dragon Robe
in Brown *Kesi* with Patterns of Colourful Clouds and Golden *Mang*-dragons

Mid-Qing period

Length of robe 138 cm
Width across both sleeves 190 cm
Width along the lower hem 120 cm
Qing court collection

The *mang*-dragon robe (*mangpao*) has a round neckline and slits both in front and behind. The *kesi* (cut silk) face is brown and the lining is in clear blue *shidisha*-gauze with veiled patterns of twining lotus sprigs. The *jiexiu* linking the sleeves and the bodice is in plain azurite blue satin. The fringes of the collar and the sleeves' end are bordered with azurite blue *kesi* decorated with colourful cloud-bats and golden *mang*-dragons. The edges are sewn with threads wrapped in gilt paper. On the body of the robe are embroidered nine four-clawed golden *mang*-dragons. In between are auspicious clouds, mixed treasures and waves lapping on the shore.

This robe was a semiformal robe for the emperor grandchildren and great-grandchildren to wear. The craft involves mainly the plain *kesi* weave and interlocking. The *kesi* craftsmanship is smooth and exquisite; the twisted gold threads even and fine and the *mang*-dragon figures are vivid, giving a sense of relief. The colour scheme is mainly merging three in gradation, poised and gorgeous at once. On the yellow tag is written record by the Qing court.

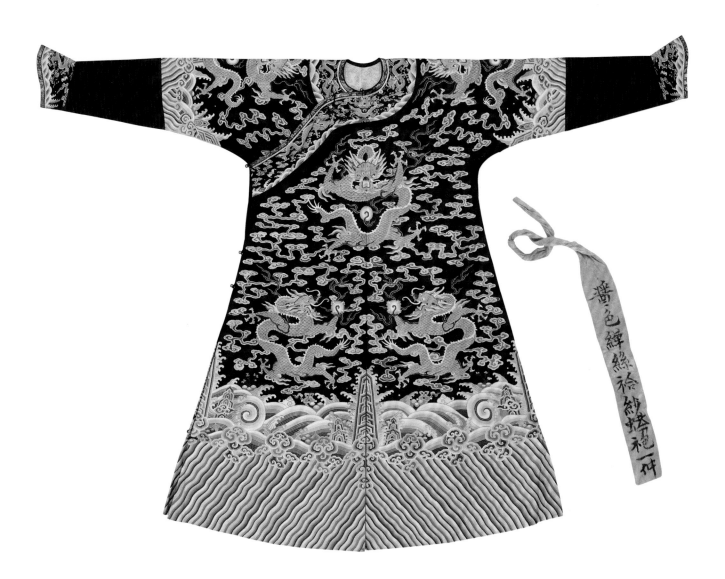

129

Fur Jacket
in Bright Yellow Plain-weave Silk with Veiled Patterns of *Jiangshan Wandai*

Qing Dynasty

Length of jacket 87 cm
Width across both sleeves 124 cm
Width along the lower hem 100 cm
Qing court collection

This is a short fur jacket with a round neckline, level cuffs, a front open in the middle and four slits. The face is made of bright yellow Jiangning plain-weave silk (*chou*) matched with lining made of mink patches in collage. On the face material are woven veiled patterns of waves lapping on the shore, the character for *wan* (卍), the stone chime, flying ribbons, etc. which would pun with "*jiangshan wandai*" ("rivers and mountains for ten thousand generations") implying state power forever.

The weave of this jacket is fine and even, the pattern composition natural and fluent, and the damask is lucid and bright. From its buttons and the form of the fur collage it can be deduced that this informal garment is meant for wearing with either side as face or the reverse.

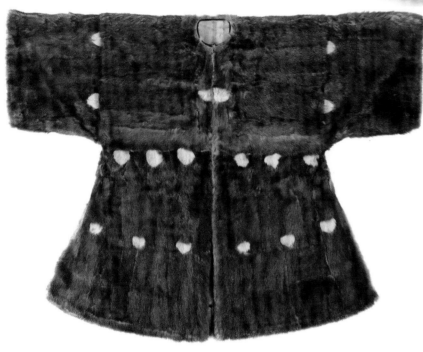

130

Lined Robe
in Blue Bamboo-mat Pattern with Veiled Floral Roundels

Mid-Qing Dynasty

Length of robe 148 cm
Width across both sleeves 204 cm
Width along the lower hem 120 cm
Qing court collection

This lined robe has a round neckline, broad lapel closing on the right, horse-hoof cuffs and four slits. The lining is made of pale blue silk tabby with veiled patterns. The face material employs various slanting twill weave to make bamboo mat patterns and plain weave to show patterns of catfish, stone chimes, auspicious knots (*panchang*) to imply long lasting surplus (*nian yu mian chang*).

The very fine and delicate weave of this robe follows very rigorous rules and each pattern unit or pass measures 37 cm. Its face material is thick and firm and it feels terse to the hands; it is much suited for making outer garments and therefore an informal robe made in sophisticated weave for the emperor.

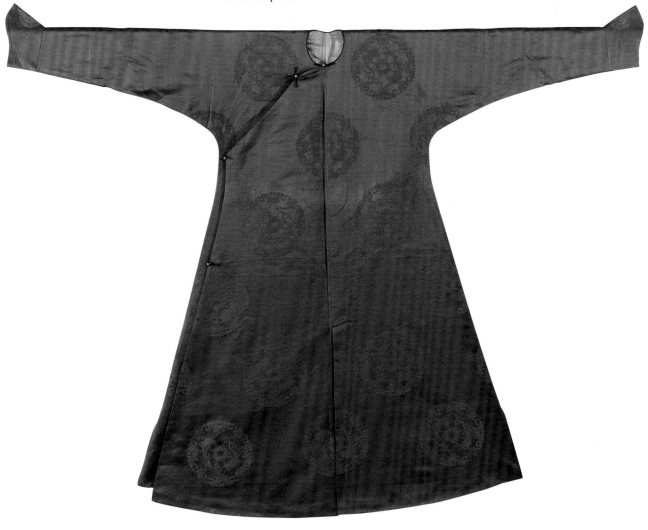

131

Fur Jacket
in Blue Plain Satin

Qing Dynasty　Kangxi period

Length of jacket　76 cm
Width across both sleeves　104 cm
Width along the lower hem　88 cm
Qing court collection

The jacket has a round neckline, level cuffs, a front open in the middle and slits on both sides as well as the back. The face is in blue plain satin and the lining is made of snow weasel fur.

The colour design of this jacket is decorous, its form simple and plain, and the craftsmanship exquisite. It was worn by Emperor Kangxi when he was out travelling. On the yellow tag is written record by the Qing court.

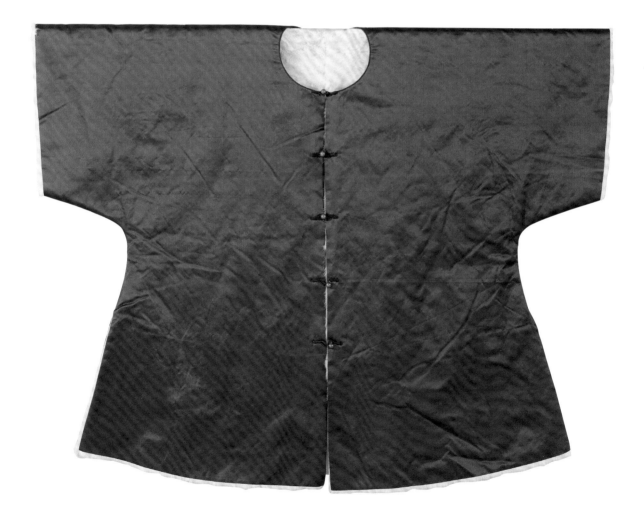

132

Floss-padded Robe
in Glossy Dark Green Satin
with Veiled Patterns of
Clouds and Dragons

Qing Dynasty Kangxi period

Length of robe 139 cm
Width across both sleeves 196 cm
Width along the lower hem 136 cm
Qing court collection

The padded robe has a small collar, a big lapel closing on the right, horse-hoof cuffs and slits both in front and behind. About one foot's length is missing down the front on the right. The satin face is glossy dark green, and the lining is made of pale blue plain-weave silk fabric (*chou*). The collar is in purple mink fur while snow weasel fur sticks out around the cuffs. All over the robe are woven patterns of square *ruyi* clouds and dragons in sets of two. Each pass or pattern unit measures 73 cm.

This robe was worn by Emperor Kangxi. It shows the characteristics of early-Qing robes. About one foot's material is missing at the lower right part of the robe's front. It is called "*quejinpao*" (front-missing robe) or "*xunxingpao*." (tour-luck robe) When the emperor went out riding, he could pin up the front of the robe at his waist; after dismounting, he could put down the front and button on the missing bit again. On the yellow tag is written record by the Qing court.

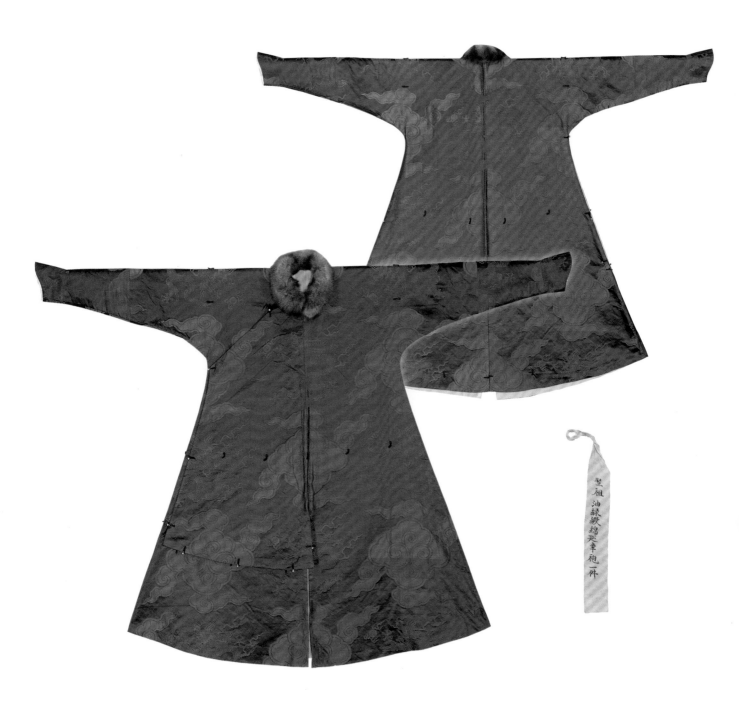

133

Travel Skirt
in Snow-sweeping Mink Fur

Qing Dynasty　Yongzheng period

Length of skirt　99 cm
Width of waist　80 cm
Width along the lower hem　110 cm
Qing court collection

The travel skirt comprises the left and the right parts in the form of a pinafore with a slit in front and a hidden pocket on either side. The face is made of snow-sweeping mink hide and the lining pale blue plain-weave silk with a blue silk ribbon in herringbone weave attached inside.

This travel skirt is made of snow-sweeping mink hide with very dense and luxuriant fur. The skin is soft and tender and the seams evenly sewn. This garment was worn by Qing emperors when going hunting in winter. The skirt has a yellow tag from Qing court.

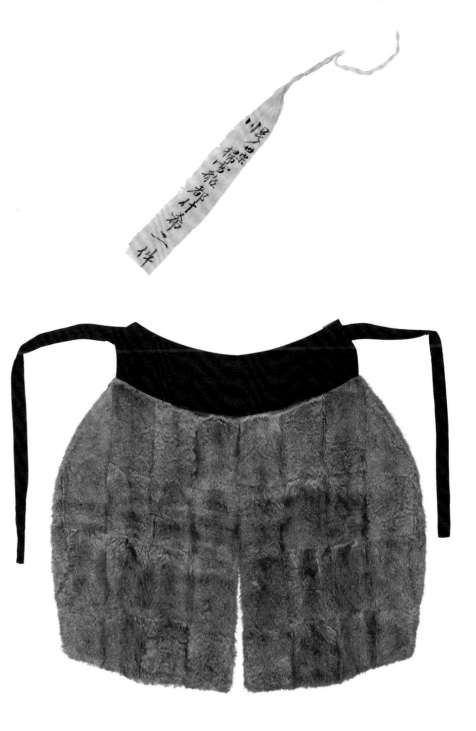

134

Fur Jacket
in Golden Yellow Satin with
Veiled Patterns of Roundels
of Dragons

Qing Dynasty

Length of jacket 71 cm
Width across both sleeves 127 cm
Width along the lower hem 82 cm
Qing court collection

The short fur jacket has a round neckline, level cuffs and symmetrical lapels open in the middle of the front. Its length reaches the seat when the wearer is sitting and its sleeves reach the elbows. The face is made of snow-sweeping mink fur and the lining golden yellow satin with veiled dragon roundel patterns.

This jacket with a face of skin and a lining of satin is contrary to the code of rites in the Qing period. It might well be an expression of royal relations trying to flaunt their wealth.

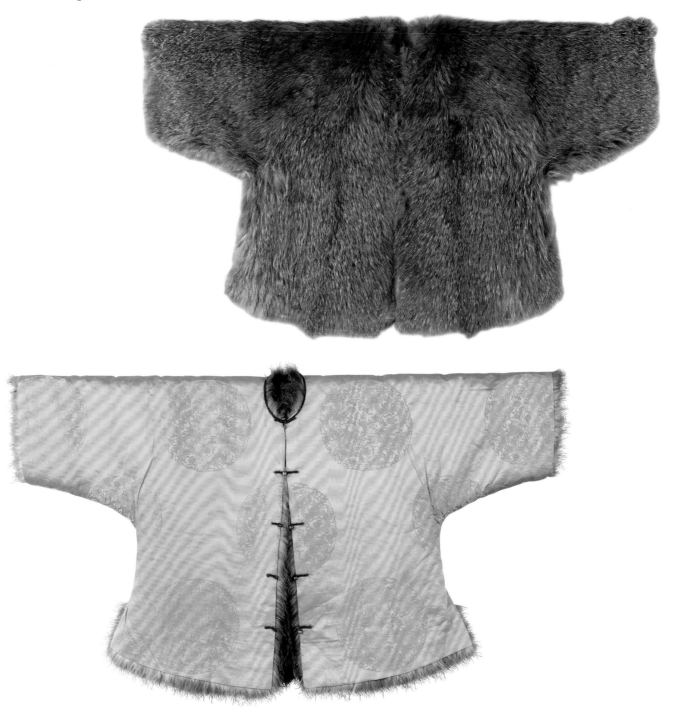

135

Unlined Rain Coat
in Bright Red Plumy Gauze
with Ripple Patterns

Qing Dynasty Kangxi period

Length of coat 127 cm
Width across both sleeves 194 cm
Width along the lower hem 136 cm
Qing court collection

The rain coat has an upright collar, a front open in the middle, level cuffs, four slits and a little extra lapel. The collar has pale blue lining and its edge is fringed with a narrow strip of azure blue plain satin. The face of the coat is made of glossy plain-weave plumy gauze, which has been pressed after weaving to create veiled patterns of ripples.

This rain coat was used by Emperor Kangxi, and it is the only extant bright red rain garment among costumes from Qing emperors. That red rain garments were used by an emperor was also a phenomenon unique to the early-Qing period. The coat has a yellow tag from Qing court.

Plumy gauze (*yumaosha*) is woven with threads spun from feathers and plumes. It is rough to the touch. It exploits the property of feather that it does not get wet for weaving water-proof garments. After weaving it was pressed and this minimizes the meshes in the weave so as to achieve the water-proof effect.

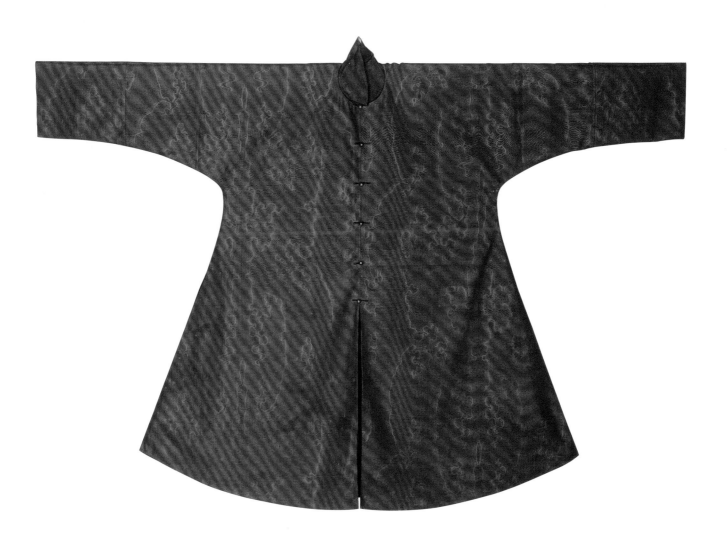

136

Padded Armour
in Bright Yellow Satin
Embroidered with Colourful Clouds
and Golden Dragons

Qing Dynasty Kangxi period

Length of bodice 75.5 cm
Width across both sleeves 158 cm
Length of skirt 71 cm
Qing court collection

The armour has an upper bodice and a lower skirt. The shoulders have protective covers and there are sleeves on the right and the left. In front and on the left are hidden seams (*zhefeng*), outside of which are golden hat-shaped pins (*jinmaoding*) and the fringe is bordered with black flannel. The lining is in blue plain-weave silk and the padding is a thin layer of silk floss. On the bodice are inlaid a ruby and a Manchu pearl (*dongzhu*) and all over are nine dragons with patterns of clouds, flames and *lingzhi*-fungi around. On the skirt are embroidered waves calming patterns from the eight treasures. The skirt is split between the right and the left crotches in yellow satin ground fringed with black flannel and stabilized with golden hat-shaped pins. There are sixteen flying dragons, in between are embroidered patterns of the flaming pearl, the calming waves, the longevity mountain and the *ruyi* clouds.

The inner ox-hide surface of the helmet is painted with black lacquer, inlaid with gold and pearls and decorated with figures of dragons. In between are sanskrit letters and patterns of silk tassels, to show that the emperor was a Buddhist or even to imply that he had incarnated into Buddha. The top of the helmet is decorated with pearls and on the side carved dragons in openwork, around which are small pearls. A piece of black mink fur hangs from the top of the helmet. The protective covers around the neck and on the ears are decorated with dragon patterns.

This armour was worn by Emperor Kangxi when inspecting the Eight Banners of the Manchu army. The needlework is rigorously neat, and the lines are very clearly defined. All the patterns embroidered on the armour are done in padded stitches. The needlework looks simple, but the three-dimensional relief creates a strongly decorative effect, which emphasizes the emperor's ultimate dignity and authority.

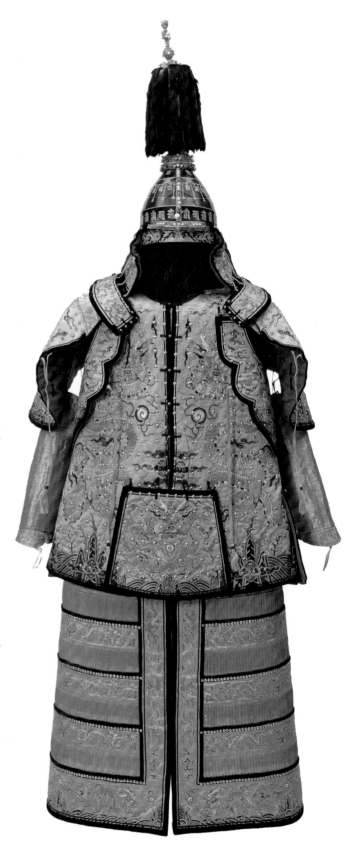

137

Lined Close-fitting Garment

in Purple *Zhangrong* with Patterns of the "Three Many" Including Happiness and Longevity

Late-Qing period

Length of garment 76 cm
Width across the shoulders 39 cm
Width along the lower hem 78 cm
Qing court collection

This close-fitting garment has an upright collar, a lapel closing between the middle of the front and the side and slits on both sides. The face is velvety and the lining is made of pale blue plain-weave silk fabric. The face has a ground of pile loops and the patterns are shown by having the relevant parts of the loop cut open to create nap. The patterns are called the "three many" including pomegranates, the Buddha's-hand melon (*foshou*) and longevity peaches to pun with sons, happiness and longevity and thus to imply plenty of sons, happiness and long life (*duo zi, duo fu* and *duo shou*). Other patterns are peonies, flying ribbons, bats, the characters for *wan* (卐) and for "longevity" to imply "ten thousand generations of happiness and longevity." (*fushou wandai*)

This close-fitting garment has fully exploited the characteristics of the special craft of *zhangrong* (pile weave in Zhangzhou style) with its different methods of weaving the face and the loops, which alternately show the bright and dark parts of the fabric to achieve the effect of different hues and shades by using only threads in the one and the same colour.

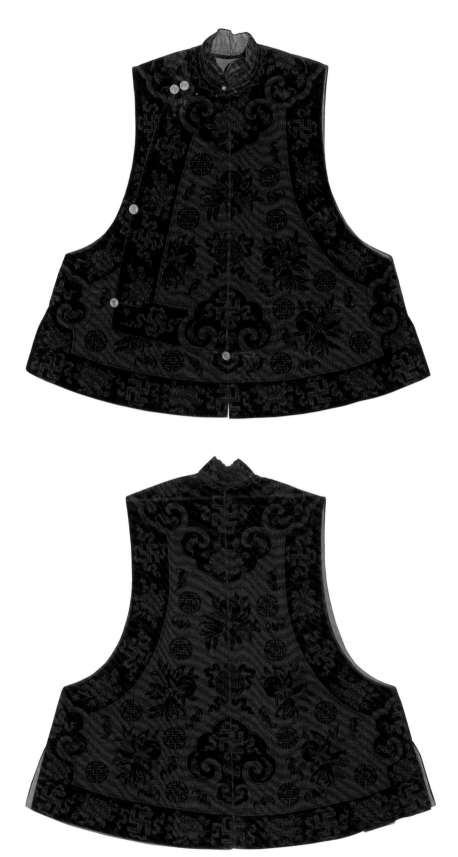

Bright Yellow Fur Jacket
in *Caoshangshuang* Hide and Lining in *Chunchou* with Veiled Pattern of Gourds

Qing Dynasty Jiaqing period

Length of jacket 63 cm
Width across both sleeves 120 cm
Width along the lower hem 80 cm
Qing court collection

The jacket has a round neckline, lapels opening in the middle of the front and level cuffs. The sleeves reach the elbows and there are three slits on the jacket. There are five copper buttons decorated with patterns engraved on fine gold. The face is made of bright yellow *chunchou* (spring silk fabric) with veiled patterns of gourds, auspicious square *ruyi* clouds to pun with "*fulu ruyi.*" (happiness and officialdom as wished)

The jacket is a casual garment for the emperor to put on top of his robe in winter. The lining is made of processed lamb's hide called "*caoshangshuang*" (frost on grass) and it is soft, light, thin and very comfortable.

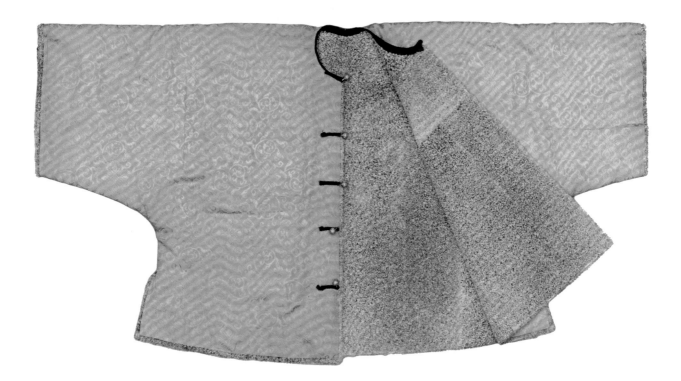

139

Bright Yellow Lined Trousers
in Satin Brocaded with Clouds and Dragons in Gold

Early-Qing period

Length of trousers 125 cm Circumference of trouser-leg opening 29 cm
Qing court collection

The crotches of the trousers are slanting and the trouser-legs have level openings. The trouser-waist is in two parts and sewn with four belts. Both the trouser-legs' openings and the trouser-waist are connected with a strip of gauze brocaded with blue clouds and dragons. The clouds and dragons on the face are arranged horizontally. The flying dragons on the sides are woven in threads wrapped in gold. The heads of the two rows of dragons turn respectively towards the left and the right to form units of patterns. In between are flaming pearls and *ruyi* clouds.

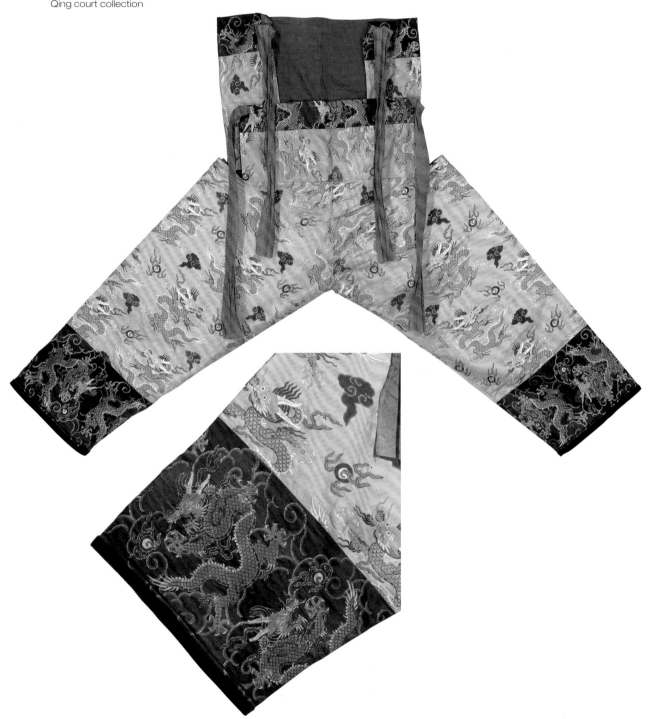

140

Lined Courtly Robe
in Golden Yellow Satin with
Patterns of Colourful Clouds
and Golden Dragons

Early-Qing period

Length of robe 137 cm
Width across both sleeves 178 cm
Width along the lower hem 126 cm
Collar 94×34 cm
Qing court collection

The robe has a round neckline, a front closing on the right and horse-hoof cuffs. There are seams where the sleeves and the main bodice meet. A collar is attached. At the back is a golden yellow silk ribbon hanging from the collar ending in Chinese knots. There are slits on both sides. The face is made of golden yellow brocaded satin and the lining in pale blue silk tabby with veiled patterns. All over are woven nine golden dragons—one flying dragon on the front, one on the back and one on each shoulder, four on the lapel and one on the lining of the lapel. In addition there are two flying dragons on each of the sleeve seams. On each sleeve is a frontal dragon and two on the collar. On the lower part are patterns of waves from the eight treasures.

This is a courtly robe worn by imperial concubines (*fei*) including the highest ranking one (*guifei*) at major celebrations and ceremonies during summer. The design is similar to that of the empress's robe.

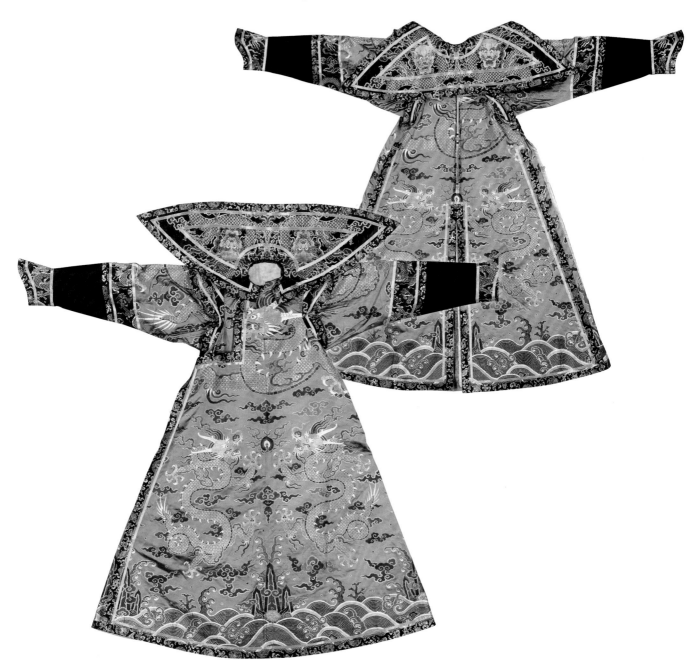

141

Lined Robe
in Light Brown Plain-weave Silk Woven with Patterns of Colourful Clouds and Golden Dragon

Early-Qing period

Length of robe 135 cm
Width across both sleeves 170 cm
Width along the lower hem 125 cm
Collar 90×33 cm
Qing court collection

The robe has a face made of light brown (*xiangse*) satin and pale blue lining of *shidisha* (gauze with tighter meshes) with patterns of roundels enclosing dragons and the mixed treasures (*zabao*). The shoulders' edges are fringed, while the edge of the collar as well as the sleeves are decorated with golden satin with azure blue clouds and floral patterns. The collar is lined in golden satin woven with red roundels enclosing dragons and *zabao*. There are no tassels and knots hanging from behind. The back has a slit. The face of the robe is decorated with two to four colours merging and receding and woven with patterns of colourful clouds, golden dragons and waves lapping on the shore.

This courtly robe was worn by imperial concubines of various ranks and other female aristocrats (*pin, guiren, changzai, fujin*) at major ceremonies during summer. The craftsmanship is exquisite; the colours merge harmoniously and the pattern designs are simple but tasteful. This is an embodiment of the superior art and craft of brocaded textiles from the early-Qing period.

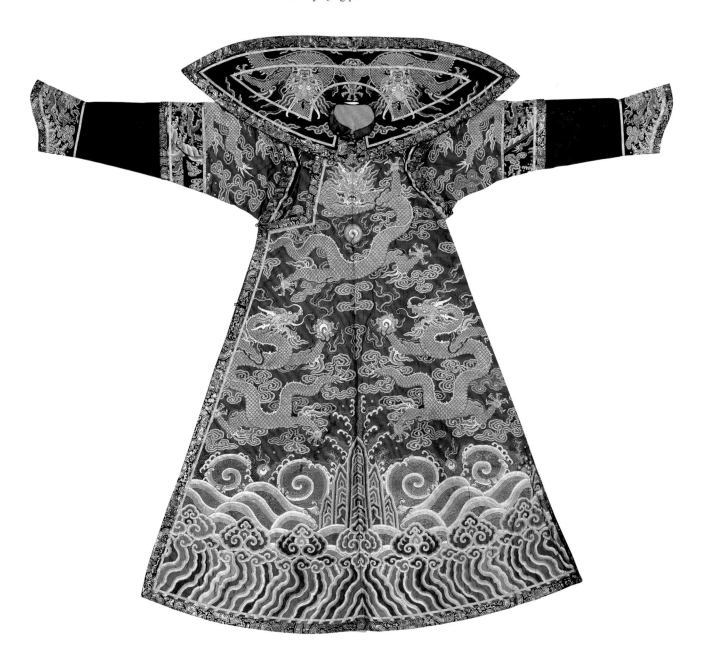

142

Snow Weasel Fur Courtly Robe
in Bright Yellow Satin Embroidered with Colourful Clouds and Golden Dragons Inlaid with Pearls and Gems on Golden Plates

Qing Dynasty Qianlong period

Length of robe 134 cm
Width across both sleeves 163 cm
Width along the lower hem 112 cm
Collar 100×34 cm
Qing court collection

The courtly robe has a round neckline, a front buttoning on the right and horse-hoof cuffs. The shoulders' edges are fringed, and the edge of the collar as well as the lower part of the robe is fringed with mink fur showing the hair tips. The lining is made of the hide of lambs and corsac foxes. All over are flowing clouds in multi-colour and waves lapping on the shore embroidered in silk threads, while frontal dragons embroidered in gold threads are found each on the front, the back and the shoulders. On the protective covers of the shoulder edges are each a frontal dragon and two flying ones on the front and the back of the lower part of the robe. On each of the sleeve seams are two flying dragons. The cutts bear each a frontal dragon.

This robe was used as a ceremonial garment by Empress Xiaoxianchun (first empress to Emperor Qianlong) at major ceremonies in winter. The decorative crafts involved are various and elaborate; the needlework is refined and the pattern design is radiant and opulent. The courtly robe ranks the highest among the three different ranks of the empress's costumes.

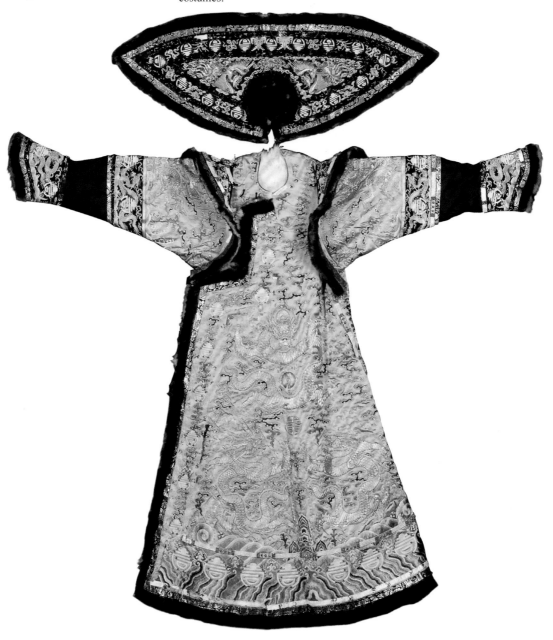

143

Lined Court Gown
in Azure Blue Satin Embroidered with Patterns of Clouds and Dragons Inlaid with Pearls and Gems on Gold Plates

Qing Dynasty Qianlong period

Length of coat 130 cm
Width across both shoulders 40 cm
Width along the lower hem 120 cm
Qing court collection

The court gown has a round neckline and a front open in the middle. It is sleeveless and there are slits on the sides. The edges are fringed with flat gold tape. The lining is made of golden satin with red veiled patterns of roundels enclosing clouds, dragons and the character for "longevity" in gold. It is decorated with nine copper buttons with engravings in gold. On both the front and the back are two upright dragons embroidered in flat coils of gold threads. In between are multi-coloured clouds and bats together with water-calming patterns from the eight treasures. Characters for "longevity" are embroidered in roundels with small pearls and corals. On the edges are decorations of gold plates inlaid with corals and turquoise. Between the gold plates are sewn pearls linked with coral beads in rows.

The court gown is a ceremonial garment for imperial concubines. It is slightly shorter than the courtly robe, and it was worn on top of the robe. The decoration of the gown with corals and pearls inlaid on gold was a novelty of the Qianlong period during the Qing Dynasty. In regard of the garment's colours, its design and form, the positions of the gold plates, the total number of these gold plates and the number of pearls and gems inlaid on them, this is in complete agreement with the court gown Empress Xiaoxianchun wears in the documentary painting of the Qing court titled "Portrait of Empress Xiaoxianchun."

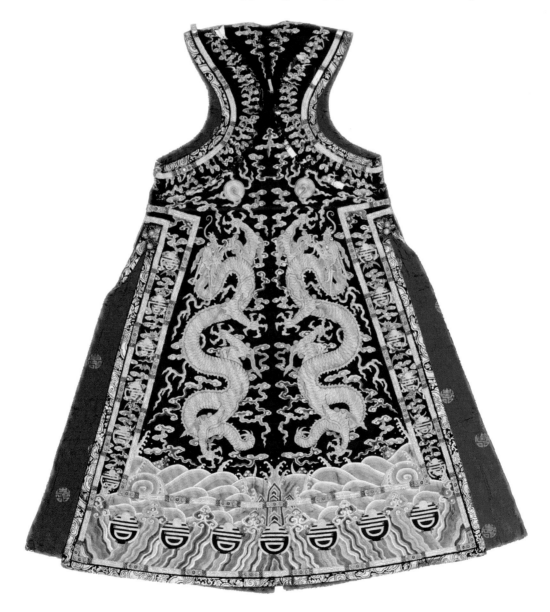

144

Lined Court Gown
in Azure Blue Satin Woven
with Patterns of Colourful
Clouds and Golden Dragons

Mid-Qing period

Length of gown 133 cm
Width across both shoulders 42 cm
Width along the lower hem 173 cm
Qing court collection

This court gown has a round neckline, a front open in the middle, no sleeves and a slit at the back. On the back hangs an apricot yellow silk ribbon with corals and tassels. The face is in azurite satin, inlaid with azurite roundels enclosing dragons and *zabao* patterns and fringed with golden satin decorated with duo-coloured gold coils along the borders. The lining is made of golden satin with red roundels enclosing patterns of clouds, dragons and the character for *wan* (卍). The face is made in the method of merging two to three colours in gradation and brocaded with two upright dragons. The lower part has folds alternating in four layers. Above are frontal dragons and below are the figures for 卍, bats, and longevity roundels to form the pattern of *wanfu wanshou* (plenty of happiness and longevity).

This garment was worn by imperial concubines and of various ranks at major celebrations and ceremonies. The pattern composition is opulent, elaborate but in good order. The colour design is harmonious and the weave is exquisite.

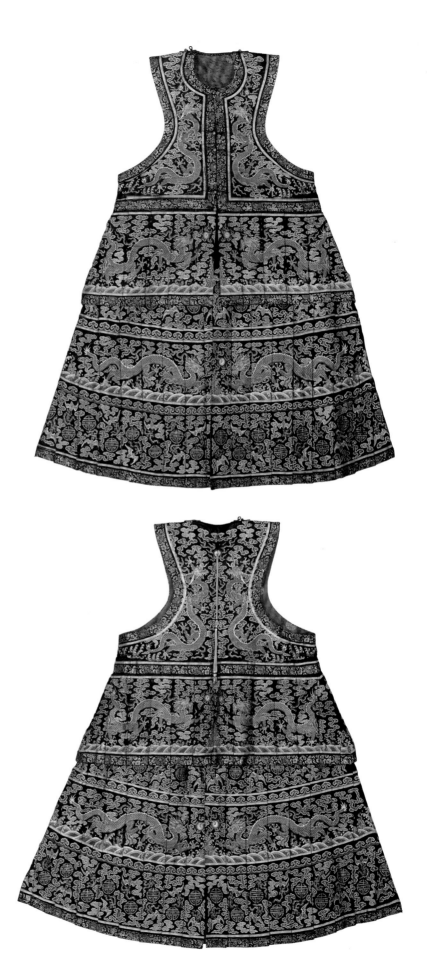

145

Lined Court Gown
in Azurite Satin Embroidered
with Patterns of Colourful
Clouds and Golden Dragons

Qing Dynasty Xianfeng period

Length of gown 143 cm
Width across the shoulders 40 cm
Width along the lower hem 130 cm
Qing court collection

This garment has an azurite satin face
and the lining is in bright red satin with
veiled patterns of the *kui*-dragon. The
beiyun pendants hanging down at the back
is with tassels made of a yellow ribbon.
The edge is fringed with flat gold leaf. All
over the gown are embroidered eighty-one
golden dragons; on the chest and the back
are respectively embroidered two upright
dragons with gold threads sewn in flat
coils. On the lower part are three layers of
folds, and in every fold is embroidered an
upright dragon. In the middle of the back is
a frontal dragon.

Among all the court gowns of the Qing
imperial concubines, this garment has most
dragons embroidered. The workmanship is
rigorous and strict; the gold threads are fine
and even and the stitches are smooth, all
demonstrating the imposing air of royalty.
The gown has a yellow tag from Qing
court.

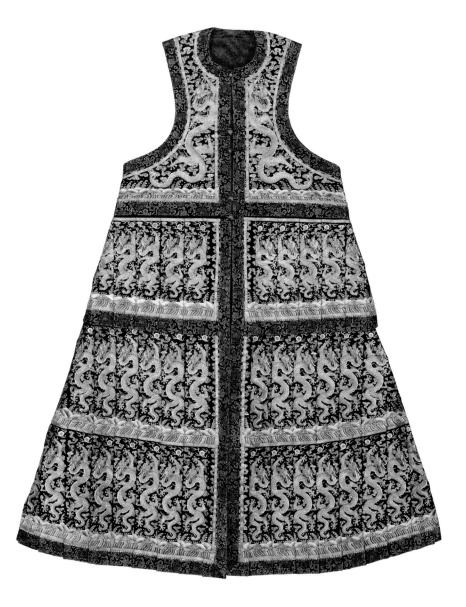

146

Lined Court Dress
in Azure Blue Satin Brocaded with Small *Mang*-dragon and Inlaid with Pearls and Gems on Gold Plates

Qing Dynasty Qianlong period

Length of dress 145 cm
Width across the shoulders 35 cm
Width along the lower hem 179.5 cm
Qing court collection

The court dress has a round neckline, a broad front buttoning on the right, no sleeves and a slit on either side. There are two ribbons hanging from the back all the way tapering down. The edges with flat gold leaves are fringed with mink and decorated with four plain silver buttons and two copper buttons engraved with floral patterns on gold. The dress is divided into three layers, the upper, the middle and the lower: the upper is decorated with red roundels of longevity on golden satin; the middle has folds in the same material; and the lower is made of blue satin brocaded with small *mang*-dragons. The upper part has double layers, the middle is single and the lower padded with floss. They are all lined with pale blue plain-weave silk fabric. On the lower part are woven four rows of colourful flying dragons decorated in between with multi-coloured cloud patterns. The edges are fringed with gold leaves and mink fur. The inner sides are decorated at intervals with 35 gold plates in long strips inlaid with corals and turquoise, at the ends of which are sewn pearls and coral beads.

The court dress is a ceremonial garment for the empress. This dress was used by Empress Xiaoxianchun and a uniquely extant piece as such. It forms a set together with the bright yellow satin courtly robe embroidered with clouds and dragons, inlaid with pearls and gems and lined with snow weasel fur (Figure 142) and the lined court gown in azure blue satin embroidered with cloud dragons and inlaid with pearls and gems on gold plates (Figure 143). The order of putting on these is to start with the inner dress, then the robe as a middle layer and then the gown on top.

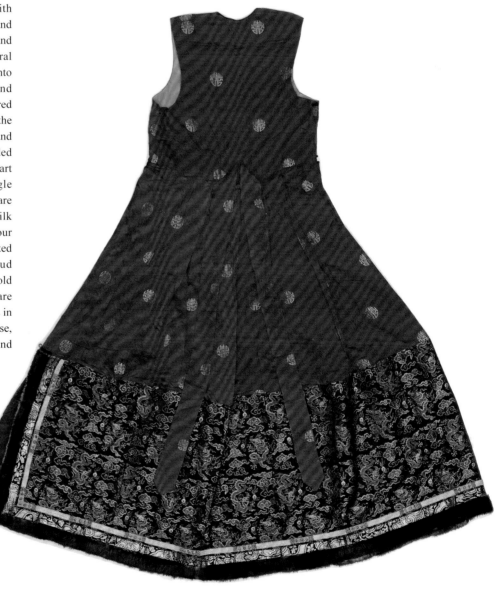

147

Lined Coat
with a Face in Red *Sha*-gauze and *Jin*-Ground Embroidered with Colourful Clouds, Golden Dragons and Meandering Patterns

Early-Qing period

Length of coat 107 cm
Width across both sleeves 117 cm
Width along the lower hem 96 cm
Qing court collection

The lined coat has a round neckline, a front open in the middle, level cuffs and slits on the sides and the back. The face is made of red gauze and the lining of pale blue *shidisha*-gauze with veiled cloud patterns. The face uses two to four colours merging and the ground is brocaded with bright yellow sewing threads to form and cover with meandering patterns. On this are embroidered in various stitches such as the straight stitch, the twining stitch, the punch stitch, the open loop and the flat-coiling stitch patterns of colourful clouds, golden dragons, the characters for 卍 and "longevity" and waves lapping on the shore.

This coat is a semiformal garment for imperial concubines. Its patterns are regular and unsophisticated. The colour design is strong and decorous and the needlework delicate. Through the multi-layers of threads and paths in embroidery and the fine outlines, a light relief effect is achieved on a heavy solid ground material.

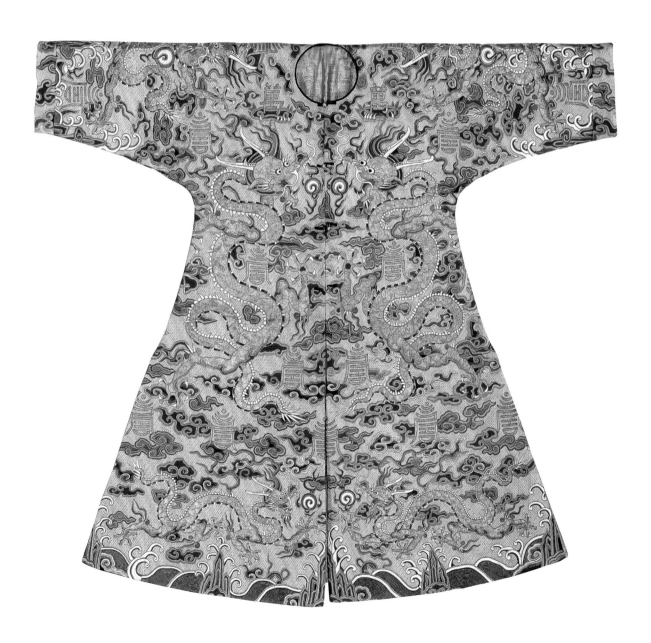

148

Floss-padded Coat
in Yellow Satin Woven with
Patterns of Colourful Clouds
and Golden Dragons

Early-Qing period

Length of coat 110 cm
Width across both sleeves 125 cm
Width along the lower hem 110 cm
Qing court collection

The floss-padded coat has a yellow satin face and a lining of clear cold blue silk tabby with veiled patterns of the "three many." (including happiness and longevity) The padding is a thin layer of floss. All over are nine golden dragons woven with threads wrapped in gold foils. The edges are outlined in flat gold leaves decorated in between with multi-coloured auspicious clouds. The lower part is woven with patterns of waves lapping on the shore and the *zabao* (mixed treasures).

The craftsmanship of this coat is exquisite and the dragon patterns give a three-dimensional feel. The colours are bright and sumptuous, radiant and eye-arresting. According to the Qing Codes of Ceremony, a dragon coat should be azurite in colour. Yellow dragon coats were found only during the early period of the dynasty, when the codes were not yet completed.

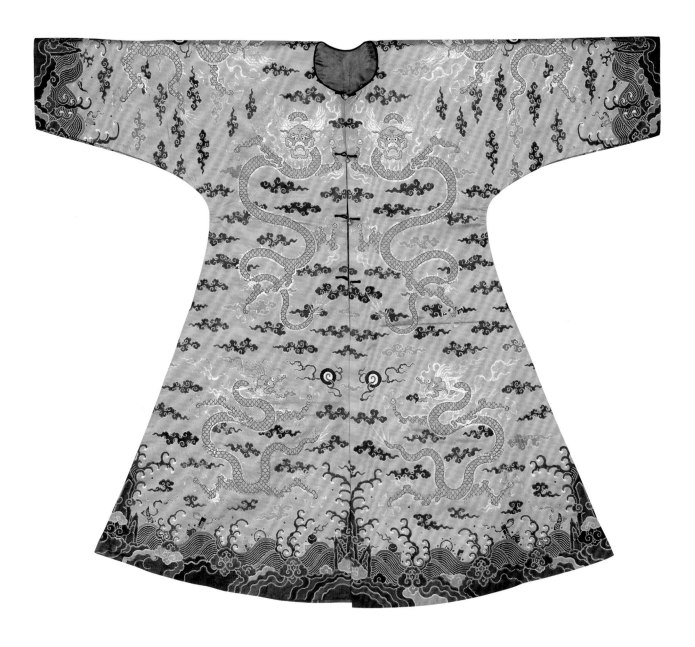

149

Lined Coat
in Azure Blue Satin with
Eight Roundels Enclosing
Dragons and Phoenixes

Qing Dynasty Qianlong period

Length of coat 152 cm
Width across both sleeves 180 cm
Width along the lower hem 140 cm
Qing court collection

The lined coat has an upright collar, a front opening in the middle, level cuffs and a slit at the back. The face is made of azure blue satin, and the lining pale blue tabby with veiled patterns of lotuses in outline. There are eight roundels brocaded with golden dragons and phoenixes on the face material, and the dragons and phoenixes are woven with gold-wrapped threads in one colour in two shades alternating. Through the variation of the shades of the hues of these threads, the dragon shows up in special three-dimensional effects and corresponds with the dancing phoenixes. Visually this achieves a *yin-yang* contrast. On the lower part are patterns of calming waves from the eight treasures and *ruyi* clouds woven with multi-coloured silk threads.

The colours of this coat are subtly merged and the way the patterns of dragons and phoenixes are combined is very special. This is the only extant dragon coat with such design from the Qing period. The coat has a yellow tag from Qing court.

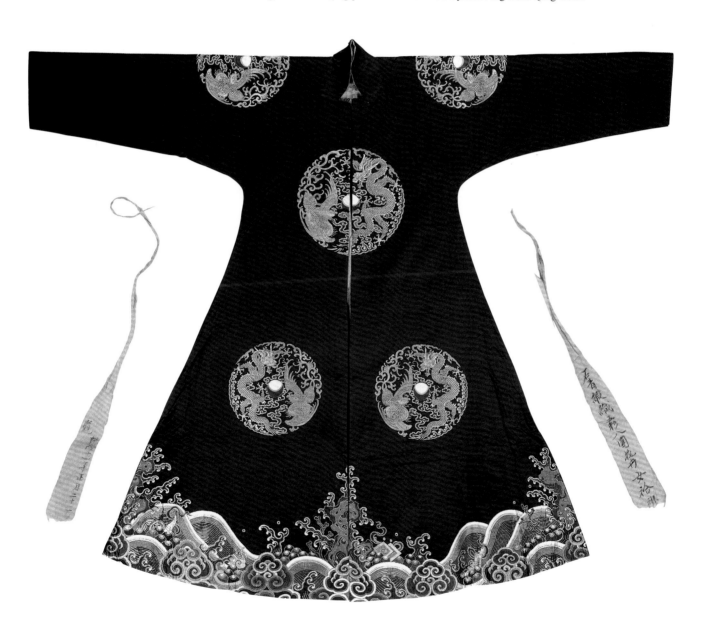

150

Lined Coat
in Azure Blue Satin Embroidered with Eight Dragon Roundels in Small Pearls Sewn Together

Qing Dynasty　Qianlong period

Length of coat 142 cm
Width across both sleeves 175 cm
Width along the lower hem 124 cm
Qing court collection

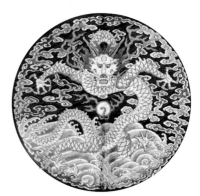

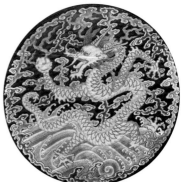

The lined coat has a face of azure blue satin and a lining of water blue silk tabby with veiled patterns. The colours of the face are two to three merging in gradation and eight roundels enclosing clouds and dragons are embroidered in stitches such as the flat coiling, the straight and the open loop together with the craft of sewing on small pearls.

This coat was worn by the empress as a semiformal garment. Its colour design is quiet, elegant, refined and exquisite, bearing still the poise and decorum of the early-Qing style. The coat has a yellow tag from Qing court.

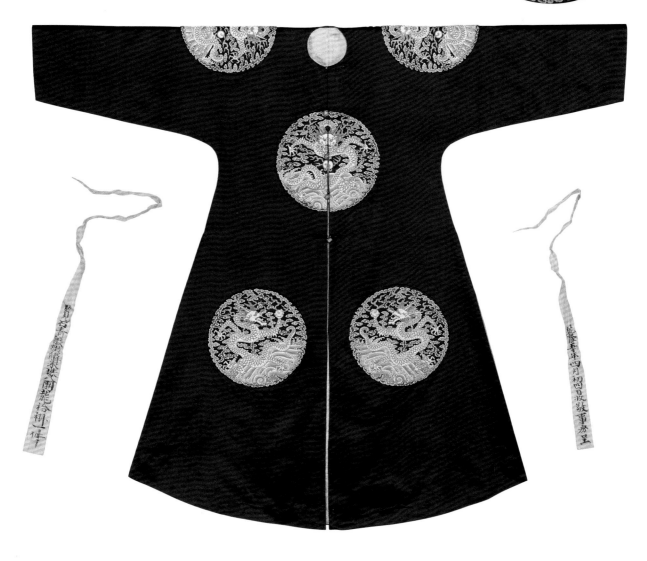

151

Padded Coat
in Azure Blue Satin Embroidered with Eight Dragon Roundels Enclosing Blue Dragons and Golden Character for "Longevity"

Qing Dynasty Jiaqing period

Length of coat 152 cm
Width across both sleeves 176 cm
Width along the lower hem 140 cm
Qing court collection

The floss-padded coat has an upright collar, a front opening in the middle, level cuffs and a slit at the back. The face is made of azure blue satin and the lining of pale blue silk tabby with veiled patterns. On the face are woven eight roundels enclosing blue dragons, golden characters for "longevity" and patterns of waves lapping the shore. The dragons look very special as if twining on the golden characters.

This coat forms a set together with lined dragon robe in light brown satin woven with eight roundels enclosing blue dragons and golden character for "longevity" (Figure 163). The coat has a yellow tag from Qing court.

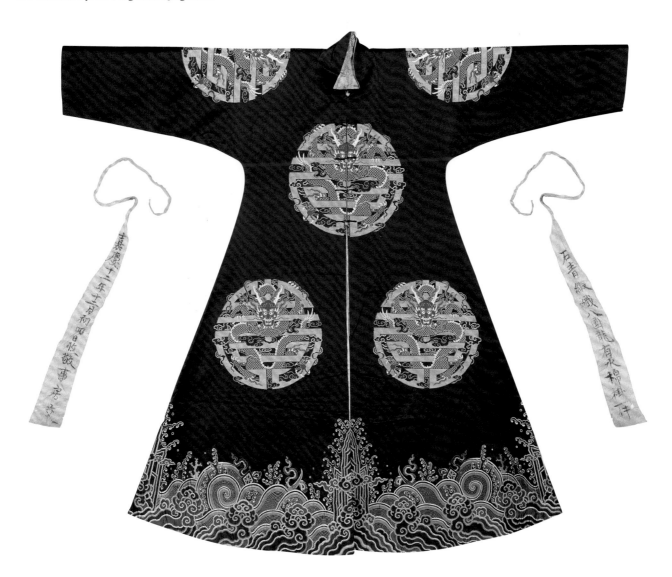

152

Floss-padded Coat
in Azure Blue *Kesi* with Eight
Roundels Enclosing Lanterns

Qing Dynasty Jiaqing period

Length of coat 142 cm
Width across both sleeves 176 cm
Width along the lower hem 115 cm
Qing court collection

The floss-padded coat has a face of azure blue *kesi* and a lining of pale blue silk tabby with veiled patterns of sprigs. All over are eight roundels enclosing lanterns in duo-coloured twisted gold threads by *kesi* (cut silk) weave. Inside the lanterns are woven the "sea house storing chips" (*haiwu tianchou*) and "red knotweed longevity stone" (*hongliao shoushi*), implying long life and prolonged life. On the lower part are woven bats, *lingzhi*-fungi, daffodils, peonies, longevity stones and the upright waves from the eight treasures, implying "immortals sending wishes for long life." (*lingxian zhushou*)

This coat is a masterpiece of the craft of *kesi* from the reign of Jiaqing. The lantern pattern has not been found in institutional records. It should be a semiformal garment for the empress during Lantern Festival on the fifteenth day of the lunar new year. The coat has a yellow tag from Qing court.

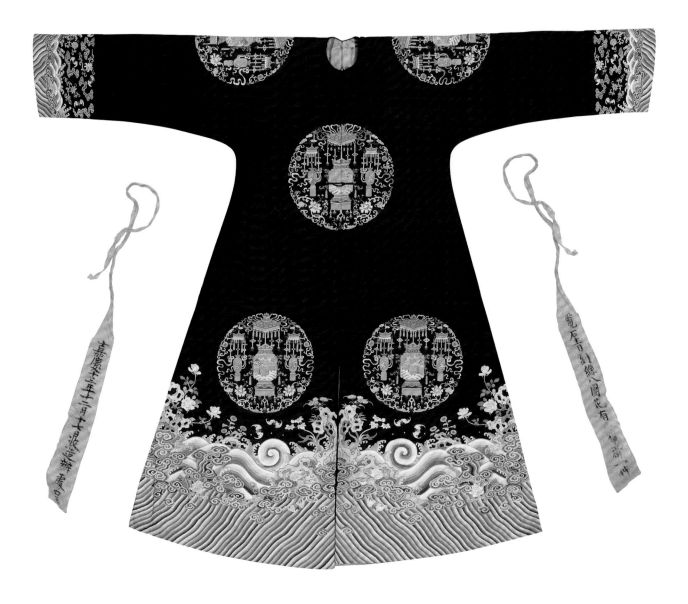

153

Floss-padded Coat
in Azure Blue Plain-weave
Silk Fabric Embroidered with
Eight Roundels Enclosing
Dragons and Phoenixes and
Patterns of Double
Happiness

Qing Dynasty　Guangxu period

Length of coat 135 cm
Width across both sleeves 176 cm
Width along the lower hem 114 cm
Qing court collection

The padded coat has a round neckline, level cuffs, a front opening in the middle and a slit at the back. In the middle of the neckline at the top is a copper button with gold inlaid engraved with patterns. There are four buckles for buttoning. The lining is made of bright yellow plain basic silk cloth, and the padding is a thin layer of silk floss. The face of the coat is woven with threads in two to five colours gradually merging and receding. On a ground of azurite blue Jiangning *chou* (plain-weave silk with Nanjing origin) are embroidered colourful roundels enclosing dragons, phoenixes and symbols for double happiness in stitches such as the straight stitch, the flat coiling stitch, the propping stitch, the open loop and the punch stitch. The needlework is exquisite and the colours opulent, accentuating the atmosphere of gaiety during wedding celebrations.

This coat was donned by the empress as a semiformal garment at the grand royal wedding. It is also called "the coat uniting the dragon and the phoenix" (*longfeng tonghe gua*). It forms a set together with the padded robe in bright red plain-weave silk embroidered with eight roundels enclosing dragons, phoenixes and double-happiness symbols (Figure 167). This is a uniquely extant treasure of the Palace Museum.

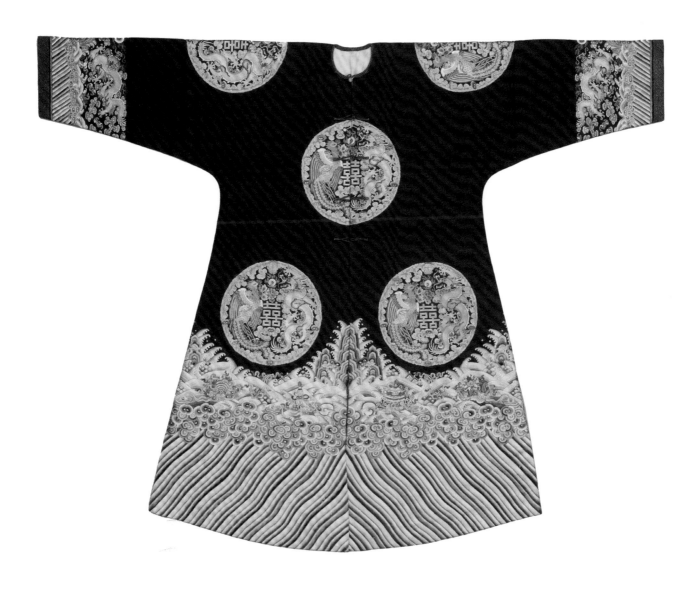

154

Lined Coat
in Azure Blue Satin with Eight Roundels Enclosing Dragons Embroidered in Flat Coiling Gold Threads and Sewn with Pearls in Close Stitches

Late-Qing period

Length of coat 141 cm Width across both sleeves 181 cm Width along the lower hem 118 cm
Qing court collection

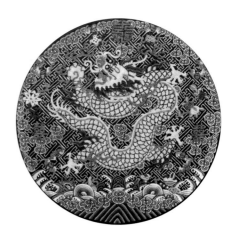

The lined coat has an azure blue satin face. The lining is made of pale blue satin woven with gold threads to show patterns of square *ruyi* and roundels enclosing dragons and the character for "longevity." The edge of the cuffs are fringed with azure blue satin woven with gold threads to show the character for 卍. The face has two to four colours merging and receding in combination and uses the craft of closely sewn pearls as well as various stitches such as the straight stitch, the open loop and the flat coiling gold threads to embroider eight roundels enclosing the character 卍, colourful clouds, dragon pearls and the upright waves from the eight treasures.

This coat was a semiformal garment for the empress. It is ground-breaking in traditional Qing embroidery by combining the use of beads, corals and small pearls and materializing the gorgeous hyperbole of late-Qing style of decoration.

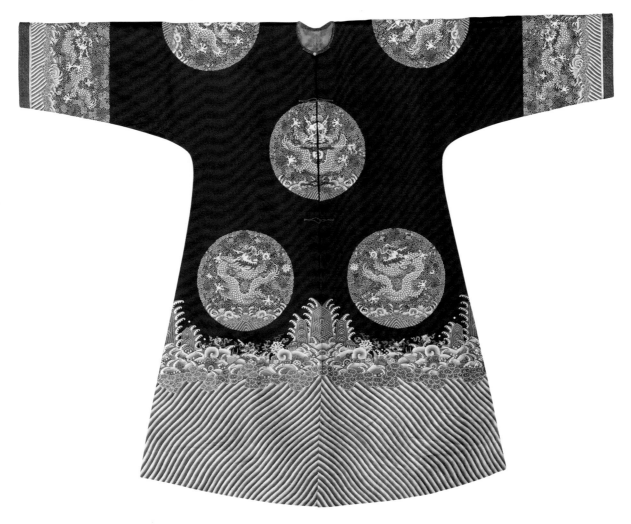

178

155

Unlined Dragon Robe
in Yellow Gauze Woven with Eight Roundels Enclosing Golden Dragons

Early-Qing period

Length of robe 140cm Width across both sleeves 180 cm Width along the lower hem 136 cm
Qing court collection

The dragon robe has a face of yellow *shidisha*-gauze with veiled patterns of roundels enclosing clouds and dragons. The collar and the cuffs are fringed with blue satin brocaded with colourful clouds and golden dragons with an outer duo-coloured edges respectively with flat coils of gold and blue threads and gold foils. The sleeves have the same colour as the gauze. The face uses threads in two to three colours merging to weave eight roundels enclosing colourful clouds and golden dragons. The lining of the robe matches with bright yellow twining lotus patterns in straight warp gauze at the roundels.

This robe has a brisk and clear composition; the weave is smooth and fine; and the colour design is poised and decorous. As an early-Qing semiformal garment for the empress, it still bears remnants of Ming costume patterns in its decoration of golden dragons on the fringes of the collar and the cuffs.

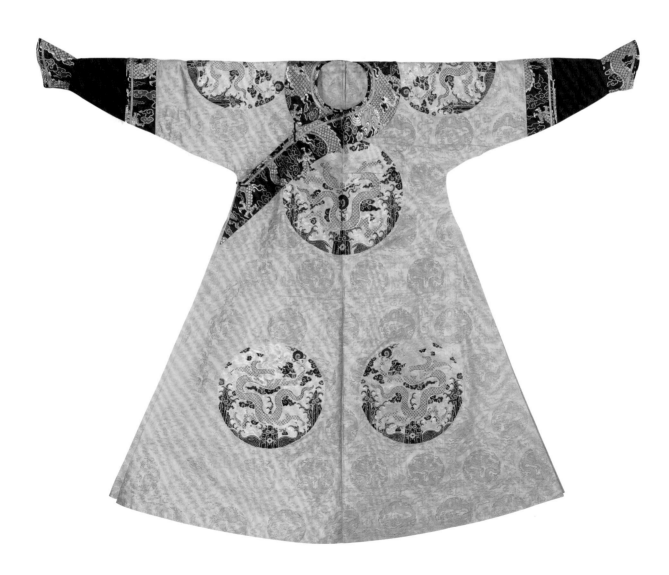

156

Lined Dragon Robe
in Bright Yellow Gauze with
Patterns of Colourful Clouds
and Golden Dragons

Qing Dynasty Qianlong period

Length of robe 142 cm
Width across both sleeves 184 cm
Width along the lower hem 122 cm
Qing court collection

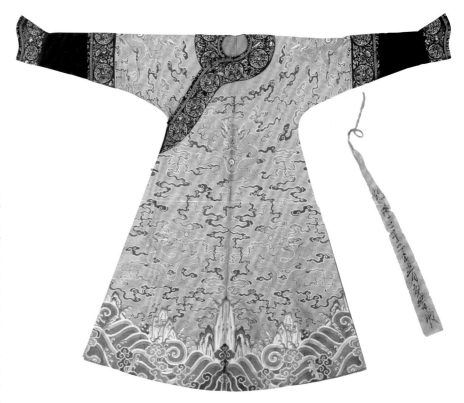

The robe has a face of plain bright yellow gauze with veiled patterns of clouds. The lining is made of pale blue *shidisha*-gauze with veiled patterns of roundels enclosing dragons and patterns of mixed treasures. The edges of the collar and the cuffs are fringed with azure blue *shidisha*, and there are embroidered roundels enclosing *kui*-dragons, cloud-bats, flowers and the eight Daoist immortals. Along the edge are decorations of golden fringes respectively in azurite satin with gold foils and winding *hui*-patterns. The face uses two to four colours merging to weave the character for *wan* (卍) linked with clouds, golden dragons, waves lapping the shore, catfish and the *ruyi* pattern, to pun with "*jiangshan wannian ruyi.*" (the country as wished for ten thousand years)

This robe is a semiformal garment meant for the empress and the first imperial concubine (*guifei*). The colour design is classical and elegant; the weave is exquisite and superb; the jacquards are lucidly delineated and the patterns are regular and alive. By virtue of the veiled patterns and the gold foil outlines, the patterns are radiant and eye-arresting. On the yellow tag is written record by the Qing court.

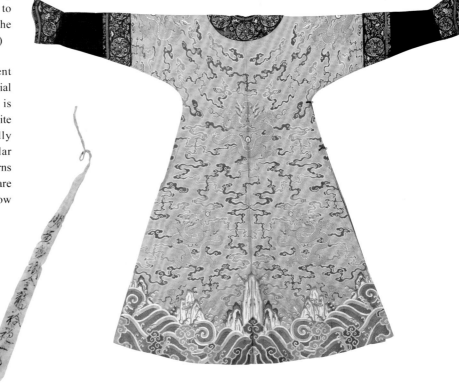

157

Padded Dragon Robe
in Apricot Yellow Satin with Woven Patterns of Colourful Clouds and Golden Dragons

Qing Dynasty Qianlong period

Length of robe 144 cm
Width across both sleeves 170 cm
Width along the lower hem 115 cm
Qing court collection

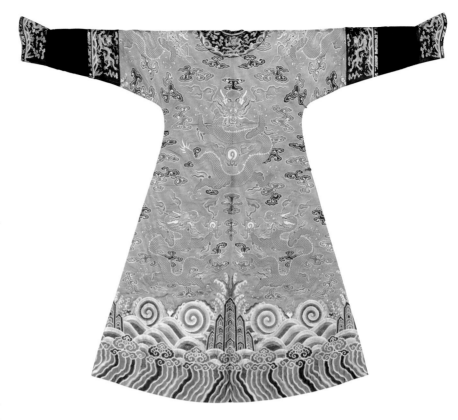

The dragon robe has a face of apricot yellow satin. The lining is made of pale blue silk tabby with veiled patterns of the characters for 卍, "happiness" and "longevity." The padding is in floss. Nine dragons are brocaded on the robe face, one frontal each on the chest, the back and the shoulders, four flying on the front lapels and one flying on the overlapping lapel. In between are multi-coloured clouds. On the lower part are waves lapping against the shore.

The robe was a semiformal garment worn by imperial concubines. Most patterns have their outline traced in gold threads. The colours are rich and noble. On the yellow tag is written record by the Qing court.

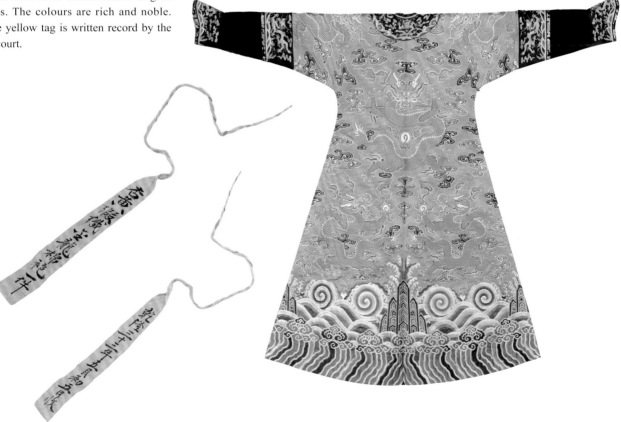

158

Lined Dragon Robe
in Light Brown *Kesi* with
Multi-coloured Clouds and
Golden Dragons

Qing Dynasty Qianlong period

Length of robe 150 cm
Width across both sleeves 179 cm
Width along the lower hem 128 cm
Qing court collection

The dragon robe has a light brown *kesi* face. The lining is made of pale blue *shidisha* (gauze with extra twining warps) with patterns of two dragons playing with pearls. Both the collar and the sleeves are azure blue and fringed with gold leaves. On the robe are woven nine golden dragons, one frontal dragon respectively on the front, the back and each shoulder, one flying dragon on the lower front, one frontal dragon on each cuff and two flying dragons each where the sleeves join the main bodice. In between are multi-coloured flowing clouds, golden character for "longevity," red bats and the figures of the twelve imperial emblems. On the lower part are upright waves from the eight treasures.

The patterns on this robe are rich in colours. The colours are pure and proper and the *kesi* (cut silk) craft is accomplished and some parts are painted on with the ink brush. Even though it was meant for imperial concubines, it has not been found in the dress codes that the twelve emblems should feature there. On the yellow tag is written record by the Qing court.

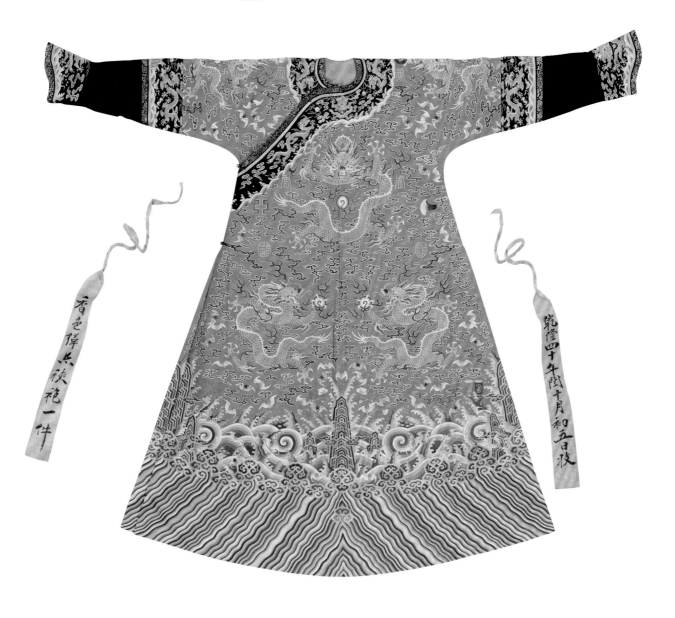

159

Lined Dragon Robe
in Light Brown *Kesi* with
Multi-coloured Clouds and
Golden Dragons

Qing Dynasty Qianlong period

Length of robe 142 cm
Width across both sleeves 176 cm
Width along the lower hem 121 cm
Qing court collection

The dragon robe has a light brown *kesi* (cut silk) face. The lining is made of pale blue straight-warp-*sha* with patterns of dragons in roundels. On the robe are woven nine golden dragons in *kesi* with gold threads and two colours merging. In between are multi-coloured auspicious clouds, and the covert figures of the eight Daoist immortals (*anbaxianwen*). On the lower part are waves lapping against the shore. In addition are woven figures of the magic peach, mansions, temples, pavilions and immortal cranes, to form the pattern of "*haiwu tianchou*" implying prolonged life and longevity.

The patterns of this robe are all woven in *kesi*, employing mainly the method of plain *kesi* weave and decorating it with the uneven propping, phoenix-tail propping, knotting and gilding as well as *kesi*-scale (*kelin*). The *kesi* craft is meticulous and refined; and the colours are various and rich, demonstrating fully the virtues of weaving with the small shuttles in making *kesi*.

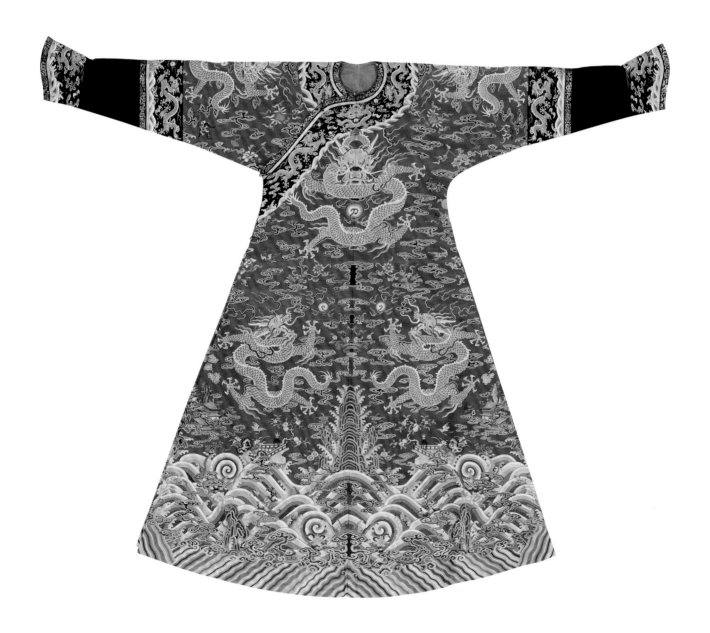

160

Unlined Robe
in Greyish Pink Gauze
Embroidered with Eight
Kui-dragon Roundels

Qing Dynasty Qianlong period

Length of robe 147 cm
Width across both sleeves 150 cm
Width along the lower hem 123 cm
Qing court collection

The unlined robe has a face of *ouhe* (greyish pink) *shidisha*-gauze. There are nine embroidered roundels enclosing patterns of "happy encounters" on the collar's edge, three each on the seams between the sleeves and the bodice and on the horse-hoof cuffs. Eight roundels with floral patterns are embroidered on the front and the back. In the centre of the roundels are characters for 卍 and "longevity." On the upper part are figures of bats and stone chimes; on the lower peonies. All around are figures of *kui*-dragons.

This robe was meant as a semiformal robe for the consorts (*fujin*) of the emperor's grandchildren, great-grandchildren and great-great-grandchildren. On the yellow tag is written record by the Qing court.

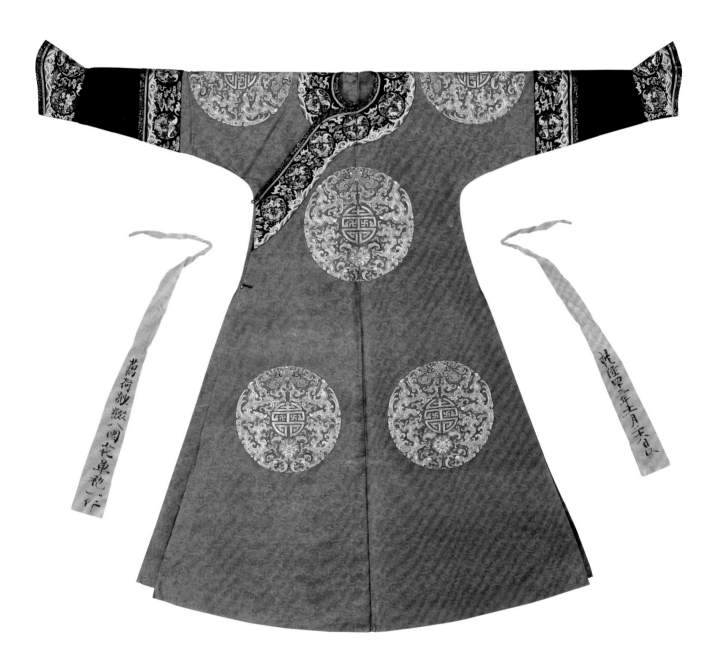

161

Padded Robe
in Green Satin Embroidered with Floral Patterns

Qing Dynasty Qianlong period

Length of robe 156 cm
Width across both sleeves 176 cm
Width along the lower hem 122 cm
Qing court collection

The padded robe has a green face and a lining of pink plain-weave silk fabric. Both the collar and the sleeves are made of azurite blue satin fringed with gold foils. On the face fabric are embroidered flowers of all seasons including the peony, the Chinese rose, the flowering crabapple, the chrysanthemum and the plum flower. In between are figures of butterflies among flowers. The minutiae details of the butterflies are touched up with dyeing by the brush. *Canhexian* stitches are employed to embroider the sprigs of peony and other flowers on the edge of the collar and the sleeves, and threads in mixed colours are used to embroider the stems, the leaves and the vines. There is a strong sense of nuances.

The craftsmanship of this robe is exquisite, showing rich variation in the needlework and the colour design is classical and elegant. It can be regarded as a masterpiece among creations of embroidery. On the yellow tag is written record by the Qing court.

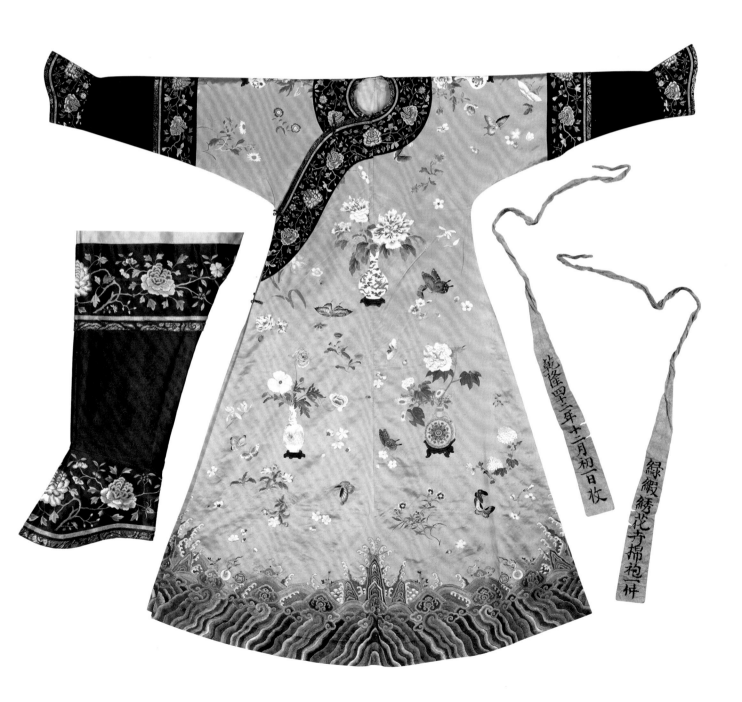

162

Lined Robe
in Light Brown Satin Woven with Patterns of Flying Phoenix

Qing Dynasty Qianlong period

Length of robe 144 cm
Width across both sleeves 174 cm
Width along the lower hem 124 cm
Qing court collection

The lined robe has a face in light brown (*xiangse*) satin and a lining in pale blue plain-weave silk. The edges of the collar and the cuffs are embroidered with roundels enclosing cranes and characters for 卍 and "longevity." The face is brocaded with nine multi-coloured phoenixes, each of which has in its beak sprigs of peony, crabapple and plum blossoms. On the lower part of the robe are woven patterns of waves lapping against the shore, the mixed treasures and *ruyi* clouds.

This robe was a semiformal garment donned by the empress during spring and autumn. Its craft combines brocade with embroidery, which usually uses colours merging in gradation and gold foils to outline the fringes. The colours are bright and sophisticated. On the yellow tag is written record by the Qing court.

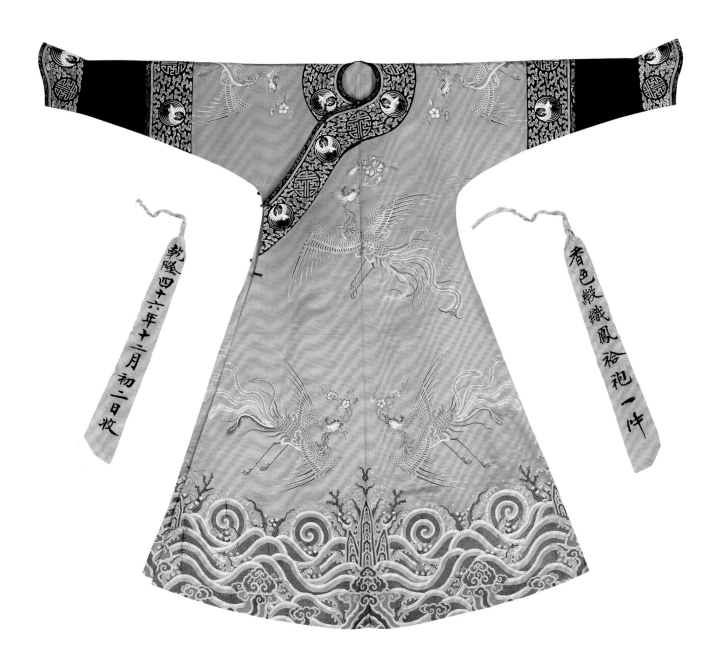

163

Lined Dragon Robe
in Light Brown Satin Woven with Eight Roundels of Blue Dragons and Golden Character for "Longevity"

Qing Dynasty Jiaqing period

Length of robe 148 cm
Width across both sleeves 180 cm
Width along the lower hem 140 cm
Qing court collection

The dragon robe has a light brown (*xiangse*) satin face and a lining of water blue plain-weave silk. The link between the sleeves and the bodice is in plain azurite blue satin. The edges of the collar and the cuffs as well as the seams are fringed with satin brocaded with roundels of dragons and clouds. On the face are eight roundels brocaded with blue dragons sewn with the character for "longevity." On the lower part are waves lapping against the shore. The golden character for "longevity" is outlined with red silk threads, while the other patterns are outlined in watery blue.

This robe forms a set with the padded coat in azure blue satin woven with eight roundels of blue dragons and golden characters for "longevity." (Figure 151) On the yellow tag is written record by the Qing court.

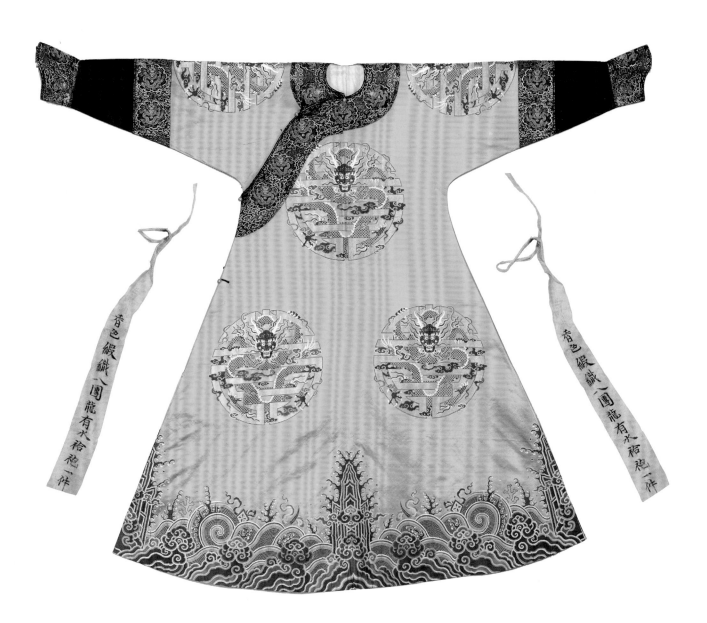

164

Lined Dragon Robe
in Light Brown *Kesi* with Eight Roundels Enclosing Patterns of Dragons

Qing Dynasty Jiaqing period

Length of robe 140 cm
Width across both sleeves 186 cm
Width along the lower hem 112 cm
Qing court collection

The robe has a face of light brown *kesi* (cut silk) and a lining of pale blue silk tabby with veiled patterns of lotus in outline. The edges of the collar and the cuffs are fringed with dragon patterns in azure blue *kesi*. All over are woven nine dragon roundels in *kesi*, one frontal dragon each on the chest, the back and the shoulders, four flying dragons on the front lapel and one flying dragon on the inner lapel. In between are decorative flowing clouds, red bats, blossoms and figures of mixed treasures. The lower part is decorated with upright waves from the eight treasures.

The kind of dragon robe with eight roundels including water was a standard dragon robe for imperial concubines in the Qing period. On the yellow tag is written record by the Qing court.

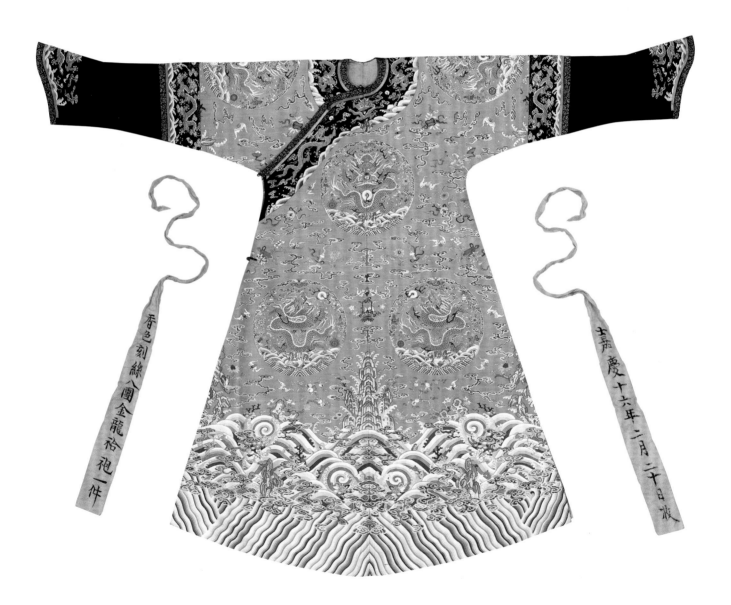

165

Lined Robe
in Bright Red *Kesi* Painted with Eight Colourful Roundels Enclosing the Four Plants of Plum, Orchid, Bamboo and Chrysanthemum

Qing Dynasty Daoguang period

Length of robe 138 cm
Width across both sleeves 204 cm
Width along the lower hem 122 cm
Qing court collection

The lined robe has a round neckline, a broad front closing on the right, horse-hoof cuffs and slits on the sides. The face is in bright red *kesi* and the lining in pale blue *shidisha-gauze*. Fringing the collar and the cuffs are patterns of plum blossom, orchid, bamboo and chrysanthemum in azurite *kesi* (cut silk), and an outer edge of patterns of the character for 卐, bats and flowers are made in golden satin. The face of the robe is painted with a brush colourful patterns of eight roundels enclosing plum blossoms, orchids, bamboos and chrysanthemums. In addition are patterns of waves lapping on the shore woven in *kesi* techniques such as the plain-weave *kesi* and the dovetailing.

The plum blossom, the orchid, the bamboo and the chrysanthemum are together called "the four *junzi* (men of virtue) among flowers," implying the virtues of righteousness, decorum and nobility.

The colour design of this robe is rich and the merging is harmonious. The *kesi* craft is minutiae and delicate and the painting is very vivid. The extraordinary width of the cuffs is a unique hallmark of costumes from the period of Daoguang. On the yellow tag is written record by the Qing court.

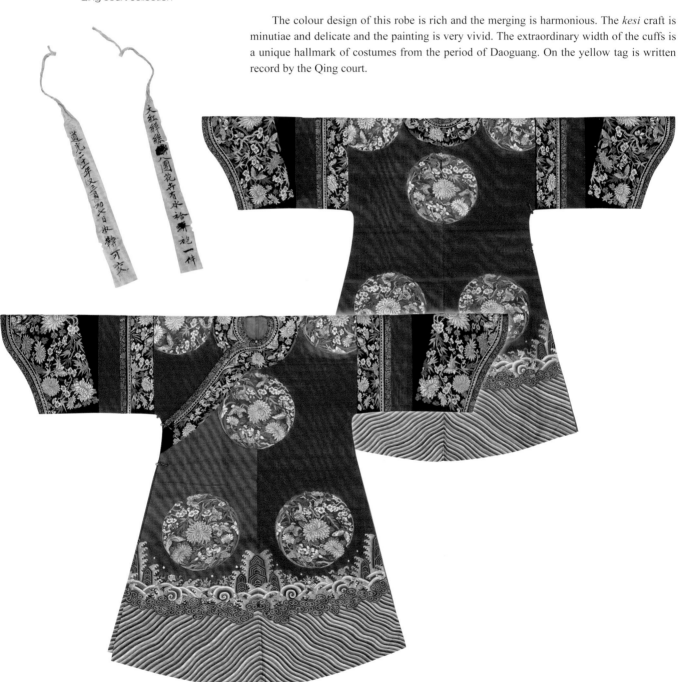

166

Unlined Dragon Robe
in Bright Yellow Gauze with *Shuangmianxiu* of Patterns of Colourful Clouds and Blue Dragons on a Ground of the Characters for "Ten Thousand"

Qing Dynasty Xianfeng period

Length of robe 147 cm
Width across both sleeves 173 cm
Width along the lower hem 126 cm
Qing court collection

The dragon robe has a bright yellow *sha*-gauze face. The edges of its collar and cuffs are decorated with golden satin woven with azure blue flowers and added an outer edge of flat coils of gold threads in two colours. There are two to five colours merging in gradation on the face, and the embroidery stitches employed include the straight stitch, the open loop, the punch stitch and the flat coils of gold threads to create on both the face and the reverse sides (*shuangmianxiu*, double-face embroidery) mirrored images of colourful clouds, blue dragons and six of the twelve imperial emblems (including the sun, the moon, the *fu*-figures, the pheasant (*huazhong*) and the wine vessel (*zongyi* symbol) on a ground of characters for 卍. Some parts are painted on with the ink brush.

The needlework of this robe is exquisite and the stitches very neat. The colours are boldly combined in harmony accentuating the main figures in the pattern design. The face material shows a very high standard of textile technology and was probably procured from the imperial storehouse. On the yellow tag is written record by the Qing court.

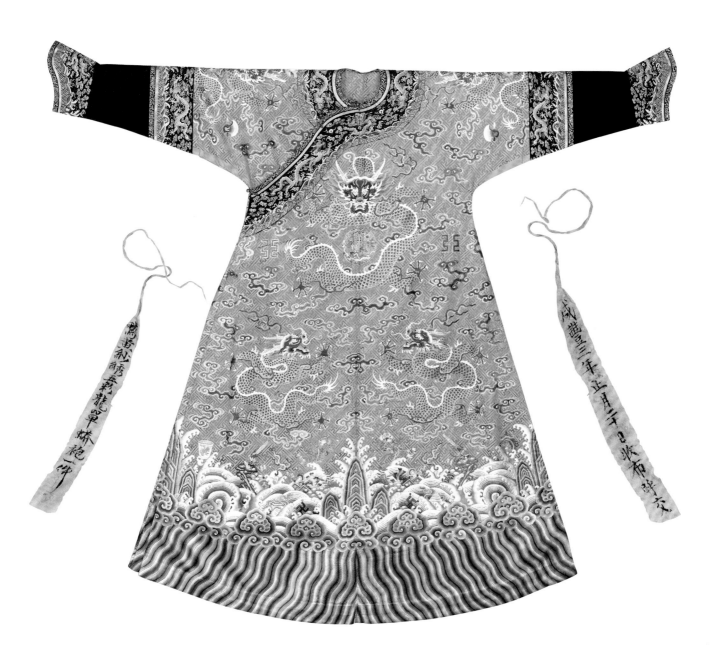

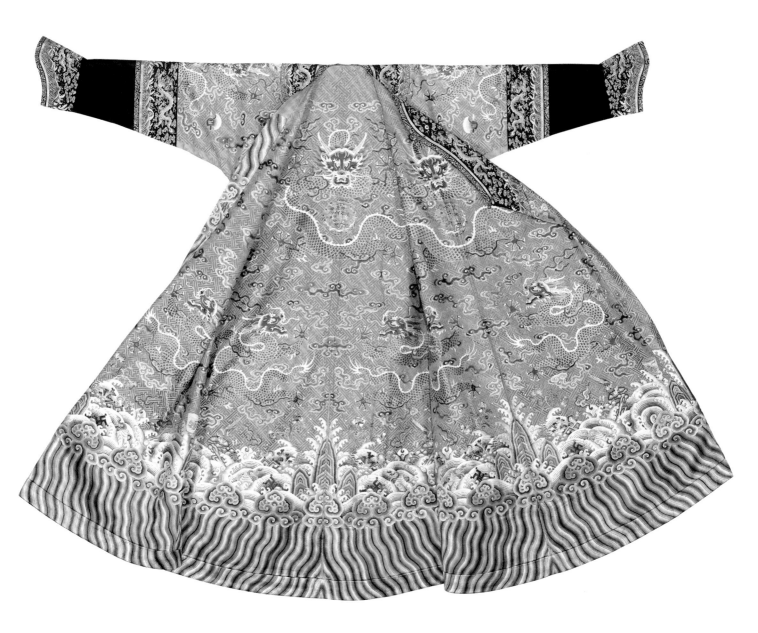

167

Padded Robe
in Bright Red Plain-weave Silk Embroidered with Roundels Enclosing Dragons, Phoenixes and Double-happiness Figures

Qing Dynasty Guangxu period

Length of robe 144 cm
Width across both sleeves 212 cm
Width along the lower hem 118 cm
Qing court collection

The padded robe has a round neckline, a broad front closing on the right, horse-hoof cuffs and slits on the sides. The face material is bright red plain-weave silk fabric, matched with a lining in bright yellow plain-weave silk, and there are five golden buttons in the shape of lotus pods. All over are embroidered various patterns with multi-coloured silk threads and gold threads. On the chest, the back, the shoulders and the lower parts both in front and behind are eight roundels embroidered with golden dragons and phoenixes and figures for double happiness, and there are also the twelve imperial emblems. In between are red characters for "double happiness," gold characters for "luck," "officialdom" and "longevity" and red figures of bats, the magic crane, the longevity peach and other mixed treasures.

This robe was a semiformal garment donned by Qing empresses at their grand weddings. It is also known as the "Robe Uniting the Dragon and the Phoenix," forming a set with the padded coat in azure blue plain-weave silk with eight roundels of dragons, phoenixes and double happiness (Figure 153). The needlework is elaborate, sophisticated and exquisite, and the patterns are sumptuous and opulent, achieving the effect of auspicious celebratory atmosphere. At the grand nuptial ceremony of Emperor Guangxu when he wedded Empress Xiaoding (i.e. later the Empress Mother Longyu), this very robe was donned by the empress-bride.

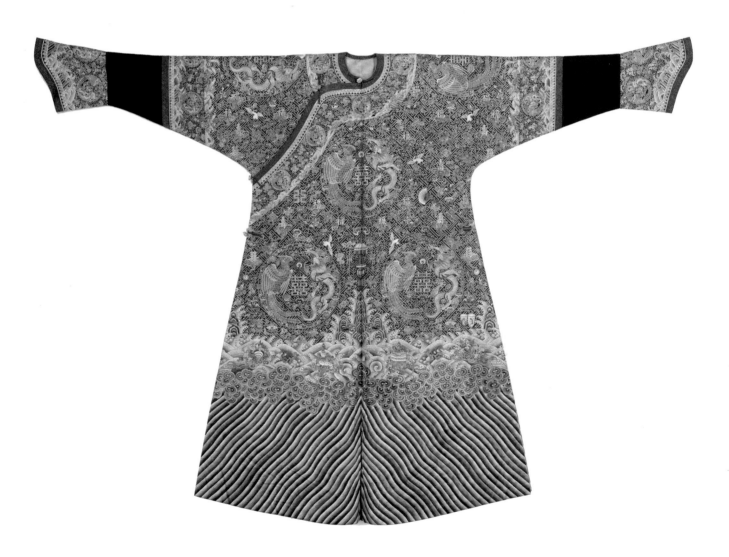

168

Padded Robe
in Bronze-coloured Satin Woven with Hundreds of Butterflies in Golden Threads

Qing Dynasty Qianlong period

Length of robe 145 cm
Width across both sleeves 190 cm
Width along the lower hem 168 cm
Qing court collection

The padded robe has a round neckline, a broad front closing on the right, horse-hoof cuffs and slits on the sides. The face material is bronze-coloured satin and the lining watery blue plain-weave silk. In between is a thin padding of silk floss. The collar and the cuffs are fringed with azure blue plain satin. The figures of hundreds of butterflies are woven on the face material by using two colours of gold threads, one reddish and the other pale gold, which alternate on the wings and the body of the butterflies, thus bringing forth an effect of ethereal elegance.

The twisted threads of this robe are fine and even, and the gold is full of lustre. The robe is an excellent sample of an informal court garment woven in gold by the Jiangning Textile Bureau of the Qianlong period in the Qing Dynasty. On the yellow tag is written record by the Qing court.

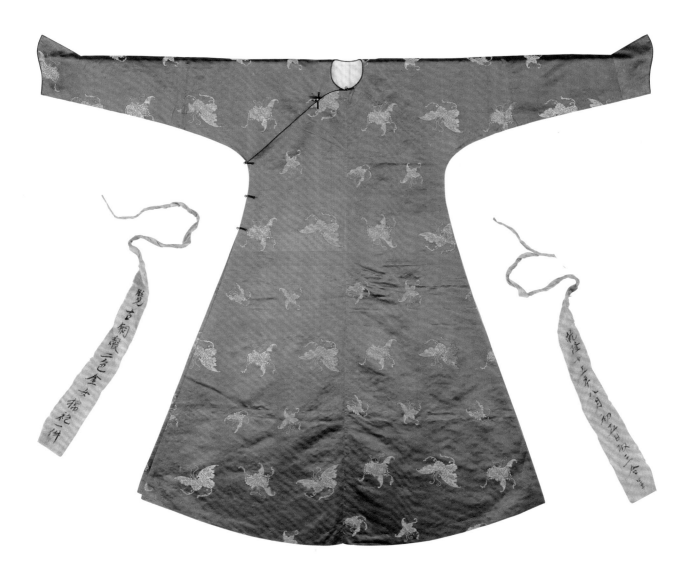

169

Lined Robe
in Purplish *Zhangduan* with Characters for 卍 and Patterns of Chrysanthemum

Qing Dynasty　Jiaqing period

Length of robe 148 cm
Width across both sleeves 180 cm
Width along the lower hem 127 cm
Qing court collection

The lined robe has a round neckline, horse-hoof cuffs, a broad front closing on the right and slits on the sides. The face material is purplish *zhangduan* (satin in Zhangzhou style) woven with characters for 卍, and patterns of winding ripple and chrysanthemum. The lining is made of pale blue silk tabby with veiled patterns of twining sprigs.

The patterns of this robe is simple and elegant. The robe has a yellow tag from Qing court and the record on the yellow tag is erroneous about the material.

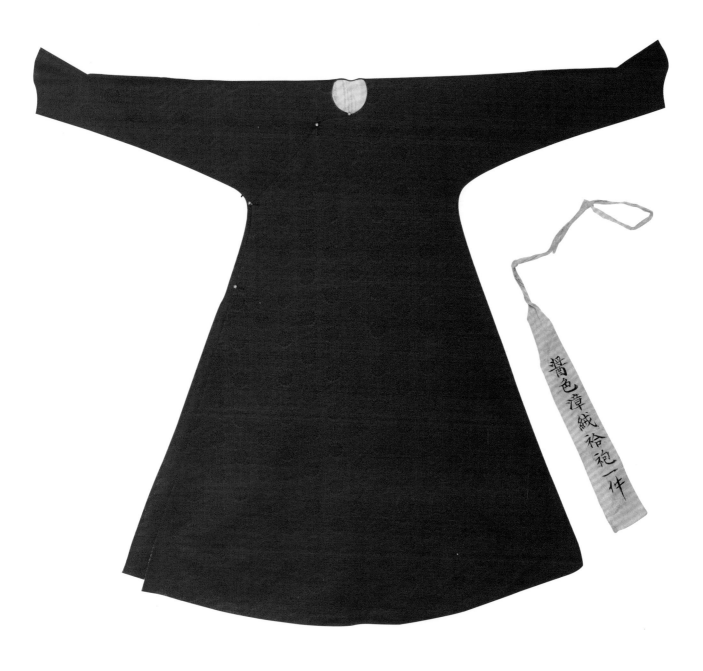

170

Lined Blouse
in Pale Blue Satin Woven with Colourful Patterns of Flowers and Butterflies

Qing Dynasty Qianlong period

Length of blouse 140 cm
Width across both sleeves 172 cm
Width along the lower hem 124 cm
Qing court collection

The blouse has a round neckline, a front with the lapel on the right, level cuffs and no slits. The face material is pale blue brocaded satin, and the lining silk tabby with veiled patterns of twining sprigs. All over are patterns of flowery plants and insects woven with silk threads in a dozen colours including red, green, light brown, yellow, crimson, watery blue, dark grey, light black and off-white. The flowers include peony, lotus, the Chinese crabapple, the plum, the pomegranate, daffodil, the peach blossom, the hydrangea, and the orchid. The plants and insects include the mantis, the cricket, the dragonfly and the butterfly. The patterns are vividly alive and exquisite.

On the yellow tag is written record by the Qing court.

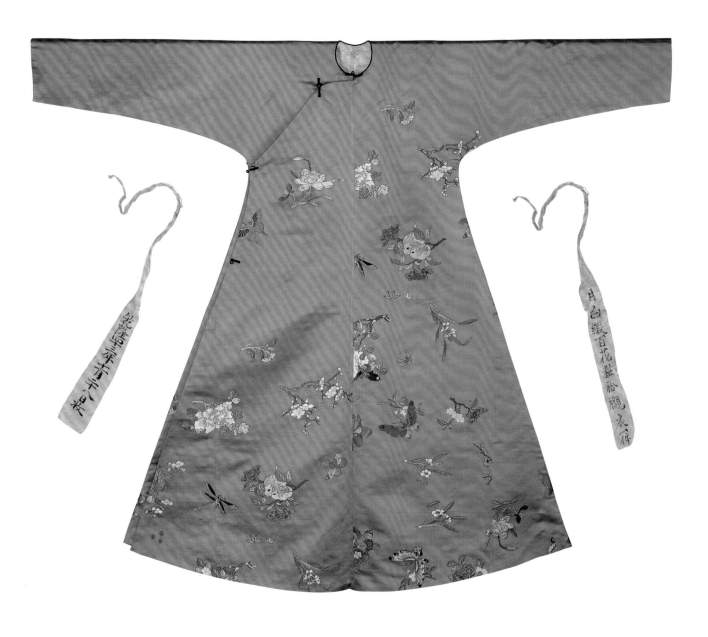

171

Unlined Cloak
in Pale Blue *Nasha* with Floral Patterns

Qing Dynasty Tongzhi period

Length of cloak 138 cm
Width across both sleeves 181 cm
Width along the lower hem 116 cm
Qing court collection

The cloak has a round neckline, a broad front with lapel on the right, short sleeves with level cuffs, slits on the sides up to the armpits. It is decorated with *ruyi* clouds. All over are azure blue gauze with embroidered fringe of lace and two silk ribbons flying on the sides. The face is made of straight-warp gauze in *nasha* (close tight stitches) to embroider twenty-odd flowers from all seasons including peonies, chrysanthemums, plum blossoms and crabapple flowers. In between are decorated with patterns of colourful butterflies.

The pattern arrangement of this garment is sparse and open; the colour design is soft and tasteful; the needlework is regular and neat; the stitches are fine and dense; the gauze meshes are airy and the material is smooth and soft and thus comfortable for clothing. On the yellow tag is written record by the Qing court.

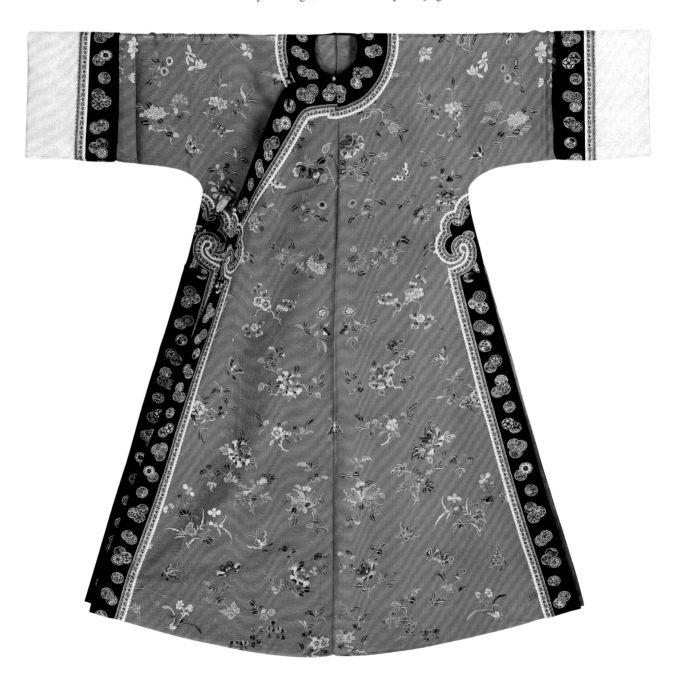

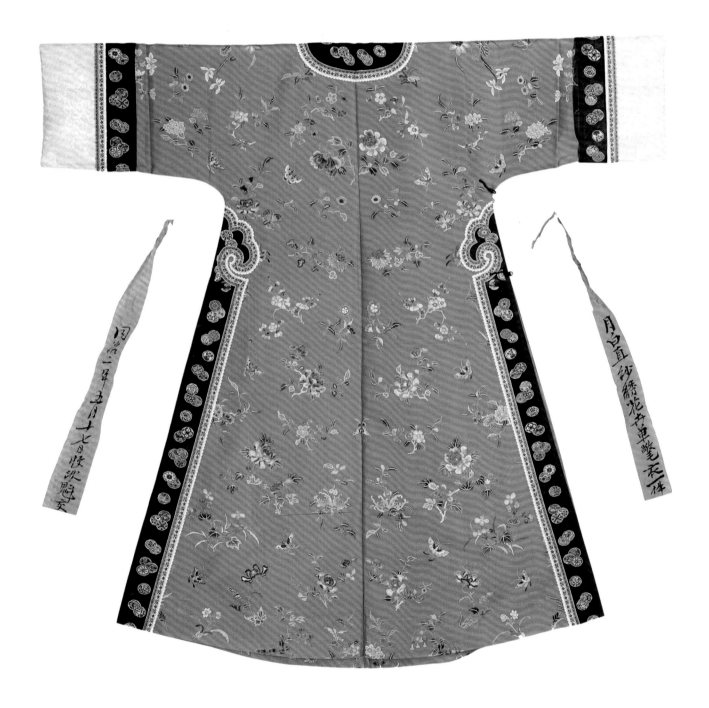

172

Lined Cloak
in Bright Yellow Satin
Embroidered with Magnolia
and Osmanthus Blooming
with Fragrance

Late-Qing period

Length of cloak 104 cm
Width across both sleeves 114 cm
Width along the lower hem 114 cm
Qing court collection

The face material of the cloak is bright yellow satin and the lining is pink straight-warp gauze with patterns of butterflies. The collar and cuffs are fringed with azure blue satin embroidered with magnolia and osmanthus patterns, and there is an additional fringe in golden satin woven with azure blue characters for 卍. The light brown silk ribbons bear patterns of two dragons playing with pearls. The method of merging two to four colours in gradation is used and stitches include the open loop, the straight stitch, the punch stitch and the flat coils of golden threads to embroider colourful osmanthus and purple magnolia, forming a picture of "magnolia and osmanthus blooming with fragrance" to imply "posterity in prosperity."

The pattern arrangement of this garment is vivid and alive. The colour pattern is opulent and noble. The needlework is exquisite. It is a masterpiece of embroidery from the late-Qing period.

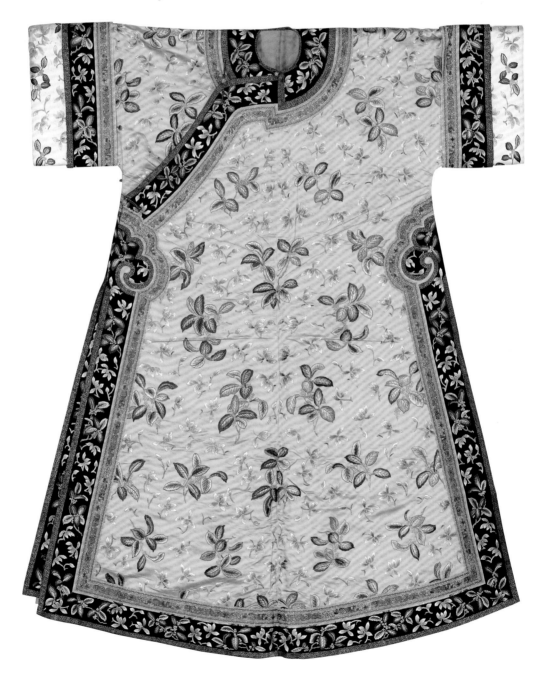

173

Lined Overcoat
in Azurite Satin Embroidered
with Three Patterns of Blue
Flowers and Butterflies

Qing Dynasty Tongzhi period

Length of coat 141 cm
Width across both shoulders 40 cm
Width of the lower part 108 cm
Qing court collection

The overcoat (*gualan*) has a face of azure blue satin and a lining of bright yellow silk tabby with veiled patterns of peonies and chrysanthemums. There are slits on the sides all the way up to the armpits. The collar and the lapel are decorated with patterns of deer and birds with a small flowery blue silk ribbon each. The edges are fringed with azure blue satin. The face material has two to three colours merging in gradation and the stitches include the straight stitch, the twining stitch and open loop to embroider the butterflies, the orchids and the plum blossoms.

The *gualan* was a casual garment worn by imperial concubines on top of their robes and dresses in everyday life. This overcoat has a quiet and elegant colour design and shows very meticulous and exquisite needlework. Its colour scheme was very popular for costumes for imperial concubines during the late-Qing period. On the yellow tag is written record by the Qing court.

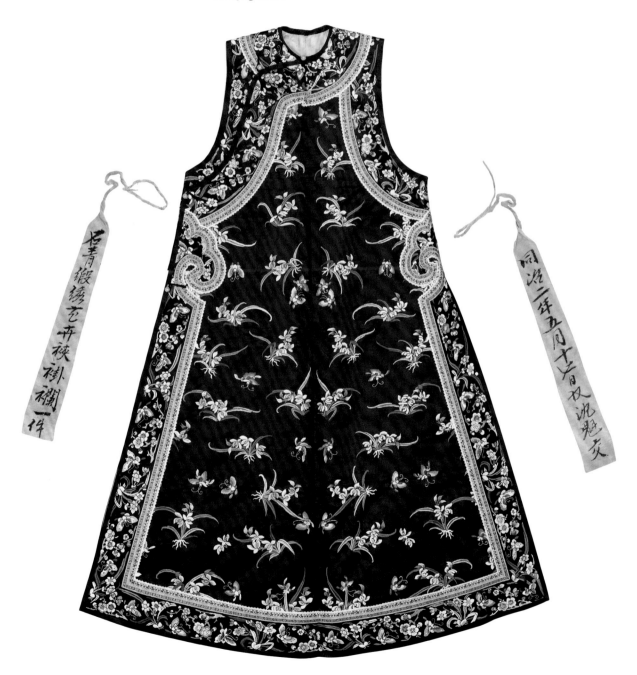

174

Lined Overcoat
in Turquoise *Kesi* with
Chinese Crabapple Patterns

Late-Qing period

Length of coat 139 cm
Width across both shoulders 40 cm
Width of the lower part 116 cm
Qing court collection

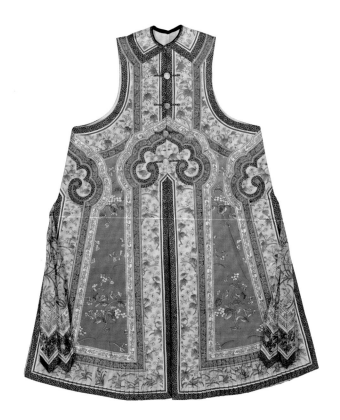

The overcoat has a face made of turquoise *kesi* (cut silk) woven with patterns of Chinese crabapples, and the lining is made of pale blue plain-weave silk. Two silk ribbons in clear blue *kesi* with plum blossom patterns hang from the inner lapel. On the sides along the slits are two greyish pink flying ribbons in *kesi* with patterns of orchids. The lower part is pleated. All along the fringe of the coat is a wavy strip of golden satin with black characters for 卍.

Under the armpits of this *gualan* or overcoat are added patterns of *ruyi* clouds, and there are several layers of ribbons sewn along the edges with patterns of blue chrysanthemums and yellow daffodils, reflecting the fashion of popular female garments during the late-Qing period.

175

Lined Close-fitting Vest
in Azure Blue *Kesi* with
Patterns of Bamboo and Rocks

Qing Dynasty Guangxu period

Length of dress 71 cm
Width across both shoulders 42 cm
Width of the lower part 93 cm
Qing court collection

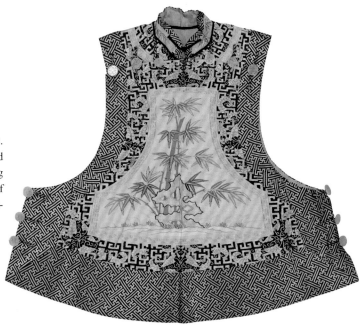

This close-fitting garment has an upright collar and no sleeves. All along the fringe is a strip of satin woven in gold threads and decorated with patterns of black characters for 卍 and meandering water. The *kesi* (cut silk) face is woven with white patterns of rocks, bamboo branches. The lining is made of greyish pink plain-weave silk fabric.

176

Magua
in Blue Satin Embroidered with Beads to Make Figures of Jasmine and Nandina

Qing Dynasty Guangxu period

Length of coat 62 cm
Width across both sleeves 136 cm
Width of the lower part 70 cm
Qing court collection

The *magua* (riding coat) has an upright collar and a *pipa*-lapel (short and crooked). The cuffs are level and there are four slits. All along the edges are golden satin fringes inlaid with bluish longish or round characters for "longevity." The face material is blue satin, and the lining is made of watery blue plain-weave silk. On the upper front and the back are figures of jasmine and nandina sprigs embroidered with coral beads and small pearls. The leaves are embroidered with threads in traditional ways. The composition is simple and neat and the colour scheme is clear and elegant.

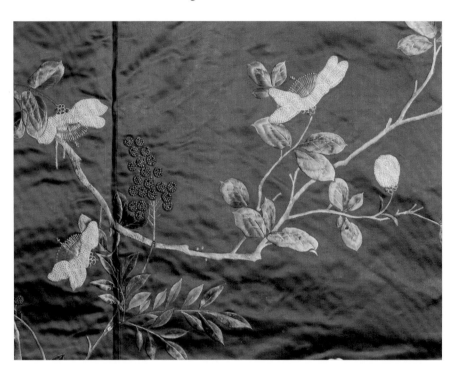

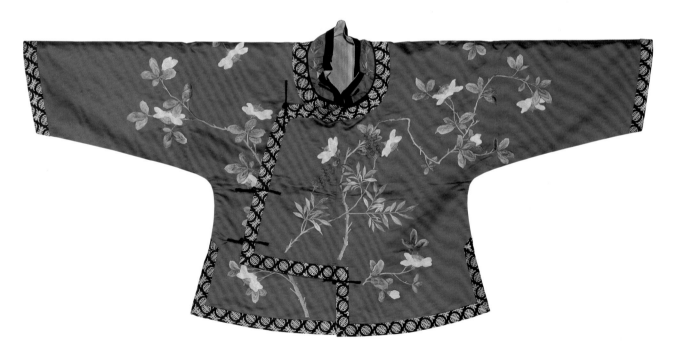

177

Fur Coat
in Bright Yellow Plain-weave Silk with Double-happiness Symbols

Qing Dynasty

Length of coat 68 cm
Width across both sleeves 144 cm
Width of the lower part 80 cm
Qing court collection

The fur coat has a face of mink or marten pelt and a lining of bright yellow plain-weave silk with veiled patterns of dragon roundels. There are slits on the sides and at the back. Along the lapel and the cuffs are mink fur strips showing upright hair straws between the mink hide face and the bright yellow lining. All over the garment are figures of 46 characters for "double happiness" made in collage of snow weasel and purple marten furs.

This coat was used by imperial concubines at grand weddings. The fur collage is exquisitely done and the characters look lucid and neat. The pelt has smooth fur and level hide. The hide has a width of thickness of only 1.5 mm and it is thin and fine like silk cloth. The upright fur straws are about 1 cm long. The craft is unsurpassably exquisite.

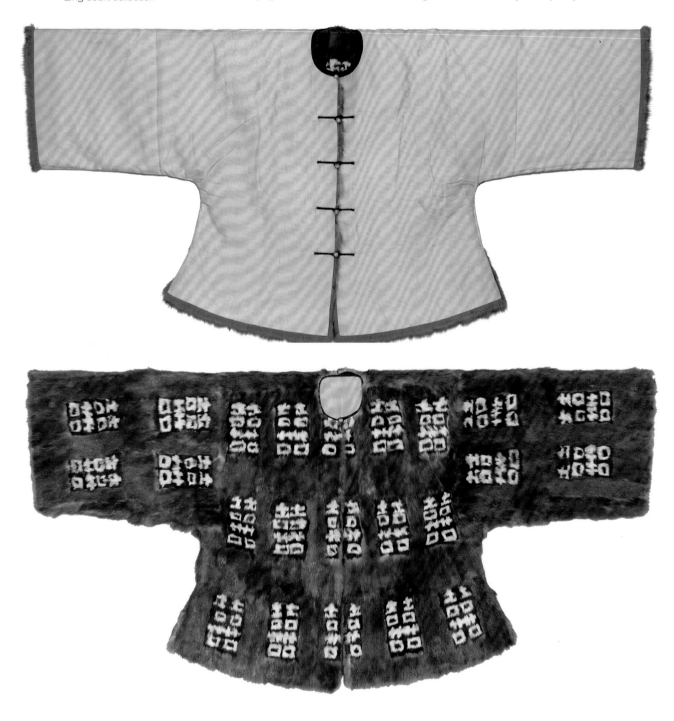

178

Unlined Courtly Robe
in Azure Blue *Sha*-gauze
Woven with Cloud and
Mang-dragon Patterns

Qing Dynasty Kangxi period

Length of robe 133 cm
Width across both sleeves 211 cm
Width of the lower part 141 cm Down-
turned broad collar 86×33 cm
Qing court collection

The courtly robe has a round neckline, a broad front with lapel closing on the right, horse-hoof cuffs and a broad collar attached. The lower part of the garment has folds and on the left is a slit. The face is made of azure blue *sha*-gauze and the links between the bodice and the sleeves are made of azure blue *shidisha*. All along the edges are fringes of gold foils. The patterns include the mixed treasures, the twining lotus, clouds and gourds with characters for "*youyuan*" and "*songchang*" inside. The lining for the collar is made of red satin woven with gold threads and characters for "*youlian.*" On the upper bodice is the brocaded persimmon calyx inside which are woven two four-clawed *mang*-dragons decorated with water patterns. Around the waist, on the collar and the cuffs are figures of flying *mang*-dragons and waves lapping the shore. The folds are woven with figures such as the golden *mang*, the *lingzhi*, the cloud-bats and waves lapping on the shore.

This robe was meant for dukes, marquises and earls as well as civil and military officials down to the fourth rank. The patterns are in bold and bright colours with strong contrast. The weaving of the *mang*-dragons with twisted gold threads was done in such a way that the middle was not completely covered so that the red was shown at equidistance, creating an effect of the red round gold (*chiyuanjin*). But the colour of all the woven golden fringes has faded, which may be due to the deficiency of gold applied.

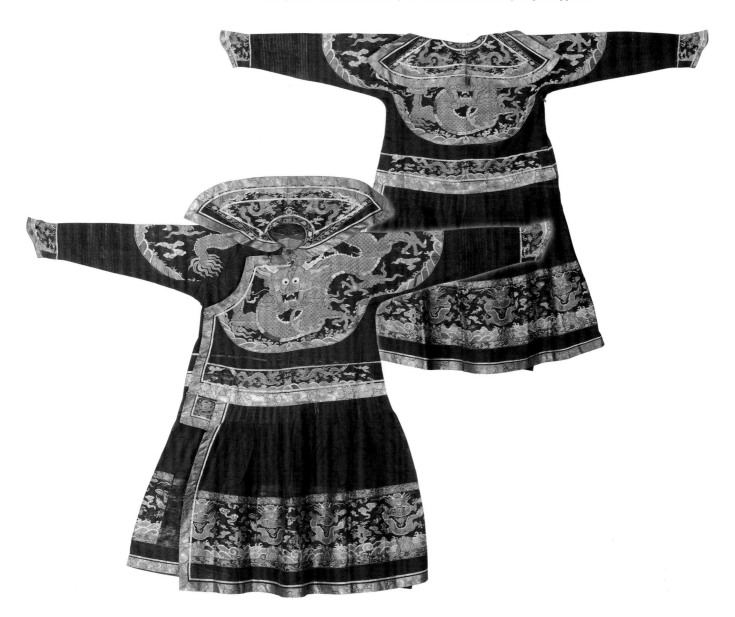

179

Unlined Coat
in Black *Nasha* with Square Insignia

Qing Dynasty

Length of coat 122 cm
Width across both sleeves 170 cm
Width of the lower part 102 cm
Qing court collection

The unlined coat has a round neckline, a front opening in the middle, level cuffs and slits on the sides as well as the back. At the top of the side slits is a polished copper button and on either side of the end of the back slit is a button loop, so that when riding, the rider could have the back of the coat lifted and fixed on the sides. The black plain-weave silk has veiled patterns of the character for "longevity" and on the front and the back is respectively a square insignia embroidered with patterns of egrets in *nasha* (close tight stitches).

The square insignia has a ground weave of black plain silk cloth, on which are embroidered figures of waves, clouds and curly plant patterns (*juancaowen*) in a string of stitches with a single filament. The frame is embroidered with cranes and a red sun in such stitches as the twining stitch, the open loop and sparse stitches, and the frame is fringed with yellow embroidered threads. It can be deduced from the insignia that this coat was meant for civil officials of the sixth rank during the Qing Dynasty.

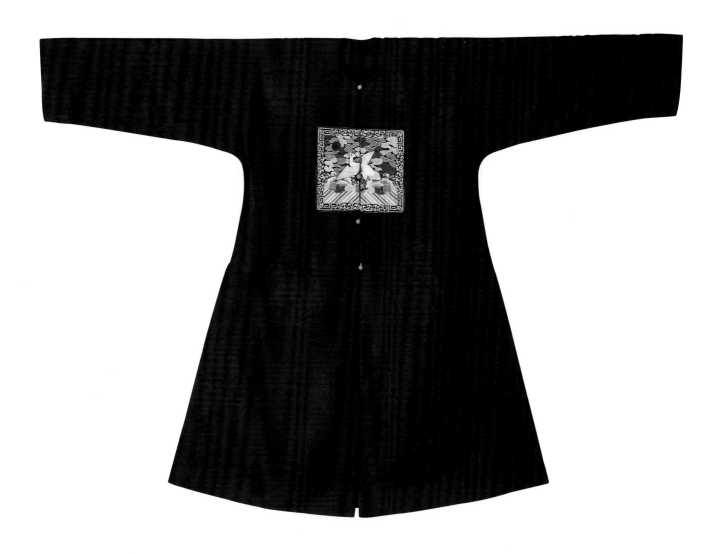

180

Lined *Jiayi*
in Bright Red Plain-weave Silk Cloth with Painted Floral Patterns

Qing Dynasty

Length of garment 126 cm
Width across both sleeves 193 cm
Width of the lower part 94 cm
Qing court collection

The garment for harnessing (*jiayi*) has a round neckline, a front with lapel closing on the right, level cuffs and slits in front and behind. The face material is red plain-weave silk fabric, on which are painted flowers in white, yellow, malachite green, deep blue and snow blue. The lining is in pale blue cotton.

This harnessing garment was made by the Jiangning Textile Bureau and meant as a ceremonial costume for ceremonial guards and scholar field officers. Other garments to match it in a set are green silk sash around the red *jiayi* and a hat with feathery tassels.

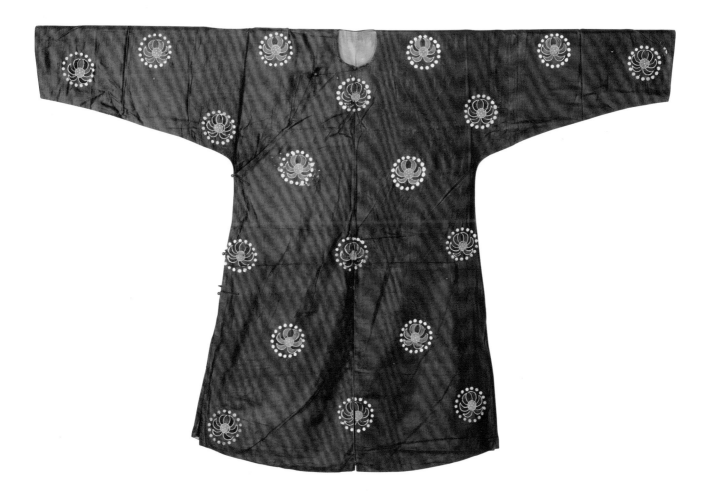

181

Winter Hat
as Semiformal Costume

Qing Dynasty

Height 18 cm Diameter 31 cm
Qing court collection

The rim of the hat tilts upward and it is made of marten fur. The top of the hat has a face of azure blue plain satin decorated with neat and even vermilion wefts in an S-twist. The very tip is a golden seat with kingfisher feather on gold plate holding a big pearl. The lining is red cotton cloth and strip to tie on the hat is blue cloth.

This hat was donned by the emperor when he wore his winter semiformal costume. On the yellow tag is written record by the Qing court.

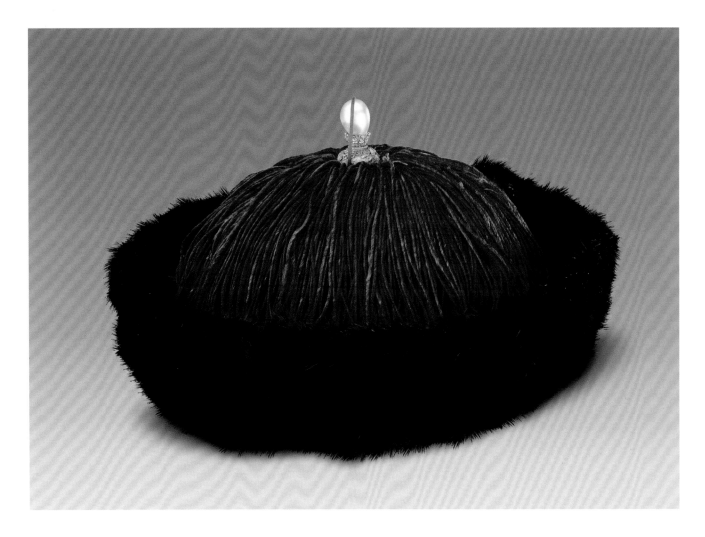

182

Hats
for Semiformal Costume

Qing Dynasty

Height 16 cm Diameter 25–30 cm
Qing court collection

These three hats were meant for three different ranks of officials wearing semiformal costumes. According to this order: The crystal top felt semiformal hat was for use by the fifth rank of civil and military officials as well as district chiefs and their consorts; the leather hat topped with *chequ* stone was meant for use by the sixth rank of civil and military officials; the flannel hat with plain gold top was meant for the seventh rank of civil and military officials as well as *jinshi*-scholars.

The hats of the Qing period are marked by the pearls or gems on top to differentiate the ranks of the wearers. There are also differences due to different seasons. There are two forms, namely, the round top and the tilted rim. The materials vary between purple marten fur and black felt. Both are decorated with red wefts.

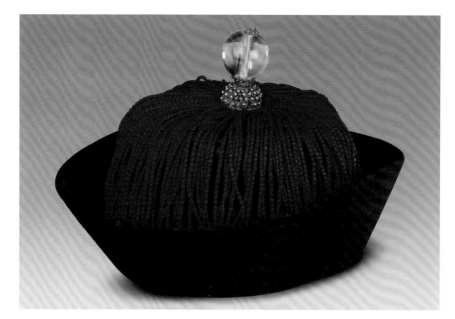

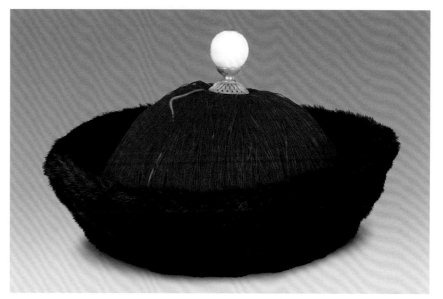

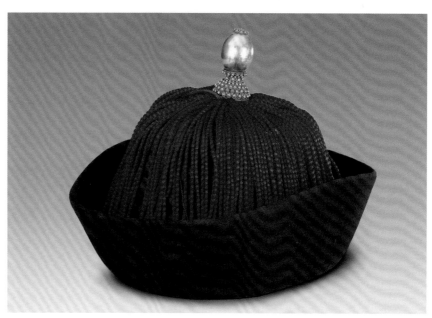

183

Hat
for Winter Travel

Qing Dynasty Tongzhi period

Height 14 cm Diameter 28 cm
Qing court collection

The hat has a black satin face and red satin lining. The tilted rim is made of black felt. There are red wefts as decoration and the top knob is tied up in red felt.

This hat was donned by Emperor Tongzhi when he travelled in winter time and it was meant to match his travel apparel. The yellow tag on it shows that it had been used for consecrations, an institution which started in the reign of Kangxi. On the yellow tag is written record by the Qing court.

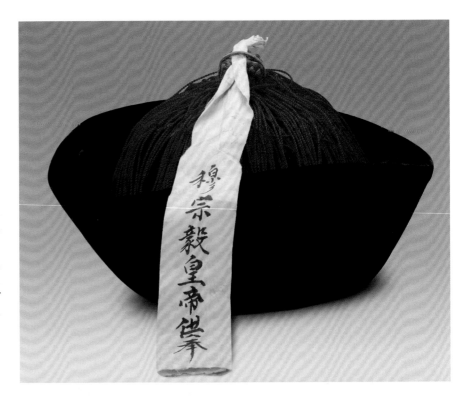

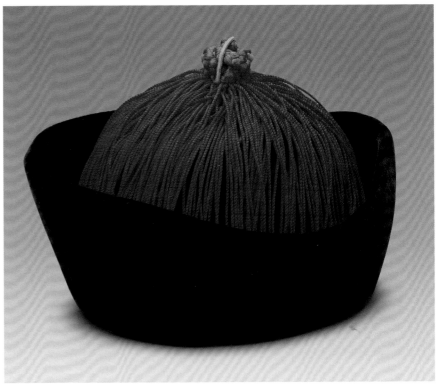

184

Hat
for Travel in Summer

Qing Dynasty

Height 18 cm Diameter 30 cm
Qing court collection

This looks like a bamboo hat. On top of it is a bunch of flowers made of bright red silk threads. All around are tassels of red twisted silk threads hanging down, and the top is decorated with a big Manchurian pearl (*dongzhu*). Underneath is a strip of blue cloth for tightening and fixing the hat. The face material of the hat is *sha*-gauze in its natural colour and woven with mat patterns. Around the edge of the hat is a fringe of golden satin woven with patterns of azure blue flowers, and there is an azure blue silk ribbon woven in herringbone patterns. The lining is made of bright red silk crepe, in which is sewn a hatband of the same material.

This hat was donned by the emperor on tours in summer time.

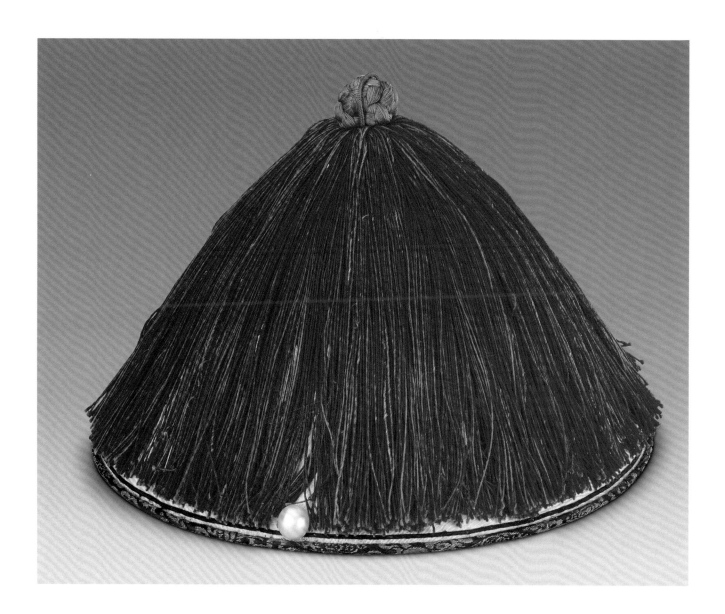

185

Ruyi Hats
for Auspiciousness

Qing Dynasty

Height 12–15 cm Diameter 18–20 cm
Qing court collection

These four *ruyi* hats are all made by sewing together six pieces of satin each. The pieces are lozenges and they form the shape of half a melon together with a round top tied up by a red flannel knob to imply "six parts (east, south, west, north, above, and below) in unity." (*liuhe yitong*) The rim of the hats are variously fringed with golden satin or plain satin, and a red tassel hangs down at the back. The decorative patterns on the hats are either sewn on with coral beads and pearls or embroidered, implying respectively "celebration of longevity and happiness" (*fushou jiqing*) and "five bats holding up longevity." (*wu fu peng shou*)

These hats are exquisitely made in splendid colours. The emperor wore them when donned in casual wear.

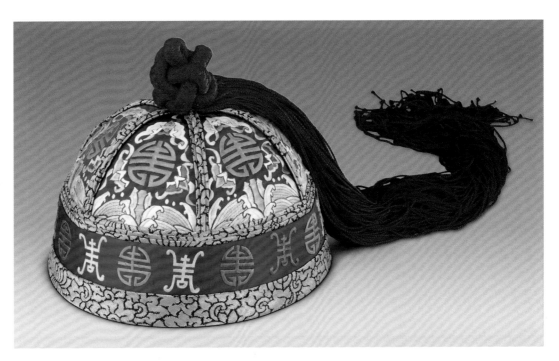

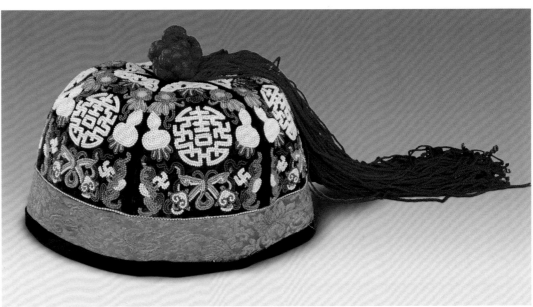

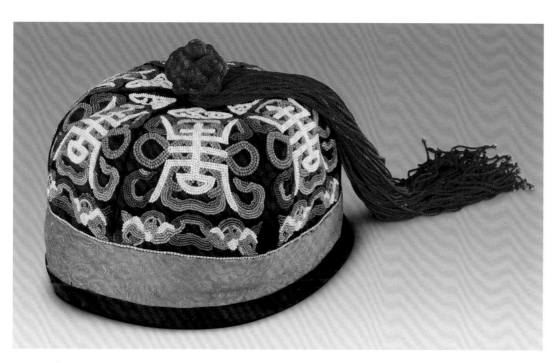

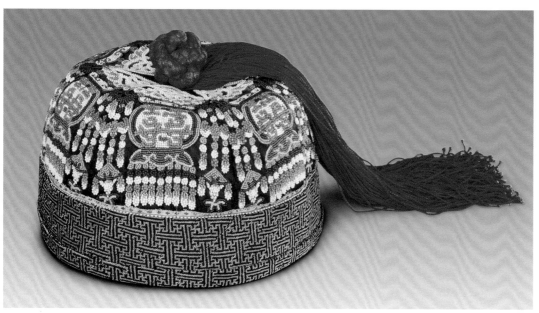

186

Court Hat
for Imperial Concubines

Qing Dynasty

Height 30 cm Diameter 16 cm
Qing court collection

This court hat is round and its rim curls up. On the top is a knob in red flannel, while the rim is fringed with black marten fur. The lining is made of red cloth. In the middle of the top is a copper knob made of copper threads in two layers, each being a phoenix holding a big pearl. At the very tip of the hat is a pinkish gem of tourmaline. The knob on the hat top is surrounded by red flannel on which stands a piece of birch bark coated with six silver phoenixes, each being decorated with a gem called cat's eye and 30 pearls. From behind the hat hangs a bunch of blue silk ribbons and a black mink piece protecting the collar. The hat follows the rule of *wuhang erjiu*, i.e. there are five strings of pearls hanging, each in two sections separated in the middle by knots made of lapis lazuli fixed by golden threads with six pearls on either side. At the end of each string is a pendant of red coral.

"*Wuhang erjiu*" is a rule stipulated in the *Daqing Huidian* (Record of Codes of the Qing Dynasty). It is a hallmark of the rank of the empress mother and the empress, though its exact content is beyond corroboration by research. There may be some inference by studying the artefacts that the *wuhang* (five rows) refers to the five strings of pearls hanging down and *erjiu* (two sets) to the two sections of each pearl string separated with the knot of lapi lapzuli.

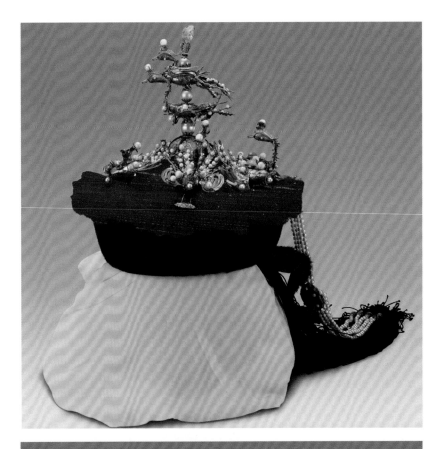

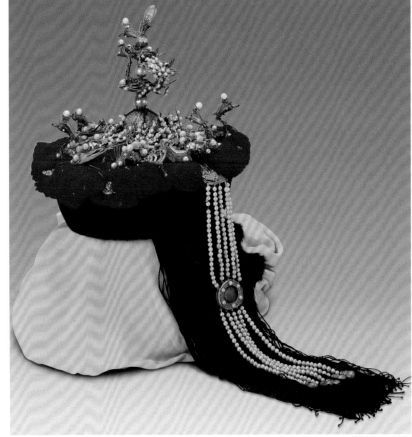

187

Hair Ornament
Inlaid with Beads and Gems

Qing Dynasty

Height 17 cm　Diameter 24 cm
Qing court collection

The hair ornament has an armature of iron wire around which are wound black silk floss. This is covered with a set of decoration comprising various beads and gems such as pearl, coral, jade and tourmaline. Kingfisher feather is added in a support made of copper threads. Patterns include characters for *wan* (卍) and "longevity," butterflies, twin coins, celestial cranes, *lingzhi*-fungi, orchids, longevity peaches, the *ruyi* staff, the brush, the gourd, the flower basket, the dragonfly, the nandina, the pomegranate and the auspicious clouds, implying "everlasting posterity" (*zisun wandai*) and "long life as wished." (*changshou ruyi*)

The *huadian* (hair ornament) is a traditional hat style for Manchurian women. As it looks like a basket turned upside down, it is also called "upside-down basket." (*fujizi*) It became a hat often donned by imperial concubines wearing semiformal costumes during the late-Qing period. It could be plain or ornate, and its design and patterns carry respective symbolic meanings.

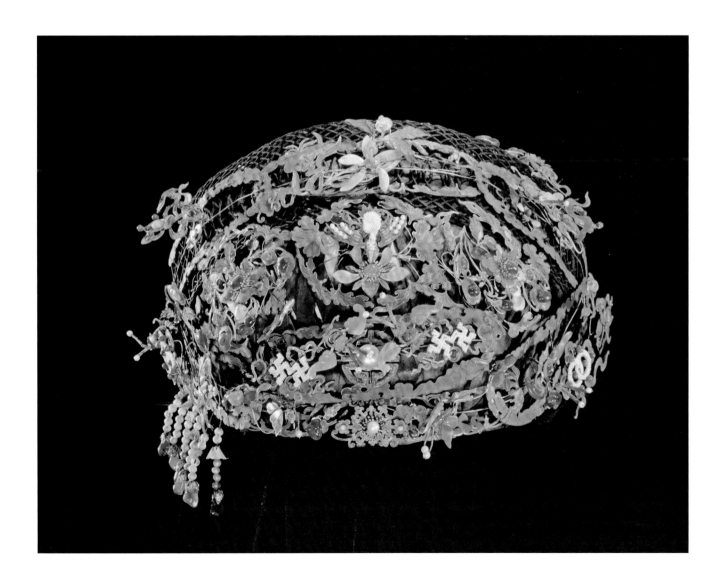

188

Golden Hairband
Inlaid with Lapi Lazuli Stones

Qing Dynasty

Outer diameter 21.5 cm
Inner diameter 18.6 cm
Thickness/Height 1.2 cm
Qing court collection

The hairband is composed of two parts—the golden hoop and the string of pearls hanging at the end. The pearl strings of this piece are already lost and there is only the golden hoop left. The hoop is composed of eight supporting parts, along the edges of the upper and lower sides of which are spiral cloud patterns, and in the centre of each is inlaid lapis lazuli. The eight parts are linked by riveting pins in the shape of plum blossoms and outside the centre are clouds made of metal threads on which are inlaid Manchurian pearls (*dongzhu*)

The golden hairband (*jinyue*) is a hair ornament for imperial concubines of the Qing Dynasty. It was put on to bind the hair before putting on the court hat. The number of sections in the hoop and the number of pearl strings are hallmarks for the status of the imperial concubine wearing it. The empress mother and the empress had hairbands with thirteen clouds carved on the gold and five strings of pearls in two sections each; the first ranking imperial concubine and other imperial concubines have hairbands with twelve clouds and three pearl strings in three sections; ordinary concubines eleven clouds and three strings in three sections; and court ladies eight clouds and three strings in three sections. This hairband was used by a court lady. On the yellow tag is written record by the Qing court.

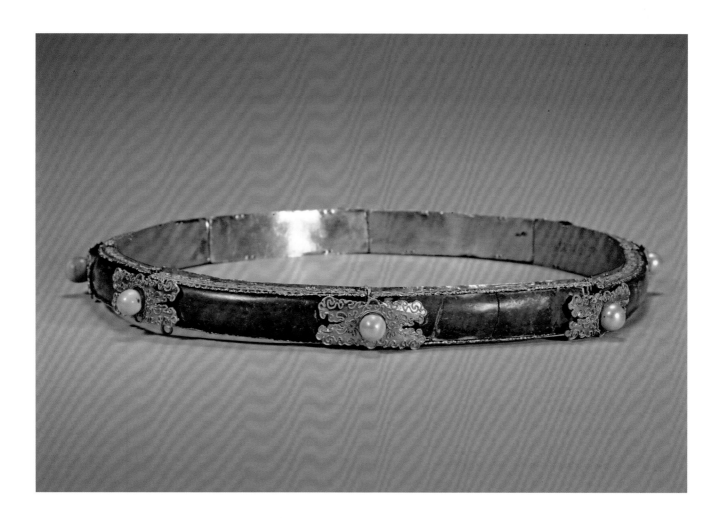

189

Golden Collar Band
Inlaid with Lapi Lazuli Stones

Qing Dynasty

Circumference 46 cm Diameter 22 cm
Qing court collection

The collar band is shaped like a ring with a flexible opening on the ring and encrusted four elongated pieces of lapis lazuli and two red pieces of other gems. On top are inlaid two pieces of ruby, two pieces of opal and one pearl. At the opening are patterns of flowers, clouds and bats engraved in gilt metal and tied each to a bright yellow silk ribbon once decorated with red beads of stone and at each corner a pendant of red semiprecious gems. Extant now is only one red bead of stone on the ribbon and the pendants are also lost.

The collar band (*lingyue*) is also called the neckring (*jingquan*). It was an ornament used by imperial concubines to keep their clothes in place around the neck.

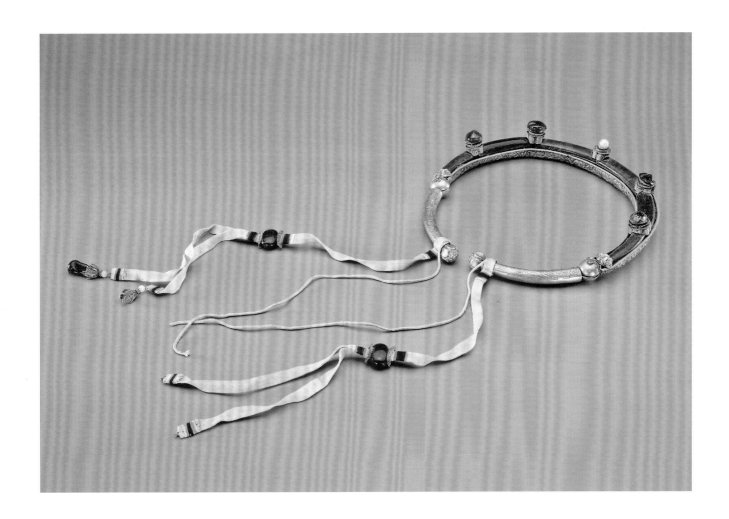

190

Court Necklace
of *Dongzhu*

Qing Dynasty　Xianfeng period

Length 139 cm
Qing court collection

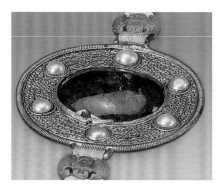

The court necklace is composed of 108 *dongzhu* (Manchurian pearls, or East Pearl), with four red coral "Buddha head" beads (*fotou*) at intervals. On either side of the "Buddha heads" are two blue crystal beads each, and under the "Buddha head" at the top is a decorative red coral "Buddha-head pagoda" (*fotouta*). From under the pagoda are two bright yellow ribbons hanging with oval plates made of gold threads inlaid with rubies and a *beiyun* tassel of pearls, which have at the upper and lower ends respectively knots with coral bats. The corner pendants are composed of a seat made of gold threads and kingfisher feather supporting emeralds inside. The court beads are in three *jinian* strings, each of which contain ten turquoise stones and from each hangs a pendant made of gold threads and kingfisher feather embedding rubies, sapphires and tourmalines.

This necklace was used by Emperor Wenzong Xianfeng of the Qing Dynasty and stored in a black lacquer drawer. A yellow tag is attached. On top of it is a yellow silk wrapping.

Dongzhu is found in the region of Songhua River, provenance of the Manchu people. It can be divided into five grades according to its size and its shape and lustre. The pearls in this court necklace have all a diameter over 10 mm and their sizes are even. They should belong to grade one. Court necklace made of Manchurian pearls are considered the most valuable and specially reserved for the emperor, the empress mother and the empress alone to wear.

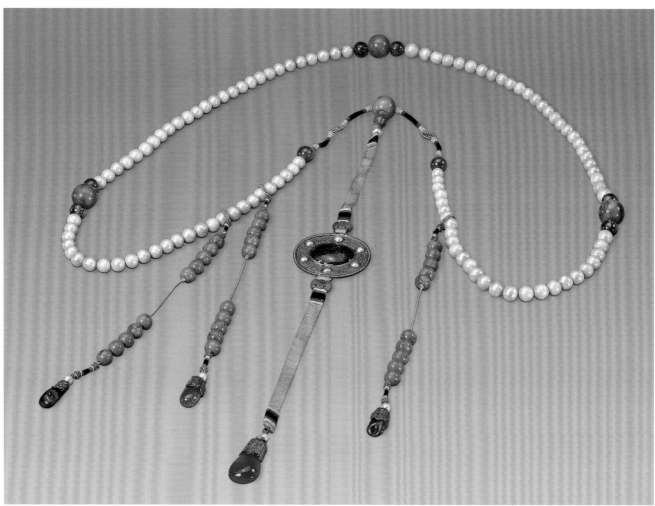

191

Court Necklace
of Red Coral Beads

Qing Dynasty

Length 122 cm
Qing court collection

The court necklace is composed of 108 red coral beads, separated by four lapis lazuli "Buddha head" beads (*fotou*) at intervals, with each a pagoda on the head and a square gold thread seat embedding an oval lapi lazuli gem hanging down a set of *beiyun* tassels. On one side of the *beiyun* are two thin plates of gold inlaid with kingfisher feather in the shape of clouds with dots of emerald, at the lower end is a big pendant of ruby. There are three silk strings (*jinian*) each threading ten beads of turquoise, at whose end are two ruby pendants and one pink tourmaline pendant.

The materials for court necklaces include the Manchurian pearl, the lapis lazuli, cloudy amber, coral, turquoise, agate, crystal, emerald, amber, incense tree, ivory and tourmaline, depending on the identity of the wearer, the grade and the occasion. It was stipulated in the codes the emperor should wear a coral necklace when attending sacrifices at the Altar to the Sun (*Chaoritan*). In addition, the empress mother and the empress as well as the first ranking imperial concubine should wear two red coral necklaces when donning court costumes.

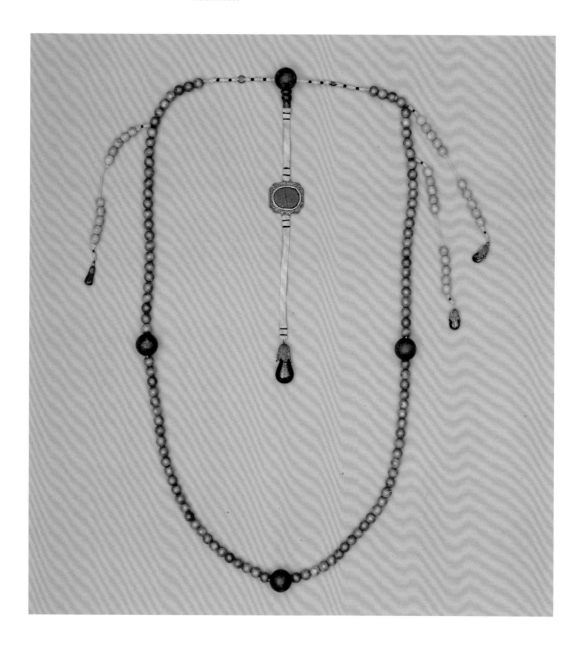

192

Three Girdles
to Semiformal Costume

Early-Qing period

Length of girdle 184–188 cm
Length of *fen* 74–77 cm
Qing court collection

All three semiformal costume sashes are made of silk and wool. The hooks are made of jade and one of them is lost. From the two sash rings are two plain white silk strips hanging straight and evenly. Around the rings are sheathed knife, purses, steel for flint and toothpick container. Hanging down are bright yellow silk ribbons tied to red coral and turquoise gems.

Semiformal sashes were tied round the semiformal or informal costumes donned by the emperor, the empress and other members of the royal house.

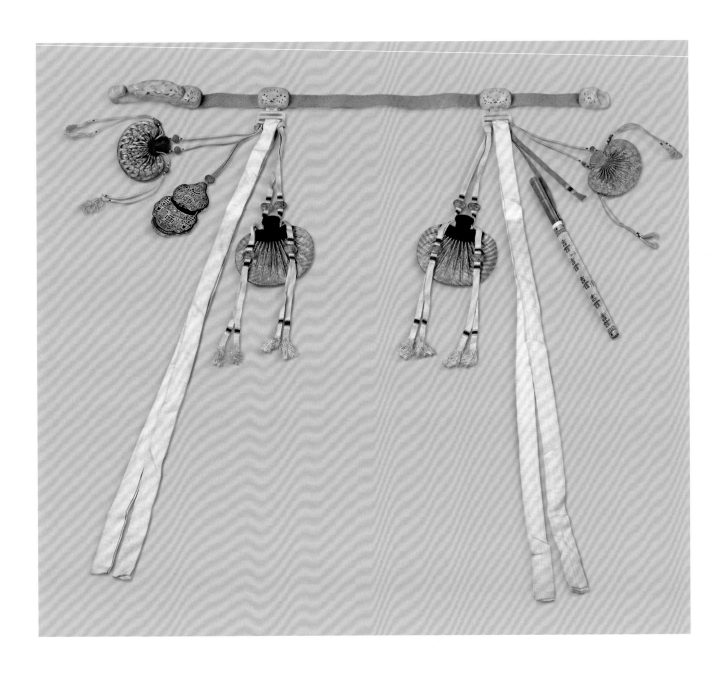

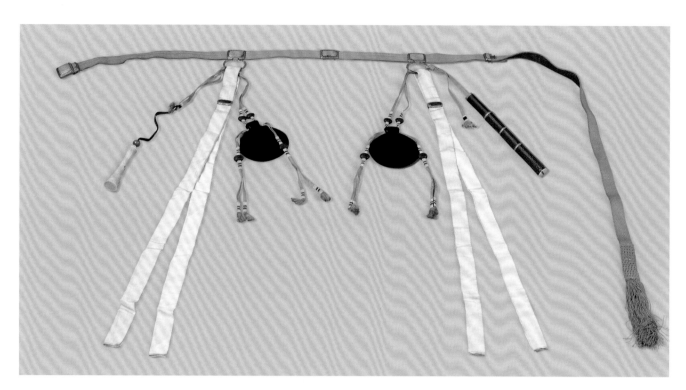

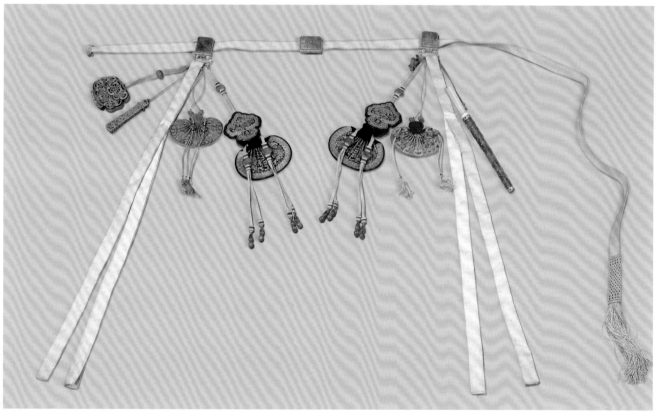

193

Two Girdles
to Travel Apparel

Early-Qing period

Length of girdle 216–224 cm
Length of *fen* 65 cm
Qing court collection

The girdle is bright yellow, with a *fen* made of Korean cloth, tied on with red ox hide rings and medium-long bands. The bright yellow ribbons are decorated with coral, turquoise, four purses, on sheath for the steel and a dagger, all being items that the emperor was bound to bring along while travelling.

The purse attached to the travel garment is embroidered with golden threads in flat coils, chain stitches and padded stitches. As the purse was often played around in the hands for the touch, the needlework is extremely delicate and fine and the stitches are very neat and smooth. Gold and silver are the main colours, which make the purse look exceptionally elegant and beautiful.

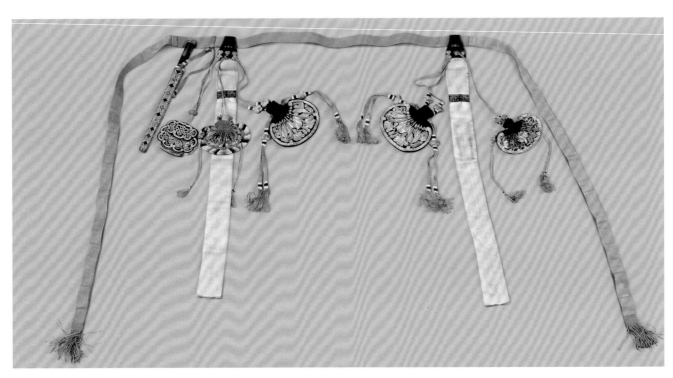

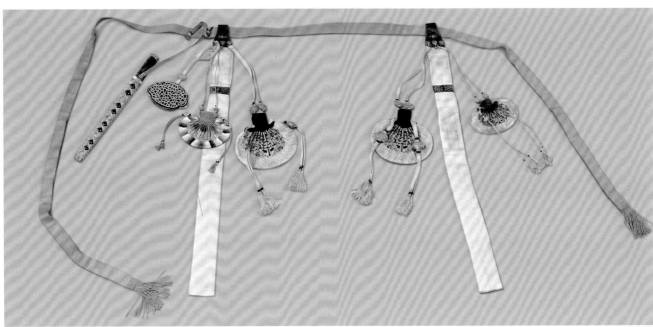

194

Handicraft Items
in Bright Yellow Satin with Small Pearls Sewn on and Embroidered with Patterns of Bats, Longevity and Double Happiness

Qing Dynasty Guangxu period

Length of fan sheath 32 cm Width 6 cm
Height of purse 9 cm Width 7.5 cm
Qing court collection

This set of handicraft (*huoji*) contains nine items: one pair of purses (*hebao*), one tobacco bag, a pouch hanging from belt (*dalian*), a pouch for watch, a sheath for fan, a pouch for betel nuts, a bag for jade thumb ring (*banzhi*) and a sheath for spectacles. They are all made of bright yellow plain satin face with strings of colourful small pearls to embroider figures of longevity, red bat, double happiness and *ruyi* clouds, forming an auspicious pattern to imply much luck (*wanfu*), double happiness (*shuangxi*) and fulfilment (*ruyi*).

The colourful beads used for making these handicraft items include: red corals, white pearls, and other gems in dark red, blue, green and purple. They have diameters around 1 mm and they are all round. The holes are punched in proper places and there are minimum spaces between the beads. The patterns stand out as three-dimensional relief. Such handicraft items were designed in the art studio at court and then made under the supervision of the court's Internal Affairs Bureau (*neiwufu*). At every festive season, these would be produced in large quantities as gifts to be presented by the emperor, the empress and the empress mother to members of the royal family and subjects close to the court.

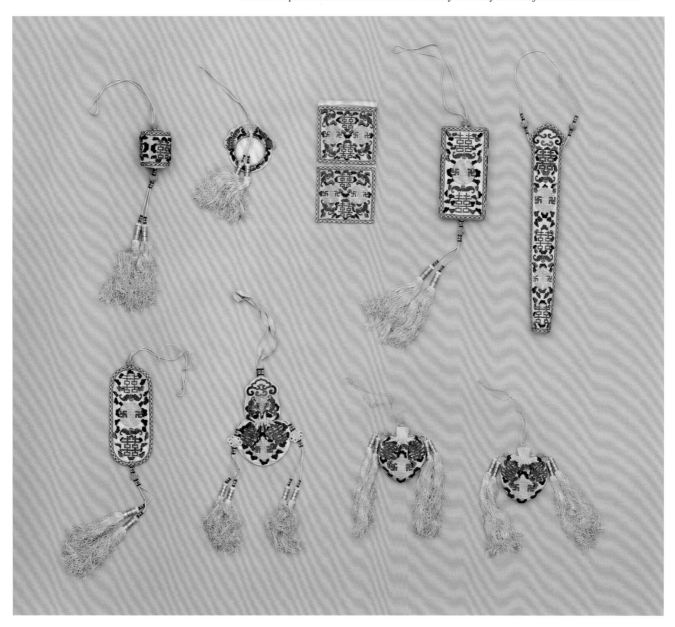

195

Handicraft Items
in Red Satin with Patterns of
Dragons and Phoenixes
Bringing Good Tidings
Embroidered in Flat Coils of
Gold Threads and Chain
Stitches

Qing Dynasty Guangxu period

Length of fan sheath 31 cm
Width 6 cm
Height of purse 10 cm
Width 8 cm
Qing court collection

This set of handicraft (*huoji*) has a total of eight items, including a pair of purses (*hebao*), a pouch hanging from the belt (*dalian*), a watch pouch, a fan sheath, a bag for the jade thumb ring (*banzhi*), a boot tucker and a betel pouch. The face is made of red satin on which are embroidered the four characters "*long feng cheng xiang*" (the dragon and phoenix bringing good tidings) in flat gold thread coils. The writing style is neat and fluent and in between are decorations of five-coloured clouds.

This set of handicraft items was specially made for the grand nuptial ceremony of Emperor Guangxu. According to the ceremonial customs of the Qing court, when the emperor was picking an imperial concubine and "making a minor betrothal" (*fang xiao ding*), the beautiful maidens would stand in line for the emperor to review and choose by attaching a purse to the button on the chosen's garment, for the sound of *he* in the word for purse puns with *he* meaning fitting or agreeable. When this sign had been given by the emperor, the beautiful maiden would become a concubine. At the grand wedding, not only should the empress's dowry include handicraft items to show the empress mother's style but also the emperor would give gifts of handicraft to maintain a good relation with his subjects.

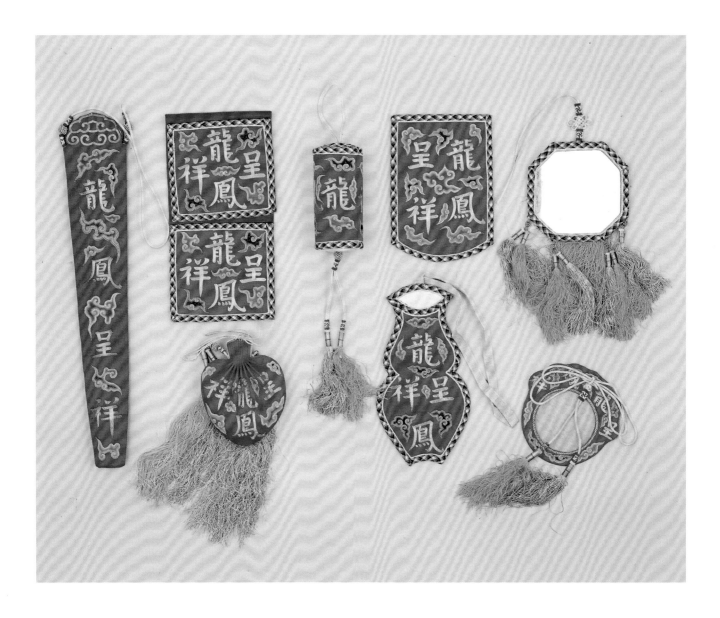

196

Court Boots
in Yellow Satin with Pointed Soles and Sewn with Beads

Qing Dynasty Kangxi period

Height 53 cm Length 25 cm
Qing court collection

This pair of boots was used by Emperor Kangxi. They are made of silk satin and the patterns are made of gold threads, small pearls and corals, which enhance the comfort as well as the looks.

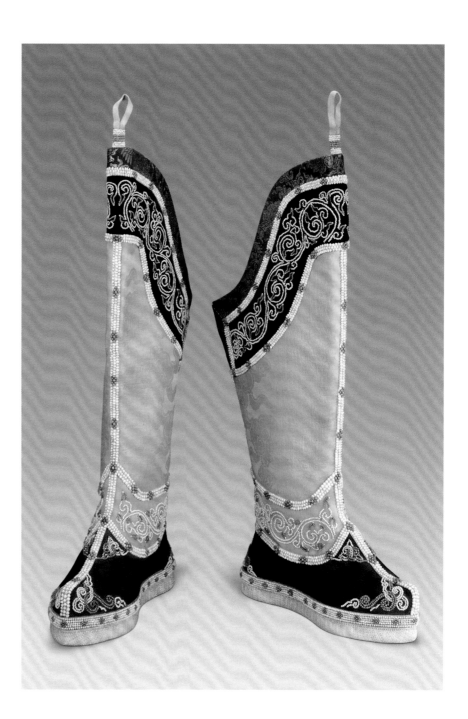

197

Court Boots
for Imperial Concubines

Qing Dynasty

Height 44 cm Length 25 cm
Thickness of soles 4–6 cm
Qing court collection

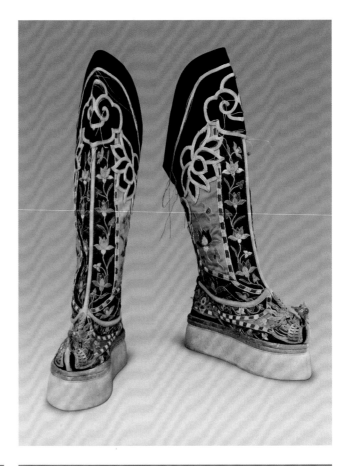

There are three pairs of court boots variously as follows: light brown boots with phoenix heads, bright yellow boots in satin embroidered with phoenix figures in gold thread flat coils, and bright yellow satin boots embroidered with pearls. They are all pressed at the seams with green leather, and their lining is either jacquard *ling*-twill or jacquard *chou*-silk. The soles are made of wood, wrapped up with cotton patchwork of natural colour.

All three pairs of court boots were worn by imperial concubines. The material was stringently picked, the craft elaborate and the workmanship exquisite. They are comfortable and convenient. Their style and design are inherited from the Manchu tradition of nomadic fashion. There is no difference between the left and the right.

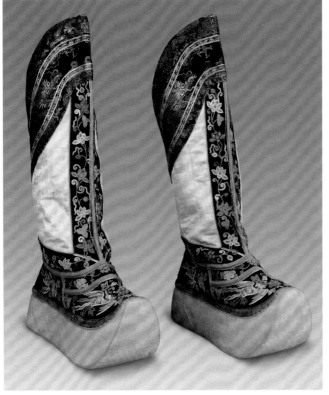

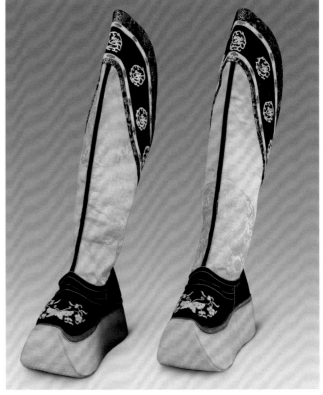

198

Shoes
in Pale Blue Satin
Embroidered with Lotus
Flowers and Sewn with Gems
on Soles like Flower Pots

Qing Dynasty Guangxu period

Height 17 cm Length 21.5 cm
Qing court collection

The upper parts of the shoes are made
of two pieces of material sewn together.
On the pale blue satin are embroidered
lotus blossoms and around the openings are
fringed with black satin with gems sewn
on. The seams at the tip of the shoes are
decorated with yellow ribbons, while the
seams at the heel are pressed with black
strips. The lining is white cloth. The soles
look like flower pots. They are made of
wood mounted with white cloth outside
and covered with white paint. The soles are
sewn with patchwork cloth.

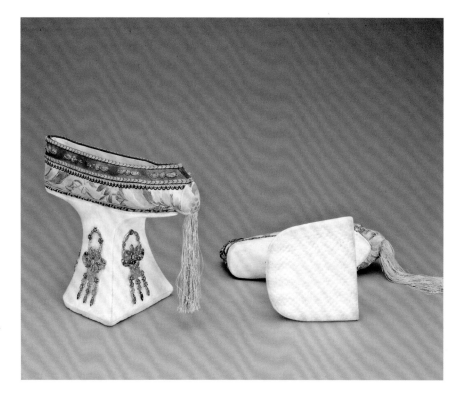

199

Shoes
in Pale blue Satin
Embroidered with Bamboo
and Figure of the
Panchang-knot and with Ingot
Soles

Qing Dynasty Guangxu period

Height 10.9 cm Length 23 cm
Qing court collection

The shoes have pale blue satin face
embroidered in colourful silk threads with
bamboo leaves and *panchang*-knots and
the tips of the shoes are decorated with
ruyi clouds. The soles are made of wood,
with a layer of white cotton cloth mounted
outside, and the cloth was decorated with
padding of *ling*-twill in floral patterns. The
colours are gorgeous and naturally merged.
Between the shoe top and the shoe sole
is pressed into a green edge of azure blue
satin embroidered with plum blossoms and
fringed with two ribbons decorated with
ruyi clouds.

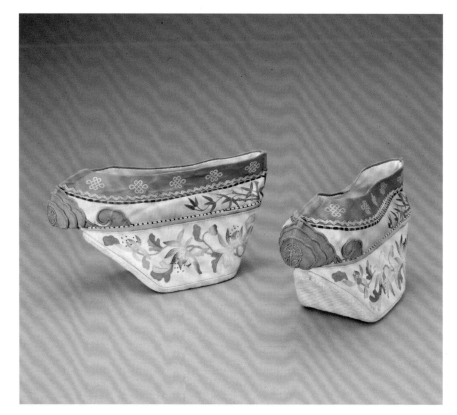

200

Long-hosed Floss Stockings

Qing Dynasty

Height 60 cm Length 23 cm
Qing court collection

These stockings have long hoses in two sections and the openings are horse-hoof shaped. On them are embroidered dragons, phoenixes, colourful clouds, waves lapping on the shore, gourds and blossoms. The craft includes weaving of coloured threads, sewing on pearls, sewing in close stitches and making flat coils of gold threads. The weaving is very delicate and fine and the embroidery elaborate.

Stockings for the Qing emperors and empresses can be divided into categories such as high legged, medium legged, low legged, unlined, lined and padded. The crafts include mainly silk weave, embroidery and painting. Stockings for male have patterns of clouds and dragons, while those for female have patterns of dragons, phoenixes and flowers.

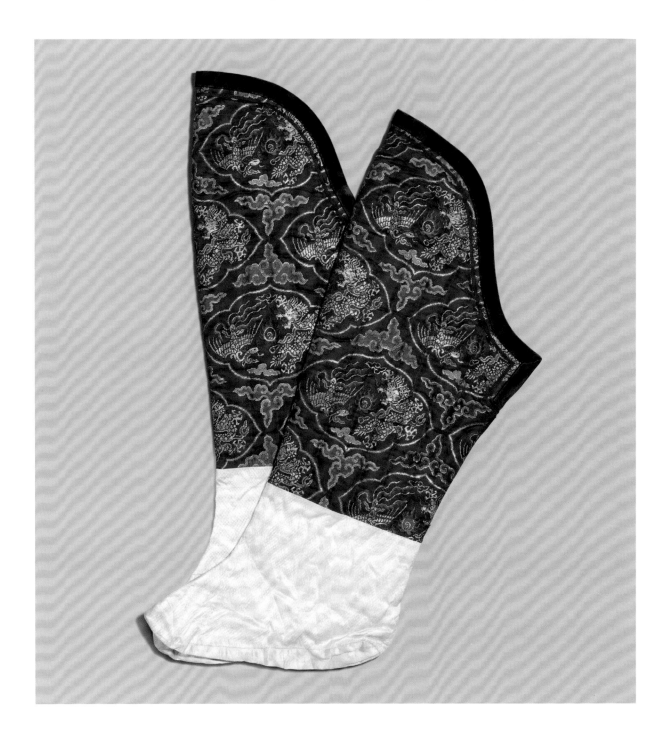

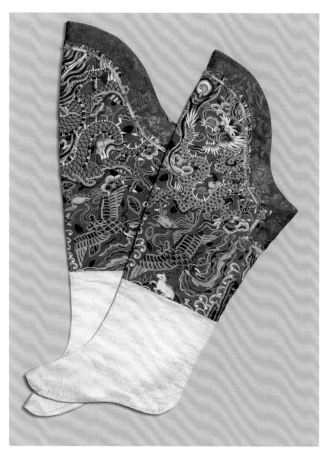

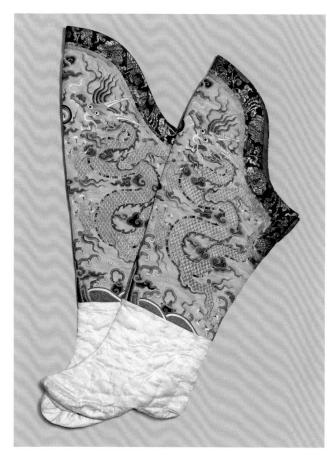

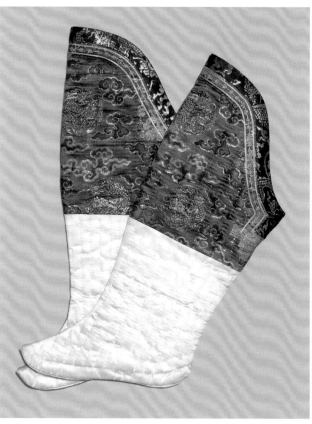

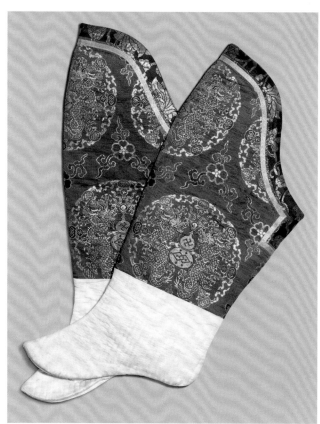

WOVEN AND EMBROIDERED CALLIGRAPHY AND PAINTING

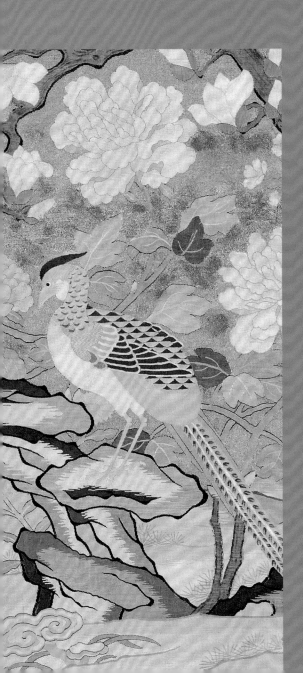

201

Kesi Scroll
of Flowers and Birds by
Zhao Ji

Song Dynasty

Vertically 26 cm Horizontally 24 cm

The picture in textile shows the flower-and-bird painting by Zhao Ji. There is a jasmine bush in full bloom and a bird perches on its branches. In *kesi* (cut silk) are woven the characters "yu shu" (imperial writing) as if carved on a seal in gourd shape and signed "tianxia yiren." (lone man under heaven)

Zhao Ji (1082–1135) is the same as Emperor Huizong of the Song Dynasty. He was adept in calligraphy and painting and admired the minutiae and vivid style. This has exerted profound influence on posterity in the painting of flowers and birds.

Kesi from the Song Dynasty is often based on the calligraphy and painting of famous people as the blueprint and it pursues the artistic nature of these works. This picture involves various *kesi* weaving methods such as the straight *kesi*, the dovetailing, the twining shuttle (*pansuo*), the straggling propping (*changduanqiang*), the wooden comb propping (*mushuqiang*) and mixing threads of different colours. The colours of the flowers and leaves merge well, and the texture of the birds' feathers look very much real. It keeps the tone of the original and surpasses the painting in that it has more texture.

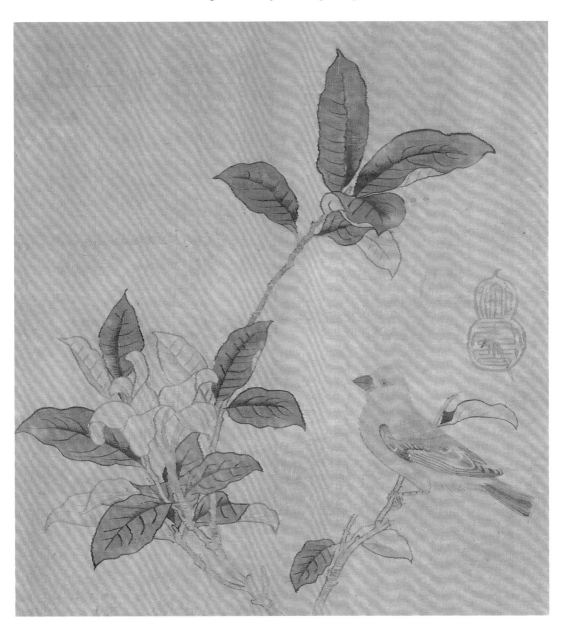

202

Kesi Scroll
of Flowers and Birds
by Zhao Ji
Song Dynasty

Vertically 25 cm Horizontally 25 cm

The picture shows the flower and bird painting by Zhao Ji in weaving. There is a green peach branch with blossoms on which a blue-plumed bird perches and among the blossoms are butterflies fluttering. In *kesi* (cut silk) are woven the signature "tianxia yiren" (lone man under heaven) and the characters "yu shu" (imperial writing) as if carved on a seal in gourd shape. On the picture's tabby silk ground is written a poem in ink. The painting is stamped with the seals "treading the nest" (ta chao) and "the house is filled with the shade of the scholar tree." (huai yin man wu)

This picture has employed various *kesi* stitches including the *pingke, gouke, changduanqiang, huanke, canhexian, raosuo, dake* and *pansuo*. The tapestry work is minutiae and exquisite and the colour scheme harmonious. This is a masterpiece of *kesi* painting from the Song Dynasty.

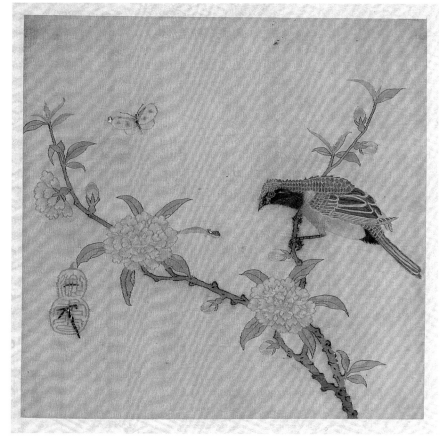

203

Kesi Scroll
of Shen Zifan's Painting of
Plum Blossoms and
Magpies in the Cold

Southern Song Dynasty

Vertically 104 cm Horizontally 36 cm
Qing court collection

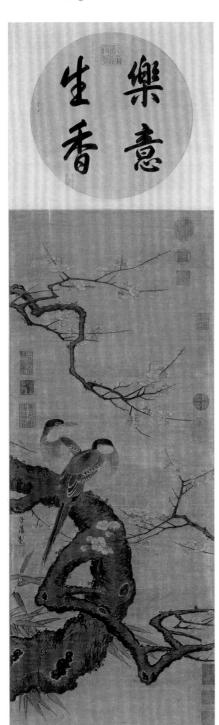

The picture shows a plum tree with an old trunk but young new branches and blossoms in full bloom. Two magpies are roosting on the sprigs in the cold and a thicket of green bamboos are seen among the branches. On the *kesi* (cut silk) is marked "made by Zifan" and the seal of "Shen." On the *yuchi* (jade pond) is the calligraphy by Emperor Qianlong in cursory script: "Leyi shengxiang" (pleasure ensues fragrance) and the seal "Qianlong chenhan." (ink brush of the imperial palace of Qianlong)

This picture has employed various *kesi* stitches including the *pingke, dasuo, changduanqiang, huanke* and *guanke*. The craft is elaborate and exquisite and the colour scheme harmonious. This is a masterpiece of *kesi* painting from the Song Dynasty. There are up to sixteen colours used in subtle combination and merging in harmony, thus fully realizing the delicate fineness and exquisite style of the original painting. It is a masterpiece of *kesi* silk tapestry from the Southern Song Dynasty.

Shen Zifan, alias Zi (dates of birth and death unknown) was from Wu Prefecture during the Southern Song Dynasty (Suzhou in Jiangsu Province today) and an eminent master of *kesi* tapestry. His works were usually based on the calligraphy and painting of famous people. They are classically elegant and vividly lifelike.

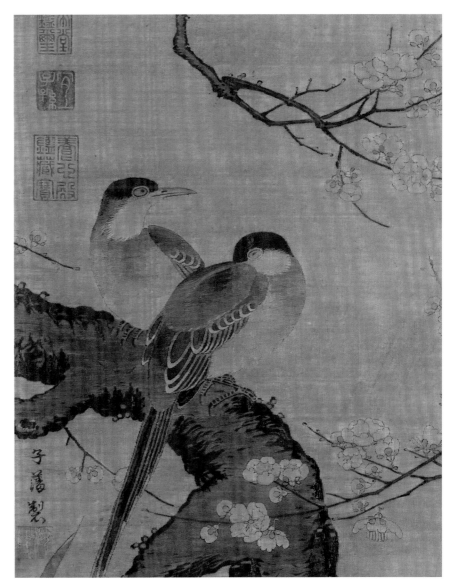

204

Kesi Scroll
of Shen Zifan's Painting of
Blue and Green Landscape

Southern Song Dynasty

Vertically 88 cm Horizontally 37 cm

The picture shows towering peaks,
misty clouds and a mighty river, on which
berths a tiny boat where an old man drinks
joyfully alone. On the *kesi* (cut silk) is
marked "made by Zifan" and the seal of
"Shen Zi."

This picture has employed various
kesi stitches including the *pingke, gouke,
changduanqiang* and *zimujing*. The
colour design is mainly blue and green. In
between the mountain, the water and the
clouds where the tapestry expression is not
adequate, some faint colour is added by
brushwork. This maximizes the effect of
painting, further enhanced by the texture
of weaving, and demonstrates Shen's
accomplishment in painting and adept skill
in *kesi* technique.

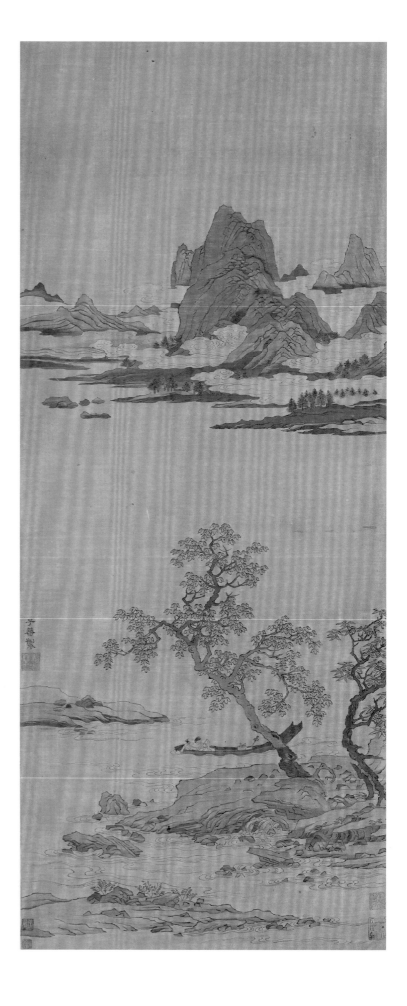

205

Kesi Scroll
of the Picture of the Eight
Immortals

Yuan Dynasty

Vertically 100 cm Horizontally 45 cm
Qing court collection

The *kesi* (cut silk) tapestry shows
the picture of the eight Daoist immortals,
Tieguai Li, Han Zhongli, Cao Guojiu,
Han Xiangzi, Lan Caihe, Zhang Guolao,
Lü Dongbin and He Xiangu celebrating
the birthday of Nanji Xianweng riding on
the celestial crane on a magic tour. In the
sky are flowing clouds and on the ground
lingzhi-fungi, bamboos and rocks.

This *kesi* picture is woven in minutiae
strokes to outline the human figures, while
the colour of the larger areas of the clothing
is made in *pingke* (plain *kesi*). When there
is a change between colours, the *dasuo*
(dovetailing) is used so as to mark the
border crevice without showing any break.
The merging of the rock colours is done
in *changduanqiang* (uneven propping),
canhexian (mixed colour threads) and other
proppings. The clouds which are expressed
by means of throwing *kesi* become very
fluent and natural. All these various
methods interchange subtly, showing adept
craftsmanship and exquisite *kesi* skills. A
touch of gold *kesi* also adds to the feeling
of opulence and beauty. This is a rare piece
of excellent *kesi* tapestry left for posterity.

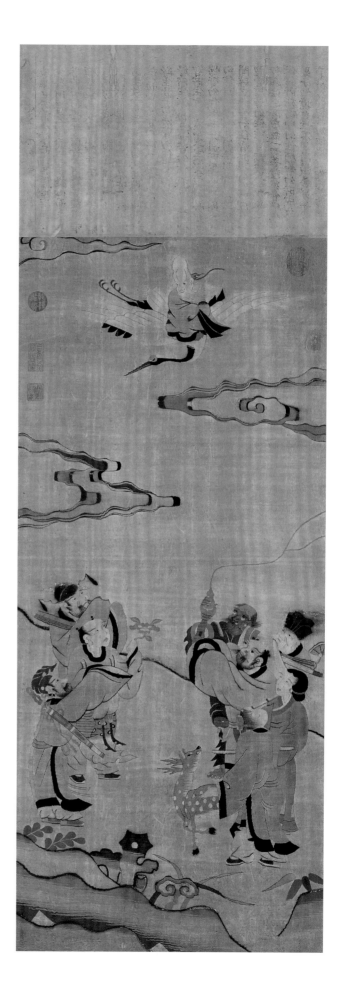

206

Pictorial Album
of Floral *Kesi*
(in Twelve Sections)

Ming Dynasty

Vertically 41 cm Horizontally 42 cm
Qing court collection

The album contains twelve sections, and on each one is a *kesi* (cut silk) woven painting of flowers including lotuses, chrysanthemums, grapes, camellias, daffodils, orchids, plum blossoms, peonies and magnolias, and among these are dragonflies, butterflies and rocks from Taihu lake.

The whole album is finished in *kesi* without involving ink and brush. The *kesi* methods employed include *pingke, gouke, mushuke, changduanqiang, fengweiqiang* and *guanke*. The merging of the colours is natural and the contrast between them is cleverly exploited to express light and shade. The *kesi* craft is so exquisite that even the worm-eaten holes on the leaves look real. It is very naturalistic.

12-1

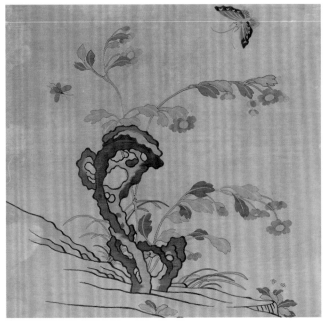

12-2

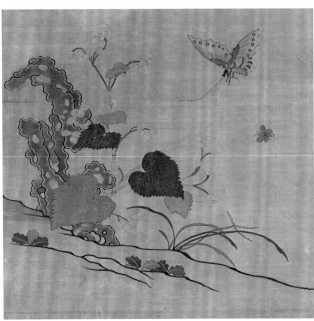

12-3

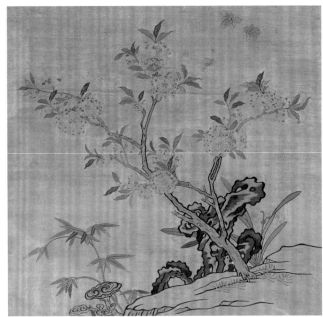

12-4

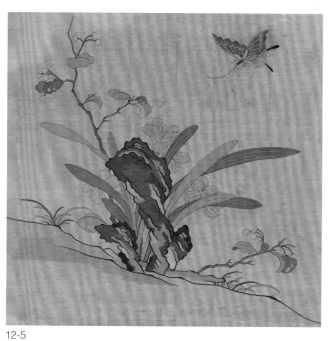

12-5

12-6

12-7

12-8

12-9

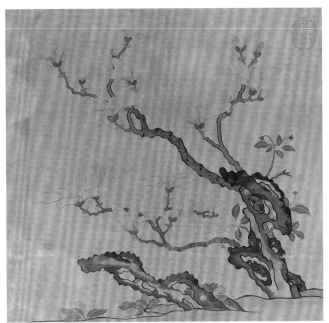

12-10

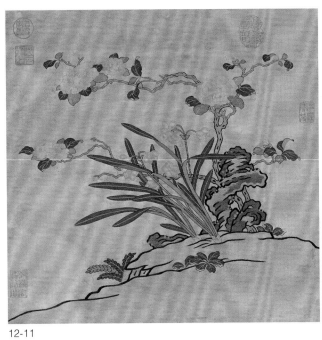

12-11

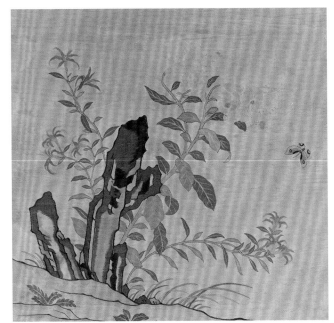

12-12

207

Kesi Scroll
of Joyful Gathering by the
Yaochi

Ming Dynasty

Vertically 260 cm Horizontally 205 cm
Qing court collection

The picture shows the glorious scene of Queen Mother of the West (*xiwangmu*) celebrating her birthday by the Jade Pond (*Yaochi*) in paradise. She holds the *ruyi* sceptre and sits in the middle. One of the two maids stands by to serve holding a fan, while the other puts things on the table. Nine fairies come forth presenting birthday gifts such as the *lingzhi*-fungus, the longevity peach and corals. Decorations in between are the phoenix, the celestial crane, the heavenly deer, the auspicious clouds, the *lingzhi*-fungus, the green pine and the jasper cypress.

This *kesi* (cut silk) tapestry has applied not only the more common *pingke* and *dake* but in minute details also the *changduanqiang, mushuqiang* and *fengweiqiang* to merge the colours. The straggling propping or *changduanqiang* makes the hair on the temples of the fairies look very naturalistic; the *gouke* (connecting cut silk) applied to the drapery folds of the clothes makes them look ethereal and the *guanke* (throwing) and the *jie* (knotting) applied to the *Yaochi* ripples and the multi-coloured clouds make them look three-dimensional. The composition of the whole picture is opulent and the colour scheme gorgeous. This is a rare treasure among *kesi* tapestry from the Ming period.

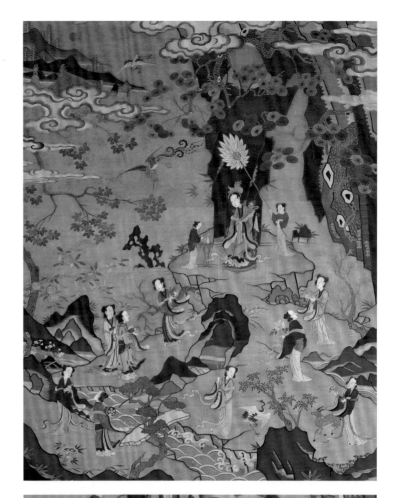

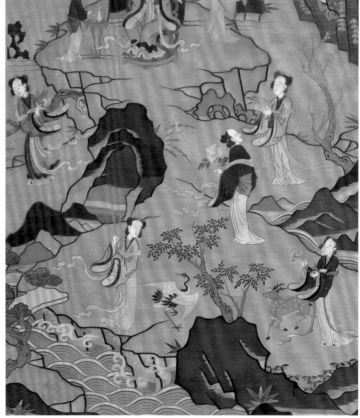

208

Kesi Scroll
of Flowers by Zhao Chang

Ming Dynasty

Vertically 44 cm Horizontally 245 cm

The scroll shows in *kesi* (cut silk) the picture of flowers painted by Zhao Chang. Its contents include peonies, fluttering butterflies, lotus blossoms, hibiscus flowers, kingfishers, plums and sparrows. At the end of the scroll is marked "made by Zhao Chang" and stamped with the seals "Zhao Chang" and "yushui."

Zhao Chang, alias Changzhi, was from Guanghan of the Northern Song period (Jiannan in Sichuan Province today). The dates of his birth and death are unknown. He was adept in painting still life of flowers and fruits, mostly sprigs and also herbs and insects. He called himself "Still Life Zhao Chang."

The *kesi* craft of this picture is extremely accomplished and fine. The colour design is classical and elegant, at once rigorous and ethereal. There is much merging of three colours in gradation: for example, the lotus is dark green on the face of the leaves, lighter green for the veins and yellowish green on the reverse side. The strength of the colour goes from dark to light in natural transition, expressing the texture and the light and shade of the curly lotus leaves. The details and the movements of the fluttering butterflies and the roosting birds are portrayed in vivid lifelikeness. There is not a single brushstroke in the whole *kesi* tapestry, but the pursuit of realistic resemblance to the flowers and birds by the Song painter is thoroughly re-presented. It is a masterpiece of a giant *kesi* painting from the mid-to-late Ming period.

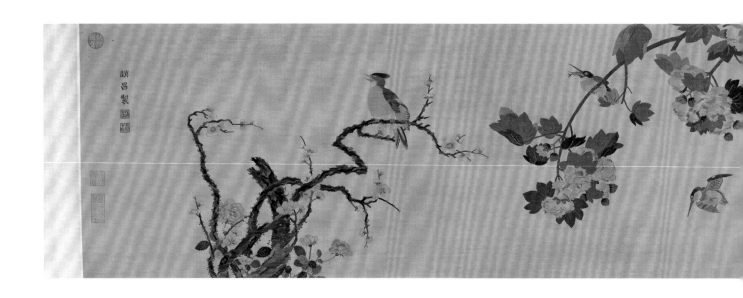

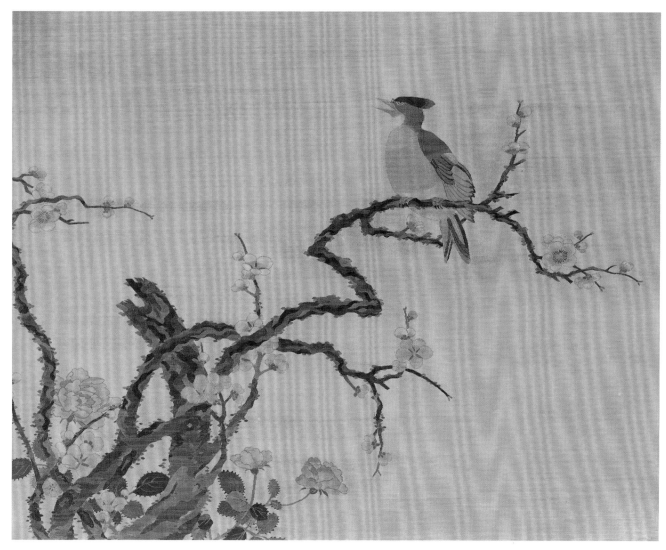

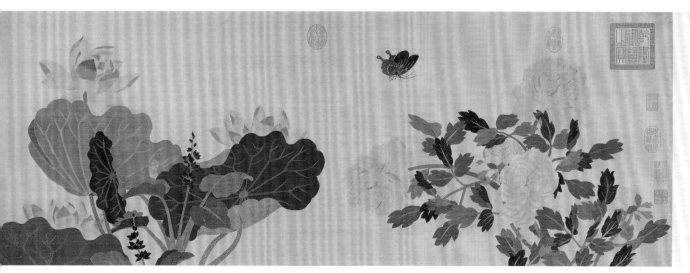

209

Kesi Screen
in Four Sections Woven with Nine Dragons

Qing Dynasty Kangxi period

Vertically 416 cm Horizontally 140 cm
Qing court collection

The screen in sections displays clouds and dragons woven in *kesi* (cut silk) on a cream-coloured silk ground. Nine dragons fly amidst auspicious colourful clouds. In between the surging waves are symbols of mixed treasures including the *fangsheng* lozenge, the ingot, the *ruyi* sceptre and corals.

This screen was an article for display at the Qing court. Its craft is mainly *pingke* in combination with *mushuqiang, changduanqiang* and *dasuo* as auxiliary methods. Brushwork is added to paint minute details such as the whiskers, the ridge and the claws of the dragons and also the lines on the waves. The scene is spectacular and represents the ultimate authority of the emperor.

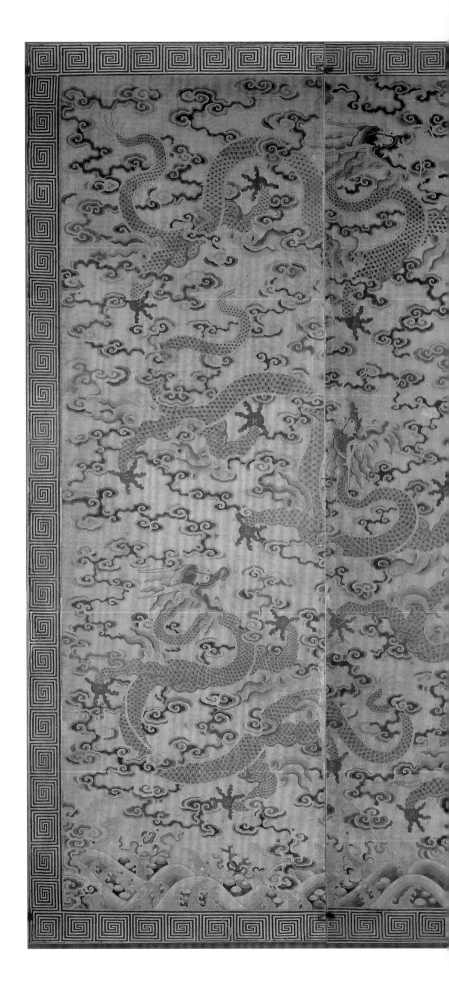

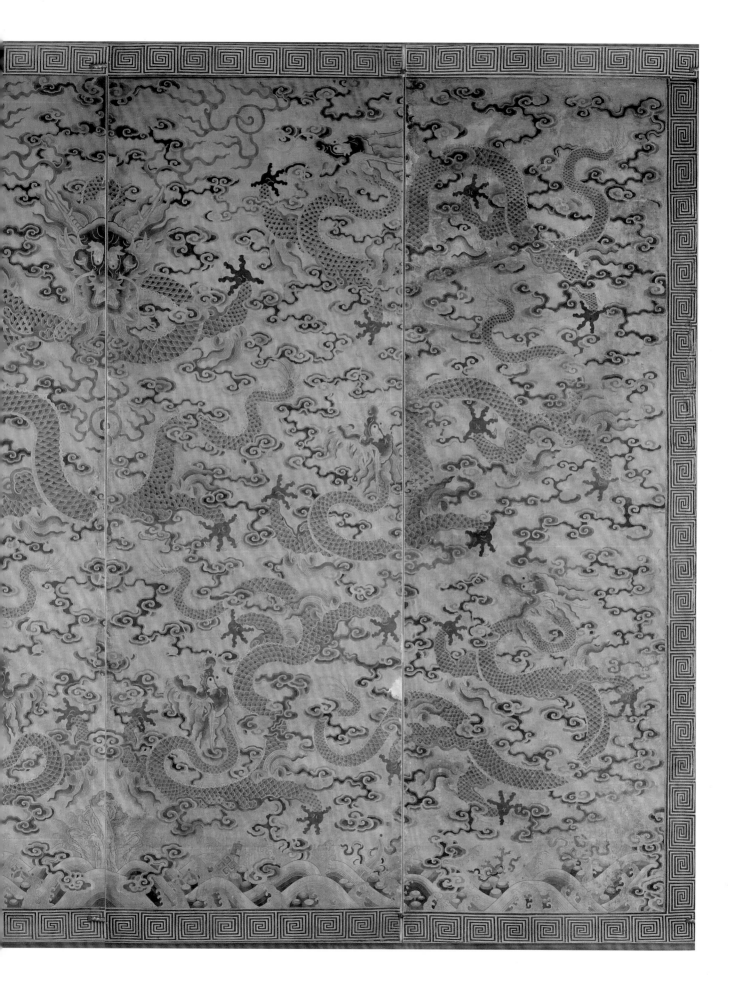

241

210

Kesi Scroll
with the Picture of Golden Pheasants and Peonies

Qing Dynasty Kangxi period

Vertically 53 cm Horizontally 87 cm

In the picture are woven two golden pheasants roosting in the midst of rocks and brooks. There are also huge peonies, elegant magnolia and gorgeous crabapple blossoms in full bloom. In the sky are colourful clouds and on the ground *lingzhi*-fungus and other herbs in thickets. All these symbolize "*yutang fugui.*" (wealth and nobility in the hall of jade)

This picture is woven mainly by adopting the *pingke, gouke, kelin, mushuqiang, fengweiqiang, changduanqiang, zimujing* and *dasuo* methods. The colour scheme is warm with golden yellow, bright red and pink. The ground weave of gold foil *kesi* (cut silk) accentuates the air of opulence in the painting. The rocks in dark blue, blue and light blue merging in gradation do not only give a strong sense of three-dimensionality but even tone down the gaudiness of the main colours, thus making the picture more natural and gentle and at the same time decorative.

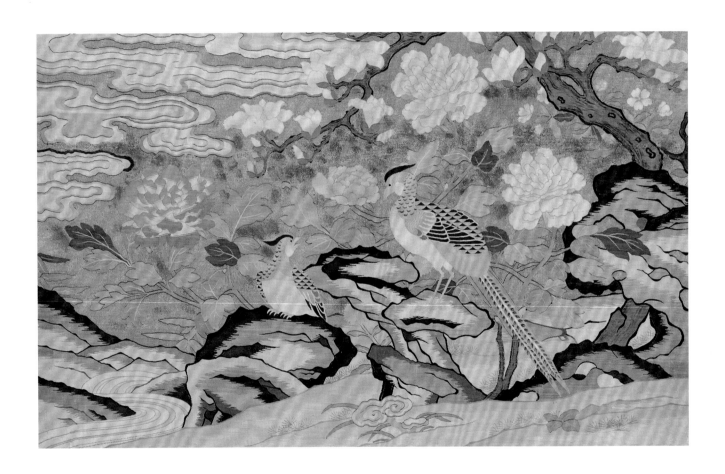

211

Kesi Scroll
of the Emperor's Painting of Vermilion Bamboo

Qing Dynasty Qianlong period

Vertically 123 cm Horizontally 43 cm
Qing court collection

The *kesi* (cut silk) tapestry is woven to re-create the picture of Bamboo and Rock painted with cinnabar by Emperor Qianlong of the Qing Dynasty. The bamboo leaves spread and gather in special composition which shows the painter's accomplished skills. On the upper part of the painting is woven the inscription by Qianlong to record that the original work was created in the sixth year of the reign of Qianlong (1741) on occasions during the time in between reading and vetting reports from ministers.

This picture employs the usual *pingke*, *dake* and *changduanqiang* techniques and the variation between darker and lighter hues of the silk threads to express the folds in the rocks and the light and shade on different sides of the bamboo leaves. It represents accurately the tones of the original painting. By the Qing period, *kesi* has shredded the splendour of the Ming period and become quietly elegant. The *kesi* weave is exquisite and the colour scheme clear and beautiful, carrying with it the special taste of the time.

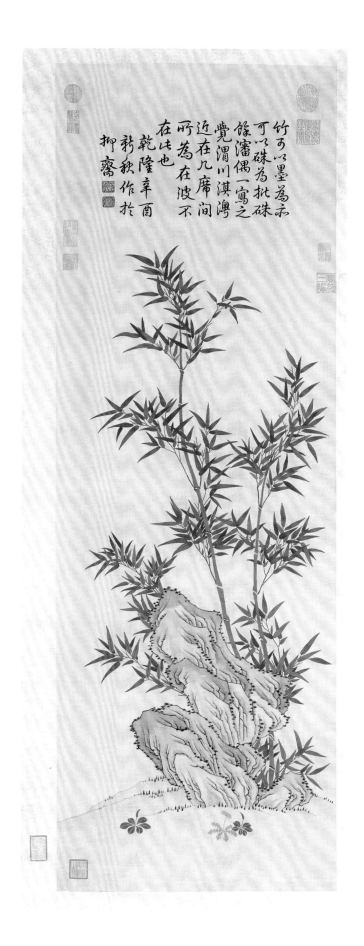

212

Silk *Kesi* Album
of Floral Painting with Poetry
by Emperor Qianlong (in
Eight Sections)

Qing Dynasty Qianlong period

Vertically 36 cm Horizontally 22 cm
Qing court collection

The album contains eight sections,
each of which contains respectively *kesi*
(cut silk) tapestry of magnolia, rose, peach
blossom, peony, pomegranate, Chinaberry
and orchid, matched with rocks and birds.
On the picture is also woven in *kesi* an ode
to blossoms written by Emperor Qianlong
together with seals carved with "qiwu,"
"congyun," "hanxu langjian," "ai zhu xue
xinxu," "chuilu," "huixin bu yuan," "de
chong fu," "yun xiasi" and "jixia lin chi."

The *kesi* craft of this album is simple,
involving only *pingke* and *gouke*. The
sunny and shady sides of the leaves are
brushed up with colour to make them more
vivid and realistic.

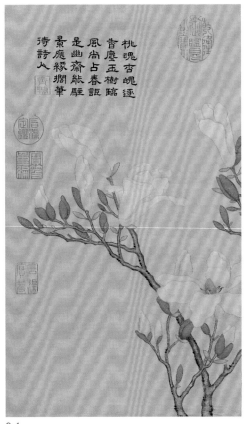

8-1

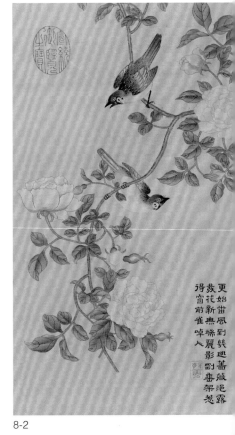

8-2

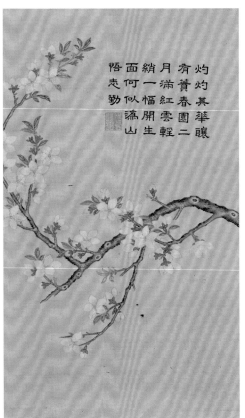

8-3

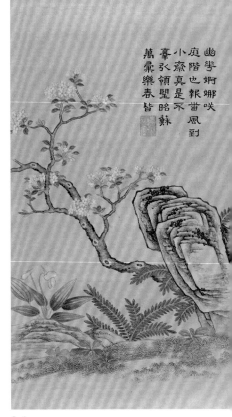

8-4

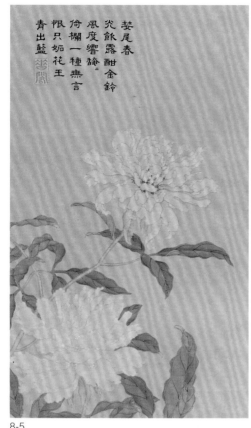

鳶尾春
炎飲露酣金鈴
風度響鈴
倚欄一種無言
恨只妬花王
青出藍

8-5

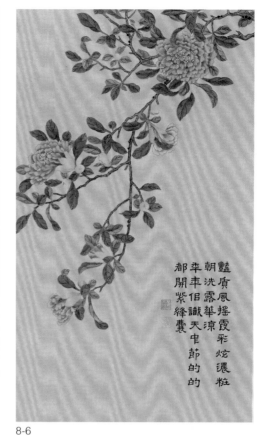

豔質風搖霞彩炫瓈粧
朝洗露華涼
牽牛但識天申節的的
都開紫絳襲

8-6

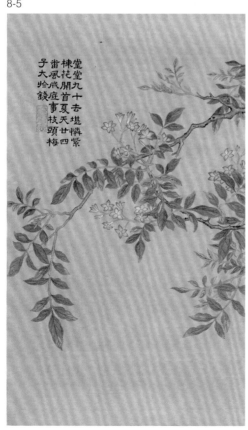

堂堂十丈堪憐紫
棟花開首夏天廿四
蕾鳳成
子大似錢庭事枝頭梅

8-7

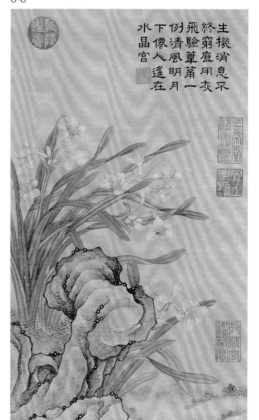

生機消息不
終窮庭用灰
飛驗葦莩一
倒清風明月
下優人遙在
水晶宮

8-8

245

213

Silk *Kesi* Scroll
Depicting King Wen of Zhou Distributing Grains

Qing Dynasty Qianlong period

Vertically 117 cm Horizontally 44 cm

The picture shows the scene of King Wen of Zhou opening the granary and dish out grains to relieve the populace's need. King Wen sits under a tree in the courtyard and watches the people fetching the grains. All trees in the yard and outside are bare and leafless, showing there is a drought and the year's harvest has been poor, while the people coming for the relief look joyful and behave in an orderly manner. This was meant to sing the praise of the son of heaven being benevolent and wise.

This *kesi* (cut silk) tapestry is woven in the methods of *pingke, dake, mushuqiang* and *fengweiqiang*. The hues are rich and the *kesi* craftsmanship is exquisite. Some brushwork has been employed to make up the details.

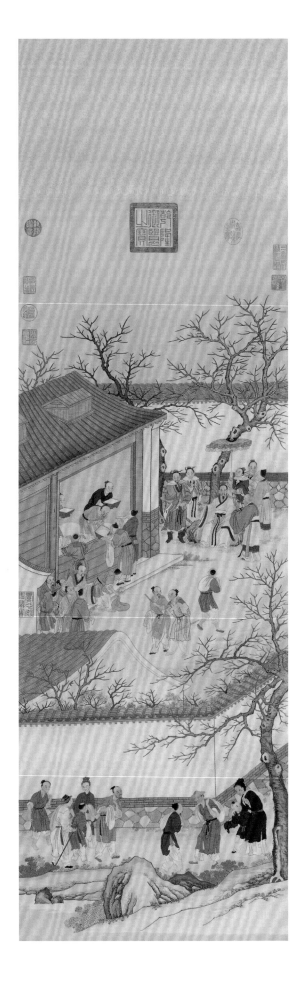

214

Silk *Kesi* Scroll
of Paradise Flycatchers with Autumn Peaches

Qing Dynasty Qianlong period

Vertically 198 cm Horizontally 59 cm
Qing court collection

The picture is woven with a peach tree full of fruit and on the tree perches a paradise flycatcher. Under the tree are chrysanthemum and crabapple in full bloom as well as rocks on the slope by a running brook. The picture was meant as congratulatory wishes for long life.

This tapestry is very sophisticated, flexible and varied in its craft of *kesi* (cut silk) weaving, mainly by means of *pingke* and *dake* with the support of *changduanqiang, guanke* and *mushuqiang*. The tip of the peaches and the rocks are in colours merging in gradation by means of the *fengweiqiang* (phoenix-tail) method. To express the withering leaves of the crabapple, small shuttles are used to change the colours frequently so as to achieve the effect of vivid naturalism. The outlines of the flowers and the leaves' veins are done by the *gouke* connecting method, showing the technique of the traditional *gongbihua*, characterized by its fine brushwork and close attention to detail.

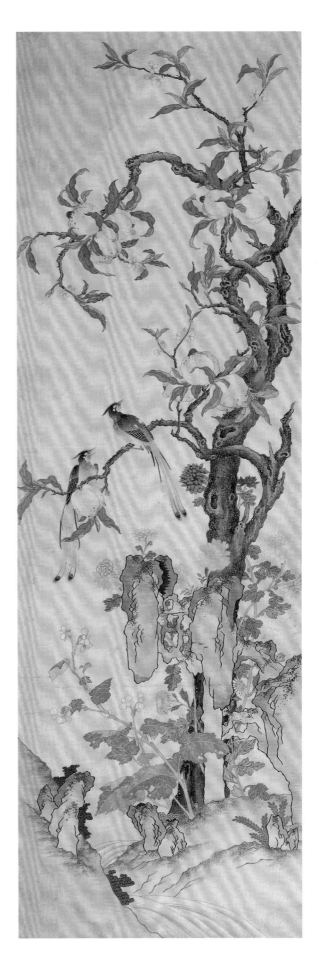

215

Scroll of *Kesi* Tapestry
in Silk of the Painting by Qiu Ying to Depict the Rhymed Prose *Fu* "Post-Red Cliff"

Qing Dynasty Qianlong period

Vertically 30 cm Horizontally 498 cm

The *kesi* (cut silk) tapestry is woven to depict the Painting by Qiu Ying to Depict the Rhymed Prose *Fu* "Post-Red Cliff." The scroll is divided in eight sections which display together a full view of the pictorial representation of the contents of the *fu*-rhymed prose "Post-Red Cliff" by the poet Su Shi from the Northern Song period. The scenes include Su Shi drinking with a guest under the Red Cliff (Chibi), their climbing up the rocks to land, and their repose in the woods, viewing things afar, abandoning the boat to get ashore, and life illusory as a dream. At the end of the scroll is written "Shifu Qiu Ying" and stamped with a gourd-shaped seal "Shizhou." The prelude at the beginning in running hand by Emperor Qianlong says, "Yunjixianzhi" and stamped with the seal: "written with the imperial brush of Qianlong."

Qiu Ying (1498–1552), also named Shifu and alias Shizhou, was from Taicang during the Ming Dynasty (Taicang in Jiangsu Province today). He was adept in painting landscape and human figures and particularly good at imitating works of the ancients. He is considered one of the four great masters of the Wu school.

This scroll is the longest among extant *kesi* paintings in the holding of Palace Museum. The preamble written by Qianlong was meant as acclaim for this work. The weaving involves silk threads in twenty-odd colours in all and the *kesi* techniques include *pingke, changduanqiang, gouke, dasuo* and *guanke*. Details of the human figures, rocks, trees and architecture have been touched up by brushwork. The delineation shows light ink strokes. The colour scheme is based mainly on azure, malachite and ochre, fully expressing the style of Qiu Ying's landscape painting.

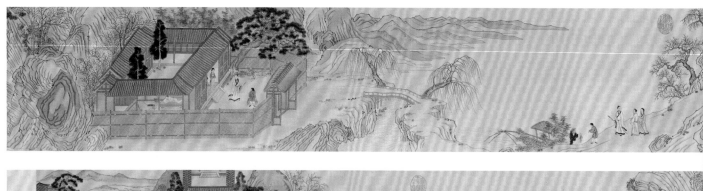

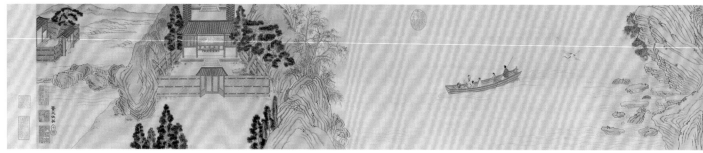

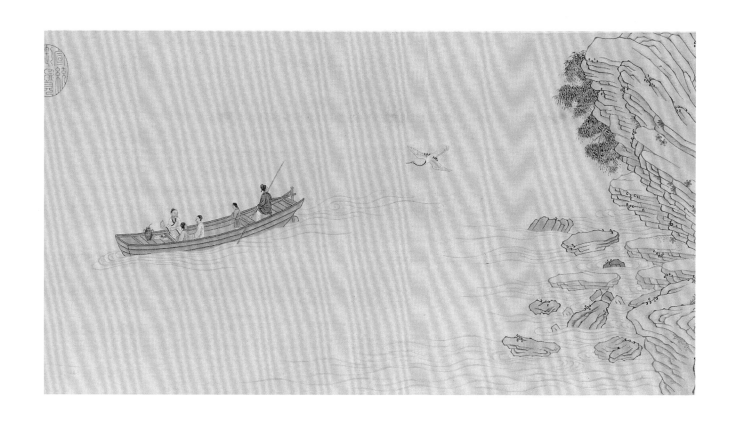

雲機仙製

216

Hanging Panel
in *Kesi* Tapestry to Depict
Wang Guxiang's Picture of
Suckling Chicks with Inscription by Emperor Qianlong

Qing Dynasty Qianlong period

Vertically **64 cm** Horizontally **36 cm**
Qing court collection

The tapestry is woven to show the painting by Wang Guxiang, in which an old bird holding a worm in between its beak flies towards some young chicks in the bamboo thicket while four young chicks flutter in excitement and have their beaks open, looking very much urgent and impatient. On the right of the picture is a poem inscribed by Wang Guxiang and stamped on are the seals "Guxiang" and "Luzhi." In addition are Emperor Qianlong's poetic inscription and the seals "ba zheng mao nian" (recorded by an octogenarian) and "zi qiang bu xi." (continuous self-reliance) By the poem is Emperor Qianlong's inscription as well as the stamps "appreciated by Qianlong," "treasure of the octogenarian," the seals of "the seal of close inspection by Sanxitang" and "benefits to descendants."

Wang Guxiang (1501–1568), alias Luzhi, was from Changzhou of the Ming Dynasty (Suzhou in Jiangsu Province today). As a painter he belonged to the Wu school and was adept in painting flowers and birds.

In order to show up the plumy quality of the birds' feathers, the craft of *kesi* pile is employed. The result is very vivid. It is evident from the emperor's inscription on the painting that Qianlong ordered the weaving of this picture and also Li Di's painting of "Chicks Waiting to be Fed" (Figure 223) was not due to their being merely paintings but rather his wish to inform ministers and officials that they should empathize with people's suffering and understand the idea that "people's livelihood is politic" and "protecting the young is truly required."

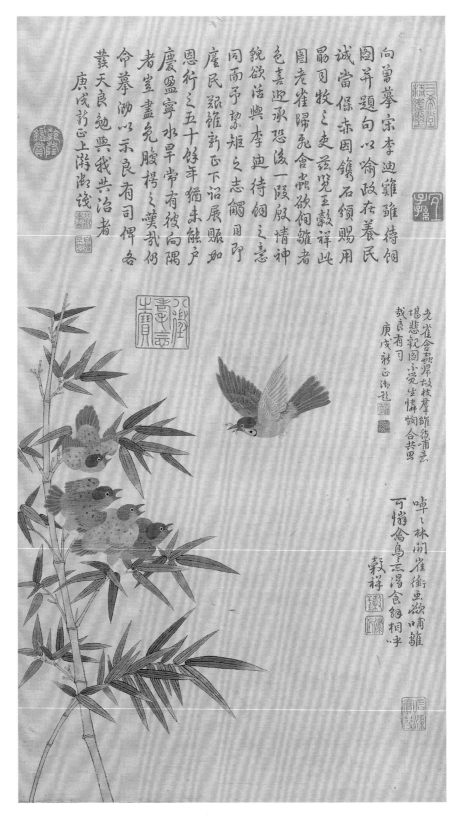

217

Kesi Silk Scroll
of Qianlong's Copy of Mi Fu's New Year Day Model Script

Qing Dynasty Qianlong period

Vertically 85 cm Horizontally 39 cm
Qing court collection

In this scroll on a light yellow ground is woven in blue *kesi* (cut silk) the emperor's copy of Mi Fu's cursive hand "New Year Day Model Script." (Yuanritie) There are stamps saying "Emperor's copy of Mi Fu's model script," "to protect the virtuous alone" and "by the imperial brush of Qianlong."

Mi Fu (1051–1107), alias Yuanzhang and also named Haiyue Waishi and Xiangyang Manshi, was from Xiangyang of the Northern Song Dynasty (in Hubei today). He was adept in calligraphy and considered one of the four great masters of Song.

This scroll recreates the verve and force of the brushstroke of the original script to its utmost. The variation is rich and the *kesi* weaving makes the turn from dots to strokes and the fine links in between resemble very closely the brushstrokes in the original.

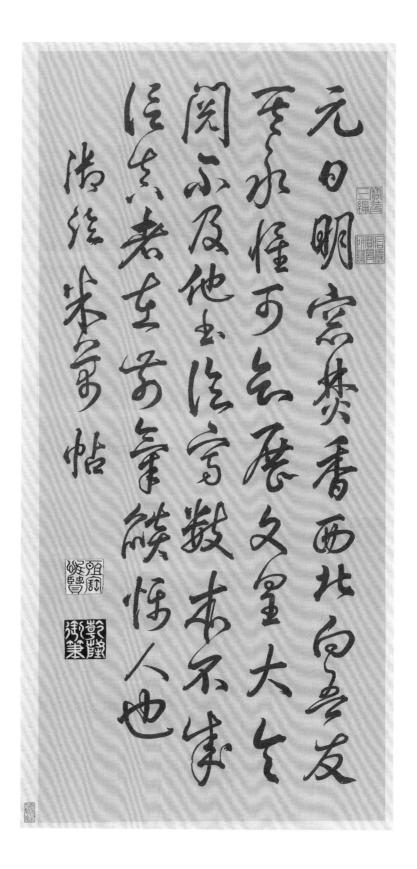

218

Kesi Silk Scroll
"Inscription on Ningshou-gong Palace" Made by Emperor Qianlong and Written by Fu Kang'an

Qing Dynasty Qianlong period

Vertically 52 cm Horizontally 136 cm
Qing court collection

The *kesi* (cut silk) tapestry weaves out the scroll of "Inscription on Ningshougong Palace" made by Emperor Qianlong and hand-written by Fu Kang'an. The contents cover the initial idea and original reason for Emperor Qianlong to have Ningshougong Palace built. On this are the stamps saying "respectfully written by the subject Fu Kang'an," "Subject Fu Kang'an" and "respectfully written." Around the border are figures of the character for 卍, bats and the character for "longevity" woven in *kesi* on brocade ground.

Ningshougong Palace is situated on the East Road outside the Forbidden City. It was built in the 28th year of the reign of Kangxi, the Qing Dynasty (1689) on the original site of Renshoudian Hall from the Ming period. Since the 37th year of Qianlong (1772) it had been renovated, modified and expanded for six years in order to provide Emperor Qianlong an abode in retirement at old age.

219

Kesi Silk Scroll
of Sakyamuni's Portrait with an Inscription of Eulogy by Qianlong

Qing Dynasty Qianlong period

Vertically 206 cm Horizontally 86 cm
Qing court collection

The tapestry weaves out in *kesi* (cut silk) a picture of a canopy under lush datura petals encircled with auspicious clouds. With the light from behind and looking very much in peace, Sakyamuni sits cross-legged in deep meditation on his precious lotus seat on Mount Sumeru. In the painting woven in golden *kesi* on a blue ground is the eulogy to Buddha written in running hand by Emperor Qianlong and stamped with seals saying, "Imperial Eulogy in Spring, the 1st month in the year of *renwu*," "Garden of Joy" and "ink brush of the imperial palace of Qianlong." The borders are mounted with patterns of twining lotus; at the top end are twin phoenixes in the clouds and at the bottom dragons in waves. The year of *renwu* was the 27th year in the reign of Qianlong (1762).

Sakyamuni was originally called Siddhartha Gautama, a prince from an ancient kingdom in northern India who left the royal house and became a monk. As founder of Buddhism, he is honoured and worshipped by both the Tantric and non-Tantric Mahayana Buddhists as the highest deity.

The portrait is woven in *kesi* with multi-coloured threads and gold threads. Methods used include *pingke, changduanqiang, gouke* and *dake.* The minute details are done in brushwork with gold outline. The colours are sumptuous and gorgeous, and the register of hues is expressed by merging colours in gradation, showing nuances to make the colour scheme gentle and mild.

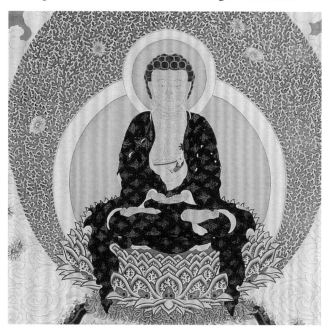

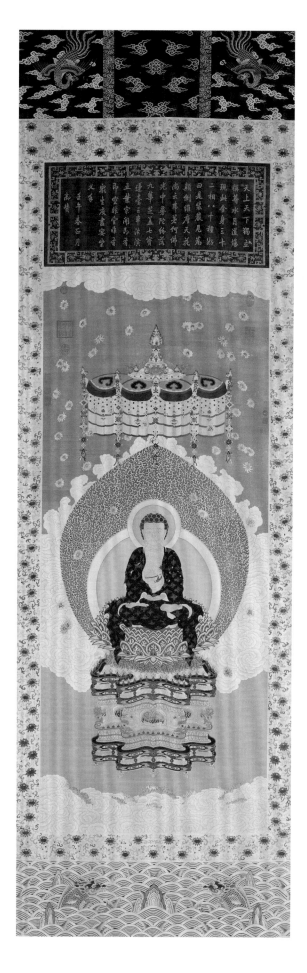

220

Kesi Scroll
in Silk Embroidered with
Laozi Riding on the Buffalo

Qing Dynasty Qianlong period

Vertically 329 cm Horizontally 137 cm
Qing court collection

In the picture Laozi, grey haired and white bearded, rides on a buffalo. On it are written two poems by Qianlong and stamped with the seals saying, "written in the summer of *jimao*," "written again on a clear mild day in *gengchen*," "ink brush of the imperial palace of Qianlong" "Qian" and "Long." *Jimao* was the 24th year during the reign of Qianlong (1759) and *gengchen* the 25th year of Qianlong's reign (1760).

Laozi was a thinker and philosopher from the pre-Qin period and founder of the school of Daoism. He has authored the *Daodejing*. According to legend, at old age Laozi rode on a buffalo and left for the west through the Pass of Hangu. The guard saw a cloud of purple air coming from the east and knew that a sage was on his way. That is the reason why posterity has often used this image of Laozi on the buffalo as an auspicious symbol.

This picture is woven by using *pingke* to make a flat surface in the *kesi* (cut silk) tapestry, and to make the detail *gouke*, *changduanqiang* and *kejin* are flexibly employed. The hair and beard of people are embroidered in closely joint stitches. The hair and the nose of the buffalo are painted with brushwork. Thus, it combines *kesi*, embroidery and brushwork and is a representative piece of *kesi* tapestry cum embroidery from the Qianlong period.

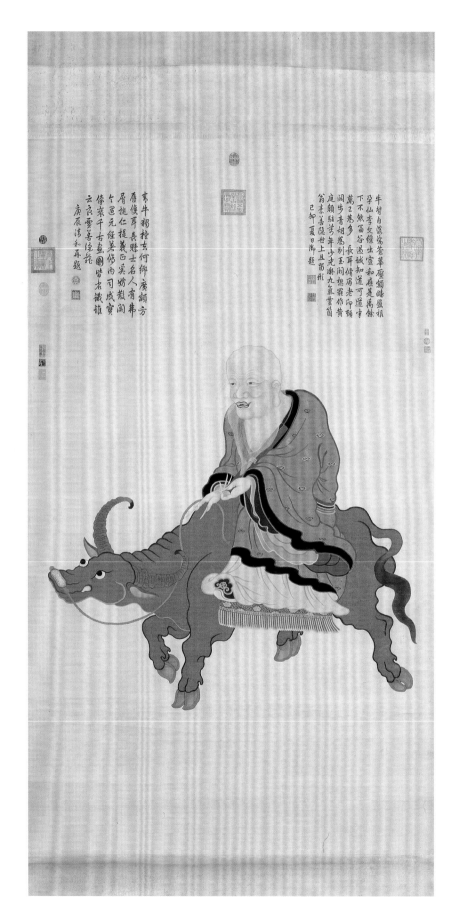

221

Kesi Silk Scroll
Embroidered with the Picture of Dispelling Chill on Double Nine Day

Qing Dynasty Qianlong period

Vertically 213 cm Horizontally 119 cm
Qing court collection

There are three lads in the picture, one riding on a goat and two going on foot, and there are also nine goats in various postures. Overall are decorative figures of flowers, pine trees, bamboo, rocks and auspicious clouds. The atmosphere is full of joy. The word for "goat" or "sheep" puns with *yang*, to imply "three strokes of *yang* start peace and prosperity" and "double nine dispels the chill." On the picture is a poem written by Qianlong with the stamps "inscribed by the emperor in *jiaping* of *xinchou*." *Xinchou* was the 46th year of the reign of Qianlong (1781) and *jiaping* was the 12th month of the lunar calendar.

This picture was originally in the holding of Ningshougong Palace. It is a work combining *kesi* (cut silk) tapestry with embroidery. The background is in *kesi*, while the rocks on the slopes, the flowing clouds and the tree trunks are woven by the methods of *pingke, dake, gouke, guanke* and *jie*. The human figures, the goats and the flowers are embroidered in basic stitches of *taozhen* and *qiangzhen*. The minute places are finely made up by various stitches of *wangzhen, zhazhen, dazi, dingzhen, dingjin, shimaozhen, jimaozhen, kelinzhen, souhezhen, fanqiangzhen, jixianxiu* and *hesexian* in accordance with the texture of the objects so as to achieve a realistic vividness. It shows the sumptuous opulence by means of refined embroidery and the soft silk lustre.

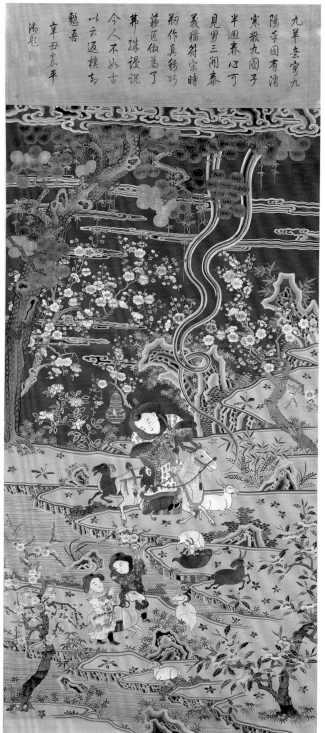

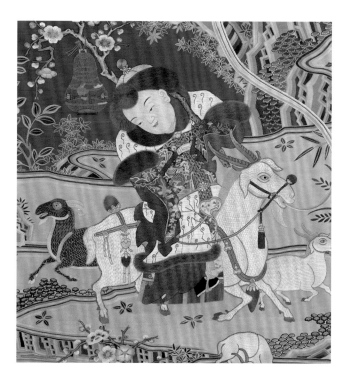

222

Kesi Tapestry
with Embroidery of Emperor Qianlong's Inscription on the Picture of the Three Stars

Qing Dynasty Qianlong period

Vertically 412 cm Horizontally 135 cm
Qing court collection

In the picture are the star of happiness, the star of officialdom and the star of longevity. The one holding a peach with his back towards the viewer is the star of longevity; the one holding a male infant on the left is the star of happiness; and the one on the right wearing a red robe is the star of officialdom. In front of him is a boy standing and holding a vase of peony. The distant hills form the background with pine trees, cranes, deer, peonies and *lingzhi*-fungi. On the upper part of the picture is Qianlong's inscription "Ode to the Three Stars" in running hand, with a stamp saying, "written by the Emperor in the month of *qinghe* of the year of *renyin* during the reign of Qianlong." In the space for verses is written "admired for growing in years" and in *kesi* (cut silk) are woven the seals saying "viewed by Emperor Qianlong," "treasure of son of heaven reaching seventy," "closely inspected by Sanxitang," "benefitting descendants" and "still studying hard all day." The year of *renyin* was the 47th year of Qianlong's reign (1782) and the month of *qinghe* was the 4th month of the lunar calendar.

This picture is woven in two to four colours merging in gradation and the *kesi* methods of *pingke*, *changduanqiang* and *dake*. In minute places such as the folds on the clothing and the body of the cranes and deer, embroidery stitches like the *dingjinxian*, *santaozhen* and *shimaozhen* are employed. There are over thirty different colours of silk threads used in the picture. The design and tones are very rich and beautiful.

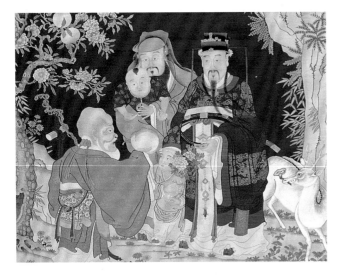

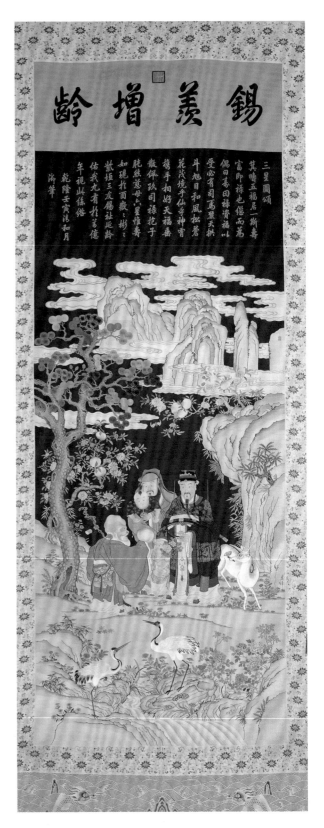

223

Hanging Panel
in *Kesi* with Pile Showing Picture of Chicks Waiting to Be Fed

Qing Dynasty Qianlong period

Vertically 64 cm Horizontally 36 cm
Qing court collection

The picture is woven to represent Li Di's painting Young Chicks Waiting to Be Fed. Two chicks, one standing and the other lying down, look anxiously waiting for being fed. In the upper part of the tapestry is an inscription in verse in *kesi* (cut silk) by Qianlong, and the stamps read, "written by the emperor in *zhongqiu shanghuan* in the year *wushen*" together with "treasure of the son of heaven reaching seventy" and "still studying hard all day." *Wushen* was the 53rd year of Qianlong's reign (1788) and *zhongqiu shanghuan* was the early ten days of the 8th month before Mid-autumn in the lunar calendar. In that year there were floods in Jingzhou, Hubei Province and that is what the phrase "disaster on the land and hunger among people" in the poem means. From this is deduced that Qianlong used the picture to tell his officials to care and empathize with people's illness and suffering.

Li Di, whose dates of birth and death are unknown, was from Heyang of the Southern Song Dynasty (the county of Meng in Henan Province today) and employed by the court's art studio. He was adept in painting birds and flowers, bamboo and rocks and beasts.

This pictutre is woven in *kesi* in twisted threads of silk and wool and the techniques involve *changduanqiang, pingke* and *dasuo* as well as the merging of colours in gradation, to show the nuance and texture of the plumes. The calligraphy is woven in silk threads by *pingke* and *dake*.

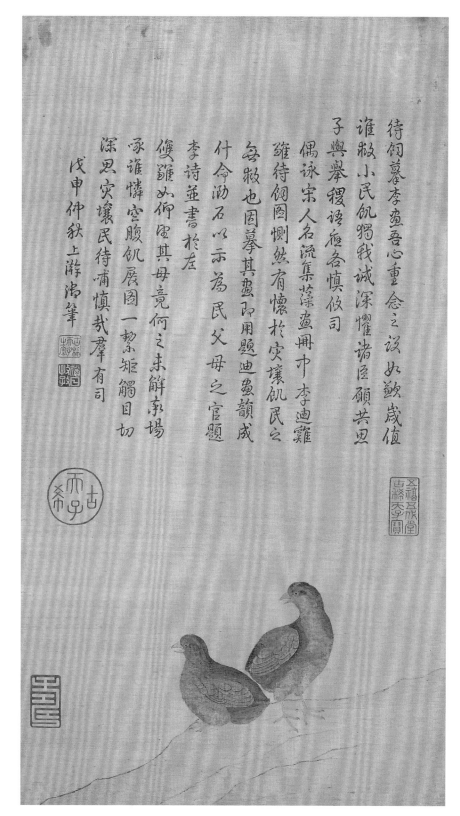

224

Hanging Panel
with Picture of Mountain
Lodge and Human Figures in
Gold *Kesi* with Embroidery

Qing Dynasty Qianlong period

Vertically 78 cm Horizontally 118 cm
Qing court collection

The picture shows a mountain lodge surrounded by hills and inside are luxuriant plants in bloom and bearing plenty of fruits. In front of the house in the courtyard, a little boy is presenting a *ruyi* staff to an old couple. By the gate to the yard another boy is approaching holding something. Outside the yard, a lady leans against a fence by the pavilion on water enjoying the view. On the bridge over the brook is a person with a staff approaching holding a child by the hand.

The main scene of the picture is woven in gold *kesi* (cut silk) while the detail is in threads of other colours. The technique involves mainly the *changduanqiang, baoxinqiang, gouke,* and *pingke.* The leaves, plants and ridge of the house are embroidered in silk threads, while the faces of the human figures are painted by brushwork. On a ground of blue, the golden tone of the picture radiates with brightness and opulence. This is a rare piece of gold *kesi* picture from the Qing period.

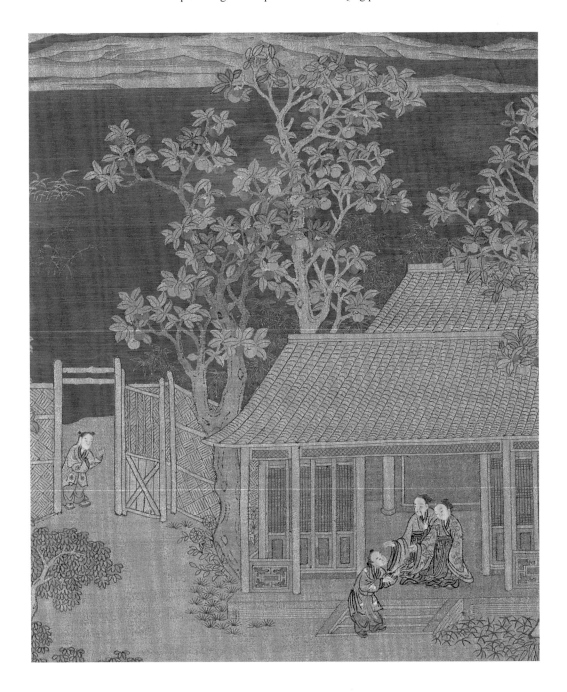

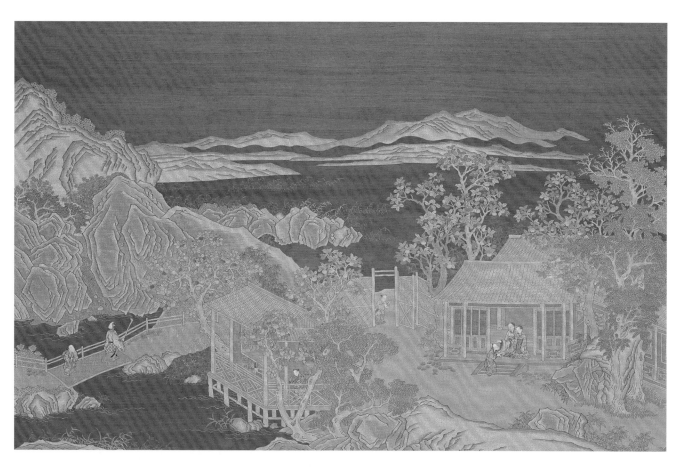

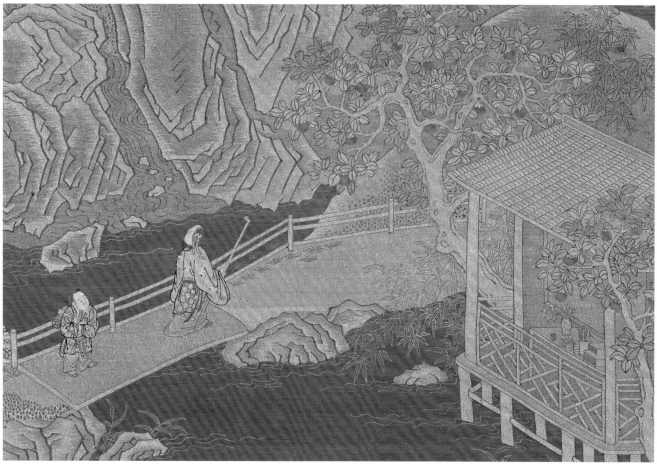

225

Scroll
in Coloured Brocade
Showing the Painting of
Paradise by Ding Guanpeng

Qing Dynasty Kangxi period

Vertically 448 cm Horizontally 197 cm
Qing court collection

The scroll is a piece of textile representing Ding Guanpeng's "Picture of Paradise in the West." In the middle is Amitabha sitting cross-legged flanked by Avalokitesvara and Mahasthamaprapta on either side, forming together the "Three Saints of the West." Around them are other bodhisattvas, arhats, warrior attendants, deities and musicians. On the upper part are ten rays of Buddha's Light and below is the ninth ranking Lotus Pond. On the nine lotus blossoms are Buddhas, bodhisattvas and arhats reincarnated from the human world.

Ding Guanpeng, whose dates of birth and death are unknown, was from Xiuning in Anhui Province during the Qing Dynasty (some say Beijing). As a court painter between late-Kangxi and mid-Qianlong period, he was adept in painting human figures, specializing in Daoist and Buddhist paintings.

Coloured brocade is double sided brocade woven with coloured wefts (or warps) led by *kongsuo* (controlling shuttle) and *changpaosuo* (long running shuttle) to show patterns. The craftsmanship of this piece is exquisite. It uses the warps as ground and wefts to show the patterns, involving a dozen colours. The composition is elaborate and dense, the scene spectacular and the human figures are many. It is the largest brocade painting to date.

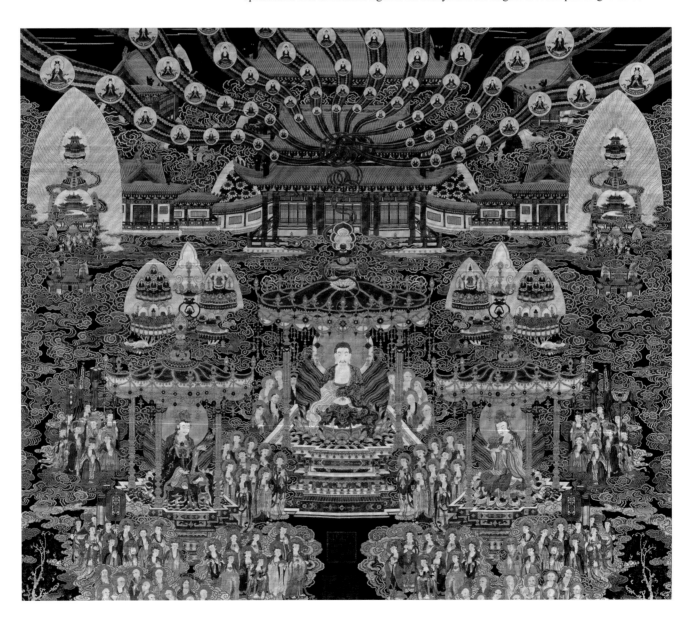

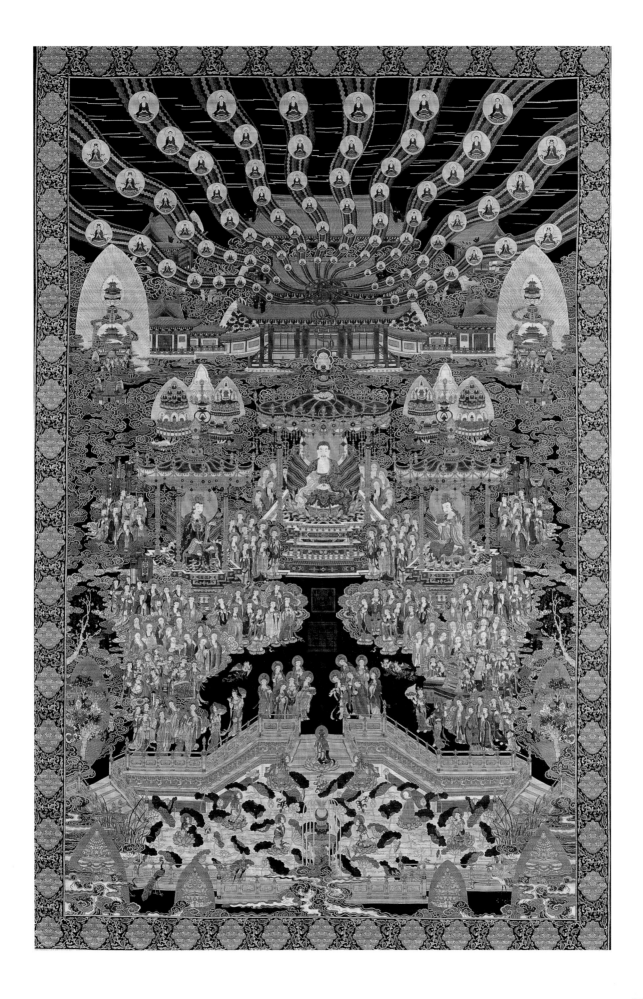

226

Scroll
of Flowers and Birds in
Coloured Brocade

Qing Dynasty Yongzheng period

Vertically 59 cm Horizontally 113 cm

On a light blue ground in this picture
are woven in colour Taihu rocks and birds
and flowers such as peonies, lotuses, egrets,
Mandarin ducks and swallows.

Two colours merging in gradation are
employed and twill patterns are woven on
a satin ground by *wasuo* (digging shuttle)
technique. It is a horizontal scroll woven
vertically in one pass with wefts as ground
and warps for patterns. The texture is open
and the jacquard weave lucid. The colour
design is decorous, demonstrating the
characteristics of the art of silk weaves in
the early-Qing period.

227

Brocade
of Amitayus Buddha Woven with Gold Threads

Qing Dynasty Qianlong period

Vertically 100 cm Horizontally 58 cm
Qing court collection

Sitting cross-legged on the *xumi* seat, the Amitayus Buddha wears a precious hat made up of five pieces, has his hair worn in a bun on top and dons huge earrings, a neckband, necklace and bangles round the upper and lower arms and the legs. His celestial garment is in red tea colour and his hands make the signs of deep meditation and hold the precious jar.

This thangka is woven on an undyed ground with gold and colourful threads. Many of the folds and creases on the clothing are woven in gold and give the drapery a sense of movement.

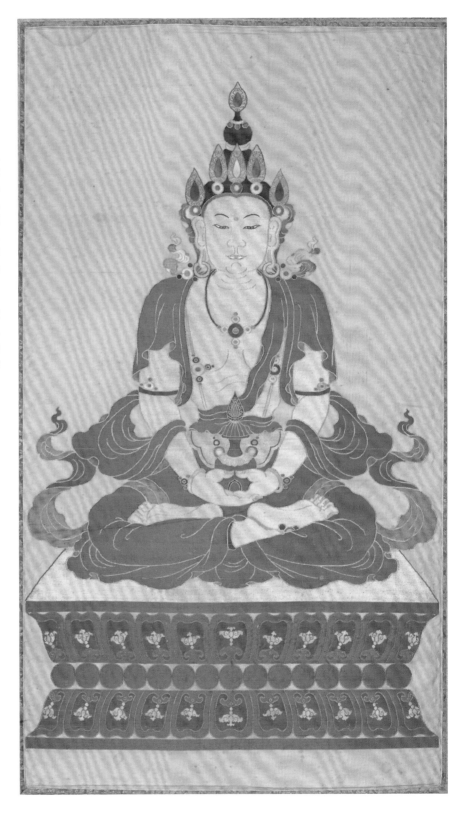

228

Brocaded Scroll
of Picture of Myriads of
Male Children Presenting
Gifts of Longevity

Qing Dynasty Qianlong period

Vertically 144 cm Horizontally 70 cm

The male children in the picture go in twos and threes, holding lotus flowers or a round box or the *ruyi* staff or stone chimes. In the picture are also peach trees, bats and cranes and deer. Every two rows of the boys form one pass or unit in the pattern. In the space for verses is written in ink in *zhuan* or seal script "shou tian bai lu." The opening phrase is "Respectfully made to celebrate the sixtieth birthday of Jiezuogong" and the closing phrase is "Conscientiously / wished by Yuan Fan in the 1st month of the year *guiwei* / inscribed by Wang Ti" and stamped with "Wang Ti's private seal."

This brocaded scroll was made during the reign of Qianlong, but the inscription was added later to make a birthday gift of it.

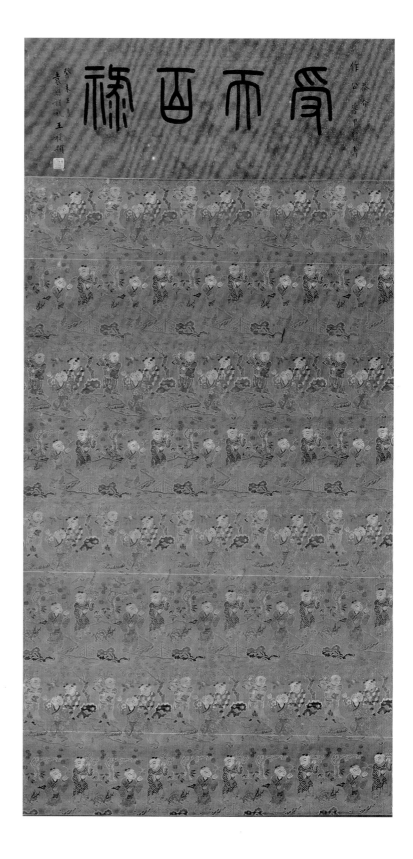

229

Zhangrong Scroll of the "Peacocks" Painting by Shen Quan

Qing Dynasty Qianlong period

Vertically 115 cm Horizontally 64 cm

The woven picture shows two peacocks standing on some rocks with their heads tilted up. The *wutong* trees are luxuriant with branches and leaves and foiled with some bamboo branches. On the picture is written "Painting from Song Dynasty imitated by Shen Quan, alias Nanping, at Mid-autumn in the year *bingchen* during the reign of Qianlong." Stamped on it is the seal "fushou." (happiness and longevity) In the lower right corner is the stamp for "Textile Bureau of Fushou in Suzhou." Bingchen was the inaugural year of Qianlong's reign (1736).

Shen Quan (1682–1760) alias Hengzhi, also named Nanping, was from Wuxing of the Qing Dynasty (Huzhou in Zhejiang Province today). A painter specializing in flowers and birds, he studied in Japan. He became much influenced by Japanese painting and adopted the best of the traditional painting of Japan. He was famous for his fine and beautiful works.

There are two categories of *zhangrong* (pile weave in Zhangzhou Style), the patterned and the plain. The plain type has no pile loops, while the patterned type has loops, parts of which are cut to make piles forming patterns. The patterns in this piece are also made by cutting the pile loops. The piles stand fine and dense. The pattern and the ground weaves show distinct contrast of light and shade, giving thus a strong sense of three-dimensionality.

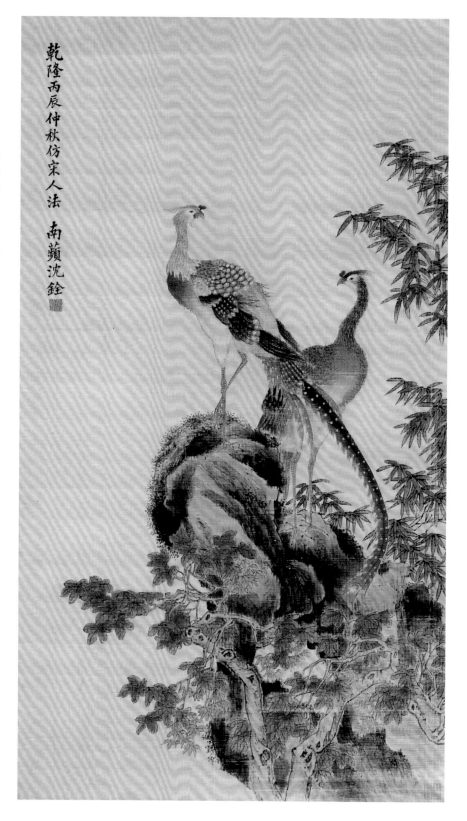

230

Screen
in Four Sections Made of *Zhangrong* Showing the Four Activities of Fishing, Wood-cutting, Farming and Studying

Qing Dynasty Jiaqing period

Vertically 108 cm Horizontally 25 cm

The screen is woven in four pictures as landscape and human figures painting showing the activities of fishing, wood-cutting, farming and studying. In the first picture is a fisherman donning a bamboo hat and straw cape, carrying a net and basket and walking on a bridge over the brook. In the distance are small sailing boats; in the second picture a wood-cutter carrying firewood on his back hobbles along a winding hill path. Among rustic cottages are green wood trees; in the third picture a peasant carrying a hoe trudges swiftly along the serpentine path. On the wayside are rocks and nearby a gurgling brook; and in the fourth picture is a scholar riding a donkey through the verdant woods completely at ease with himself.

These pictures are finished with brushwork on the *zhangrong* pile (pile weave in Zhangzhou style). The cut piles making the patterns stand up terse and dense, while the uncut loops making the ground are broad, level and smooth. The contrast achieves a unique effect.

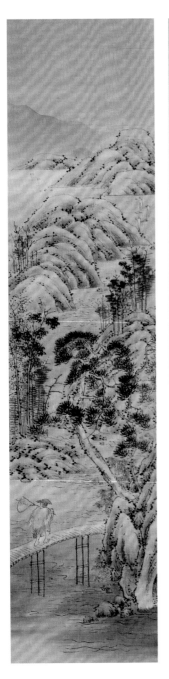

231

Zhangrong Scroll
of Landscape Painting

Qing Dynasty

Vertically 62 cm Horizontally 60 cm
Qing court collection

The scroll of *zhangrong* (pile weave in Zhangzhou style) is a woven picture of a snow scene. In the foreground on the slope by the bank are thickets covered with snow, withered branches and the verdant pines and cypress. On the unfrozen bank of the other side of the river are crows roosting or flying, and in the distance are vaguely visible hills. It evokes a quiet lonesome atmosphere.

This picture is created by first cutting the pile in accordance with the patterns and then brushing on with ink and colour. Where the pile loops have been cut light is refracted and this gives rise to a special three-dimensional sense to the texture. The cutting was done exquisitely resulting in very distinct nuances. This represents the special traits of the School of Lingnan (south of the five ridges, i.e. Guangdong and Guangxi) during the Qing period.

232

Album
with Twelve Sections of Paintings of Flowers and Birds in *Guarong*

Qing Dynasty Qianlong period

Vertically 34 cm Horizontally 24 cm

There are twelve sections to the album, each depicting flowers and herbs like corn poppy, peach blossoms, Chinese rose, crabapple, dianthus chinensis, azalea, bamboo, Chinese herbaceous peony and chrysanthemum, foiled by birds, butterflies and Taihu rocks.

Guarong (scraped pile) is thin velvet made with split filaments with the patterns pasted or painted on in accordance to the blueprint. This album shows the style of flowers and birds paintings by the woman painter Wen Chu from the Ming period. The colour scheme is without a main structure but it is fresh and elegant. The painted brushes are bright and the detail minute. The picture evokes a strong sense of texture and the silk threads have clear lustre and run in distinct directions.

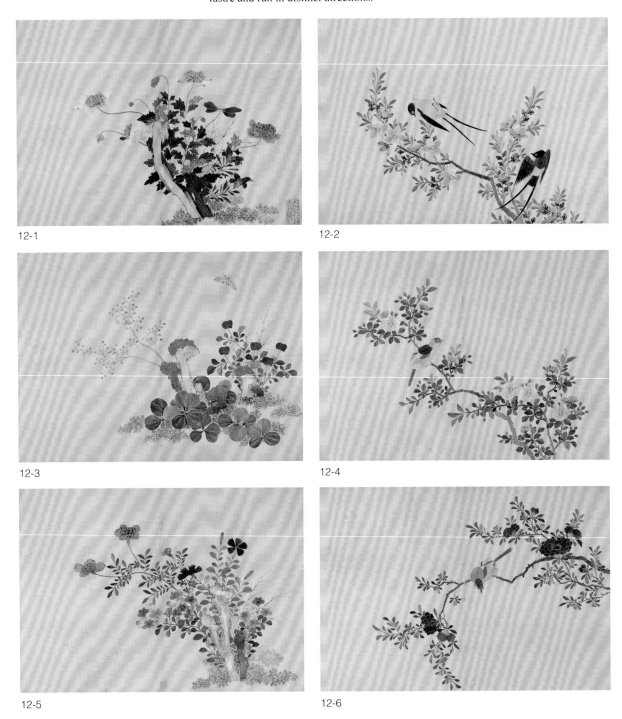

12-1

12-2

12-3

12-4

12-5

12-6

12-7

12-8

12-9

12-10

12-11

12-12

Album
of Famous *Guxiu* from the Song and Yuan Dynasties (in Eight Sections)

Ming Dynasty　Chongzhen period

Vertically 33 cm　Horizontally 25 cm

There are eight parts in the album. They are Han Ximeng's embroidered facsimiles of paintings from the Song and Yuan periods. On every page is an embroidered painting and on its opposite page is the verse eulogy in calligraphy by Dong Qichang. At the end of the album is a veiled postscript by Gu Shou, Han Ximeng's husband, to recount the process of embroidering the album. In red are embroidered the seals "Needlework by member of Han clan," "Handmade by Ximeng." In the small regular script is stated that the album had once ended up with the Liulichang in Beijing.

Guxiu (embroidery of Gu style) originated as the family embroidery of the clan of Gu Mingshi in Shanghai during the reign of Jiaqing, the Qing Dynasty. The embroidery is well-known for its looking like painting and therefore called "painting in embroidery." Han Ximeng was the wife of Gu Mingshi's grandson. Being adept in painting flowers and birds in minute detail and in embroidering, Han Ximeng became the representative artist of *guxiu*. Her needlework is fine and subtle and her works are life-like. This album represents her best production.

On the first page is the picture of "Washing a Horse" by Zhao Mengfu from the Yuan Dynasty, in which is embroidered a man washing and scraping a horse clean in the river, on whose bank are weeping willows. The embroidery is made with silk threads in a dozen colours as well as threads wrapped in gold, and the needlework includes stitches like the *taozhen, gunzhen, qizhen, jiezhen* and *pingjin*, supported with painting in light malachite, making the human figure and the horse very life-like. Every picture is matched with a corresponding inscription.

The second embroidered picture "Deer" depicts a deer with "plum-blossom dots" strolling by the lake side. The body of the deer is embroidered by *jitaozhen* stitches, showing the fine and dense hair and the lucid texture, as if it was seen at close quarters. The longevity stones in the water are embroidered by *qiangzhen* stitches in gradually merging shades of blue threads, decorated here and there with green, orange and yellow to emphasize the texture. The rocks on the shore are made mainly in *santaozhen*, supported by painted dots, achieving the effect of water ink painting.

In the third picture "Mending the Imperial Robe," a woman is paying full attention to embroidering a dragon robe. The stitches employed include the *taozhen, the qiangzhen* and *panjin*. The colours are rich, varied, fresh and brisk. The needlework is fine and the detail is life-like. The folds on the bodice, for example, are embroidered in *qiangzhen* stitch with orange threads of dark and light nuances, while those on the skirt are embroidered with six or seven long slanting floating threads in light green, making the lines of the robe fluent and natural and their texture realistic. The hair and one of the weaving hands are made out in brushwork. This work is a combination of painting and embroidery.

The fourth part is the picture of "A Quail," in which is embroidered a quail turning its head down looking for food. The plumes of the fowl are embroidered in *shimaozhen* stitches and the claws in *dingzhen*. The texture is expressed by changing the directions in which the threads run. The dark reddish brown of the quail sets the main tone of the picture, foiled by the brightness of green leaves and red fruits, which makes the sharp contrast interesting.

The fifth part is "Landscape Painted by the Mis," an embroidery of a landscape in water ink. The Mis refer to father and son Mi Fu and Mi Youren of the Song Dynasty, who created the style of landscape painting in which misty scenes are depicted through the subtle tainting with water ink. In order to bring forth the tone of untrammelled expression of water ink, this embroidered picture employs only the simple stitches of *taozhen* and *qizhen* and uses often broader areas of merging colours, thus going away from the *guxiu* tradition of many varied stitches and threads in many colours.

The sixth picture "Squirrel on the Vines" is an embroidery showing a squirrel climbing on some grape vines and poised to pick the heavy strings of grapes. The squirrel is embroidered in *jitaozhen* stitches to show the texture of its hair better than painting. The colours are rich and various colour scales are used to show the different degrees of ripeness of the grapes. Details like the squirrel's whiskers and the worm eaten holes in the vine leaves are so finely depicted that they are clearly visible. This picture has also a corresponding inscription.

The seventh picture "Hyacinth Peas and Dragonflies" shows in embroidery a pair of dragonflies mating on a sprig of hyacinth peas. The outline of the inner edges of the plant is embroidered in *gunzhen* stitches to show the network of veins. The beans are made in *diexiu* in order to give them volume protruding. The bigger areas of the leaves are made with *santao* and the flowers with *pingtao* and *qiangzhen*, so as to make the transition look natural. The colours alternate between dark and light tones in order to show the different ages and degrees of well-being of the flowers. The *bingwenzhen* used to embroider the wings of the dragonflies helps evoke a sense of translucence.

The eighth picture "Fisher-hermit in the Flowery Brook" shows in embroidery an islet in the river with the backdrop of distant hills and a lone fisher on the cold river. The embroidered inscription reads "A hermit-fisher in the flowery brook / painting by Huang He Shanqiao as imitated by Han Ximeng." The needlework of this picture is fine and not stilted. The rocks and the tree trunks are embroidered in *souhezhen* and *qiangzhen* stitches, willow branches and leaves in *qizhen*, pine needles in *songzhen* and the boat awning in *bianzhen*. The Taihu stones and the slopes are lightly brushed up with colours.

一鑑涵空毛龍是浴鑒

魚九方風橫颠玉

屹如權奇譬予霹東籥

霊迤雲萬里在目

10-1

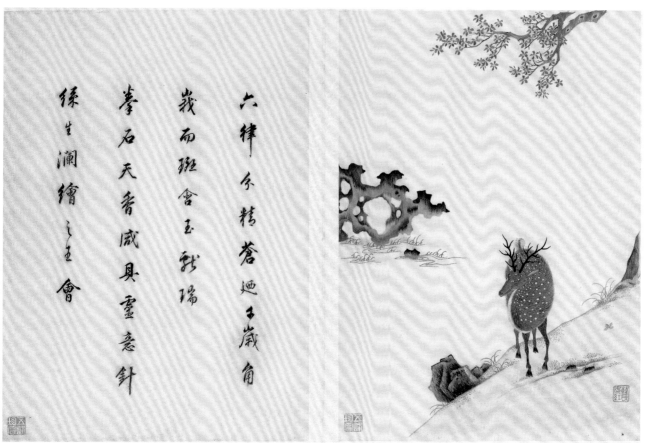

六律不精蒼迤玉歲角

巖而斑含玉軒璃

拳石天香咸具靈意針

綠生瀾繪之王會

10-2

271

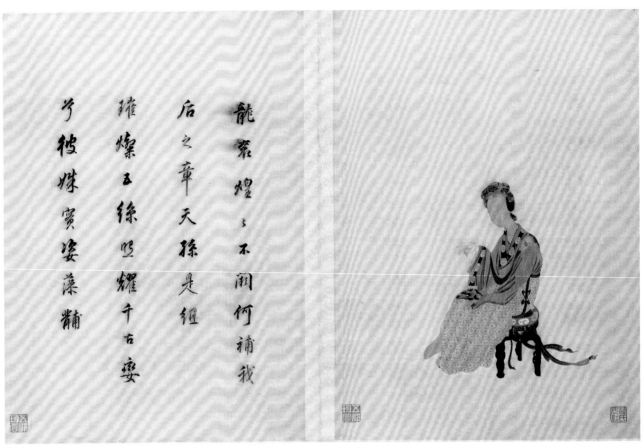

龍衮煌煌不闕何補我

后之章天孫是緝

璀燦玉絲照耀千古姿

芳彼姝實姿藻繢

10-3

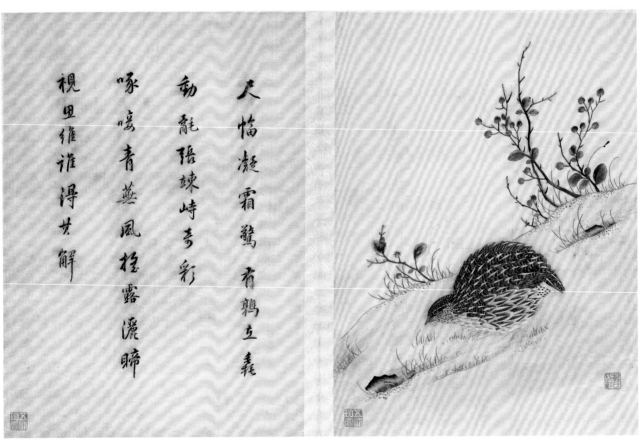

尺幅凝霜驚春鵒立義

動龍語棟峄寄彩

啄嗥青燕風搖露瀼瞬

視里維誰得其解

10-4

南宮頫筆未來神針綫

墨含影山畫之雪深

泊然幽賞誰入其林徘

細延佇閱有嘯青

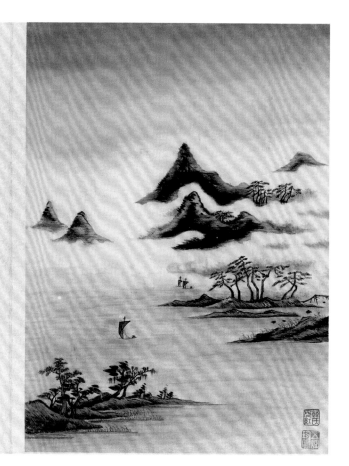

10-5

宛有芬龍乃言博雲翠

帳群苞雲漿作釀

文貌腮之翔騰紅上態

指靈蛾玄工蓋秋

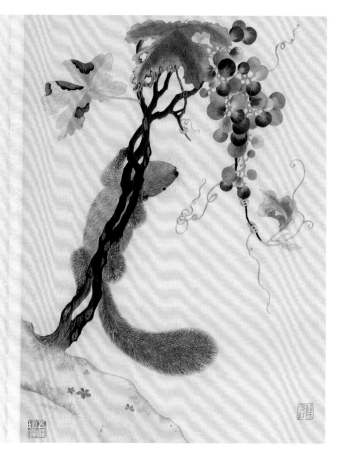

10-6

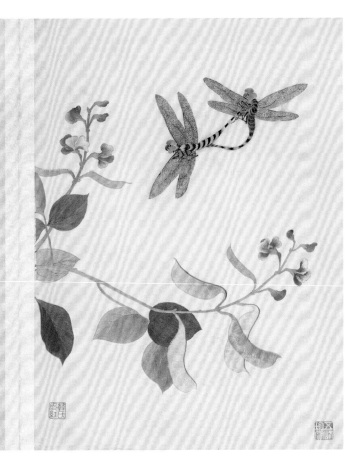

此身也天　翮翔雙羽逍
遙凌空吸露而肴
莒苔風清伺伏何而影
蒻生絹騅似仙鑪

10-7

平羔樂隱
倣黃鶴山樵筆
韓氏希孟

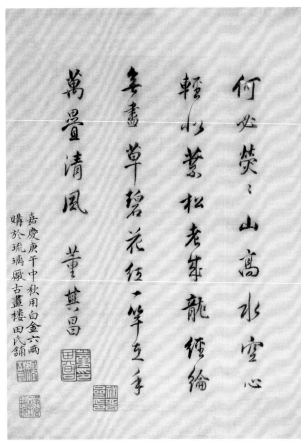

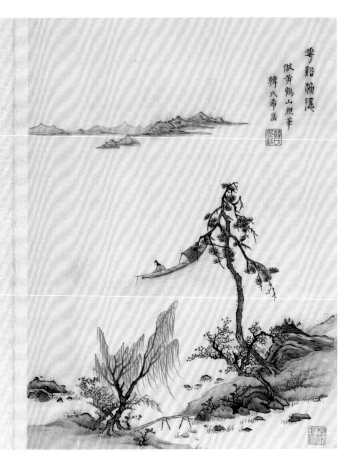

何必焚〻山高水空心
輕水紫松老年龍纏編
参畫草碧花经一筆至手
萬疊清風　董其昌

嘉慶庚午中秋用白金六兩
購於琉璃廠古畫樓田氏舖

10-8

274

在女紅而刺繡猶之乎士行而曰雕蟲見此然古來
稱神絶稱每自不朽惡在針絲位中不足手秋
也者廿年來海內所以珍龍吾家繡蹟者倖于
雞林價重而價鼎餘光楮堆令百里地無寒女之
歎第五綵一睎工拙易淆余肉子希孟氏別具慧心
居常喑其太濫甲戌春搜訪宋元名蹟摹臨八種
曾而不知單精運巧霞寐擅鑒譽己窮數年
之心力矢宗伯董師見而心賞之詰余技至生余無
一二繡成彙作方册觀者靡不舌撟手舞見所未
以雅僅涅於寒銛暑溽風冥兩临时布毅溢
事註天清日麗鳥悅花芊攔取眼前靈活之氣
刺人與綾師益詫欻以為非人力也欣然濡毫連
領贊語女紅末技乃摩大匠鴻章密謂家珍
決不効年利然而一行正龐不與偶伏輿名鉅
加之鑒賞賜以品題庶絲管常彩永播永
藝苑之素閫匪特余誇耀于肇紫百而已也付在
崇禎甲戌仲冬日繡佛齋主人顧青潛謹識

10-9

嘉慶壬申暮春之初過五峯主人
淨香室觀顧家希孟氏繡宋元名
蹟巧奪天工雖古所稱針神者
當亦不過如是也　湘林識

10-10

234

Guxiu Scroll
of the Prime Minister Wandering Freely
End of Ming and Beginning of Qing Dynasty

Vertically 143 cm Horizontally 40 cm

The embroidered picture of *guxiu* (embroidery of Gu style) shows an old man drinking alone under some bamboo and on the table are dishes and the *ruyi* sceptre, while a boy stands by waiting with a wine vessel. In the foreground are two boys holding respectively a dish and a book going between the corridor and the bridge. On the picture is embroidered a poem. In red are embroidered the seals "Garden of Dew Fragrance" and "Tiger Head."

This picture is embroidered with two colours merging in gradation and the stitches include *qizhen, taozhen, wangxiu, gunzhen* and *chanzhen*. The outlines are embroidered with silk threads and painted with ink. This combination has not only kept the tradition of Chinese painting in drawing the outline and filling the inside with colours but also created the unique tone and effect of coloured silk threads running on the textile. The needlework is exquisite and the colours merging are natural and elegant.

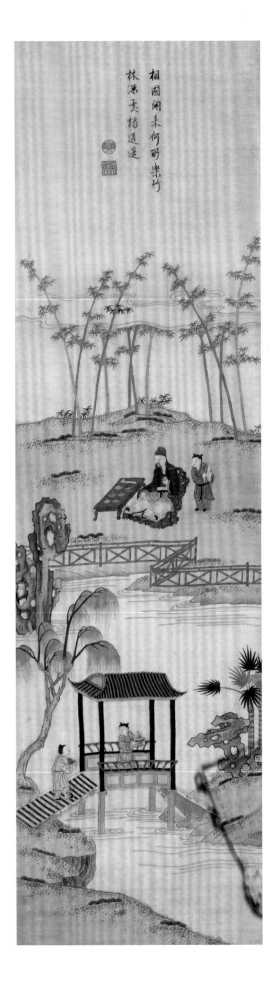

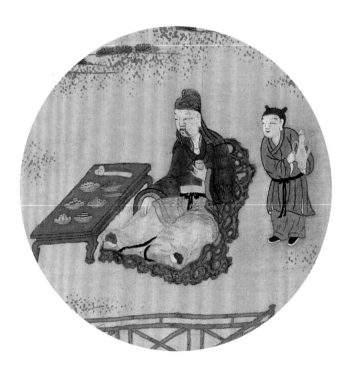

235

Guxiu Scroll
of the Seven Virtuous Men
of the Bamboo Forest

Qing Dynasty Kangxi period

Vertically 130 cm Horizontally 44 cm
Qing court collection

This is an embroidered picture of the Seven Virtuous Men of the Bamboo Forest. They were either playing chess or sitting chatting with each other. The embroidered inscription says, "A thousand poles of embellished bamboo calms the dusty air; the seven scholars' quiet joy in learning and poetry overflows." In red are embroidered the seals "Garden of Dew Fragrance" and "Green Jade Studio."

"The Seven Virtuous Men of the Bamboo Forest" stands for Ji Kang, Ruan Ji, Shan Tao, Xiang Xiu, Ruan Xian, Wang Rong and Liu Ling during the Wei-Jin period. They were good friends spending their leisure in a bamboo forest and thus became known as the Seven Virtuous Men.

This picture is a typical sample of *guxiu* (embroidery of Gu style) in which embroidery and painting are combined. The human figures, the trees, the bamboo and the brook as well as the inscription are embroidered; the mountain rocks are embroidered only in their outlines and then painted inside, while the Taihu rocks are all painted. The needlework involves mainly stitches like the *taozhen, wangxiu, gunzhen, shimaozhen* and *jiezhen.*

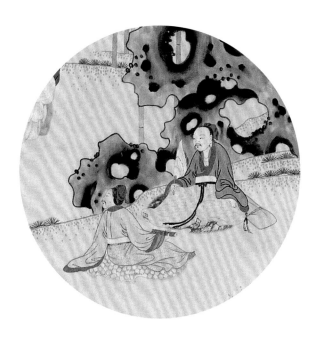

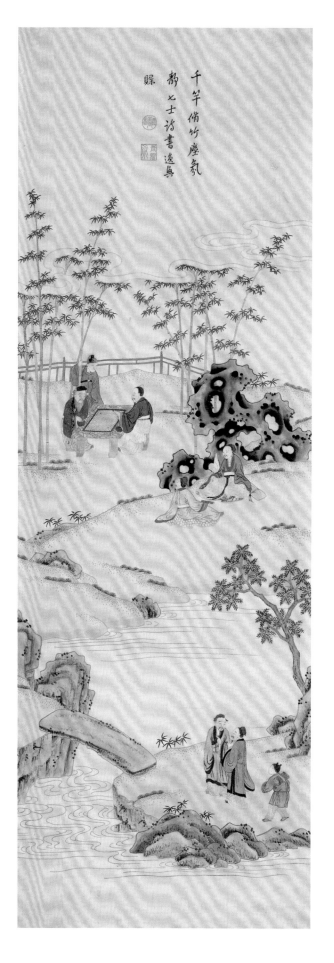

236

Guxiu Scroll
of the Picture of Hunting
Wild Geese

Qing Dynasty Kangxi period

Vertically 96 cm Horizontally 44 cm

The *guxiu* embroidery (embroidery of Gu style) depicts the scene of a hunter on horseback stretching his bow and arrow to shoot wild geese. He is shaven bald and dons a close-fitting robe with sash and wears boots, which is typical apparel for riding archers among nomads of the north. In ink are written verses by Wang Wei of the Tang Dynasty. In red is embroidered "acquired by the Green Jade Studio."

This picture has employed silk threads of many colours and embroidered by stitches such as *pingtao, dazi* and *panjin*. The human figures and the equestrian equipage are so delicately embroidered that the threads look like plumes and the creases on the clothing traced with gold and the floral groups are lucid and vivid. The equipage is embroidered with *panjin* to show the metallic lustre and feel. The depiction of distant hills and the green pines are somewhat simplified, whereby *gunzhen* is employed to trace the outline of the hills and *jiezhen* to embroider the pines, supported by light colouring.

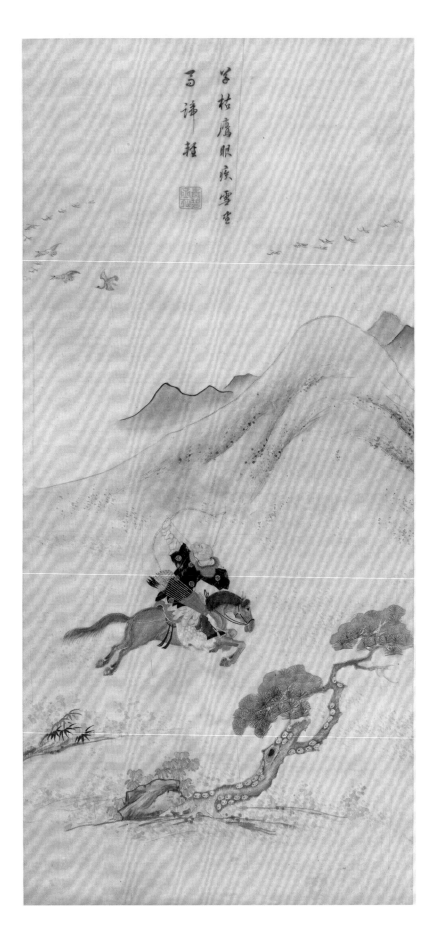

237

Guxiu Scroll
of *Jingangjing* Pagoda

Qing Dynasty Qianlong period

Vertically 213 cm Horizontally 69 cm

The picture depicts in *guxiu* (embroidery of Gu style) the pagoda for housing the *Jingangjing* (Vajracchedika Sutra). The border around is embroidered with gold threads in *huiwen* patterns. Inside every level of the pagoda is a shrine showing Sakyamuni in different looks and postures while expounding Buddhist teachings. In the first layer a Subhuti is raising a question for Sakyamuni to answer on his lotus seat, while Buddha sits there cross-legged and makes the sign for doing this. Inside the pagoda is embroidered the full text of the Vajracchedika Sutra, starting from above the head of Sakyamuni and running from right to left.

This novel composition of this picture uses the text of the sutra to form the body of the pagoda. While the text is embroidered in *gunzhen, xiechanzhen* and *taozhen*, the portrait of Buddha is embroidered in *taozhen, shimaozhen, xiechanzhen* and *gunzhen*. The needlework is exquisite. The outline of the pagoda is traced with gold threads, *chiyuanjinxian*, and silver threads in *pingjinfa*. The great amount of gold used makes the scroll's radiance dazzle the eyes.

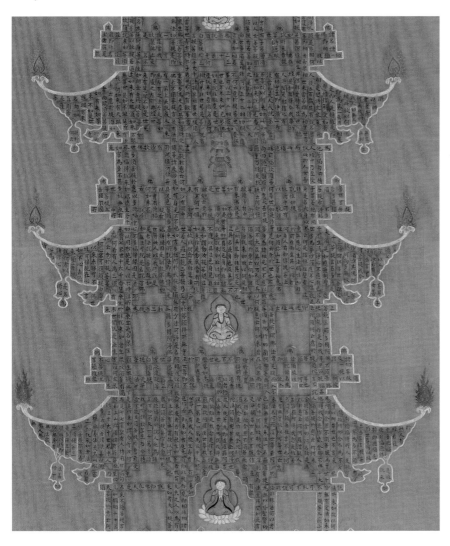

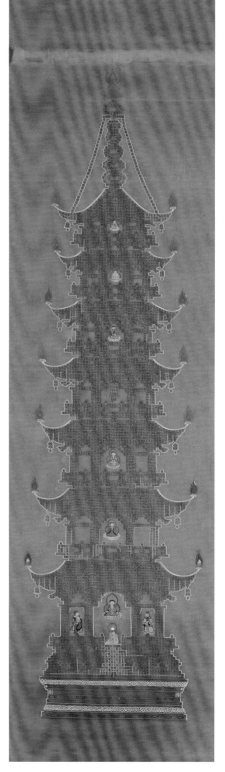

238

Album
of Picture of Fifty-three
Gurus Embroidered in *Guxiu*
(Fifty-four Sheets)

Qing Dynasty

Vertically 27 cm Horizontally 24 cm

There are altogether fifty-four sheets in the album, and this volume contains sixteen. The embroidery shows how the Sudhanakumara in the Avatamsaka Sutra went through mountains and rivers and other hardship in order to visit and learn from fifty-three gurus (Kalyanamitra) and in the end attained Buddhahood. On every page is shown one Sudhanakumara together with his guru. The inscription in ink says, "Reverently consecrated by Buddhist Follower Zhao Yong" and in red embroidery the seal "Yong." The ink inscription ends with the Heart Sutra and two seals in red reading "Luxiangyuan Garden" and "Lord Migong."

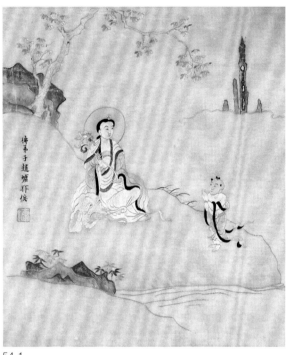

54-1

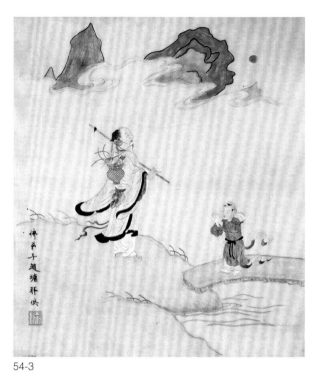

54-3

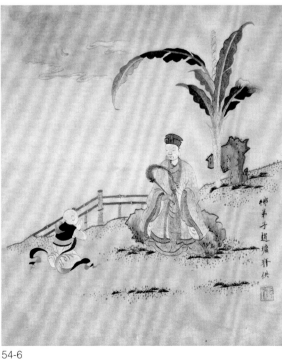

54-6

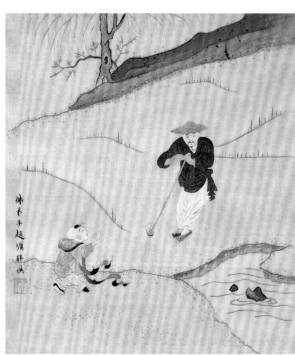

54-8

Many human figures feature in this album, and their expressions and manners are very vivid, showing the style of portraits painted by Ding Yunpeng and Wu Bin of the Ming Dynasty. Over ten different stitches have been employed, including the *taozhen, qizhen, gunzhen, jiezhen, dingzhen, panjin, pingjin, qiangzhen, bianzhen, wangzhen, jimaozhen, dazi* and *kelin.* Silk threads in over twenty different colours have been used for the embroidery, supplemented with brushing in ink and colours. It combines the advantages of *guxiu* (Gu embroidery) needlework and the exploitation of colours, worthy of a masterpiece of embroidery from the Qing period.

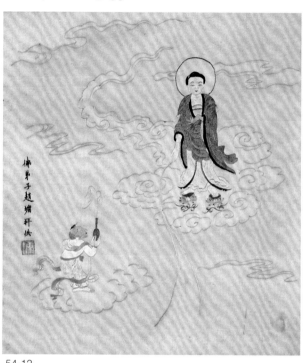

54-12

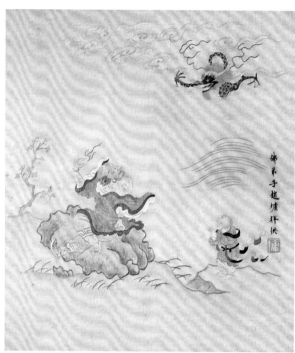

54-13

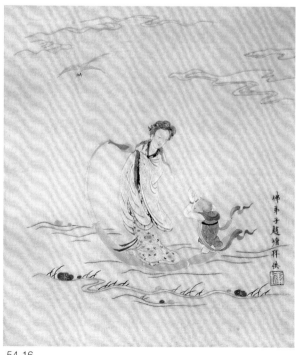

54-16

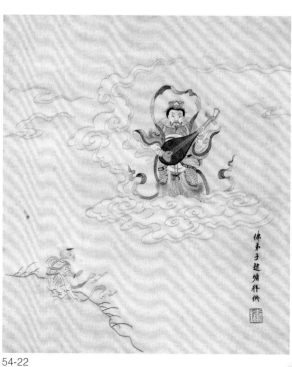

54-22

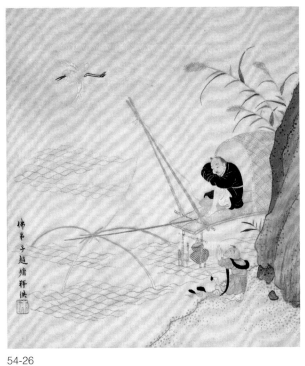

54-26

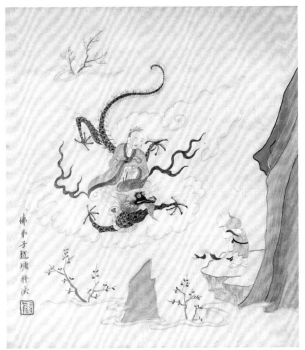

54-27

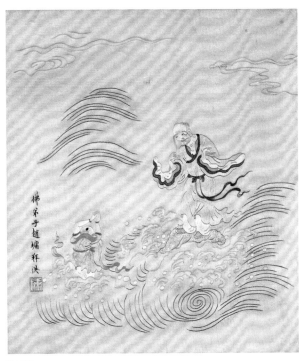

54-32

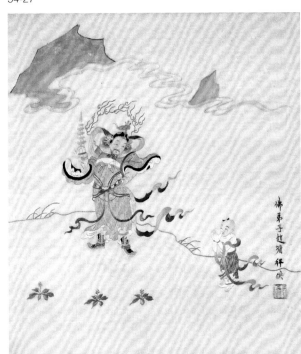

54-33

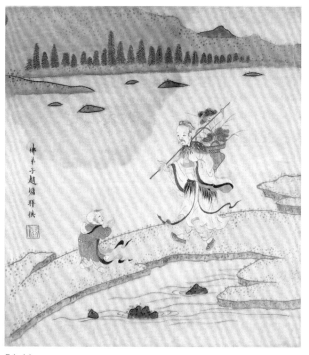

54-44

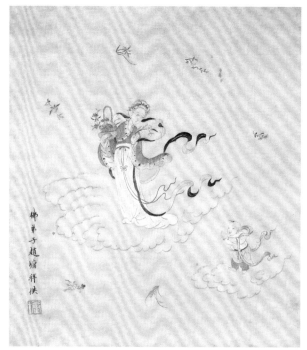

54-45

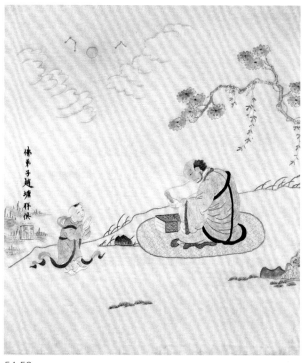

54-52

54-54

239

Scroll
of Mandarin Ducks and
Lotus Blossoms Embroidered
with *Yixian*

Ming Dynasty

Vertically 136 cm Horizontally 54 cm

The embroidery shows a scene of a lotus pond, in which lotus blossoms are in full bloom and a pair of mandarin ducks are frolicking in the water by the bank. On the bank are magnolia flowers radiantly blooming and two butterflies flutter among the twigs.

This picture is embroidered in similar methods to the *suxiu* (embroidery in Suzhou style) employing mainly *taozhen* stitches. The lotus blossoms are made with red and white threads intertwining. The mandarin ducks are made in *kelin* as well as *taozhen* stitches to show up the plumy wings. Even though the butterflies are small, they involve several different stitches including *taozhen, xiechanzhen, shimaozhen* and *jiezhen* in alternation.

Embroidery with *yixian* ("clothing yarn") started in Shandong, thus also called *luxiu* (Shandong embroidery), and it is representative of folk embroidery in the north. The craft is usually based on velvet damask as ground weave and the embroidery is made with clothing yearn made from two threads twisted together. The patterns are bold and free, forming a strong contrast against the fine threads and light colours of the boudoir embroidery south of the Yangtze.

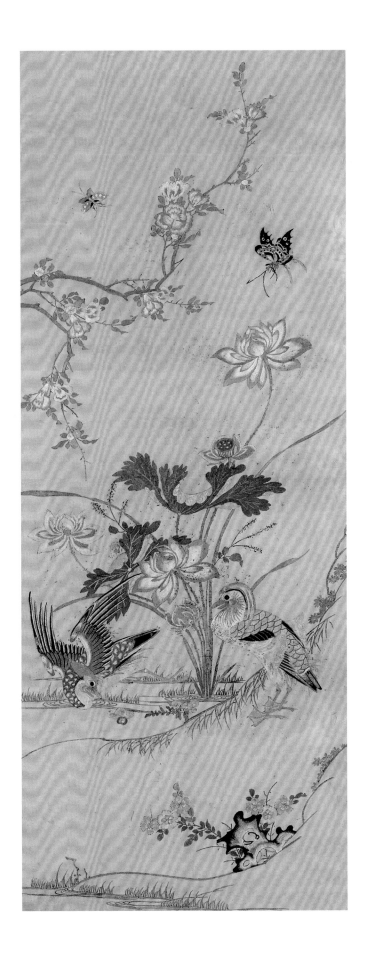

240

Scroll

of Mandarin Ducks and Hibiscus Blossoms Embroidered with *Yixian*

Ming Dynasty

Vertically 140 cm Horizontally 57 cm

The embroidery with *yixian* ("clothing yarn") shows a scene of a pair of mandarin ducks swimming closely together among the reeds in a pond. Above them are hibiscus flowers in full bloom.

The embroidery has employed *qiangzhen* stitches, *dazi* and *chanzhen*. The face composition is open and bright, the design simple and vigorous, and the needlework strong and bold. But despite the general style of boldness, the details are refined and delicate. The expressions of the ducks, for example, are vivid and fine, and the plumes are exquisitely embroidered, showing natural colours and lustre and suggesting a three-dimensional feel. It is a work of elegant beauty achieved through simple medium.

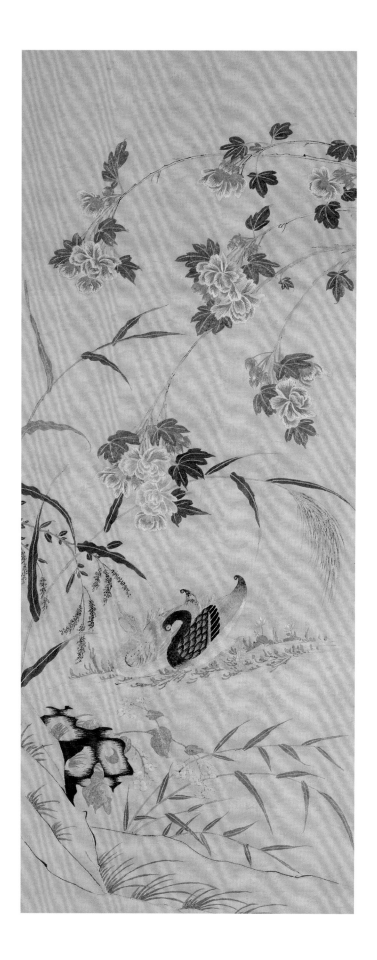

241

Mounted Fragment
of a *Guangxiu* Painting
Showing a Hundred Birds Singing

Qing Dynasty

Vertically 74 cm Horizontally 52 cm

The mounted fragment shows the picture of a hundred birds singing embroidered on a beige twill tabby ground. The birds include the peacock, the pheasant, the Mandarin duck, the quail, the humming bird, the myna, the parrot and the cock. They are foiled by three goats and flowers like the peony, the lotus, the chrysanthemum and the cockscomb. The scene is opulent and the colours gorgeous, implying "*san yang kai tai*" (three *yang* brings peace) and "*fugui ronghua.*" (wealth and prosperity)

This piece embodies the characteristics of Guangdong embroidery in that it is more elaborate and gorgeous than *guxiu* (Gu embroidery), leaving barely any space unfilled, and that its needlework is finer and more delicate than that of *luxiu* (Shandong embroidery), employing over ten different stitches such as the *taozhen, qizhen, dingzhen, gunzhen, shimaozhen, jimaozhen, zhazhen, dazi, kelinzhen, songzhen, wangzhen* and *jiezhen*. The birds' plumes and feather in particular are very sophisticated in their directions and stitch textures, achieving an exceedingly close resemblance to real life.

Guangxiu (embroidery in Guangdong style) is also called *yuexiu*, meaning Guangdong embroidery in general. Its needlework is elaborate and varied, its colour scheme gorgeous, its composition intricate, its embroidered objects naturalistically vivid, its stitches neat and the craftsmanship exquisite.

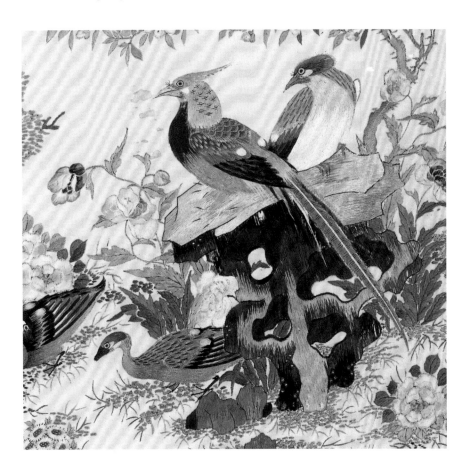

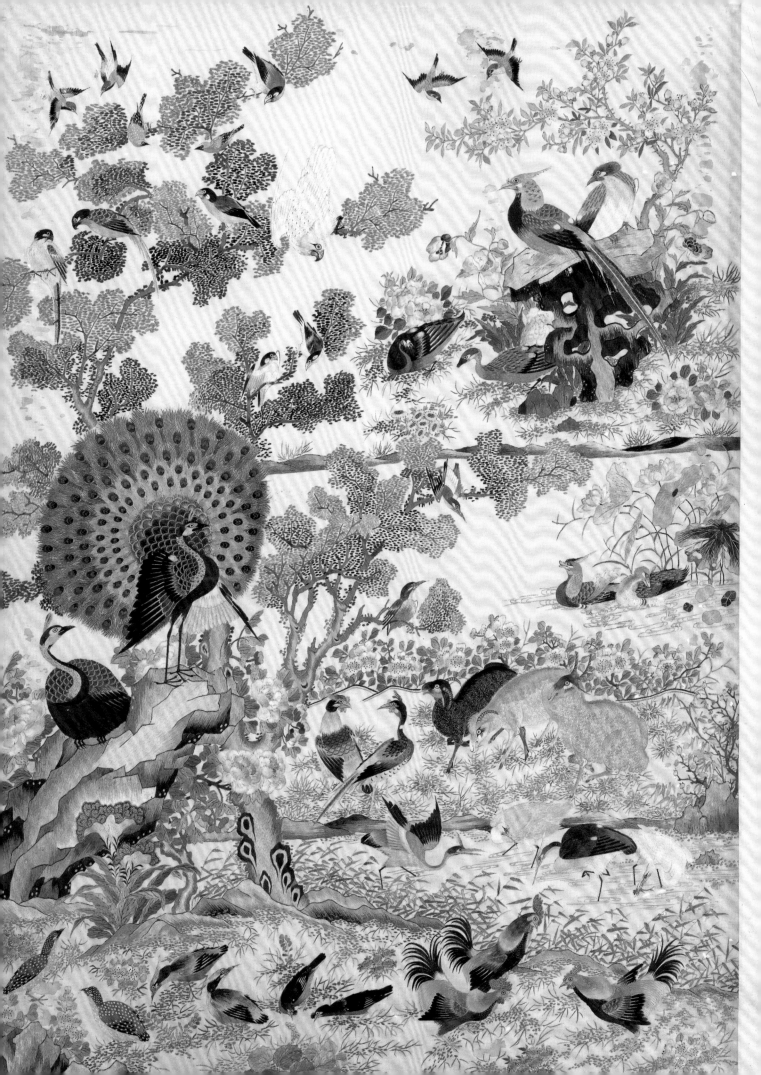

242

Mounted Fragment
of the Picture of *San Yang Kai Tai* in *Guangxiu*

Qing Dynasty Qianlong period

Vertically 67 cm Horizontally 52 cm

The mounted fragment shows the embroidery of three goats standing on a ground of off-white satin. In between are green plants and birds of good omen. In the sky is a bright red sun overhead. It is a spring scene of harmony and all things grow and thrive.

The *Book of Change* says, "The first month is a symbol of peacefulness, and three *yang* lines form the lower trigram." At this time winter ends and spring begins, *yin* waning and *yang* waxing. It is a time of good fortune. Thus folklore has it that the "three goats" symbolize the "three *yang* opening peace" (*san yang kai tai*) as a good saying to start the new year.

This picture is embroidered with the stitches of *bianzigu, niuzhen, kelinzhen, dazi, sachazhen, shimaozhen, zhazhen* and *fengchezhen*. The *bianzigu* (braid stitch) is employed in particular to achieve the texture of fleece standing up to enhance the three-dimensional feel. The colours are bright but not gaudy, the colour scheme is well coordinated, and the composition is opulent. It is a masterpiece of *guangxiu* (embroidery in Guangdong style).

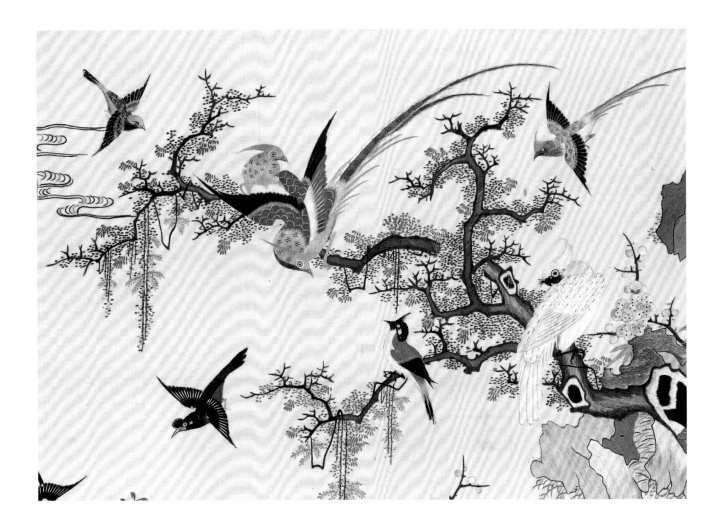

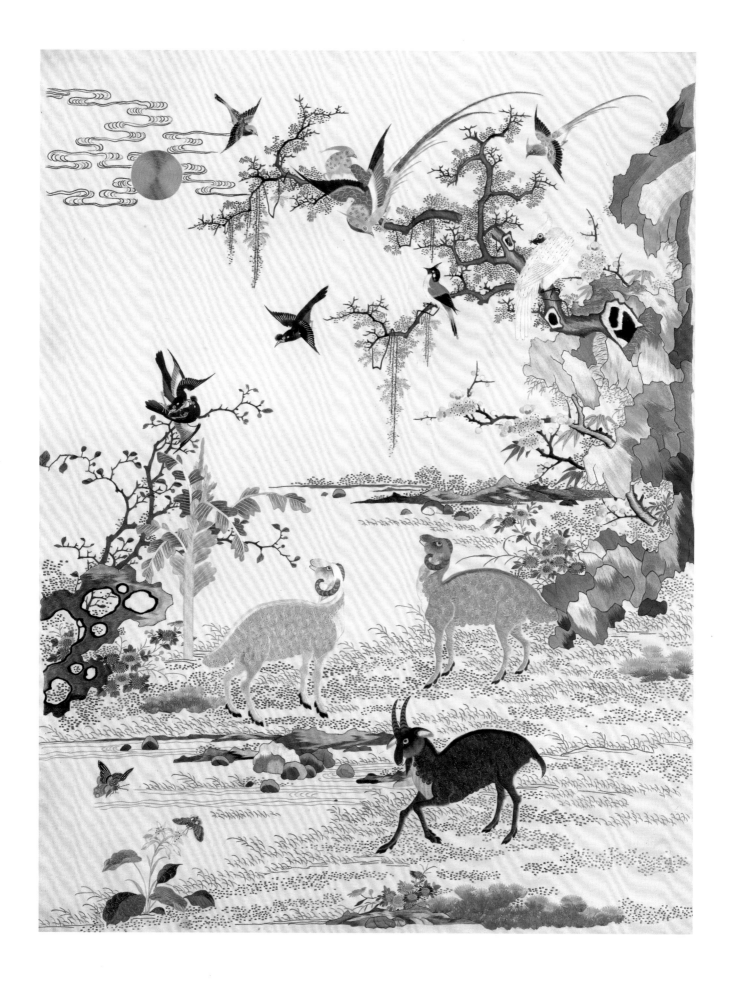

243

Mounted Fragment
of *Guangxiu* Picture Showing
Deer and Cranes Sharing
Springtime

Qing Dynasty

Vertically 68 cm Horizontally 52 cm

The embroidery shows a pair of dappled deer strolling leisurely under the green pines. Some celestial cranes fly around and some roost on the branches.

There are also plum blossoms, *lingzhi*-fungi, chrysanthemums and daffodils as well as quails, cocks and bats. The word for deer, *lu*, puns with six and crane, *he,* with agreement, thus *liuhe*, meaning six parts (east, south, west, north, above, and below) in agreement to say *liuhe tongchun* as a well-wishing phrase for longevity.

This *guangxiu* embroidery (embroidery in Guangdong style) has combined traditional Chinese *gongbi* painting (characterized by fine brushwork and close attention to detail) with the method of perspective in western painting. The texture of the muscles and the furs of the deer is expressed through the use of the minute stitches of *taozhen* and *shimaozhen*; while the cranes and cocks are embroidered with stitches like the *shimaozhen, taozhen, sizhen, dingzhen* and *kelinzhen* so as to achieve the effect of the arrangement and lustre of the feathers and plumes; while the rocks, trees and flowers are made with stitches such as the *sachazhen, fengchezhen, taozhen, qizhen* and *niuzhen*. The composition is opulent and the nuances are rich. The stitches are neat and fine and the colour scheme is gorgeous with very natural merging. All this surpasses even the beauty of brushwork.

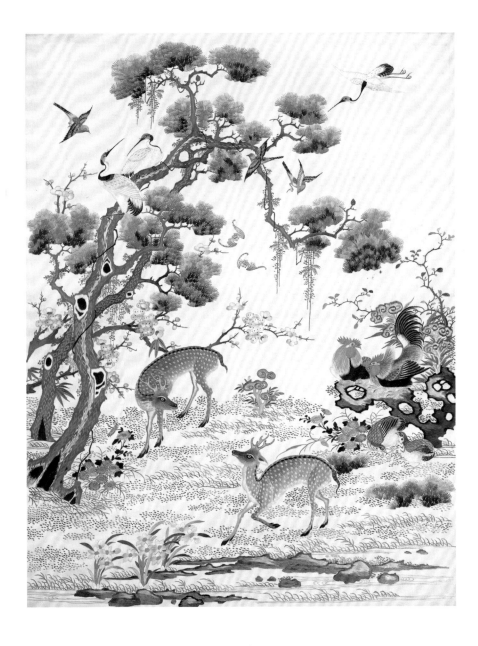

244

Court Fan

with *Shuangmianxiu* Showing Infants at Play and
Handle of Red Sandalwood Inlaid with Ivory

Qing Dynasty Qianlong period

Vertically 34 cm Horizontally 29 cm
Qing court collection

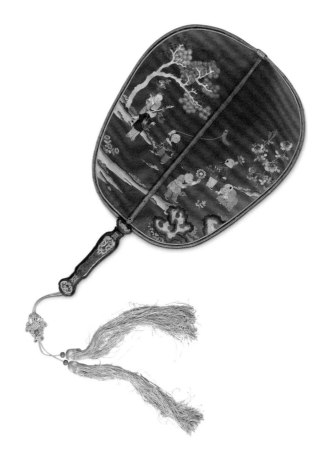

The court fan is a double-face embroidery on red plain silk
chou ground and it is identical on both sides. In the picture are
six small children playing, some holding a vase, some carrying a
long spear on the shoulder, some flying a kite, some holding up
some fruit, some holding a toy windmill and some spinning a top.
Decorations include pine trees, Chinese rose and Taihu stones. All
this is to imply a lot of children and happiness and that all is well.

The stitches employed in the embroidery include the *santao,
gunzhen, canhexian* and *pingtao*. The embroidery is done on
both faces and there is no trace of any loose threads or knots. The
craftsmanship is consummate and a masterpiece of *suxiu* (Suzhou
embroidery).

Shuangmianxiu (double-face embroidery) is embroidery
showing the same colours and designs on both faces of the material
and done at the same time. It is unique to *suxiu*.

245

Court Fan

with *Shuangmianxiu* Showing Pines and Cranes
for Longevity and Black Lacquered Handle

Qing Dynasty

Diameter 25 cm
Qing court collection

The court fan is a *shuangmianxiu* (double-face embroidery) on
white twill tabby *ling* ground showing two celestial cranes strolling
leisurely under a pine tree. All around, on the slopes, are auspicious
flowers and herbs, composing a picture of "pine and crane for
longevity" (*songhe yannian*) to imply the wish for long life.

The pine tree on the fan is embroidered in *taozhen* and the
flowers and herbs in *xiechanzhen* and *zhichanzhen*, while the
outline of the slope is traced in *gunzhen* and the long legs of the
celestial cranes in *zhazhen*. The quietly elegant colours and the
open and candid composition are effectively decorative.

246

Scroll

of Embroidery with Closely
Sewn Beads in *Dazizhen*
Stitches to Show Picture
of *Bogutu*

Qing Dynasty Jiaqing period

Vertically 71 cm Horizontally 35 cm

This work is an embroidery on a
ground of cream-coloured *chou* plain
weave, showing flowers in a vase,
the Buddha's-hand melon (*foshou*), a
ceremonial jade disc and stationery to
form the picture of embracing all antiquity
(*bogutu*), implying good taste and nobility.

The composition is open and candid
and the stitches vary from *taozhen* for the
vase and basin, to *panjin* and *dingzhen*
for the lozenge pattern of the seat, and to
qizhen for the ceremonial jade disc. The
outline of the silk ribbons is traced with
double-filament twisted yarns; the head of
the ribbons, the Buddha's-hand melon, and
the peony buds are made with *dazizhen*
(seed-packing) stitches; the peony leaves
are embroidered in *qiangzhen* with duo-
coloured threads, and the peony petals are
embroidered with closely sewn beads.

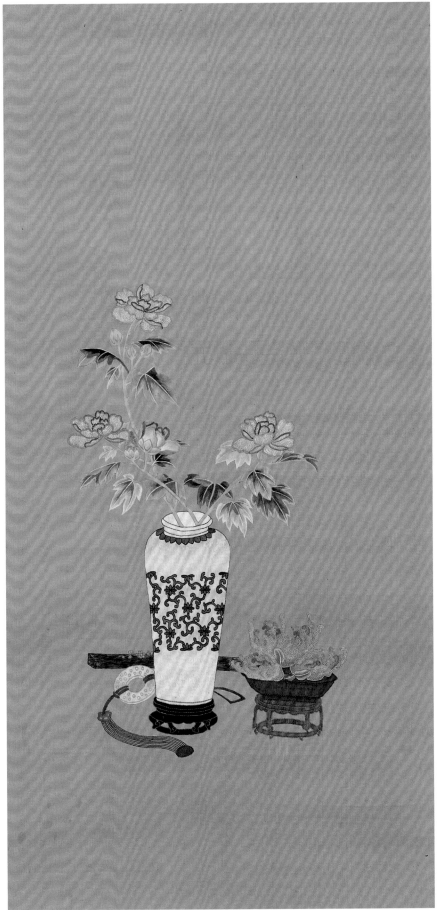

247

Scroll
of Hair Embroidery Showing Bodhidharma Crossing the River

Qing Dynasty Kangxi period

Vertically 65 cm Horizontally 32 cm

The picture embroidered depicts the scene of Bodhidharma crossing the river on a reed leaf. He lifts his clothes with his left hand, carries on his shoulder a pole for shoes and treads on a reed branch, while his clothes and scarf wave in the winds. On the left upper corner is embroidered a folk-song. The last two seals embroidered in red are indecipherable.

Bodhidharma is the initial patriarch of Chan (or Zen) Buddhism. A native of south India, he navigated to Guangzhou during the period of the Southern Dynasties and later went up the river to reach Northern Wei, where he travelled around and taught Chan Buddhism in Luoyang and Songshan. His influence is long lasting, and thus the allusion to "Bodhidharma Crossing the River."

Hair embroidery is embroidery done with human hair instead of silk threads. Even though some of the hair straws in this embroidery have already dropped and got lost, the lines and tones of the picture are still vivid. This sample is an outstanding piece of hair embroidery from the Qing period.

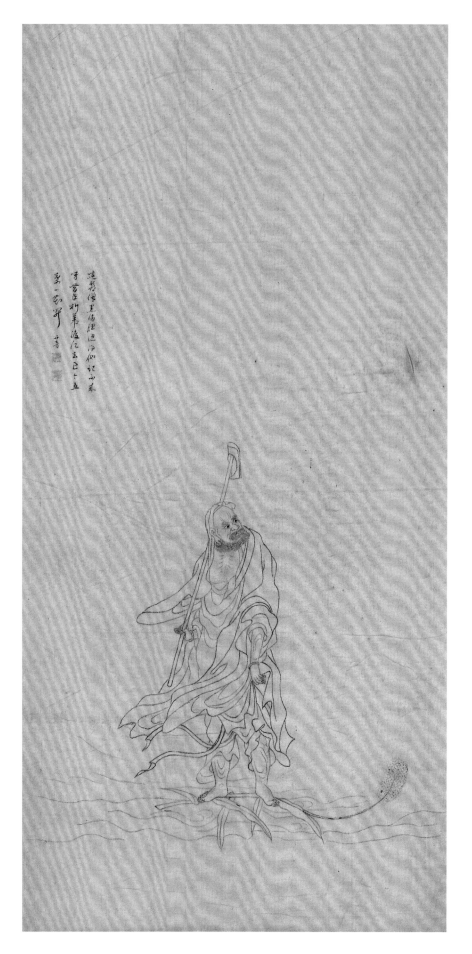

248

Scroll
of Picture of Celestial Deer
in Straight-warp
Gauze in *Nasha*

Ming Dynasty

Vertically 29 cm Horizontally 26 cm

The picture is based on a gauze ground of two warps interlocking and a celestial deer embroidered in traditional *suxiu* (Suzhou embroidery) method with perpendicular stitches of single-filament threads in a string. The deer lies quietly in peaceful composure and its back is decorated with tortoise shell design. Its surroundings are adorned with *ruyi* clouds and under them are waves lapping the shore. Both the top and the bottom of the picture are embroidered inscriptions of Emperor Qianlong's acclaim.

The celestial deer is a mythic auspicious animal from antiquity. According to legend, only when the world is peaceful and a sagacious and virtuous monarch appears would the celestial deer surface. Therefore, it is a symbol of heyday.

Nasha (close tight stitches) is also called *naxiu*. It is based on a plain gauze weave ground on which to embroider patterns with multi-coloured threads. This picture is embroidered in neat and minute stitches; its colour scheme is elegant and mild, and its merging of colours in gradation is very natural. It is a highly decorative work.

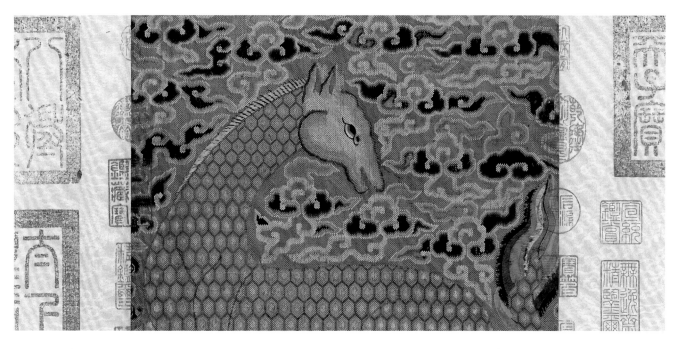

古蘊華含

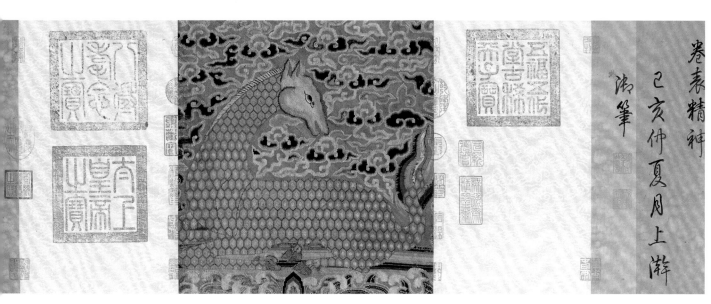

卷表精神
己亥仲夏月上澣
御筆

249

Scroll
of Picture of Spring Buffalo Embroidered in *Nasha*

Qing Dynasty Qianlong period

Vertically 35 cm Horizontally 92 cm

The picture of a spring scene is embroidered in *nasha* (close tight stitches) on an undyed square-mesh *sha*-gauze ground of natural colour. In the foreground are pavilions with corridors, willows in verdancy, flowers blooming and people enjoying outing in nature. In the distance are green hills and at their foot are children flying kites and buffalos plodding on leisurely.

The composition is beautiful with the people and the scenery in harmonious order. The craft involves two colours merging alternately in gradation and slanting stitches in a string. The stitches include *qizhen, taozhen,* and *pingjin,* and the light and shade are made out with two silk yarns of different colours.

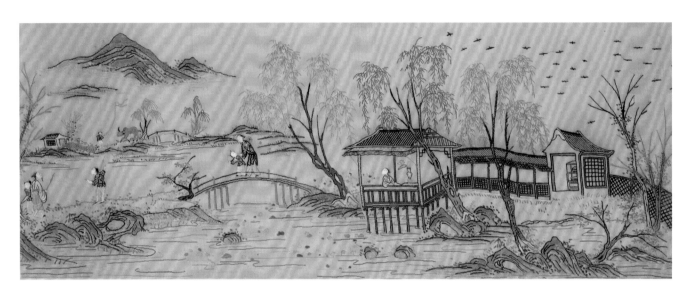

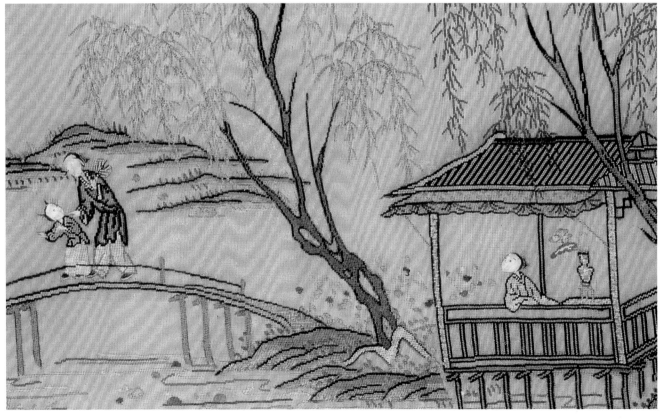

250

Embroidery
in *Duiling* Showing Ushnishavijaya

Qing Dynasty Qianlong period

Vertically 61 cm Horizontally 45 cm
Qing court collection

The Ushnishavijaya has three faces and eight arms. She wears a crown of jewels, has her hair down to her shoulders and clad in heavenly garments of various colours. With her right hand holding a double vajra in front of her chest she bears a diamond noose in her left hand. Other hands on the right carry the Vairocana Buddha incarnation and the arrow and making the sign of alms-giving, while on the left are hands making the sign of fearlessness and carrying a bow and holding the precious jar. She sits cross-legged on a lotus throne drifting and floating on rough waves. Above is the blue sky with auspicious clouds and the sun and the moon reflecting each other's light.

The Ushnishavijaya is the incarnation of Vairocana, the Amitayus Buddha and the White Tara, known collectively as the three longevity deities in Tibetan Buddhism and therefore symbols of happiness and long life.

This thangka in *duiling* (pile-up silk twill tabby) uses a blue satin ground on which to make a Buddhist picture by sewing on other silk damask textiles such as *ling, chou, duan* and *sha* in piles and adding in other embroidery stitches to create convex images. On the reverse side is white *ling* twill tabby and an inscription in ink made out in the four languages of Han, Man, Meng and Zang (Chinese, Manchurian, Mongolian and Tibetan).

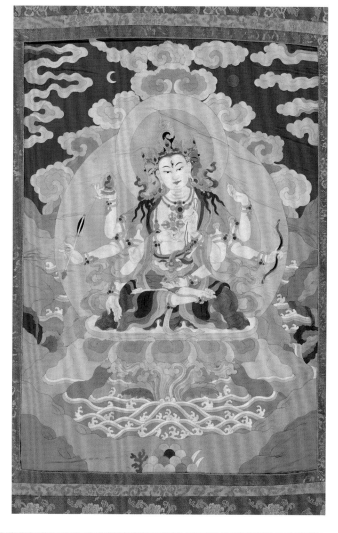

251

Album
of Emperor Tang Minghuang and Imperial Concubine Yang Guifei in the Opera *"Changshengdian* Hall" Embroidered in *Duiling* Collage

Qing Dynasty Guangxu period

Vertically 39 cm Horizontally 33 cm
Qing court collection

The album contains embroidery of the personae in stage costumes in the Peking opera "Changshengdian Hall." (Hall of Eternal Life) The emperor Tang Minghuang wears his crown and a mask with three whiskers, dons a bright yellow cape with dragon roundels and hold a fan, while the imperial concubine Yang Guifei wears a phoenix crown and a shawl of clouds over her shoulders and dons her courtly garments fully decorated with flowers. On the side of the portrait are their names.

This album is made on a blue satin ground with a collage of bits of *ling*-twill in various colours to make out the human figures, stuffed to make them stand out. Colours are subsequently painted on, and glazed glass (*liuli*) beads, floss balls and ribbon tassels are then added for decoration.

Duiling (pile-up silk twill tabby) is a technique of embroidery. It pastes small bits of *ling* twill tabby of various colours and cut in various shapes to form together a pattern; the borders of which are sewn tight with silk threads.

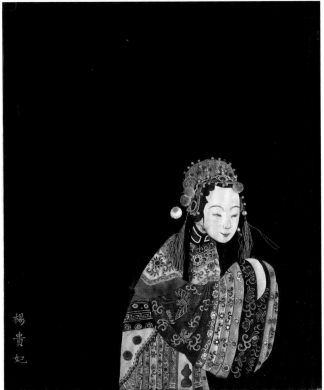

252

Screen
with Pictures of the *Yutang Fugui* in Full View
(Twelve Folds)

Qing Dynasty Qianlong period

Vertically 225 cm Horizontally 63 cm
Qing court collection

The screen has twelve folds with flowers and birds embroidered in perspective on a ground of azure blue plain satin. The plants include the peony, magnolia, crabapple and bamboo, and among the flowers and trees are Taihu stones, flying fowls and herbs, implying "*yutang fugui.*" (wealth and nobility in the hall of jade, or "Jade Hall of Opulence")

The screen can form a full view with all twelve folds together or each separately as an independent picture. The composition is rich and the colour scheme beautiful. The picture is detailed and fine and the embroidery pursues relentlessly an effect of gorgeous opulence by making use of all the virtues of different schools of the craft. It is a typical product of courtly embroidery from the Qing period.

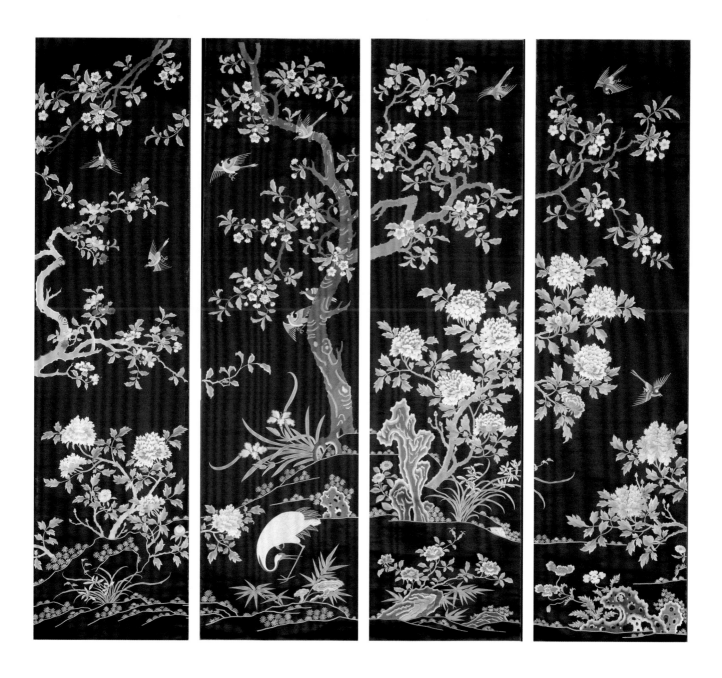

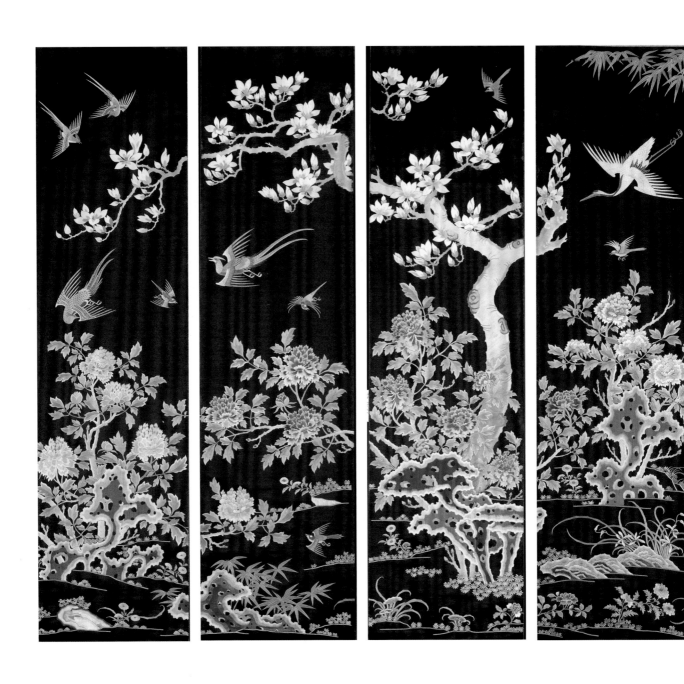

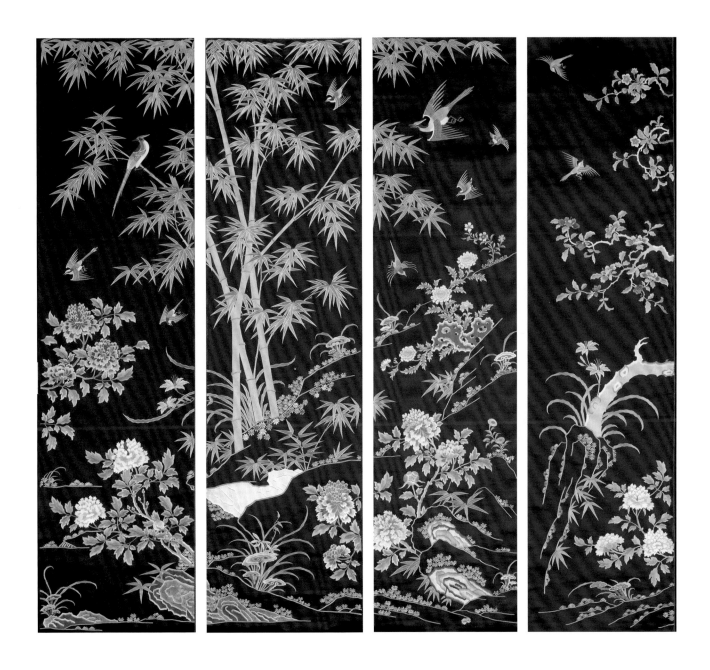

253

Embroidery Showing Scroll
of Still Life of Flowers by Emperor Qianlong

Qing Dynasty Qianlong period

Vertically 36 cm Horizontally 96 cm
Qing court collection

The embroidery shows the still-life painted by Emperor Qianlong of flowers like the plum blossom, the apricot blossom, the peach blossom, the peony, the crabapple and the daylily. At the end of the scroll is written "with the emperor's brush in the Chan (Zen) chamber at mid-spring in the year of *wuzi*." In red embroidery are the seals for "ink brush of the imperial palace of Qianlong" and "jixia lin chi." At the head of the scroll embroidered in red are the seals for "ink brush of the imperial palace of Qianlong" and "xintianzhuren." *Wuzi* was the 33rd year of Qianlong's reign (1768).

This scroll is embroidered in stitches like the *pingtao, dieqiangzhen, xiechanzhen* and *dazi*. The composition is brisk and neat and the colour scheme clear and bright. Its tone is quietly elegant and its style delicately simple.

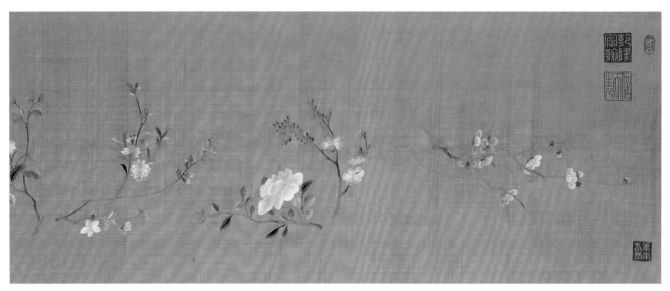

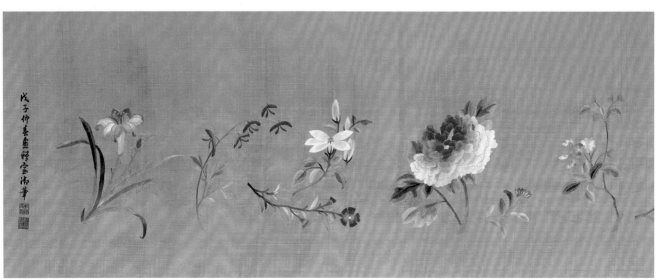

254

Scroll
of Embroidered Portrait of Guan Yu

Qing Dynasty Qianlong period

Vertically 117 cm Horizontally 43 cm
Qing court collection

The embroidery shows red-faced Guan Yu twisting his beard and sitting on a bluestone covered with tiger skin and dark-faced Zhou Cang holding his long-handled *yanyue* knife carved with blue dragons standing behind in waiting. On the upper part is an inscription of acclaim. In red are embroidered the seals for "predecessor a tiger head," "kowtow" and "Green Jade Studio."

This picture is embroidered with stitches like *santao, panjin, dazi* and *dingzhen*. The folds in the clothing with their creases and shades are expressed by the variation of dark and light hues of the threads' colours, giving the sense of nuances. The texture of muscles is vividly made out by subtly mastering the minute transitions between closely related colours on the human faces.

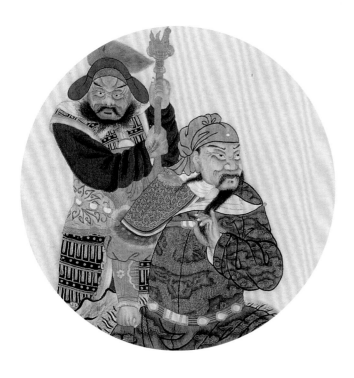

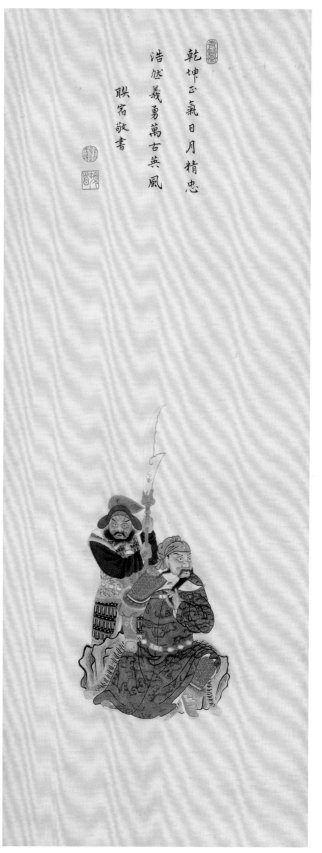

255

Scroll
of Embroidered Picture
of Paradise with
Qianlong's Acclaim

Qing Dynasty Qianlong period

Vertically 290 cm Horizontally 148 cm
Qing court collection

This embroidery of the Buddhist paradise is made on a ground of plain-weave silk *chou*. Amitabha is in the middle. On either side in waiting are Bodhisattva and Mahasthamaprapta; around them are lokapalas, arhats, warriors and musicians forming layers of protection and totalling 297. These are folied by halls and pavilions, precious trees, lotus blossoms and auspicious birds. In the magic pond is embroidered Qianlong's inscription in Chinese, Manchurian, Tibetan and Mongolian and "acclaimed by the Emperor in the month of *zhonghuan* at Mid-spring in the year *renyin*." Embroidered in red are the seals for "Qian" and "Long." *Renyin* was the 47th year of the reign of Qianlong (1782). Mid-spring month of *zhonghuan* denotes the middle of the 2nd month in the lunar calendar.

This embroidery has employed over ten different stitches. The craftsmanship is exquisite; the composition is finely tuned and well ordered; the needlework is ethereal and delicate and the colour scheme is gorgeous. It is a masterpiece of court embroidery from the period of Qianlong.

Amitabha is also known as Amitabha Buddha or Amitayus Buddha. It is recorded in the Mahayama Sutra that Amitabha made a wish to set up a pure land of the west to help all sentient beings to become enlightened and succeeded in achieving boundless dignity and virtue. Thus Amitabha commands great respect and becomes broadly propagated.

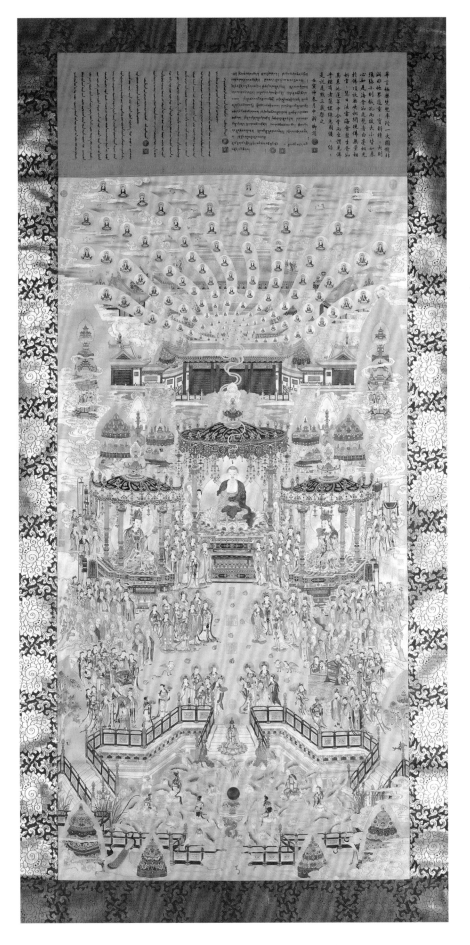

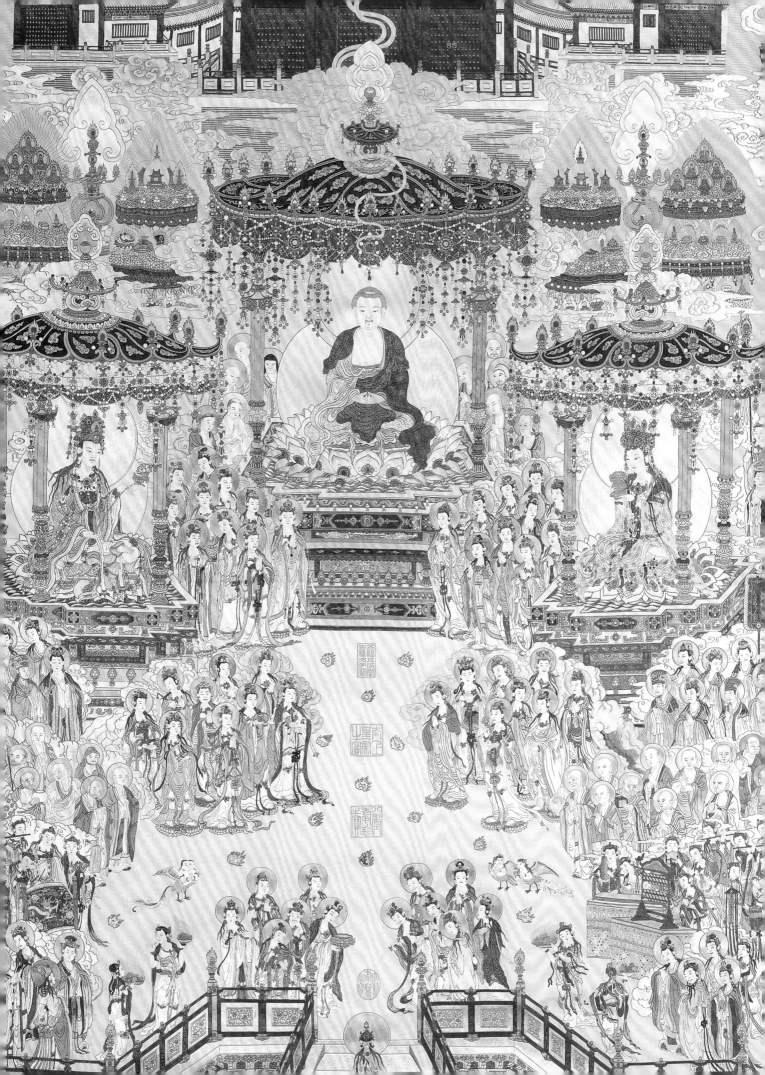

256

Embroidered Scroll
of Portrait of Amitayus Buddha with Inscription by Emperor Qianlong

Qing Dynasty Qianlong period

Vertically 169 cm Horizontally 61 cm
Qing court collection

The picture of Amitayus Buddha is embroidered on a ground of blue plain-weave silk *chou*. The Buddha sits cross-legged on a lotus throne holding a lotus blossom in his hand. Overhead is a lotus canopy and behind is the ligtht of Buddha. On one side, embroidered in gold threads is the message of acclaim by Emperor Qianlong, saying, "Acclaimed by the emperor in the month of *zhonghuan* at Mid-spring in the year *dinghai*." In red are embroidered the seals: "Qian" and "Long." Dinghai was the 32nd year of Qianlong's reign (1767).

The needlework of this portrait is extremely fine and smooth. The main stitch is *zhengqiangzhen* and the grain is very lucid and neat. The Buddha's light embroidered in *pingjin* accentuates the image of Buddha in golden radiance. Other stitches used are *xiechanzhen, wangzhen* and *dingzhen.* The colours are rich and the threads gorgeous. The merging of colours in gradation is exquisite. The colours are bright without losing a well-blended harmony.

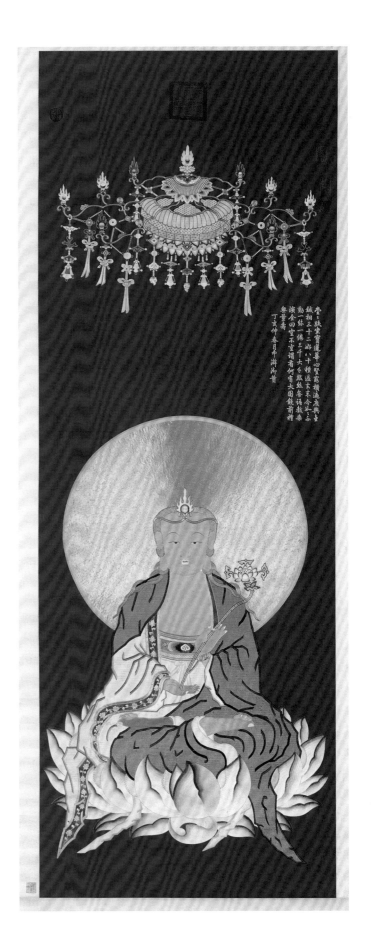

257

Scroll
Showing Avalokitesvara Embroidered by Wang of Jiang Clan (Jiang Wang Shi)

Qing Dynasty Qianlong period

Vertically 96 cm Horizontally 52 cm
Qing court collection

This is a picture of Avalokitesvara embroidered on light green satin. She is holding a willow sprig with a calm and composed countenance. By her side is a white parrot holding rosary beads between its beaks and fluttering its wings to take flight.

This portrait is embroidered in stitches like *qizhen, taozhen, chanzhen, wangxiu, dingxian* and *pingjin* with a single colour in gradually changing shades, while the hair and the eyebrows of the Avalokitesvara are brushed on with ink. The threads are split fine and the lines fluent. Most outstanding is the parrot, which is embroidered in fine and neat stitches with rich nuances and paths in embroidery as if the bird were coming alive.

Jiang Wang Shi was the wife of Jiang Pu (1708–1761) the senior secretary to the emperor during the reign of Qianlong of the Qing Dynasty. She was adept at the art and craft of embroidery. Avalokitesvara, is also called *Guanshiyin* or *Guanzizai Pusa*, being the Buddhist symbol of Compassion and Wisdom and one of the three saints of the west, and occupying a supremely important position in Mahayana as well as folk Buddhism.

258

Scroll
of Avalokitesvara with a Thousand Hands and a Thousand Eyes Embroidered in *Manxiu*

Qing Dynasty Qianlong period

Vertically 75 cm Horizontally 50 cm
Qing court collection

On a ground weave of undyed satin in natural colour is embroidered an Avalokitesvara with a thousand hands and a thousand eyes standing on a seat of lotus holding a Buddhist instrument. Overhead in the sky are other buddhas circling around. In the lower part on left and right are Tsong-kha-pa and Dalai Lama.

The Avalokitesvara with a Thousand Hands and a Thousand Eyes is also called the Avalokitesvara with a Thousand Hands, Avalokitesvara with a Thousand Arms and Avalokitesvara with Eleven Faces, being one of the thirty-three incarnations of Avalokitesvara. The meaning is to protect all sentient beings with a thousand hands and to watch over the human world with a thousand eyes.

Manxiu (full-covering embroidery) is embroidery that covers the ground fully with stitches of embroidery without revealing any part of the ground weave, being the most elaborate of embroidery. Stitches employed in his scroll include the *qizhen, qiangzhen, taozhen, jixian, pingjin, chanzhen* and *dingxian*. Parts of it are dyed with colours merging in gradation. The composition is opulent and the colour scheme gorgeous. It is a masterpiece of "full embroidery" (*manxiu*) from the Qing Dynasty. The lower part of the portrait is adorned with white silk twill tabby (*ling*) on which is written an inscription in Chinese, Manchurian, Mongolian and Tibetan.

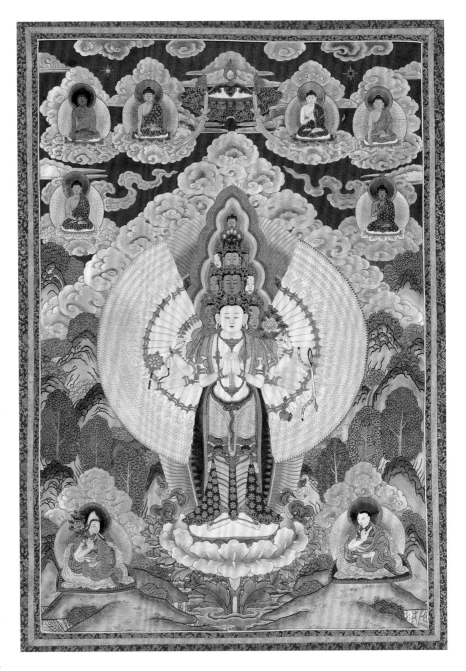

259

Scroll
of Maitreya Embroidered in *Manxiu*

Qing Dynasty Qianlong period

Vertically 60 cm Horizontally 34 cm
Qing court collection

The picture depicts the scenes of Maitreya helping sentient beings in the mortal world to get enlightened and inheriting the dharma in heaven. The embroidery depicts some eighty figures including the *Milefo* (Maitreya), the grub thob chen po (Great Achiever), Atisha and the heavenly musicians.

Maitreya is also called *Mile Pusa*, being a disciple of the Great Buddha and entering nirvana before Buddha. He was born in the inner court of Tusita and Sakyamuni predicted that he would become Buddha after passing, for he was both a *Pusa* (bodhisattva) and a *Weilaifo* (Maitreya) and thus manifests both the image of Buddha and the image of Bodhisattva.

This portrait is embroidered in *manxiu* (full-covering embroidery) with stitches like the *taozhen, qizhen, dingzhen, pingjin* and *bianzhen*. The needlework is exquisite and the colour scheme very rich. The outline is traced with *jixian* and *jinxian*, achieving the effect of radiance in the portrait. It is an embroidery masterpiece from the reign of Qianlong of the Qing period. On the reverse side on the white *ling* fabric is written an inscription in Chinese, Manchurian, Mongolian and Tibetan.

260
Embroidery
of Secret Buddha of
Father Tantra

Qing Dynasty Qianlong period

Vertically 93 cm Horizontally 68.5 cm
Qing court collection

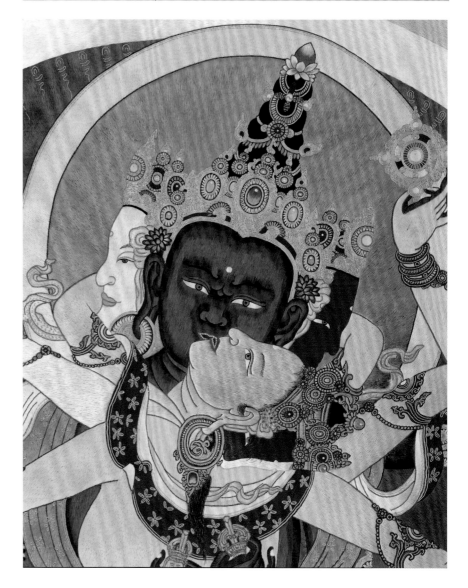

This embroidery shows the Secret Buddha with a male body showing a blue sign of Karmamudra (twin body), three faces and six arms. The main arms embrace his prajna Sparshavajri and hold in each a diamond club and a diamond bell, symbolizing method and wisdom. On the right the hand holds a dharma wheel and picks a lotus blossom, while the left hand holds the precious Mani pearl and a sword. He sits cross-legged on a lotus throne. In the upper part are Great Vajradhara, Nagarjuna, Gelug, Marpa Lotsawa and Satkaya-darsana; in the lower part are Mahakala and Brahmana.

The Secret Buddha is *Miji Jingang* (Guhyasamaja), also known as *Jimi Jingang*, and the Qing court called him "Secret Buddha in a Male Body," representing the "Buddhas of Three Generations, (i.e. the past, the present and the future) with the three mysteries of the symbol, the word and the mind being gathered as undifferentiated." It is the honourable Upaya as one of the five honourable supreme Yoga deities in Tibetan Buddhism.

This thangka is embroidered with stitches like *pingjin, pingxiu, santao* and *dingxian.* On the reverse side is white twill tabby *ling,* on which is written an inscription in ink in Chinese, Manchurian, Mongolian and Tibetan.

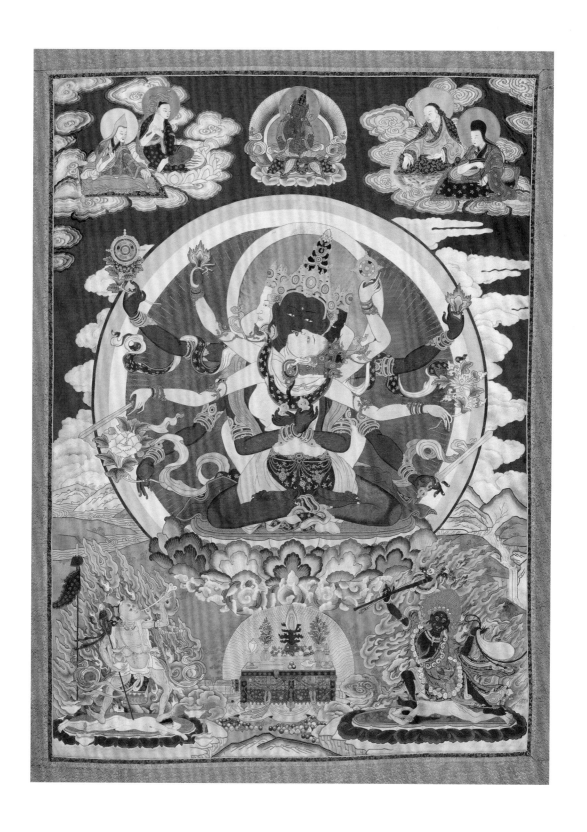

311

261

Embroidery
of Shamvara of Mother Tantra

Qing Dynasty Qianlong period

Vertically 93 cm Horizontally 68.5 cm
Qing court collection

The Shamvara of Mother Tantra (*Shanglewangfo*) is also known as Shamvara Buddha. She makes the blue sign of karmamudra (*shuangshen*), and has four faces and twelve arms. She wears a crown of skull to show immanence and valiance. On her back is the skin of a white elephant and round her waist is a belt of tiger skin to show fearlessness and bravery. Around her neck hangs a necklace of beads made of human skulls to show the full set of Buddhist sutras. The twelve double-handed arms symbolize the twelve truths and there is a Buddhist instrument in each hand. The main arms hold Vajravarahi stretching out her right leg to step on a man and a woman, to show the conquest of anger and sexual desire. In the upper part are the Indian Great Achiever (grub thob chen po) and Lama of Dge-lugs-pa and in the lower part is Mahakala with six arms.

Shanglewangfo is also called *Shengle Jingang*. Since she belongs to the matriarchal of the Supreme Yoga, the Qing court called her "*Shanglewangfo* with a female body." She is collectively revered by various sects of Tibetan Buddhists such as Satkaya darsana and Gelug.

This thangka is embroidered in the stitches of *pingjin, dingxian, pingxiu and taozhen*. The reverse side is white *ling* twill tabby, on which is written an inscription in ink in Chinese, Manchurian, Mongolian and Tibetan.

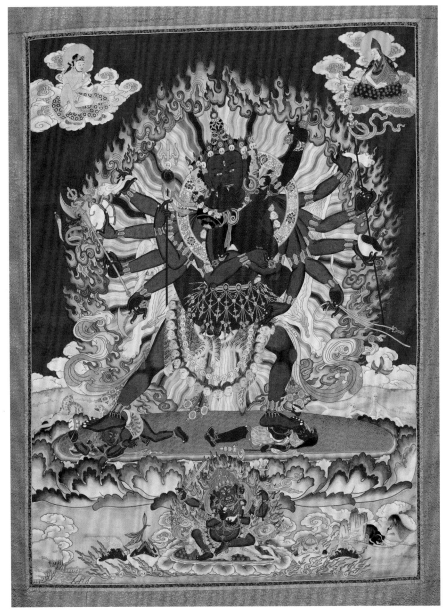

262

Embroidery
of Raktayamari with a Male Body

Qing Dynasty Qianlong period

Vertically 94 cm Horizontally 68.5 cm
Qing court collection

Raktayamari is the same as Yamantaka or Vajrabhairava. He makes the sign of the twin image of Karmanudra and has nine faces, thirty-four arms and sixteen feet. His main face is a bull's head, on top of which is the smiling face of Manjusri (*Wenshu Pusa*) to show the image of valiance. His main arms embrace the white *Mingfei* Vidyadhari and his hands holds some Buddhist vessels to show wisdom, valiance, firmness and supreme might. The eight feet spread out and the right ones step on beasts symbolizing the eight achievements, while the left ones step on birds, to symbolize the eight self-existences of quietude. Under the eight beasts and the eight fowls are *tianwang* and *mingfei*. In the upper world are two Indian Great Achievers, and in the underworld is Yama (King of Hell).

The Yamantaka (*Daweidebuwei Jingang*) is also known as *Daweide Jingang*, being one of the five honourable deities in the Supreme Yoga and belongs to the patriarch continuation, representing the valiant image of Manjusri (*Wenshu Pusa*).

The colour design of the silk threads in this thangka combines the gradually receding and merging techniques. The stitches employed include the *pingxiu, dingxian, pingjin, santaozhen* and *xiechanzhen*. Details are slightly touched up with ink. On the reverse white *ling* side is written an inscription in Chinese, Manchurian, Mongolian and Tibetan.

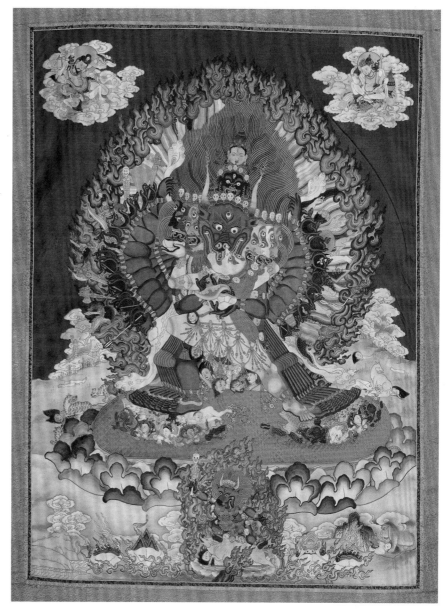

263

Embroidered
Portrait of Shri Devi

Qing Dynasty Qianlong period

Vertically 69 cm Horizontally 50 cm
Qing court collection

The Shri Devi has a blue body and a fierce look. She wears a crown of skull; her three round eyes stare widely and unsightly teeth stick out from her open mouth. Tassels hang from her skull crown. In her left hand is a kapala (skull bowl) full of child's blood and in her right hand she wields a warrior's hammer. At her waist is pinned on a plate for catching ghosts and she rides on a mule with three eyes wading through a sea of blood on which are skulls. This symbolizes that she has gone through the three worlds of heaven, earth and water. In the upper world are the warriors Guhyasamaja, Raktayamari and Shamvara Buddha. In the lower part are only various deities under the Shri Devi.

Shri Devi is also known as *Palden Lhamo* (the Auspicious Daughter of Heaven). She is the supreme Goddess Protecting the Dharma in the pantheon temple of Tibetan Buddhism.

This thangka uses only the method of gradually receding colours and the stitches involve the *pingxiu, dingxian, pingjin* and *xiechanzhen*. The fine details are touched up with ink. Around the portrait is a border of red gold satin decorated with golden characters for "longevity." The reverse side is white *ling* twill tabby. An inscription in ink is written in Chinese, Manchurian, Mongolian and Tibetan.

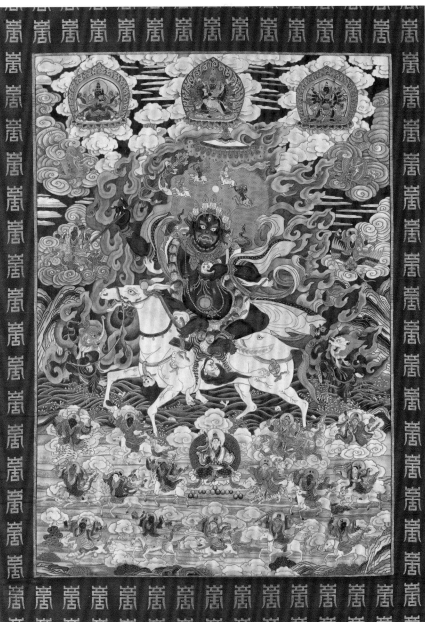

264

Embroidered Scroll
of the Hibiscus and the Auspicious Bird

Qing Dynasty　Daoguang period

Vertically 71 cm　Horizontally 35 cm

On a ground weave of undyed plain silk *chou* in natural colour is embroidered a hibiscus tree in full bloom, on which an auspicious bird with whitish brow is roosting. Under the tree are longevity stones and chrysanthemum flowers to imply wealth and long life.

This picture is embroidered entirely in multi-coloured silk threads. The variety of stitches is rich and the needlework is exquisite without being tainted with ink for augmentation. It is a rare sample of embroidery from late-Qing period.

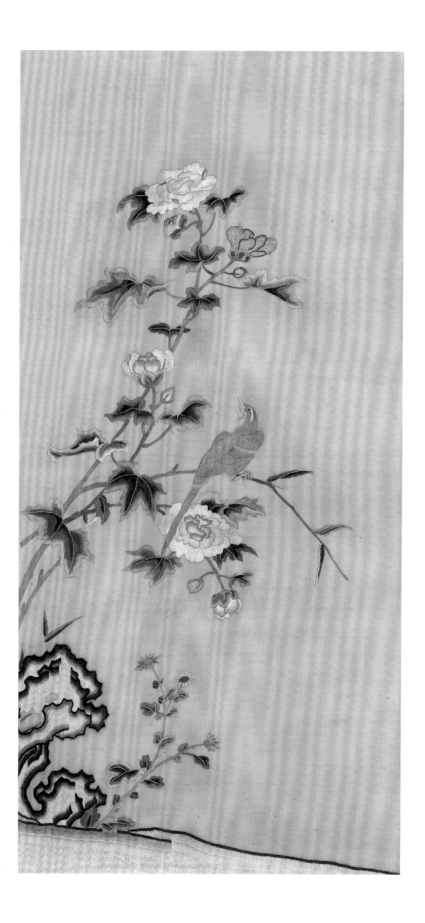

265

Knotted Pile Carpet
with Patterns of a Pair of
Luanfeng on Dull Red Ground

Ming Dynasty

Length 450 cm Width 435 cm Height of
pile 2 cm
Qing court collection

The face of the carpet is somewhat square. In the centre of the carpet is a *luan* and a *feng* flying towards each other. In between are sprigs of peony. *Luan* and *feng* are a pair of male and female mythic birds often appearing together. They are the symbol of loving man and wife, harmonious family, many offspring and prosperous clan, sometimes called "*luanfeng heming*."

This carpet specially reserved for the inner court Jiaotaidian Hall of the Ming Dynasty used to be spread on the ground of the Hall. The *luan* and *feng* have a big head and a narrow neck and their heads look like flowers with teeth-edges, showing the artistic style of the Ming Dynasty and corresponding with the dragon and phoenix decorations on the beams and the *luan* and *feng* patterns on the doors of the same Hall, implying "*luanfeng chengxiang*" (a fond couple in matrimony), and "*tiandi jiaotai*" (heaven and earth in peace) and showing the specific designs of the carpet in relation to the elements of the architecture.

The Jiaotaidian Hall was built during the reign of Jiajing of the Ming Dynasty. It is situated between the Qianqinggong Palace and the Kunninggong Palace. It was where two successive Ming empresses received their birthday gifts.

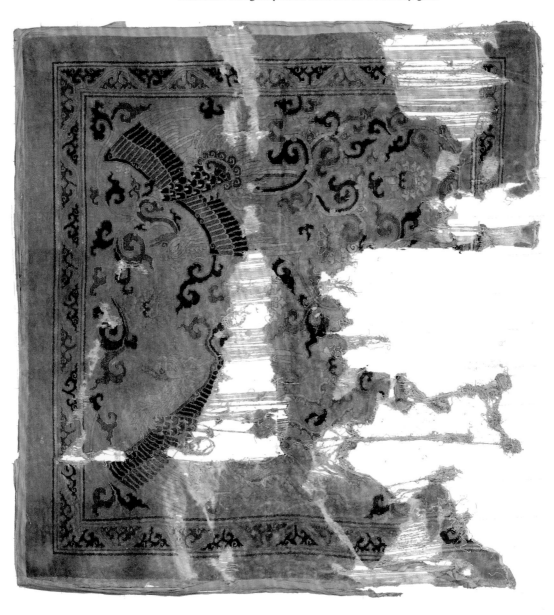

Knotted Pile Carpet
with the Patterns of Four Dragons on a White Ground

Qing Dynasty　Shunzhi period

Length 600 cm　Width 400 cm
Qing court collection

The carpet is rectangular and its composition shows reference to the dragon patterns from the Ming period. It is woven with the wool from the Mongolian sheep called *tanyang*, which is elastic or bouncy and comfortable to tread on.

Both the three great halls of Taihedian, Zhonghedian and Baohedian, and the halls of the inner court's Qianqinggong Palace would use carpets with dragon designs. This carpet was specially made for Qianqinggong Palace. But Emperor Yongzheng opined that "carpets with the dragon head is unsuitable for treading on. So all dragon carpets would be used for other purposes and no such carpets would need to be made for posterity." Thus for a long period during the reign of Yongzheng carpet weaving was suspended and not until the reign of Qianlong was the activity revived.

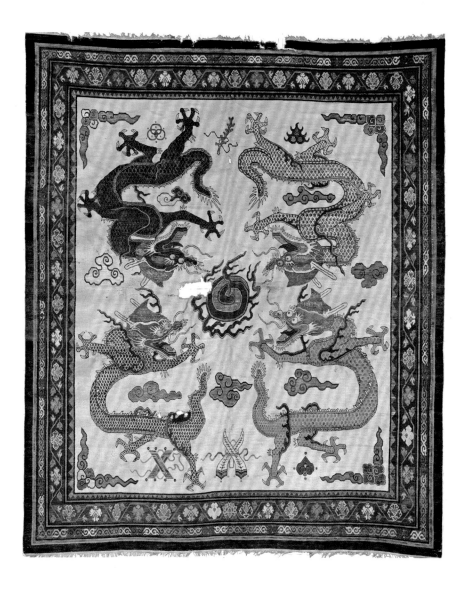

267

Knotted Pile Carpet
Woven with Gold Threads in the Middle and Silver Threads on the Fringes in Floral Pattern

Qing Dynasty Kangxi period

Length 346 cm Width 212 cm Length of tassels 12 cm
Qing court collection

The carpet is rectangular. On the face are horizontally arranged herringbone patterns woven with yarns of three twisted gold threads and two twisted silver threads. On the reverse are horizontally arranged herringbone patterns woven with yellow silk threads. The colours include black, green, blue, turquoise, beige, golden and pale blue. The contrast is strong but pleasing for the eye.

This carpet was made in Xinjiang region. Its surface is thin and level; the weave is fine, the pattern design elaborate and the colours splendid. Xinjiang carpets are known worldwide for its long history and advanced technique. Their designs, patterns and colours are all rich in national characteristics and Islamic cultural style.

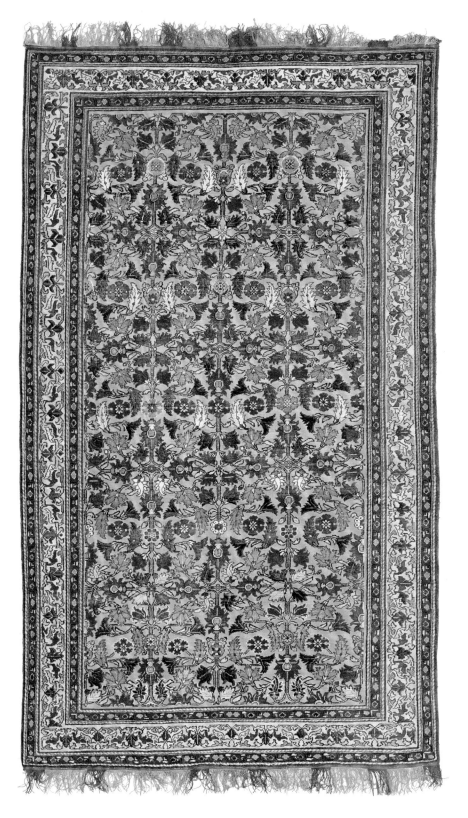

268

Knotted Pile Carpet
with Patterns of Clouds, Bats and *Kui*-dragons on a Blue Ground

Late-Qing period

Length 241 cm Width 155 cm
Height of pile 1.8 cm
Qing court collection

The carpet is rectangular. The ground weave is blue, on which are woven scattered clouds and bats and four *kui*-dragons in the corners as well as one in the centre of the carpet. The bats are red, the clouds alternately in blue and white forming a graded merging of two or three colours with nuances, which evokes an aesthetic sense of natural harmony.

Ancient colours were derived from plants and minerals, for example, the Tibetan saffron for red with a tinge of yellow, the bright blue in Ningxia carpets from indigo and olive green from the buds of the *huaishu* (Chinese scholar tree). These natural colours do not cause any damage to the wool and they even provide it with a coat of protection. Furthermore, with the passage of time, these colours become even softer and more beautiful.

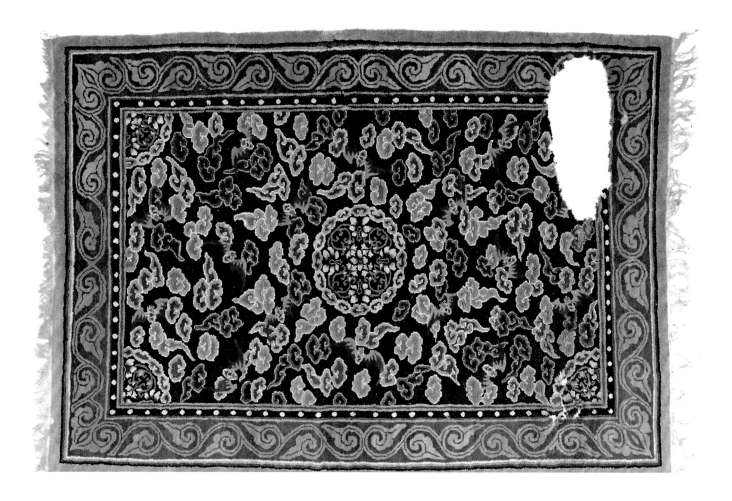

269

Knotted Pile Carpet
with Western Floral Patterns
on Cream-coloured Ground

Late-Qing period

Length 475 cm Width 318 cm
Height of pile 0.3 cm
Qing court collection

This British machine-woven carpet with pile loops is composed of the carpet borders and the carpet core. The face is covered with pile loops standing up. The texture is terse, level and bouncy, giving a comfortable feel to the feet. The core is decorated with knitted roses in red, green, blue, yellow, brown and white intertwined with coloured ribbons. The borders are also decorated with such ribbons.

Owing to the limitation of machines of the time, the width of machine-woven carpets from the period is narrow. Thus, court carpets of this category had often the core and the borders woven separately and put together according to requirement. This made it easier to have them in various places and their use became more flexible.

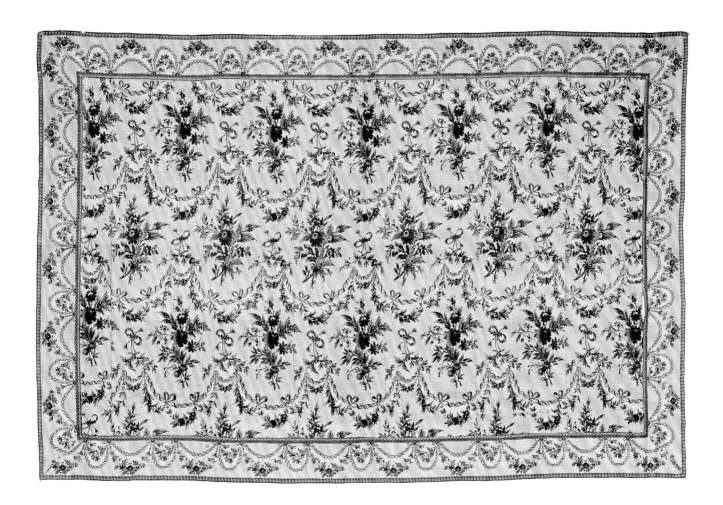

270

Kesi Carpet
with Patterns of Human Figures for the Window

Mid-Qing period

Length 366 cm Width 267 cm
Qing court collection

This carpet for the window combines the use of bright glossy silk threads with bold thick wool yarns. On the carpet is woven in *kesi* (cut silk) technique a new year scene of a traditional family gathering including fifty-six people. The carpet has two border decorations with the outer edge wrapped in black satin. Inside are decorations of continuous patterns of sprigs and sprays.

According to archive records, every winter, all doors, windows and inner walls of the palaces and halls in the Forbidden City would have to be covered with hanging carpets to keep warm. The window carpets were custom made to measure according to the dimensions of the windows, and they were thin and easy to roll and store. Like wall hangings, they could keep warm and beautify the environment. This carpet was the third product made specially for the northern window to the imperial chamber Yangxin Hall. The previous two whose sizes were not fitting became used for other purposes.

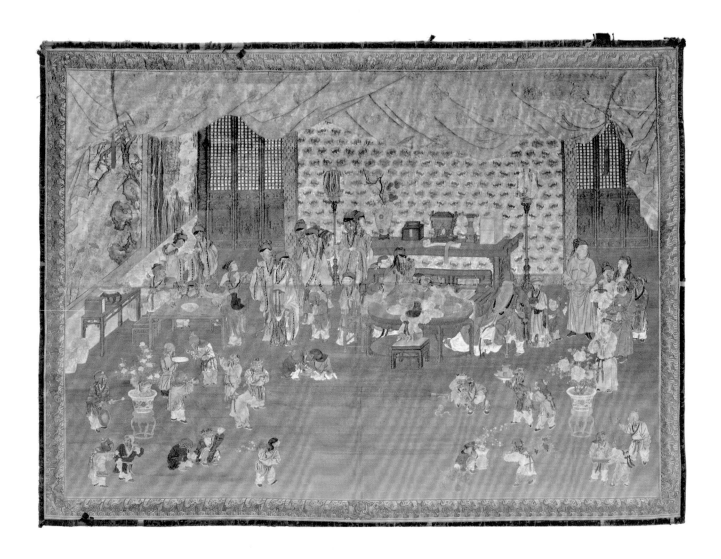

271

Wall Carpet
Made with Gold and Silver Threads in Coils to Make the Pattern *"Yutang Fugui"*

Qing Dynasty Qianlong period

Length 647 cm Width 278 cm
Qing court collection

The ground of this wall carpet is based on cotton warps and cotton wefts. The surface is woven with silk threads in over twenty colours combined by gradually merging two or three at a time to make pattern designs of *"yutang fugui"* (nobility and prosperity in the hall of jade) including the *lingzhi*-fungus, peony, bamboo, osmanthus, pomegranate and magnolia, together with butterflies and rocks. With the contrast of gold and silver threads they look opulent and gorgeous.

The blueprint for the patterns of this wall carpet was a sketch for a painting at the court of Qianlong and the work shows the high standard and art of carpet making of the period. Being both artistic and functional, it is a decorative article of high aesthetic value.

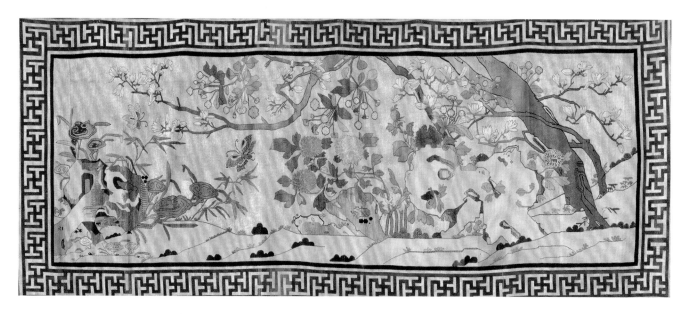

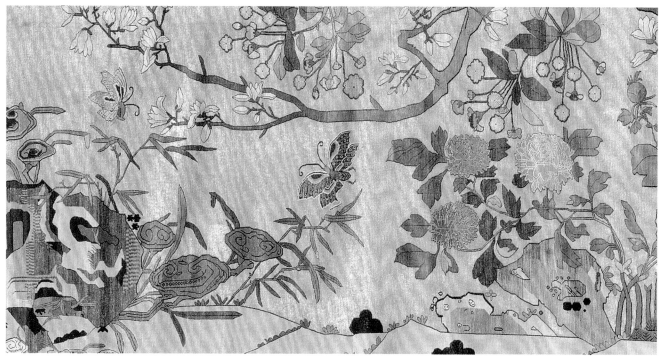

272

Knotted Pile Chair Panel

with Yellow Ground and
Patterns of Coiled Dragons

Late-Qing period

Length 180 cm　Width 88 cm　Height of
pile 0.8 cm
Qing court collection

The sitting part of the chair panel is rectangular and the part against the back is in the shape of the character for "mountain." (*shan*) The basic warps and wefts are both made of cotton with one coloured weft after every two wefts intertwining in the shape of "8" woven by the method of *choujiao*. A frontal dragon forms the main pattern foiled with auspicious clouds. Along the borders are dragon clouds and waves lapping against the shore. The patterns on the back-supporting part are made according to the requirement of its triangular shape, making neat but lively and natural curves.

This carpet has body and it was made in Ningxia region in accordance with the pattern designs as ordered by the court during the late-Qing period. The only blemish to its perfection is the use of chemical dyes, which are bright in colour but lack the softness and beauty of natural dyes made from plants.

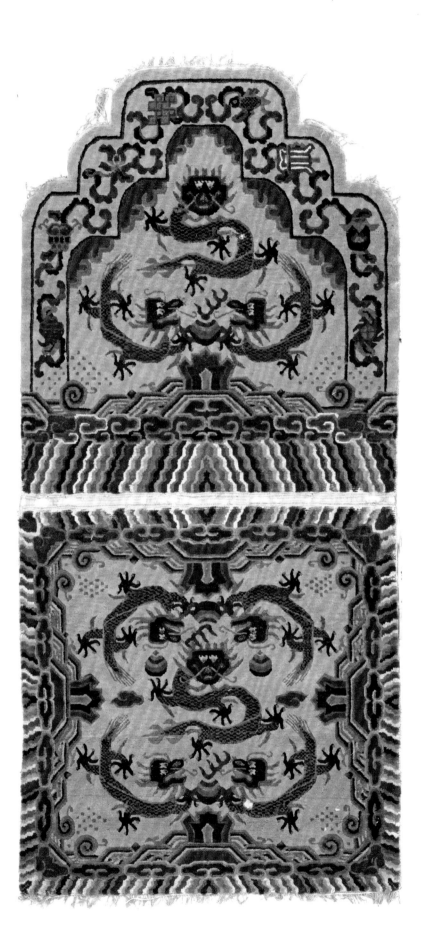

273

White Flannel Lining
of Curtain for a Jehol
Mongolian Yurt

Mid-Qing period

Length 540 cm Height 372 cm
Qing court collection

The main body of the curtain is made of *duoluo* wool with red floral patterns printed on a yellow ground. The lining is white flannel decorated on the reverse with turquoise silk tabby *chou*. The top edge is fringed with *duoluo* wool printed with black patterns on a red ground, leaving an opening in the middle and two on the sides for doors. The door in the middle is made of white *chou* that looks like wood. On the lintel is a painting made by the court painter Qian Weicheng and there is a poem by Emperor Qianlong is written in calligraphy by the calligrapher Yu Minzhong. On the sides are paintings by the court painter Fang Zong. On the panes are cloud dragons and waves lapping against the shore.

This yurt curtain is made of choice material for the emperor to be secluded inside the yurt. On its top at equal distances are hooks. The thick white flannel is good for keeping warm, while the *duoluo* wool surface made in the west is thin and light, being both decorative and convenient for mounting and dismounting.

The Qing emperors from Kangxi to Xianfeng went annually for hunting at the Mulan Ranch Reserve and practise the arts of archery and riding. When the emperor went hunting, they stayed in such yurts which were as comfortable as the palace with all the daily articles in place. Such curtains were also necessary for partitioning different spaces for various purposes.

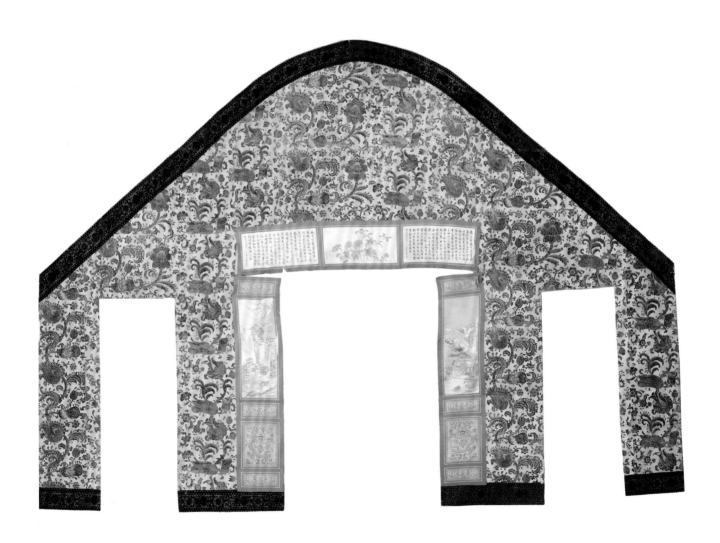

Dynastic Chronology of Chinese History

Xia Dynasty	Around 2070 B.C.—1600 B.C.
Shang Dynasty	1600 B.C.—1046 B.C.
Zhou Dynasty	
Western Zhou Dynasty	1046 B.C.—771 B.C.
Eastern Zhou Dynasty	770 B.C.—256 B.C.
Spring and Autumn Period	770—476 B.C.
Warring States Period	475 B.C.—221 B.C.
Qin Dynasty	221 B.C.—206 B.C.
Han Dynasty	
Western Han Dynasty	206 B.C.—23 A.D.
Eastern Han Dynasty	25—220
Three Kingdoms	
Kingdom of Wei	220—265
Kingdom of Shu	221—263
Kingdom of Wu	222—280
Western Jin Dynasty	265—316
Eastern Jin Dynasty Sixteen States	
Eastern Jin Dynasty	317—420
Sixteen States Periods	304—439
Southern and Northern Dynasties	
Southern Dynasties	
Song Dynasty	420—479
Qi Dynasty	479—502
Liang Dynasty	502—557
Chen Dynasty	557—589
Northern Dynasties	
Northern Wei Dynasty	386—534
Eastern Wei Dynasty	534—550
Northern Qi Dynasty	550—577
Western Wei Dynasty	535—556
Northern Zhou Dynasty	557—581
Sui Dynasty	581—618
Tang Dynasty	618—907
Five Dynasties Ten States Periods	
Later Liang Dynasty	907—923
Later Tang Dynasty	923—936
Later Jin Dynasty	936—947
Later Han Dynasty	947—950
Later Zhou Dynasty	951—960
Ten States Periods	902—979
Song Dynasty	
Northern Song Dynasty	960—1127
Southern Song Dynasty	1127—1279
Liao Dynasty	907—1125
Western Xia Dynasty	1038—1227
Jin Dynasty	1115—1234
Yuan Dynasty	1206—1368
Ming Dynasty	1368—1644
Qing Dynasty	1616—1911
Republic of China	1912—1949
Founding of the People's Republic of China on October 1, 1949	